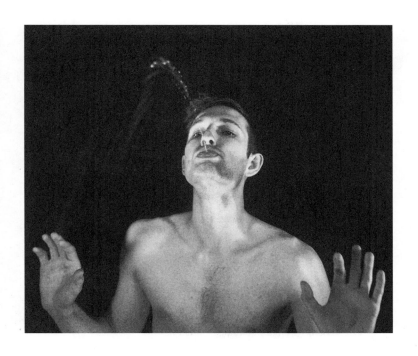

PAJ Books
Bonnie Marranca and Gautam Dasgupta
Series Editors

Art + Performance
Meredith Monk, edited by Deborah Jowitt
Rachel Rosenthal, edited by Moira Roth
Reza Abdoh, edited by Daniel Mufson
Richard Foreman, edited by Gerald Rabkin
A Woman Who . . . : Essays, Interviews, Scripts, by Yvonne Rainer
Mary Lucier, edited by Melinda Barlow
Gary Hill, edited by Robert C. Morgan
Bruce Nauman, edited by Robert C. Morgan

Bruce Nauman

Edited by Robert C. Morgan

A PAJ Book

The Johns Hopkins University Press Baltimore + London

9 8 7 6 5 4 3 2 1

The Johns Hopkins University Press
2715 North Charles Street
Baltimore, Maryland 21218-4363
www.press.jhu.edu

A catalog record for this book is available from the British Library.

Library of Congress Cataloging-in-Publication Data

Bruce Nauman / edited by Robert C. Morgan.
 p. cm. — (PAJ books. Art + performance)
 Includes bibliographical references.
 ISBN 0-8018-6906-4 (pbk. : alk. paper)
 1. Nauman, Bruce, 1941 —Criticism and interpretation. 2. Video art—
United States. 3. Conceptual art—United States. I. Morgan, Robert C.,
1943– II. Series.

N6537.N38 B775 2002
700'.92—dc21 2002050728

Frontispiece: Self Portrait as a Fountain, 1966. Edition of 8. 19⅞ × 23¾ inches
(50.5 × 60.3 cm). Courtesy Sperone Westwater, New York. © 2000 Bruce
Nauman / Artists Rights Society (ARS) New York. Part of the work *Eleven
Color Photographs*, 1966–67/1970. Portfolio of eleven color photographs.

Credits may be found on page 395.

To Sarah

Initially the immediacy of video's medium interested me. It was a lot easier and cheaper than film, a very intimate kind of medium. When you work it with someone else, you do that in a different way than you do film, a more comfortable way. The video monitor has an object presence in relation to the spectator. I'm generally not interested in that. I'm more interested in things happening in time . . . over a period of time.

Bruce Nauman, September 10, 1987

Contents

III Interviews

IV Artist's Writings

Photograph gallery follows page 314.

Acknowledgments

To construct a book on the work of an artist such as Bruce Nauman, which is diverse in thought, multilayered in meaning, and given to a subtle richness of experiential exploration, requires considerable cooperation on the part of many individuals. For an anthology of criticism that focuses on Nauman from a performative and new media perspective, it has been necessary to select those writings that fit this context through either a historical, critical, or theoretical understanding. I wish to acknowledge each of the writers in this volume who granted us permission to reprint their work. Given the current market-orientation toward Nauman, getting reproduction rights for images from many collections, foundations, and museums has been difficult. I wish to acknowledge the assistance of those who have helped in getting permissions: Janet Hicks at the Artists Rights Society, Galen Joseph-Hunter at Electronic Arts Intermix, Maureen Pskowski at the Donald Young Gallery (Chicago), Angela Westwater and Karen Polack at the Sperone Westwater Gallery (New York), Lise Connellan at the Hayward Gallery (London), and Catsou Roberts at the Arnolfini Gallery (Bristol, UK). Thanks to Bruce Nauman's assistant, Juliet Myers, for her supportive help. Also I would like to thank Carol Zimmerman, my editor at the Johns Hopkins University Press. Bonnie Marranca and Gautam Dasgupta, the co-editors of the PAJ Art + Performance series, were catalysts from the beginning of this project. I would like to give them both a warm thank-you. Finally, I want to acknowledge the extraordinary dedication of my personal assistants, Stefano Pasquini, Oneil Edwards, and Warren Holt, who kept this book moving even under the most dire of circumstances. Having followed and admired the work of Bruce Nauman for more than twenty-five years, I am de-

lighted to have had the opportunity to coordinate this project. I would like to thank him for his generosity in agreeing to be the subject of a critical anthology on his work.

Bruce Nauman

Robert C. Morgan

Bruce Nauman

An Introductory Survey

The challenge involved in categorizing Bruce Nauman is re-
lated not only to the breadth of different media with which he works
but to his persistence in exploring art as an investigation of the self.
The problem touches on the subjectivity of the artist. How does one
find a single, all-encompassing category that locates the work of such
an artist? For Nauman, the self is not merely a repository of expressive
needs; it is a complex organic and social mechanism continually being
redefined in relation to physical space. The question that continues to
surface in Nauman's art is whether this complex mechanism of the self
can ever be defined, or whether it simply exists as an ongoing work-in-
process, an aggregate of systemic interventions that have no clear reso-
lution.

Nauman's early work (1965–69), including his wax and resin sculp-
tures, his early conceptual pieces, his films, and later his videotapes, was
done when he was still in his 20s. Yet the maturity of these works con-
tinues to astound art historians and critics worldwide. This may suggest
that Nauman's early work reveals a fundamental concept at the core of
his aesthetic—that the self is less resolved than it is confounded
through language. In other words, the self is not defined by language;
rather, language in all its structural and deconstructed permutations is
what defines the self.

Given the actions and procedures, both material and conceptual, de-
veloped by Nauman at the outset of his career, one might conclude
that his approach to art was built on the exhaustion of rational (for-
malist) solutions. Inspired early on by Wittgenstein's *Philosophical In-
vestigations* (1953), Nauman's work began to develop along parallel,
sometimes intersecting trajectories that emphasized the inability of ra-
tional solutions to define art.[1]

1

Early Influences

Bruce Nauman was born in Fort Wayne, Indiana, in 1941. He grew up in Wisconsin, where his initial interests were largely music. He played bass with jazz combos, studio classical guitar, and piano, always with a clear structural orientation. The composer Arnold Schönberg's concept of 12-tone composition was of particular interest to Nauman as, years earlier, it had been for the avant-garde composer John Cage. When Nauman attended the University of Wisconsin at Madison, his initial field of study was mathematics. Later, he evolved toward art, focusing primarily on abstract landscape paintings before eventually making his way toward sculpture.

His first important contact with artists came as a result of attending graduate school at the University of California, Davis (1964–66), where he was surrounded by powerful influences such as Robert Arneson, Wayne Thiebaud, and William T. Wiley. During this period, Nauman developed a flurry of diverse interests. He moved away from his former landscape paintings toward working with abstract-shaped canvases. These would eventually lead to a series of minimal forms made of wax and fiberglass, often related to the dimensions of his own body. This was followed by a series of short film studies made in collaboration with William Allen and Robert Nelson.[2] By the end of graduate school, Nauman was focused on conceptual issues of time, space, duration, and process. These issues became the foundation of a new vocabulary whereby the artist began to further explore material form in relation to his own body and his concept of self.

What Nauman brought to the foreground in his early "body sculptures," such as *Brass Floor Piece with Foot Slot* (1965–66), *Wax Impressions of the Knees of Five Famous Artists* (1966), and *Neon Templates of the Left Half of My Body Taken at Ten-Inch Intervals* (1966), constituted an acknowledgment of the body's absence. In each work, the material signifiers imply the disappearance of a body or bodies. There is the unmistakable reference to a performance—a hermetic form of temporal sculpture—in which the physical body interacts with the object or material form. In *Brass Floor Piece* the body interacts arbitrarily—a posteriori—with the object. In *Wax Impressions* and *Neon Templates,* the interaction of the body suggests an a priori relationship to the molded material that defines the object. In all three works, the viewer mediates between the artist's action and the work's physicality.

One may identify these forms as remnants of a physical action or relics from another time—an existential, performative moment—strangely detached from the idealistic spiritual equivalence so endemic to the modernist abstraction of the early twentieth century.

Eccentric Abstraction

At the forty-eighth Venice Biennial (1999), Bruce Nauman shared with Louise Bourgeois the prestigious Golden Lion Award, one of the most important international awards granted in the visual arts. Although these artists are separated by nearly two generations, this was not the first time they had been jointly recognized. It began in 1966, when the art critic Lucy Lippard organized an exhibition at the Fischbach Gallery in New York called "Eccentric Abstraction."[3]

Lippard's intention was to merge the prevailing minimalist tendency in New York with the European transplant of surrealism. She was interested in integrating the standardized reductiveness of minimal art with something more erotic. By selecting a hybrid group of eight virtually unknown artists, she hoped to discover an art that, in her words, employed "a long, slow voluptuous, but also mechanical curve, deliberate rather than emotive, stimulating a rhythm only vestigially associative—the rhythm of postorgasmic calm instead of ecstasy, action perfected, completed, and not yet reinstated."[4]

"Eccentric Abstraction" was the exhibition where Bruce Nauman found his first significant New York exposure. Both he and Bourgeois were chosen along with six other artists, including Eva Hesse and Keith Sonnier. Nauman was living not in New York but in northern California. He had just completed his M.F.A. degree at Davis and was in the process of moving to nearby Vacaville. He was making process-oriented sculpture and experimental films. Bourgeois, a French artist married to art historian Robert Goldwater, made sculpture that consisted of abstract biomorphic figurations, mostly in wood. Eva Hesse, a German-Jewish immigrant, began her career in painting, studying at Yale University under Josef Albers. Hesse had slowly moved from painting to relief sculpture during the previous year. Keith Sonnier was exploring hybrid materials within a minimal context. Other artists included in the exhibition were Don Potts, Frank Lincoln Viner, Alice Adams, and Gary Kuehn.

In 1966, Nauman's sculptural activity was about casting shapes that related to accretions of space and measurement in relation to his own

body. His early work—constructed in fiberglass, steel, aluminum, wax, neon, tar, wood, and plaster—retained a quality of roughness about the surface in order to trace his working process.

It is Nauman's concern for temporality in his use of materials—a clearly assigned phenomenological awareness endowed with a nearly ritualistic analysis of time—that has always distinguished his approach to art. Although both Nauman and Bourgeois share a certain reference to the body, Nauman's work tends to appear more literal and more direct in its process-orientation. His plastic casts, wax templates, films, videos, and holographic works do not carry the same metaphorical edge—the symbolic intrigue—associated with Bourgeois' references to psychoanalysis and surrealist aesthetics. Nauman moved according to a different trajectory, one that was more involved with the literal processes of how art is made, with the problems of concept in relation to material, with mind in relation to body, and with art in relation to language.

Language and Paradox

While Nauman's earlier work acknowledges a strong adherence to phenomenology (the bedfellow of existentialism), one cannot ignore the references to language that are implicit within his phenomenology.[5] Nor can one avoid the absurdist convolutions of language in Nauman's work that alter the conventional understanding of the body in reference to language. In works such as *From Hand to Mouth* (1967), Nauman uses a cliché to question a form of representation. Just as the painter Jasper Johns, Nauman appears to raise the issue as to whether language is capable of defining forms of material reality. To go "from hand to mouth" suggests a poverty of means, a kind of desperate act—a means to survival on the most fundamental level. How to exist within the flood of information?

From Hand to Mouth, as with Nauman's body sculptures, is also a relic based on an impression, a mold taken from the body. In fact, the sculptural object is a fragmented mold, a linear strip of wax over cloth cut out to form the passage from hand to mouth. So here we are! the artist seems to ask. Yes, here—with our senses, alienated from ourselves, ironically detached. It is as if the artist were digging into the very foundations of behavior, where assumptions regarding our ability to communicate through language are suspended, hovering in a perpetual crisis, not knowing whether the synaptic leap between the words being spoken and the event being described are contiguous. What is "hand to

mouth"? In the case of Nauman's sculpture, meaning is suspended somewhere between an expression of poverty and a literal measurement from one part of the body to another. The work literally extends from the mouth, where words are spoken, to the hand, where material objects are grasped and the material sensation is felt in relation to a context of use. In this sense, Nauman is representing a suspension of belief, the fulcrum between a virtual and tactile meaning, within a changing world pressured through the rapid advance of new information technologies, a world that we can rarely admit to knowing.

There are many examples in Nauman's early work (1966–69) in which this suspension of belief occurs. Here are two. One is a sign, printed on a transparent window shade in 1966, that reads: "The true artist is an amazing luminous foundation." The other is a spiraling neon sign from 1967, considered by the artist as either a window or wall sign, which reads: "The true artist helps the world by revealing mystic truths." In either case, we don't know exactly what the artist means. They read paradoxically, not unlike the early works of Jasper Johns in which the painting of a flag becomes both a simulation and a representation. With Nauman's signs we are in a similar bind, caught between meaning and nonmeaning. We don't know exactly how to perceive their meaning. Is Nauman being sincere in the poetic sense, or is he being cynical in the philosophical sense? We simply don't know whether to accept these statements as sincere or cynical, whether they are imbued with personal meaning or whether they are nonsense. Again, one might say that the artist is at the fulcrum of meaning, the place where language cannot be pinned down, where we cannot expect an exact meaning, where we simply do not know which direction to turn.

Another aspect of Nauman's work, beginning in the late 1960s, were his constructed corridors. While less concerned with the explicit tension of language, as in the sign works, the corridors deal with other kinds of structural problems, focusing more directly on the physical relationship of the body to the act of perception.[6] The opposition is less intellectual, less conceptual, and more given to corporeal experience. In walking through the *Corridor Installation* (1970), for example, one may catch glimpses of where one has been in video monitors situated at ground level at the start and finish of the section. In being within this room of corridors, a certain tension is revealed not only between language and experience (that is, how the subject defines where she is, has been, or is going), but also between experience and sensation. Whereas the former suggests a deepening cognitive relation to percep-

tion and memory, the latter is more connected to the body, to the sensory disposition that falls into place at each moment of entry.

Performance, Film, Video

Nauman's early interest in developing a conceptual style of performance art involved the medium of film and eventually the video camera. In one of these the artist held an 8-inch fluorescent tube in various positions against his body for a specific duration. He repeated the performance three years later, using a video camera, in a work pragmatically entitled *Manipulating a Fluorescent Tube* (1969). The use of the video camera raised the issue as to whether the tape was merely a document of the performance or whether Nauman intended to transform the effect of his action by presenting the videotape as an autonomous work.

In a videotape, entitled *Violin Tuned D E A D* (1969), the artist pushed the autonomy of the video apparatus one step further by turning the camera at a horizontal position, thus revealing the body position of the artist as sideways while playing a violin. The literalness of the title is suggested by the fact that the four strings of the instrument were tuned to D E A D. Initially conceived as a performance, the video camera further heightened the artist's concentration on the sound as he played the notes sequentially over and over, thus inciting a kind of hypnotic drone. *Violin Tuned D E A D* also related to a previous ten-minute black-and-white film, entitled *Playing a Note on the Violin While I Walk around the Studio* (1967–68), in which the artist quite literally played a single note while ambulating around the studio floor. The later video version, however, adds an additional element of ironic humor through the lateral positioning of the artist's body, thus implying a wake or elegy being played by the artist in behalf of himself.

Slow Angle Walk (Beckett Walk) (1968) functions as a kind of hybrid between a performance document and an autonomous tape. Again, the video camera is positioned sideways so that the subject (the artist himself) appears to be walking up the wall, but of course his position always remains static in the middle of the frame. The persistent issue here is how to maintain balance in the process of moving from one point to another. Yet one also understands that balance is contingent on a certain tension or, put another way, an uncertainty that underpins the effort being made to keep one's balance. The process is complicated both in its physical movements and in its mental calculations. If the artist-performer loses his grip, he falls. A related tape, *Re-*

volving Upside Down (1969), shows the performer (Nauman) standing on one foot in the center of his studio revolving round and round, but very slowly. The angle of the camera places him in the upper center of the frame, thus suggesting an antigravitational pull, an obverse attachment to the ceiling, as if the performer were suspended overhead.

Manipulation of the camera to alter the viewer's orientation to the performance calls attention to the physical fact of the TV screen and to the monitor as an apparatus or even as an appliance. In another tape from the same year, entitled *Lip Sync,* we see an extreme close-up of the lower portion of the performer's face wearing headphones, again turned upside down. Throughout the duration of the tape, the performer repeats the title, occasionally pausing in order to swallow or catch his breath. In *Lip Sync,* as in the other film and video works from this period, we are given the literal presentation of things as they are, but we are also confounded by our inability to receive meaning from them. We are lost in a quandary, left with the urge to decipher something that has no context. *Lip Sync* is a tautology—a self-defining mechanism—with little or no basis by which to understand the self independently of its own actions.

In Nauman's adaptation of the video medium to the early "body art" pieces (1968–70) and to the later video installations, such as *Clown Torture* (1987) and *Shadow Puppets and Instructed Mime* (1990), we sense in the hiatus between these works more than stylistic changes.[7] In the decade and a half separating the early from the later video works, there are social, political, cultural, technological, and economic changes that have transformed everyday life into a sequence of conflicting spectacles. Nauman's videotapes both record and transform how we see everyday behavior to the point where we can no longer describe the effect or deal with its accompanying frustrations. In this sense, his video works and his material sculpture, including his linguistic and figurative neon signs, function as implicit complements to one another.

Nauman and the Concept of the Absurd

Irony is not cynicism. In many ways, these are the opposite of one another. Whereas great art may breed irony, hopelessness gives way to cynicism. Irony is a positive sign, a rebellion against mindless authority and oppression, whether personal or political. Within the realm of irony is the conflict of the tragic-comic, as in Hal Roach's Laurel and Hardy during the 1930s. Irony may foment an unrelieved tension, a suspension that gives us transcendence. Recognizing the absurd holds a

quality of redemption, offering a certain lightness to heightened conflicts that appear unresolvable. Absurdity can be felt in many ways, approached from many angles—some spiritual, some secular.

In reading the critical literature on Bruce Nauman over the past thirty years, one may notice an extraordinary number of both scholarly and coincidental remarks that point in the direction of what existential playwrights and critics once called the "theater of the absurd." In a major touring retrospective of the artist's work, which opened at the Reina Sofia in Madrid in 1994, a video installation, entitled *Shit in Your Hat —Head on a Chair* (1990), was shown in one of the final galleries of the museum.[8] The work consists of a large video projection depicting a mime performing a series of absurd rituals. The projection appears on a wall behind a straightback chair suspended at an angle from the ceiling. A life-size representation of a man's head, cast in wax, is mounted on the seat of the chair. The experience of seeing this work incited one critic to offer this insightful remark: "The mime's determination to obey, in high mime style, the voice's humiliating instructions makes the work's sadism a victimless crime. Perhaps—and may induce a shocking reflection on the unpleasant things we all do every day, as well as we can and even with pride and joy, at the behest of unsympathetic powers."[9]

In *Shit in Your Hat—Head on a Chair,* Nauman is setting up a confrontation between the artwork and the viewer. There is an intrinsic conflict built into the work, a conflict that is being played out in front of the viewer. The mime is leading the way, confronting us with the spectacle of the head on the chair—a weirdly discomforting surrealist association. There is no resolution available. There is nothing to justify the action that stands before us. Yet this absence of resolution, suggestive of the absurd, does not imply the absence of a structure.

To build a conflict in the dramatic sense, a structure (often consisting of hidden metaphors) is a necessary and indispensable part of the work. In this sense, one can refer to a relativist aspect to Nauman's oeuvre. The video installation (the term most appropriate to the genre described above) is defined within a systemic vocabulary. The terms are given—*etant donnes,* to cite a phrase from another of Nauman's early influences: Marcel Duchamp. The twisting and altering of the terms against the conventions of art is something both artists share. They both confront the language that is used to define art, and thereby provoke new meanings in relation to the specific phenomena they may choose to represent.

Again, Wittgenstein comes into play. In a work entitled *A rose has no teeth* (1966), Nauman purloined the phrase from the philosopher's writings.[10] He then stamped the words into a sheet of lead and wrapped it around the trunk of a tree. Like Magritte and Johns before him, Nauman raises the question concerning the familiar, yet unstable relationship between art and language. How are the terms of art configured in relation to meaning?

In raising the question, Nauman operates in the gray zone between the conceptual aspect of language and its physical presence as a sign. By positing something unresolvable—"a rose has no teeth"—in relation to language, the prevailing absence leans heavily in the direction of the absurd. As Wittgenstein has shown, there is no exact equivalence between what seems to be the case and what is the case. Nauman uses this notion to incite a similar tension in his tree plaque. Nauman constructs an opposition without giving us a resolution, thus evoking the absurd.

The question arises for Nauman as it did for Duchamp in *Etant donnes* (Given): Where is the passage, the penumbra, as it were, among language, experience, and sensation? Nauman's work follows a curious line of inquiry that crosses over between art and literature throughout the counterformalist traditions of the twentieth century. In all cases, the only possible resolution is the impossibility of imposing a resolution. Only the tension prevails. And within the prevailing tension is the condition of the absurd.

In the case of Nauman, it is the systemic absurd—an absurd that is less ontological than Samuel Beckett and less pragmatic than the "Activities" of Allan Kaprow.[11] Thus, for Nauman, the absurd—the suspension of conflict without resolution in order that the tension may prevail—may be understood in systemic terms. It is a matter of playing out the system, a procedure not unrelated to the early "nonvisual structures" of another conceptual artist, Sol LeWitt.

Nauman's systemic absurd is fundamentally a conceptual act, but one that always occupies the presence of the physical world, the phenomenon of material reality. In this regard, Nauman is perhaps closer to the "body art" in the early Vito Acconci, where a system is put into operation often to subvert our assumptions related to the psychology of behavior.[12] Where Nauman differs from Acconci is in his detachment, his disinterestedness from his own subjectivity. Even in Nauman's 16 mm films from 1967 to 1968, such as his four-part installation, entitled *Art Make-up,* the artist's relationship to the self is removed, implying a sequence of self-effacing gestures. Here Nauman treats the body—his

own body—as an object of curiosity, almost as if he were unsure that the body he was covering with pigment belonged to himself. In contrast to the more indulgent side of Acconci's systemically absurd approach to the body, as in *Seedbed* (1972), in which the artist masturbated under the floorboards of a ramp installed in the Sonnabend Gallery in New York, Nauman is more removed, more uncertain, and ultimately more given to the language that confounds the body. Even in the more explicitly intimate films, such as *Thighing* (1967), *Bouncing Balls* (1969), and *Gauze* (1969), Nauman is testing the limits of the language as a means of articulating his intention while at the same time removing himself from any evidence given to the service of expressionism.

Nauman and Beckett

A good deal of attention has been focused on the artist's affinity with the content found in the plays and novels of Samuel Beckett. Whereas Beckett is identified with the existentialist movement, particularly in France, at midcentury, Nauman is associated with the development of conceptual art nearly twenty years later. Much of the affinity between the two artists as perceived by critics and cultural historians is less about a convergence of ideology or belief than an affinity of understanding based on implicit visual signs. There is a certain attention given to both phenomenology and language in both artists, a certain flair for the nondrama, the "play" that exists within the human condition, often perceived as a hovering sphere of absurdist sensibility.[13]

What may startle the reader with a penchant for contemporary literature is how close Nauman's video performances come to characters created by Beckett. An example would be the two hoboes in *Waiting for Godot* who enact their desperate lives in isolation of one another in some unknown desolate place—a country road, a tree. Replete with anxiety, Vladimir and Estragon project their sadomasochism onto one another in a way not so removed from Nauman's protagonist in *Clown Torture*. The metaphor of oppression—whether psychological or political—is an implicit theme in Beckett as it is in much of Nauman's work.

In her essay "Circling Oblivion," Ingrid Schaffner also makes clear this correspondence, referring specifically to Nauman's 1987 videotape *Clown Taking a Shit* (one of the tapes used in the video installation called *Clown Torture*): "Commensurate to Nauman's clown on the toilet is Beckett's Krapp. Coincidental to both their work, although implied practically from the start, clowns as full-blown circus figures only emerge late in Beckett's work and lately in Nauman's."[14]

In *Krapp's Last Tape* (1958), the sensation of time is a lingering man-ifestation of memory. An old man sits at a table, starting and stopping a reel-to-reel audiotape recorder. He sits paused in reflection, listening to himself, remembering events he can no longer articulate, events that have become abstractions, bereft of feeling—conflicted abstractions, driven by angst and manifested only as recorded instances of time. The audiotape is filled with doubts and hesitations, blockages of emotion, where the thought cannot adequately be said, where there is a hin-drance, a notion that something has been lost in time. Krapp is caught in a succession of voids, incapable of feeling, desperately sensing the ir-retrievable. The process ends in self-dislocation, a degeneration of pho-netic utterances. Through the recordings, Krapp recognizes sound as distilled time, as anguished abstract time representing the past. He is forced to confront his own past, his self-doubt and ultimate self-efface-ment. He becomes the anti-protagonist who, according to theater critic Martin Esslin, "deals with the flow of time and the instability of the self."[15] Thus, memory has been transformed into a series of incongru-ous instants unable to make sense, unable to find resolution.

In many ways, Krapp's despair is equally present in Nauman's clown. The clown began to appear in Nauman's work in the mid-1980s after the artist had taken a hiatus from video-making for more than a decade. The clown is not simply an abstract performer, as in Nauman's early studio performances, such as *Bouncing in the Corner, No. 1* (1968) and *Bouncing in the Corner, No. 2: Upside Down* (1969), but functions as an incarnation of metaphor, a hybrid circus characteriza-tion somewhere between Buster Keaton, Bozo, and Pierrot.

In one section of a video projection from *Clown Torture* (1987), we witness the performer as he is dowsed repeatedly by pails of water in close quarters. The clown is confined, unable to escape. One might un-derstand such antics as the acting-out of extreme pathos. In this case, the clown represents internal frustration as he is caught between con-flict and resolution or, in more general terms, between experience and his inability to understand, and therefore to narrate the subjective terms of his experience. In addition to Beckett's Krapp, Nauman's *Clown Torture* relates to his ongoing interest in the "language games" of the Viennese philosopher Ludwig Wittgenstein and more explicitly to the confessions of torture and isolation described by the Argentine writer Jacobo Timerman.[16] In the various segments of *Clown Torture,* Nauman uses the persona of the clown to displace reality, as in the single-channel version of *No! No! No!* (1987), and thereby to double

the illusion of reality, in order to redefine subjective experience as an inexorable and alienated presence contingent on absence, a state of mind where language fails to conform directly to sensations of the body.

Confrontation, Provocation, and Thought

There is a confrontation aspect that pervades Nauman's work, whether in the form of sculptural objects, architectural projects, performances, films, videotapes, drawings, prints, video projections, or installations. In an interview with the critic Joan Simon (1987), the artist describes his interest in making art that carries the effect of "getting hit in the back of the neck (with a baseball bat)—you never saw it coming, it just got you, it just knocked you down and you never knew where it came from or what to do with it."[17] There is a performative connotation here. Like Buster Keaton—an actor whom Beckett employed in *Film* (1964)—or Laurel and Hardy, Nauman's comment suggests slapstick, a type of vaudeville theater, often ironic and amusing. The absurd always holds a balance between comedy and tragedy, and it is the fulcrum of this balance where Nauman's work resides.

The confrontational aspect of Nauman's work is not always direct. It often occurs at an obtuse angle. Both time and concept enter into the work. We are confronted by an action that seems absurd, a loose configuration of physical movements or gestures that seemingly goes on and on. At times, the duration feels interminable. But the action has a duration, and that duration is a composition in time, a compilation of instants that, in the case of the early films and videotapes, is meant to exhaust the possibilities of an idea, in fact, a system of thought. Yet it's always a system that informs the work, a lamination of ideas in conjunction with time itself, a phenomenological response to the synaptic charges of mind in relation to body and body in relation to perception. This is made clear in video installations, such as *Good Boy Bad Boy* (1985), which is complemented by a neon wall piece two years later. In each case, the figure of a man's head and a woman's head appear in twin video monitors—the produced, clearly timed execrations about being a good and bad boy. The systemic use of the language is precisely spelled out in the neon wall sign. Thus, the verbal actions made in the two tapes are equivalent to—but not the same as—the language of the neon sign. There is a parallel relationship between the two, and it is this parallel relationship that gives the two works their necessary tension.

Good Boy Bad Boy (1985) offers a confrontation with the phenom-

enology of the self. Given the work's precisely timed, systemic aspect, built on a series of linguistic permutations (not unrelated to LeWitt), the work eludes metaphysics in favor of a linguistic tension. The longer one observes the action, both verbal and gestural, the more the work's conceptual references begin to stick in the brain. In the case of the earlier black-and-white tapes, such as *Revolving Upside Down* (1969), the sheer physicality of the body moving in the illimitable space of the artist's studio, with its properties so sparsely attenuated, gives over to a mental act, what Duchamp understood as the *cervelle,* the "brain-fact."[18]

Thus, a duration can also be confrontational just as an object, artifact, or construction can exist as a reduction in its own space. Even though a sixty-minute videotape has a duration and thus is perceived through time, it may seem unreasonable for most viewers to remain engaged. While this may, in fact, be true, one has to recognize that the viewing experience is different from the actual work. One gets the idea of a work, such as *Good Boy Bad Boy,* within a few minutes. Yet the duration of the tape is the means that engages the system (not the viewer) by inciting intervals of time within the system. The action or series of actions becomes a physical fact, something that we endure as a condition of time and space, something that may confine us, such as in *Bouncing in the Corner, No. 2: Upside Down* (1969), and provokes us into the realm of thought as we confront the action as a physical happening.

We may sense the resonance of a tactile idea, an idea that has experiential resonance, an idea given to time and memory. The videotape entitled *Wall-Floor Positions* (1969) is a clear example of this process. The more one focuses on the artist's body, observing the movements as they change and shift every few seconds, while maintaining a sequence of discrete variations and permutations in relation to the wall and floor, it becomes apparent that there is a considerable endurance of mind-body coordination in operation. To hold a position while thinking ahead to the next movement, trying not to repeat the positions that have already been shown, over a duration of sixty minutes (the length of a Sony Portopak tape), is no mean feat. An extraordinary focus and concentration is required through an attention to the rhythm of the movements in conjunction with the pauses. Having watched this tape with students numerous times, one becomes cognizant of associations of metaphor that leap beyond the systemic permutations. One may recall a relationship to gravity—a fact we all know, just as we know breathing, but rarely consider in conscious terms. Further reading may

go more deeply into themes of psychoanalysis—primary narcissism as represented in the recurrent fetal position or the sublimation of sexual desire.[19]

Conclusion

One might consider Nauman—who photographed himself in *Self Portrait as Fountain* (1966)—as a key figure in the avant-garde. However, there is some speculation as to whether the avant-garde as it developed in the 1960s is still with us. Some would say that the marketing manipulations and publicity of artists in recent years have made the existence of a real avant-garde implausible. When the term is used nowadays it is often stated with a certain degree of cynicism. The overwhelming influence of the global market on artists has had a marked impact not only on the way art is seen but in the way it is understood. It has impacted the way art is produced and the manner in which it is promoted and sold. This was predicted by Clement Greenberg in his essay "Avant-Garde and Kitsch" (1939) and later, from a different perspective, by Renato Poggioli.[20] While the term may have been useful in the 1960s at the time Nauman was becoming recognized, it is difficult to say that the artist's context is still the same. In such an environment it is difficult to conceive of an avant-garde as having any power of resistance or any relevance other than as an "underground" phenomenon, a prediction made in the 1960s by none other than Marcel Duchamp.

Yet Nauman has become one of the most sought-after artists on the international circuit. He is invited to participate in major exhibitions and has been awarded several international retrospectives. Rather than associating him with a bygone avant-garde, it is perhaps more realistic to say that, at the moment, his work is operating under the domination of a multinational corporate art world within the larger context of globalization.

Nauman has had the great fortune of being associated with some of the most renowned and preeminent galleries of contemporary art—Leo Castelli, Konrad Fischer, Nicholas Wilder, Sperone Westwater, among others. He has emerged as one of the three or four most valued artists of his generation. In spite of his success, Nauman has chosen to live in geographical isolation in the New Mexico desert, far removed from the high-powered art world centers. In some sense, this is testimony to the artist's need to be removed from the trivialities and the clutter that stand in the way of art, thus allowing him to think about art as a phenomenon of the self.

His early photograph, *Self Portrait as Fountain,* may be interpreted as both ironic and optimistic (so typical of his position). The artist is a living fountain, an instigator of truth in a hypermediated world, yet at the same time it is difficult to ignore the corruption, deceit, and mindless academic repetition that have evolved over the years in relation to any presumed truth. Nauman has given himself the distance. Like Beckett, Bourgeois, and Duchamp, the encapsulating vision of Bruce Nauman, fraught with the absurd tensions of language and experience, functions as a catalyst, as a transformer, and finally as a resistor to all that is fashionable and predictable in a media-ridden art world.

Notes

1. Coosje van Bruggen, *Bruce Nauman: Drawings 1965–1986* (New York: Rizzoli, 1988), 9.

2. Ibid., 10. One of the important films of this period was *Fishing for Asian Carp* (1966), in which the artist explores the concept of duration based on a chance happening. The length of the film is largely determined by the unpredictable moment of catching the fish. The notion of an "instructional film" is confused with that of documentation, thus suggesting that art gives no direct meaning but rather provides the source-point for investigating the nature of art.

3. Lucy R. Lippard, "Eccentric Abstraction," in *Changing* (New York: Dutton, 1971), 98–111.

4. Ibid., 111.

5. Marcia Tucker, "PheNAUMANology," *Artforum* 9, no. 4 (December 1970): 38–44.

6. It would appear that Nauman's phenomenology is related although not directly influenced by certain perceptual ideas offered in the writings of the French philosopher Maurice Merleau-Ponty; see, e.g., *The Primacy of Perception* (Evanston, Ill.: Northwestern University Press, 1964).

7. Nauman did not make videotapes between 1970 and 1984.

8. Walker Art Center, Minneapolis (in association with the Hirshhorn Museum and Sculpture Garden, Smithsonian Institution), "Bruce Nauman" exhibition organized by Kathy Halbreich and Neal Benezra. Catalogue edited by Joan Simon. Essays by Neal Benezra, Kathy Halbreich, Paul Schimmel, and Robert Storr. Participating museums: Museo Nacional Centro de Arte Reina Sofia, Madrid (November 30, 1993–February 21, 1994); Walker Art Center, Minneapolis (April 10–June 19, 1994); The Museum of Contemporary Art, Los Angeles (July 17–September 25, 1994); Hirshhorn Museum and Sculpture Garden, Smithsonian Institution, Washington, D.C. (November 3, 1994–January 29, 1995); and The Museum of Modern Art, New York (March 1–May 23, 1995).

9. Peter Schjeldahl, "The Trouble with Nauman," *Art in America* 82, no. 4 (April 1994): 85.

10. Coosje van Bruggen, "The True Artist is an Amazing Luminous Fountain," in *Bruce Nauman,* 17–19.

11. Robert C. Morgan, "Allan Kaprow's Happenings and Activities and the Actions of Joseph Beuys," in *Between Modernism and Conceptual Art* (Jefferson, N.C.: McFarland, 1997), 21–30.

12. "Vito Acconci" (edited by Willoughby Sharp and Liza Bear), *Avalanche* no. 6 (Fall 1972).

13. In a catalogue published by The Aldridge Museum of Contemporary Art on the occasion of an award given to Nauman (1995), the critic Ingrid Schaffner wrote an essay analyzing the works of the two artists. Recently (February 4–April 30, 2000), an entire exhibition with an extensive catalogue was devoted to the affinities between the artist and playwright at the Kunsthalle in Vienna. There are other analyses of Beckett in relation to Nauman's work used by Coosje van Bruggen (*Bruce Nauman*) and an extensive essay by Gils van Tuyl, entitled "Human Condition/Human Body: Bruce Nauman and Samuel Beckett" (1997), Hayward Gallery, London. *Bruce Nauman* (in cooperation with Kunstmuseum, Wolfsburg, Centre Georges Pompidou, Paris, and The Museum of Contemporary Art Kiasma); organized by Christine Van Ashe, July 16–September 6, 1998; pp. 60–75; not to mention the artist's early video work, *Slow Angle Walk* (1968), also referred to as the *Beckett Walk.*

14. The Aldrich Museum of Contemporary Art, Ridgefield, Conn. (in cooperation with the Cleveland Center for Contemporary Art); curated by Jill Snyder; May 4–August 31, 1997; p. 24.

15. Martin Esslin, *The Theater of the Absurd* (Garden City, N.Y.: Anchor, 1967), 40.

16. Many references have been made to Wittgenstein in Nauman's work. Coosje van Bruggen asserts that the artist read Wittgenstein's posthumous book, *Philosophical Investigations,* in the early 1960s (*Bruce Nauman,* 9). In the catalogue edited by Joan Simon, the "Chronology" points out that Nauman read Timerman's book, *Prisoner Without a Name, Cell Without a Number* (New York: Vintage Books, 1981), 182.

17. Nauman quoted from a filmed interview with Joan Simon in *Four Artists: Robert Ryman, Eva Hesse, Bruce Nauman, Susan Rothenberg* (New York: Michael Blackwood Productions, 1987).

18. Robert C. Morgan, *Conceptual Art: An American Perspective* (Jefferson, N.C.: McFarland, 1994), 7–9.

19. Nauman's earlier still photograph, entitled *Failing to Levitate* (1966), in which a man lies in a supine position on the studio floor, offers the germination of the more kinesthetic *Wall-Floor Positions.* Give the absurd, but quasi-mystical content inferred in *Failing to Levitate,* there is an ironic representation of the conscious in relation to the unconscious—a surrealist theme often employed in the films and photographs of Man Ray, an artist with whom Nauman has acknowledged an affinity.

20. Clement Greenberg, "Avant-Garde and Kitsch," in *Clement Greenberg: The Collected Essays and Criticism,* vol. 1: *Perceptions and Judgments, 1939–1944,* ed. John O'Brian (Chicago: University of Chicago Press, 1986), 5–22. Renato Poggioli, *The Theory of the Avant-Garde* (Cambridge, Mass.: Belknap Press, Harvard University Press, 1968).

I Essays

Marcia Tucker

PheNAUMANology

Experience shows that human beings are not passive components in adaptive systems. Their responses commonly manifest themselves as acts of personal creation.
—René Dubos, *Man Adapting*

Since his first provocative New York exhibition at the Leo Castelli Gallery in 1968, Nauman's work has become increasingly complex. We are no longer able to take refuge in art-historical analogies to Duchampian esthetics or reference to visual affinities with the work of Johns, Oldenburg, or "process" art. Nauman's roughly built acoustical and performance corridors; his elusive camera/monitor pieces; his unenterable channels of air current; his "dance" pieces and slow-motion single-image films—all seem to defy our habitual esthetic expectations. To encounter one of these pieces is to experience basic phenomena that have been isolated, inverted, taken out of context, or progressively destroyed.

Nauman does not represent or interpret phenomena, such as sound, light, movement, or temperature, but uses them as the basic material of his new work. Our responses to the situations he sets up are not purely physical, however. Man alone among animals is able to symbolize, to respond not only to the direct effect of a stimulus on his body, but to a symbolic interpretation of it. This interpretation (and its emotional or psychological corollaries) is conditioned by all other experiences a per-

Originally published in *Artforum* 9, no. 4 (December 1970): 38–44. Also published in the catalogue for the touring exhibition, "Bruce Nauman," Kunstmuseum, Wolfsburg; Centre Georges Pompidou, Paris; Hayward Gallery, London; Nykytaiteen Museo, Helsinki, 1997/1999. *Bruce Nauman* (London: South Bank Centre, 1998), 82–87.

21

son has had, and which he involuntarily brings to bear on every new situation. Each person will, therefore, respond to the physical experience of Nauman's work in a different way.

Nauman carefully constructs his pieces to create a specific physical situation. Although he is no longer interested in ways of making art nor in the "interpretation" of a made object, he feels it is still important that a piece be neither over- nor under-refined. In this way focus can be directed to the experience and our response to it, rather than to the object itself.

The structures of sound and movement as a basic function of human behavior and communication are the phenomena which provide not only the artist, but the linguist, the anthropologist, the philosopher, and the social scientist with the sources of our knowledge of man. These are Nauman's concerns, and he sees his art as more closely related to man's nature than to the nature of art. This attitude is evidenced by his evolution from the making of objects and the recording of activities, to his present concern with manipulations of phenomena.

He has utilized progressively intricate "extensions" of the human body, the same extensions that man has evolved in order to live, to communicate, and to adapt to his environment. They range from writing, which extends language, and the telephone, which extends the voice, to complicated mechanisms like the computer, allowing memory and calculation far beyond the capacity of any human source.

Because Nauman's earlier work consists of visual puns, verbal plays, and manipulations of nonart materials, the intent of this work largely resides in the objects themselves. Recently, by dealing with the ways things are experienced instead of how they are made or perceived, the intent of the work is realized only through the physical involvement of the spectator. To this end, Nauman has investigated a wide variety of modes of communication, each of which is increasingly complex in the responses it is capable of effecting. They include language (both spoken and written); nonverbal sounds, both natural (breathing, walking) and artificial (clapping, making music); physical gesture (facial expressions, body manipulations, dance); and the extension of any or all of these by artificial or technological means.

Our bodies are necessary to the experience of any phenomenon. It is characteristic of Nauman's work that he has always used his own body and its activities as both the subject and object of his pieces. He has made casts from it (*From Hand to Mouth, Neon Templates of the Left*

Half of My Body Taken at Ten-Inch Intervals, etc.) and manipulated it (in earlier performances using his body in relation to a T-bar or neon tube, as well as in the holograms). He has made videotapes of his own activities (*Bouncing Balls*) and films of parts of his body being acted upon; *Bouncing Balls* and *Black Balls* are slow-motion films of Nauman's testicles moving and being painted black. He has questioned, in various pieces, his behavior as an artist and his attitudes toward himself as such. He has contorted his body and face to the limits of physical action as well as representation. By making audiotapes of himself clapping, breathing, whispering, and playing the violin, he has also explored a range of noises made and perceived by his own body.

This concern with physical self is not simple artistic egocentrism, but use of the body to transform intimate subjectivity into objective demonstration. Man is the perceiver and the perceived; he acts and is acted upon; he is the sensor and the sensed. His behavior constitutes a dialectical interchange with the world he occupies. Merleau-Ponty, in *The Structure of Behavior,* stresses that man *is,* in fact, his body, despite the essential ambiguity of its being at once lived from the inside and observed from the outside. Nauman has used himself in this way as a prototypical subject for the pieces. These works are meant, essentially, to be encountered privately by one person at a time. Where earlier the artist was the subject and object of recorded situations, now it is the spectator who becomes both the actor and observer of his own activity.

Ordinarily we are unable to experience both things simultaneously— at least, not without a mirror and an extraordinary degree of self-consciousness. At the Nicholas Wilder Gallery in Los Angeles Nauman set up a series of wallboard panels running parallel along the length of the gallery. Cameras and videotape monitors were set up in such a way that a person walking the length of one corridor and turning into the next would see himself on a monitor only as he turned the corner. The space set up is longer and narrower than most spaces we find or make for ourselves. The corridors therefore occupy an ambiguous and uncomfortable realm between too much space, which creates feelings of isolation and disorientation, and too little space, which causes cramping and tension. In this case, both are experienced simultaneously. At the same time, the image on the screen further disorients the viewer because he sees himself at a distance, from below and behind. He is prevented from being intimate with himself because he is not even allowed to meet his image head-on. Ordinary experience of the space between

man and his image is the frontal, 12- to 16-inch space we normally allow when looking into a mirror.

Like most of his work, this situation does not deal with a concept of space, but with the sensation of it. Its effect goes beyond that of a purely physiological reaction to become a highly charged emotional experience. It is similar in feeling to the impact of seeing, but not immediately recognizing yourself in the reflective surface of a store window as you pass it.

Other pieces deal more specifically with the physiological and emotional effects of time. Even according to the most stringent scientific analyses of time, pure (or absolute) time cannot be measured, because every lapse of time must be connected with some process in order to be perceived. We define time, therefore, according to our experience of it. When looking at a static object, the phenomenon of time, of *how* we perceive something, can be separated from *what* we are looking at, which does not change. In Nauman's slow-motion films, he uses uncut footage, taken from an unchanging vantage point. In them, a repeated simple change occurs in the object itself, while the way we perceive it does not change. *Bouncing in the Corner, No. 1, Bouncing Balls,* and similar films confound our experience of time by a transference of the functions usually assigned to objects and phenomena.

The performance pieces, which Nauman says have duration, but no specific time, operate in a similar fashion. For example, two dance proposals require a performer to work on one exercise for ten to fourteen days before giving an hour-long performance of it. One process involves the use of the body as a cylinder, in which the dancer lies along the junction of wall and floor facing into the angle formed by them. He straightens and lengthens the body through its center into the angle. A second piece uses the body as a sphere, curled into a corner. The dancer attempts to compress his body toward the central point of the sphere, and then toward the corner. Changes in movement during the performance would be barely perceptible to the audience, but the discrepancy between our normal expectation of how long it takes to perform or perceive a given activity, and Nauman's distension of that time, creates extreme tension.

Other kinds of tension resulting from the physiological effect of changes in pressure on the auditory system are used by Nauman. One such piece is an acoustically paneled corridor whose two walls converge. Another is a parallel, staggered group of 8-foot acoustical panels

to be walked between. Nauman has pointed out an analogous situation existing in nature, when certain winds or approaching storms can create even minute pressure changes in the atmosphere, which are said to account for widespread emotional instability and increased suicide rates in a given area.

The "emotional overload" that he is interested in can be partly accounted for in these kinds of terms, but is also due, in a less definable way, to how much of his own ideas and feelings he has been able to incorporate into the work—to how personal it is. For him, this quality is essential, even if it is impossible to measure or evaluate.

> I think when you attempt to engage people that way—emotionally—in what you're doing, then it's difficult because you never know if you succeed or not, or to what extent. In other words, it's easier to be professional, because then you can step outside the situation. When you bring things to a personal level then you're just much less sure whether people can accept what's presented.[1]

Since the emotional responses to each piece differ according to the receptor, it is almost impossible to name them; loneliness, delight, anxiety, surprise, frustration, serenity, and other private feelings provide the sensory poetry of this work.

> Even a long time ago, when I was painting, I could get to a point where everything worked except for one part of the painting which was a mess, and I couldn't figure out what to do with it. One way was to remove that part of the painting. The other way was to make that the important part of the painting; that always ended up the most interesting.

The artist's concern with making the "difficult" aspect of a work its focus need not be seen as perversity or artistic sadism, but as a viable working method. For example, Nauman has stated that art generally adds information to a situation, and that it seems reasonable to also make art by removing information from a situation. In fact, sensory deprivation experiments have shown that only the essential information needed to identify a thing tends to be picked up from a surrounding group of stimuli.

One of a group of pieces operating on this principle consists of an empty sealed room and an accessible room. An oscillating picture of the open room and its occupants (if any) is projected onto a monitor in the sealed room. Spectators witness only the videotape of the closed space, rather than the expected image of themselves. The elimination

of extraneous material here clarifies the work's intent by making its focus immediately apprehensible.

Mixing up two kinds of information that are similar but not quite the same is still another means of effecting sensory dislocation. For instance, at Galleria Sperone in Turin last year Nauman made a piece in which touching one wall of the gallery produced the sound of that touch on another wall. He relates this phenomenon to the use of skew lines in mathematics, where two nonparallel lines are situated in relation to each other in space, but never meet.

> If you make the lines very close—he says—it's the point at which you get to an optical illusion. Even though you understand how it works, it works every time. It's sort of the way I felt about how these pieces worked. Touching and hearing later, there were two kinds of information that occurred that were very close. You couldn't quite separate them, and you couldn't quite put them together. And so the experience has to do with that confusion that occurs. It's very hard to understand why that turns out to be a complete experience, but it does.

Another method used by Nauman in *Second Poem Piece* is to radically alter the sentence "YOU MAY NOT WANT TO SCREW HERE" by progressive removal of words. Differences in the degree of information and changes in our emotional response to each line occur immediately upon reading (i.e., participating in) the work. By removing semantic information until only the words "YOU WANT" are left, the degree of emotive content is increased.

In the audiotapes of breathing, pacing, clapping, and playing violin scales, sounds are differentiated from "noises" by periodicity, which arouses the expectation of pattern in the listener. Intent is thereby revealed through rhythmic structuring. In another tape, he whispers over and over, "GET OUT OF THE ROOM. GET OUT OF MY MIND." This highly charged message, delivered regularly and repeatedly, confuses us because we generally associate repetitive messages with a low expressive content.

In a performance at the Whitney Museum last year [1969], a similar situation was structured by using an abrupt, emotionally charged movement. Nauman, his wife Judy, and Meredith Monk each stood about a foot away from respective corners and bounced the upper part of their bodies into them repeatedly for an hour. In both kinds of work, Nauman is also interested in how a movement or sound becomes an exercise, how an exercise becomes a performance, and how specific responses to the performance can be controlled.

In some informal and unpublished notes entitled *Withdrawal as an Art Form*, Nauman describes a diverse group of phenomena and possible methods for manipulating them. He is involved with the amplification and deprivation of sensory data; with an examination of physical and psychological responses to simple situations that yield clearly experienceable phenomena; with our responses to extreme or controlled situations, voluntary and involuntary defense mechanisms, and biological rhythms.

Among his notes, there is a plan for a piece which is, at present, impossible to execute:

A person enters and lives in a room for a long time—a period of years or a lifetime. One wall of the room mirrors the room but from the opposite side; that is, the image room has the same left-right orientation as the real room. Standing facing the image, one sees oneself from the back in the image room, standing facing a wall. There should be no progression of images; that can be controlled by adjusting the kind of information the sensor would use and the kind the mirror wall would put out. After a period of time, the time in the mirror room begins to fall behind the real time—until after a number of years, the person would no longer recognize his relationship to his mirrored image. (He would no longer relate to his mirrored image or a delay of his own time.)

This piece, he says, is related to a dream which he had a long time ago, and could only be done eventually with the aid of a vast computer network.

The experience of such a room, were it possible to build, would slowly alter the way in which we, as human beings, know ourselves in relation to the world we inhabit. If what we know of the world is the sum of our perceptions, and our physical, emotional, and intellectual reactions to our environment, then to effectively manipulate these factors is to effect a virtual change in that world.

Nauman's work continues to explore these possibilities. Like the mirror piece, the computer and the dream exemplify the polarities of man's nature, and consequently of his art.

Note

1. All statements by Bruce Nauman are taken from taped interviews with the author made during August 1970.

Jonathan Goodman

From Hand to Mouth to Paper to Art:

The Problems of Bruce Nauman's Drawings

Intent and idea are manifest in Bruce Nauman's drawings as the first means of externalizing the art that is always close to the artist in expression of self.

In the recent exhibition of his drawings at the New Museum in New York City, Bruce Nauman has proved himself a capable and inventive artist and draftsman. As a 1960s whiz kid and leading conceptual artist, Nauman has never lacked opportunities to show and be seen. By and large, critics have written favorably about his mixture of high technology, abstraction, and the traditional media of sculpture and painting, but, at the same time, there has been concern about the apparently reductive and self-reflexive elements in his work. Robert Pincus-Witten, in particular, has questioned Nauman's methods, writing that the artist who depends so extensively on the investigation of his own body "becomes, in a certain sense, his own *objet trouvé*— hence narcissistic."[1]

Nauman's work does in fact risk being labeled "narcissistic" because he makes use of his body in his art in a highly personal way. The self-obsessiveness Nauman demonstrates in using, for example, his body as a template for a neon sculpture, or his knee in a number of drawings, is disconcerting because the art appears openly self-contained. Yet, at the same time, his art does attempt to communicate—one writer has defended his work as belonging to the "venerable tradition of the self-portrait, which has been a stable and significant part of the history of art since the mid-fifteenth century."[2] And another author, Brenda Richardson, has written an astute response to the Nauman critiquers,

Originally published in *Arts Magazine*, February 1988.

seeing his self-referential technique as part of the larger continuum of artistic expression:

> it is one approach to extending the work's meaning, by adding simultaneous specificity and mystery through its reference to a particular, complex, physically measurable, metaphysically unknowable individual. Self-referential content introduces the object's maker as an active component in the experience of the work of art, optioning a silent and potentially more personalized dialogue between artist and viewer.[3]

Because the self is finally a mystery in an absolute sense, the investigation of self by someone truly interested in exploring and then restating the self in visual terms lies fully in keeping with the traditional art values of representation and communication of self.

Richardson's suggestion that a "potentially more personalized dialogue between artist and viewer" can occur with such an approach centers on a key facet of Nauman's art—its intensely personal feeling. Even when doing his most public and political work, Nauman's method remains personal; his response as an individual takes precedent over less subjective means of communication. His effectiveness as an artist lies in his willingness to define sharply his response to social and aesthetic questions. The details of his work—even those in his most conceptual art—have a way of asking the viewer to take his or her own response and subject it to the same scrutiny. A large part of Nauman's success, too, results from his natural command of the traditional art media—his drawings emphasize his remarkable skills.

Drawings based in Nauman's physical characteristics comprise only a small number of the 150 drawings that were exhibited. Yet, in addition to underscoring Nauman's personalism, they function as a point of reference in his work, because they point out the persistently *human* basis of Nauman's abstractions. Nauman's physicality implies both an adherence to and a distortion of the body as evidence of human activity. A number of his projects have involved the construction of corridors, such as *Live Taped Video Corridor* (done in 1969–70), meant to isolate the viewer and limit his perception, and one of his videos has screened his genitals, painted black, in isolation. In these instances, Nauman seems intent on establishing the autonomy of the body by creating an aesthetic, and at the same time physical, isolation to match the isolated self experienced in contemporary art. Nauman's problem is not that he fails to distance himself from us, and each of us from each other, but that he succeeds so well.

The schematic nature of many of the drawings emphasizes the abstraction belonging to their as-yet-unrealized physicality, but Nauman's sculptures often fulfill the drawings' promise. A particularly beautiful example of his sculpture, the wax piece entitled *From Hand to Mouth* (done in 1967), illustrates Nauman's abilities and concerns. Ostensibly a wax cast of the artist's mouth, arm, and hand, it is also a visual pun of the expression "from hand to mouth." The physicality of the sculpture couldn't be more obvious (and it is one of the few overtly figurative works Nauman has created), but the Duchampian irony evident in the physical representation of the figurative phrase makes the sculpture the classic postmodernist piece that it is. Nauman's taken a figure of speech and literalized it, representing its abstract content with a physical, if fragmented, sculpture. What does the work mean? Is the phrase "hand to mouth" referring to the economic lot of the artist? The very translation of the phrase makes us ponder its more abstract and unusual qualities. Nauman's transfiguration of the literal makes his work very provocative: what you see is what you get—but what you get is also transformed.

Just as Nauman's physical representations of his body are at once solipsistic and transcendent, so is his thinking at once figurative and oblique, referring to natural expression and abstract idealism. This conflation of representative terms, at once figurative and abstract, might explain one of Nauman's preoccupations—the imaging of words. His literalization of phrases or single words points out the artist's fascination with what he cannot see, what is literally not there. Some of his drawings emphasize words as emblem or image; in one done in 1966, he has printed in capitals a phrase that begins in the upper left-hand corner and moves clockwise around the rectangular sheet, with the exception of the last two words, which begin in the upper-left-hand corner and move down: "THE TRUE ARTIST IS AN AMAZING LUMINOUS FOUNTAIN."

No statement could be truer—or more obvious. It is a physical representation of the metaphysical, and the hackneyed words are saved only by what seems to be the artist's total guilelessness in putting the statement out as a piece of art. Once again, what you see is what you get, and the statement's bold bravado somehow buoys it up, despite its simultaneous self-righteousness. Nauman's lyric style takes the risks inherent to all art posed as metaphysics: trivialization and self-regard. But Nauman has consistently proven his serious intentions by demonstrating his absorption with these risks; again and again, he finds in the

simple statement and the physical representation of the abstract visual signals of reality—everyone's reality. It's a dangerous route to take—the line between creative absorption and self-absorption is thin. But it is also very contemporary to parody the artist's stance by presenting it in extreme terms, and then taking it so far that the extremism of the position becomes beautiful.

It may be that Nauman is more interested in the properties of words as vehicles of action than as the building blocks of particularly transparent art statements. Because words are an especially human means of communication, they are also innate vehicles of political values: "It is through language, and its power to move people, that demographies and governments are altered in the course of time."[4] While *The True Artist* drawing seems deliberately naive, even coy, on one level, Nauman means what he says. Part of his attractiveness as an artist stems from his willingness to take a stance like that—no matter how affected it may seem.

The drawings themselves play a number of roles: sometimes they seem to be part of the process of Nauman's thinking; sometimes they furnish precise directions for the completion of a piece; and sometimes Nauman makes of them finished works that are fully realized on their own terms. Other drawings reveal Nauman's long-standing interest in contemporary social and political issues—for example, violence in the relations between the sexes or South Africa's system of apartheid.

In most cases the drawings have a sketchy, rather than finished, quality to them. But even in their sprawling state they communicate Nauman's engaging, slightly quirky intelligence. In a 1967 drawing of the 1966 neon sculpture *Neon Templates of the Left Half of My Body Taken at Ten-Inch Intervals,* Nauman has fully sketched the delicate beauty of his piece. It faithfully reproduces the neon sculpture's delicate wiring connecting the seven lengths of tubing, and it also stands as an early embodiment of Nauman's techniques. The piece is totally dependent on the outline of Nauman's body, and in a sense *Neon Templates* is a solipsistic work of art. At the same time, the sculpture presents that physicality in an *abstract* way, offering the viewer seven semicircular tubings of neon as the only trace of Nauman. This work can be thought of as the physical representation of Nauman's absence in both abstract and figurative terms—abstract because of the materials used and the lack of specific representation, and figurative because the work is based on and does suggest Nauman's body. *Neon Templates* works because of the different elements converging in it, making it successful

on a number of levels. The drawing's faithful presentation of the sculpture documents its presence and functions as its own completed work.

Other drawings dependent on Nauman's physical existence for their subject matter include *My Last Name Exaggerated 14 Times Vertically* (done in 1967) and *My Name as Though It Were Written on the Surface of the Moon* (also done in 1967). These works are both studies done in conjunction with Nauman's neon sculptures of the same name. And with the *Neon Templates* drawing, they share a fascination with the personal signifiers of a life rendered abstract by absence or exaggeration. According to Brenda Richardson, the abstraction of *My Last Name* was historically based: "The ration of extension of *My Last Name*—fourteen times—derived from classically determined proportions for physical beauty. The fifth-century B.C. Greek sculptor and architect, Polyclitus, specified that the perfect body should be seven times the height of the head."[5] This drawing owes its abstraction to the distortion of the classical ideal—Nauman doubled the classic ratio to arrive at a distortion that pushed a legible name into the realm of abstraction.

In much the same way, *My Name as Though It Were Written on the Surface of the Moon* takes Nauman's first name and distorts it—by repetition of each letter ten times. The inspiration of this piece, according to Brenda Richardson, is based on Nauman's seeing the first moon pictures: "Nauman watched the television transmissions which assembled pictures from the fragments beamed back by satellite. The eccentric overlay of the puzzle-like fragments as they locked into a readable composition impressed him as much as the texture of the images."[6]

In one version of *My Name* as a drawing, two sheets with letters drawn on them were taped together, and in the other a collage of photographs of the drawing exists. In these works as well, the artist has taken something intensely personal about his existence—his first name—and rendered it abstract by subjecting it to a process that roughly follows the pattern of the visual integration of the first moon pictures. His appropriation of a high technology of visual representation doesn't work as well as the abstraction did in *My Last Name*—the simple repetition of elements does not translate into visual terms as striking as those of the exaggerated last name. But the drawing does illustrate Nauman's belief that the visual processes of high technology can be used with great effectiveness in art.

Some of Nauman's strongest drawings concern sculptural-architectural projects. Three drawings were done for an underground structure

commissioned by the Kroeler-Mueller Museum in Otterio; the structure was to be embedded in the museum's sculpture garden.[7] While the plan was never completed because of the tract's sandy soil, these drawings give a good sense of how Nauman approaches a public project. Essentially sculptural in conception, this project calls for two shafts, one slanted approximately 30 degrees from the other, which is vertical. The shafts meet underground, and according to Nauman's notes scribbled on the drawings, the top of the straight shaft is open to the sky only, while the other shaft contains a stairway leading 30 feet down into the earth, where a door connects the shafts.

These drawings, one part blueprint, one part thinking aloud, and one part finished work, effectively evoke the project's depth and feeling of isolation. Some 30 feet underground, the viewer looks up the straight shaft to where one can catch a glimpse of sky—and the view is singular both as a visual experience and as a strong metaphor for what takes place, metaphysically, when we look at something. These drawings show Nauman at his best—his descent into darkness, rewarded by a door opening to a shaft that reveals a glimpse of light, has a conceptual power that the drawings match. His method has resulted in the physical representation of a remarkably cogent and unified metaphor. Nauman's projects consistently display this grasp of the abstract as a correlation for spiritual, nonembodied experience, and his practice, making use of the body, literally incorporates the physical as part of this experience.

For most of his adult life, Nauman has lived on the West Coast. During 1965–66, he did graduate work in art at the University of California in Davis. After moving around a bit, he settled in Pasadena for ten years. Then, in 1979, he moved to Pecos, New Mexico, living on a farm where he now works.[8] The drawings done from 1979 do not so much veer away from as echo Nauman's earlier work. He has designs outlining plans for interlocking tunnels, and there is a powerful study of a square tunnel becoming a circular one. Particularly striking are the studies based on the Foucault pendulum chair. John Foucault was a French physicist who "was the first actually to demonstrate in experimental form the fact . . . that the earth turns on its axis."[9] These drawings envision the sculpture as a chair, encompassed by several geometrical constructions, which sounds the notes D-E-A-D when the chair "make[s] contact with the points in the surround."[10] Nauman indicates in the drawings the political situation he is commenting on; sometimes it's South Africa, sometimes Africa.

These drawings illustrate Nauman's increasing interest in art as political statement and his penchant for abstracting the political statement to make it viable as art. The physical presence of the chair, most likely a reference to the chair the victim of torture is interrogated in, bears no overt reference to an actual, particular political situation, although we are left with an open sign of death in the sounding of the musical notes. In conjunction with the title *Diamond Africa,* these notes sound a death knell with a geopolitical significance that we are made to be very much aware of. But even so, we experience the piece first as conceptual and abstract art, rather than overt political reference.

It is hard to determine how effective a conceptual approach is in representing contemporary political problems—the situation in South Africa requires direct involvement, rather than the abstracted gaze, for political action. It seems that Nauman's technique is working against him when he attempts the political statement; no matter how eloquent the implications of those drawings may be, they remain politically imprecise because they imply, rather than state, the problem. Like most artists trying to face political issues, Nauman's caught between attempting the impossible—relating the issues abstractly—and stating the obvious. Choosing the former gives his art an aesthetic unity that a politically direct poster might lack, but the message is weakened by the drawings' abstract strength. It may be that the processes of abstract art can function only during periods of aesthetic and political freedom in the culture, but then this very openness undercuts the value of the political statement, or at least diffuses it. Nauman's political art proves more eloquent about his intentions in contemporary American culture than it is insightful regarding South Africa's reliance on diamond mining to maintain apartheid.

A number of the more recent drawings repeat Nauman's long-term fascination with words. One, *American Violence* (done in 1981), depicts a rough swastika made up of such phrases as "stick it in your ear," "rub it on your chest," and "sit on my face." The vulgar sexual tenor of these statements correlates with several drawings done as preparatory studies for neon sculpture, many of which are both violent and sexually graphic. In one drawing, *Punch and Judy II,* Nauman's made the following note: "Birth + life = sex = death." The drawing variously represents double murder, double suicide, and fellatio; its brutality makes a too neat and too simple reduction of sex as both an aggressive and self-destructive impulse. But, like the swastika consisting of sexually charged phrases, it proves a vigorous realization in art of a complex

idea. Nauman's tendency to simplify metaphysical complexity when expressing it in art leaves the viewer undecided about whether or not the representation has done justice to the complexity; even so, the terms of his expression are sufficiently sumptuous that we experience it as distanced from its original conception.

Nauman's art invites speculation, and our response may not be what he had in mind. Yet we can always respond to his use of traditional media; his drawings convince aesthetically because they have been expressed aesthetically, and the politics, whether implied or outspoken, do not so much dominate as add another dimension. Nauman's work, even at its most conceptual, takes part in a tradition: the key to his work lies in recognizing it as a statement of intent. If the drawings look self-reflexive at times, this quality belongs as much to our culture's general domain as to Nauman's specific thought processes. The problem is ours, as well as Nauman's; like most good artists, he is representative of his time.

Notes

1. Robert Pincus-Witten, "Bruce Nauman: Another Kind of Reasoning," *Artforum*, Feb. 1972, p. 33.

2. Marcia Tucker, "Bruce Nauman," in Jane Livingston and Marcia Tucker, eds., *Bruce Nauman: Work from 1965 to 1972* (Los Angeles: Los Angeles Museum of Art), pp. 32–33.

3. Brenda Richardson, *Bruce Nauman: Neons* (Baltimore: Baltimore Museum of Art, 1982), p. 17.

4. Ibid., p. 22.

5. Ibid., p. 25.

6. Ibid., pp. 25–26.

7. Dieter Koepplin, "Reasoned Drawings," in *Bruce Nauman: 1965–1986* (Basel: Museum für Gegenwartskunst, 1986), p. 28.

8. Coosje van Bruggen, "The True Artist Is an Amazing Luminous Fountain," in *Bruce Nauman: Drawings 1965–1986* (Basel: Museum für Gegenwartskunst, 1986), p. 12.

9. Richardson, *Bruce Nauman*, p. 33.

10. Ibid.

Amei Wallach

Artist of the Showdown

Bruce Nauman says he wants his art to hit you on the back of the neck like a baseball bat. He wants it to be that blatant, that startling, that confrontational. For nearly twenty-five years he has been making sculptures, installations, drawings, videos, prints, and neon mini-dramas that knock us off balance and force us to face ourselves in a showdown on the big questions of art, sex, death, rejection, collusion, frustration, and violence.

Lately he's been showing a group of works that make violence seem so beautiful, frustration so compelling, and our ambivalence about both so flagrant that, suddenly this winter, many card-carrying art watchers are declaring that, at 47, Bruce Nauman is one of our most extraordinary artists.

"Here's somebody that's dealing with issues of self in society who uses text, who uses video, and yet is never didactic," says artist and critic Robert Storr. "I think he is of his kind, and of most kinds, the best around. He's dealing with issues of spirit or emotion that are very profound, much more so than a lot of neo-smart art. It gets to you and gets under your skin the way Expressionism is supposed to and seldom does."

For decades, the Dutch-born writer and curator (and wife and collaborator of artist Claes Oldenburg) Coosje van Bruggen has felt that Nauman was "really a great artist," who, like a great many other conceptual artists of his generation, had been overlooked and ignored in his own country, however admired he is in Europe. She has made something of a quest to set the record straight, beginning with a huge

Originally published in *Newsday*, January 8, 1989. *Newsday*, Inc. ©1989. Reprinted with permission.

36

retrospective of Nauman drawings that traveled in Europe and this country two years ago, and culminating with a series of books that start with Nauman and will include John Baldessari, Lawrence Weiner, and Joseph Kosuth.

The irony is that her big book on Nauman—released by Rizzoli this weekend, and celebrated with an exhibition of Nauman prints at the Sperone Westwater Gallery at 142 Greene St. through January—arrives just at the moment when Nauman is emerging as a hero of the mainstream.

Always potent, his work suddenly has become accessible too, because for the first time he is willing to reveal in his art some real details about who he is.

Bruce Nauman drives down the road in his blue Chevrolet pickup, raising red dust. Past Pinon Trailer Park. Past Sanchez Wrecking. Past jumbles of mobile homes and wooden shacks and outhouses with solar panels on the roof.

He came to live in this town of Pecos, New Mexico, north of Santa Fe, in 1979. He is settled at the top of a hill as forested with pinon and juniper as you can get 7,000 feet up. The air is thin and clear, and there is room for dogs, horses, and chickens; there is a place to hang out blue jeans and orange towels to dry in the chill, dusty air.

Nauman has always managed to absent himself from the heart of the art world, although he was just 27 when Leo Castelli gave him his first New York show in 1968. The closest he ever came to living in New York was that winter in Southampton, making videos with Sony equipment borrowed from Castelli.

He and Richard Serra were the hot artists that year and, by the end of it, he says, "I felt abused by people wanting something. I felt I used up every idea I had in six months." He remembered how the artist Paul Waldman used to tell him that "When he was in New York he did three times the amount of work, that he needed that pressure. But I felt the work should come from you and not from pressures from people around you. It seemed important to have some distance from the art world."

Nauman moved to southern California, but to Pasadena, not the more leading-edge Los Angeles.

By the time he arrived in Pecos, he was divorced and his children were just about ready for high school. It was around the time when conceptual art seemed like a phase and the fashionable were looking

elsewhere for their art thrills. Castelli kept showing Nauman regularly, however, and thoughtfully neglecting to send him reviews. With the little money that came his way in those has-been days, Nauman built a house. It is utterly an artist's house: simple and spare, and the fact that the ceiling is sheathed in plywood and the windows are the size they are because that is the size that came cheap has everything to do with it.

There's a bearskin on the living-room floor—with a fine Italian hat perched on its head; a wood stove; books and magazines on the old chest that serves as a coffee table: *Farrier's Journal, The New Yorker.*

And there's a great deal of evidence of the nonsense he is so fond of: like the sepia photographs for a poster for a local coffee shop and close-ups of a saddlebag that belongs to an old trail hand with whom he sometimes rides into the mountains. The saddlebag habitually houses a thermos of coffee, and after all these years it has been disfigured in an altogether suggestive way. "I thought that would be good for a coffee shop," says Nauman.

Bruce Nauman is a quiet man. Quietly funny. A contemplative man who commits acts of visual aggression. He says that he once compared notes with his old friend, the poet and critic Peter Schjeldahl, and it is anger and frustration that drive them to work. It certainly doesn't show. Sitting back, in his neat western shirt and his scuffed cowboy boots, he considers a question so thoroughly that it can be nervous-making for those who are not as comfortable as he is with silence.

He has been talking about problem solving. At one point he studied to be a mathematician, and he has been saying that he wants his art to be as clear, as direct, and as elegant as a mathematical solution. That to solve a problem you have to get outside it.

The question is: But how do you do that?

He sits Rodin's *Thinker*-fashion, hand on chin, for a very long time. "You restate the problem," he says at last.

The problem he has been considering lately is: What is our relationship to torture and political violence?

The solution draws on what has happened to him in his years in New Mexico, the years of his 40s, while he was living with a companion and always at least one of his children on this high hillside, learning to ride, hunting, carefully crafting hunting knives because he needs some outlet for his God-given gift for making things. When he is making art, he reins in the gift so it will not get in the way of the elegant and aggressive solution.

There is a hint of place in the latest solution, of the West. He is let-

ting us know in a way clearer than ever before that his own experience has gone into this piece that arouses in us such feelings of horror, paranoia, and reluctant admiration. There are coyotes, and raccoons, and deer, and bear. They seem horrific, because they are dismembered and flayed. But in fact, they are taxidermist forms, ordered out of a catalogue and cast in polyurethane foam. In the version that was exhibited at the Sperone Westwater Gallery last fall, *Hanging Carousel (George Skins a Fox),* the flayed animals slowly rotated around a color monitor on which we could observe George, a hunting friend from up the road in Pecos, skinning a fox and talking about it. In order to see and to hear George, you had to get so close to the mumbling monitor that you were entangled with these terrible animals, following them around in their relentless circle. But what George was saying and what he was doing was not horrific at all; it had to do with craftsmanship.

As in so many of Nauman's pieces, you knew you were being controlled. You were being told where to stand and where to move and if you didn't, you couldn't get to the heart of the matter. So feelings ran high when you confronted this piece which had more complex things to tell us than a pile of Amnesty International reports, including that there may be an art to killing.

"I like that confusion," Nauman says. "I like formalizing the awful image so it can be beautiful and things are going on other than the actual stuff that's going on. It's what Warhol did with the 'Disaster' pictures. Maybe it's like watching television news. Or you watch a lot of sports, and then they sell beer and cars, and it's all young people having a good time, sounds and pictures all mixed with products and the lack of a moral message."

Nauman puts the moral message back in. He has always behaved as though the purpose of art were a moral one. In the early days, in 1967, when he was just beginning to make the neon sculptures for which he is most popularly known, he fashioned a neon spiral out of the words: "The True Artist Helps the World by Revealing Mystic Truths."

In the rambunctious, nose-thumbing 1960s, the phrase seemed all parody—perhaps even to Nauman himself. It's clear now, though, that there has always been an essential part of Nauman that believed it.

He thinks perhaps he came by his moral purpose growing up in the Midwest and studying art in San Francisco.

His father spent a great deal of his time on the road and moving the family about, from Fort Wayne to Schenectady, to Milwaukee, to Appleton, and back to Milwaukee. As the oldest child, Bruce Nauman got

the brunt of all that moving, always the outsider in a new place, losing old friends, holding back, getting the lay of the land, hesitant to make new friends. A great deal of his art since then has concerned the inside and the outside of circles.

At the University of Wisconsin he studied mathematics. "But I wasn't good enough. I had friends with that kind of passion for the work. Now I think it's the same for mathematicians and artists; there are some people who like to be poking at rules and testing. I always liked the kind of mathematics that took on why anybody would want to do mathematics."

When Nauman began making art, the first questions he asked were why anybody would want to do art. At Wisconsin, his art professors were socialists with a high sense of moral purpose, but weren't that interested in new currents that were beginning to move westward in the early 1960s, like abstract expressionism.

Willem de Kooning has always been Nauman's lodestar, because de Kooning was forever testing the rules, and because he put his obvious gifts for color and for drawing at the mercy of making a picture that was more true than it was beautiful.

At the San Francisco Art Institute, where Nauman taught in the mid-1960s, "There was this strong sense that art ought to have meaning and if somebody liked it you'd probably screwed up," he says. "You had to spend long days working in the studio and you just weren't supposed to make it pretty; if it was pretty you'd sold out."

Nauman loved to move paint around on canvas, but he couldn't come up with a purpose for doing so, so he gave up painting. He began making fiberglass sculptures out of body parts and simple movements. He was alone in a studio, and all he had to work with was himself. His elegant solution at this point was that any activity that an artist conducted in the studio was by definition a work of art. He made *Neon Templates of the Left Half of My Body, Taken at Ten-Inch Intervals* and holograms of himself *Making Faces.*

All along there were the neon pieces that ranged from word plays: *Violin/Violence* to little neon plays in which a neon man hung from a gallows, or neon men and women held out hands in greeting and ended by killing each other.

By the 1970s, he was studying himself minutely in order to examine feelings he could force his viewers to replicate in what he called "Corridor" pieces. These were pieces in which you would be walking down a corridor of his creation, turn a corner, and come upon a video mon-

itor of yourself seen from the back. Or, you would enter a cage within a cage in which you would be trapped in a corridor and everyone could see you.

"A number of those corridor pieces came out of a dream," he says. "It was about being in a long corridor and there was a room at the end of the corridor. The light was a yellow-gray color, dim. There was a figure on the left, unidentified. I had the dream many times and I kind of figured it must be a part of myself I hadn't identified. It seemed important to objectify myself." In the end he used a chair as an evocative stand-in for the human body.

He was interested then and now in the tension between what the artist reveals and what he protects himself from revealing in the high-risk, vulnerable situation of art-making.

And so when he began making his first political statements in 1981, the emblematic chair became an almost unbearable revelation of himself.

At the time, van Bruggen writes in her book, he was reading Jacobo Timerman's *Prisoner Without a Name, Cell Without a Number,* in which the Argentine newspaperman described his own torture: "They sit me down, clothed, and tie my arms behind me. The application of electric shocks begins. . . . During one of these tremors, I fall to the ground, dragging the chair."

Nauman suspended an upside-down chair in a triangle of 14-foot-long boards (in the finished piece they became steel beams) that hung by cables from the ceiling in a manner that was claustrophobic and excruciating to observe. He called it *South American Triangle.*

But the taxidermist's animals are even more revealing. And so are the rat pieces, like the one he showed at the Leo Castelli Gallery this fall. This consisted of a large, quite beautiful glass maze, a television camera that picked up images of those who came too close to the maze, and images flashed on the wall of a rat trying to get out of the maze and of a man beating a leather bag over and over and over in a loud rhythm.

Nauman's long relationship at the time was ending slowly and painfully, and there seems some connection. Also though, the rat maze has a great many references to other not-so-quietly desperate lives.

And somehow, at the same time, he was able to relinquish some control and to reveal himself altogether in an utterly lyrical video. It was made in two versions—one a ballet, *Rollback,* in collaboration with the artist and songwriter Terry Allen for San Francisco's Margaret Jenkins Dance Company, whose high point is a nutty rendition of "Home on

the Range." The other is *Green Horses*, a two-monitor video sculpture without music. In both there are two screens. On one Nauman puts a horse through its paces and then rides into the gorgeous countryside in glorious color. In the other, he is riding upside down most of the time and the colors are an equally gorgeous wash of greens and fuchsias. It is the complete American dream of riding off into the sunset.

And in a way he has. Last October he met the painter Susan Rothenberg, rendering them both so happy that a great many of their friends are happy too. He's looking to set up a studio in New York; she's looking to do likewise in New Mexico. And together they went to the Village Vanguard not too long ago and came upon an image that one way or another Nauman will use in his new work: It is of a piano player, playing hour after hour behind the horns.

"I'd like to make a tape of a piano player," he says. "I like that idea of things not being about a beginning and an end. Things go on and on. I don't know what I'll do with it. But it's just a start."

It brings to an end one of those terrifying fallow periods that come with the territory for an artist who is willing to change so radically and so frequently. Nauman found himself so blocked, a few months ago, that he couldn't even demonstrate for his friend George, how to draw a circle in silverpoint.

"I couldn't even doodle."

He's learned to sit out those times—both in himself and in other artists. "Now I wait and watch and see what happens. I see how people do over a lifetime of work," he says. "It has to do with maintaining that curiosity about the world."

Coosje van Bruggen

Sounddance

Nauman's first films, made in 1965–66, are about seeing: "I wanted to find out what I would look at in a strange situation, and I decided that with a film and camera I could do that."[1] These early films are about how an artist makes his choices: what objects or events in the visual field to focus on, what to include in the frame and what to crop out, and, in general, how to handle the camera. Nauman later remarked that it was Man Ray's films that had made him aware of the conceptual possibilities to be achieved through the manipulation of the camera. For him, the most original aspect of Man Ray's film work was that act of throwing the camera in the air while the film was running, not what he chose to record with the camera; it did not matter if the event took place in a room or outdoors. To Nauman, the use of film—which he considered an optical illusion—was a way to see the artist in direct relation to his ideas, unencumbered by the existence of an object whose physical presence might distract from those ideas. Another advantage of using film or photography was that they both would be accepted as "truthful records," without the question being asked of whether or not they were art. The closest Nauman came to "just making a film without considering it art" was one he made with William Allan, *Fishing for Asian Carp,* 1966.

Around 1966–67, working alone in his studio in San Francisco and in William T. Wiley's studio in Mill Valley, Nauman began to develop a strong body awareness, which resulted in his making casts of parts of his body. He not only focused his attention on individual body parts, as in *Device for a Left Armpit,* 1967, but also used his body as a standard for measuring his surroundings. For instance, in a series of draw-

Originally published in *Bruce Nauman* (New York: Rizzoli, 1988), 235–40.

ings from 1966, Nauman literally applied the rule, taught in every art school, that the human body is ideally about seven heads tall. One study from this series shows a human figure neatly divided into a stack of seven units of equal height; it also shows three units consisting of cross-sectional slices of a torso. Still another, from 1967, *Wax Templates of My Body Arranged to Make an Abstract Sculpture,* shows seven such slices piled up to form a teetering "column-body." Nauman's complex vision of the human body seems to relate neither to a keen interest in human anatomy nor to the humanistic ideal of self-definition. Instead, it addresses controversial comparisons between the human body and machines that have been made since the latter part of the nineteenth century. A watercolor from 1966, *Glass Templates of the Left Half of My Body Separated by Cans of Grease,* makes a correlation between the organic character of machines and the rigid mechanism of the human frame. Another study, *Templates of the Left Half of My Body Every Ten-Inches, Spaced Out to Twenty-Inch Intervals (Doubling My Height),* also 1966, would stretch the figure across the floor of a room. In the 1967 *Wax Templates of My Body Arranged to Make an Abstract Sculpture,* each of the templates is given the name of the body part with which it is associated: head, shoulder, chest, waist, thigh, knee, and calf. Here Nauman disassembles the human body according to abstract industrial production techniques; each disjointed part has to be examined in order to understand how the whole works. The various body parts can still be identified in the abstract templates, but they have lost their uniqueness; they can now be replaced by spare parts. In a related sketch from 1967, on which Nauman wrote "7 wax templates of the left half of my body spread over 12 feet," the human body is divided into seven separate templates that expand in space. The effect in this work is similar to that of a production line: the whole is dismantled and laid out for eventual reassembly. In a related idea, Nauman abstracted a specific body part by physically stretching it in a pair of drawings, both entitled *Six Inches of My Knee Extended to Six Feet,* 1967; he used a similar tactic in pieces such as *My Last Name Extended Vertically Fourteen Times,* 1967. In another work he extended his first name by repeating each letter horizontally ten times: *Bbbbbbbbbbbr-rrrrrrrrruuuuuuuuuuuccccccccccceeeeeeeeee.* Next he taped together the sheets with the different letters written on them, laid them out on the floor of the studio, and photographed them in many segments. By varying the distance between the camera and the paper, photographing from farther away at the ends and from a lesser distance at the center of

the stretched name, Nauman created the impression that the letters are lying on a curved surface. This piece, *My Name As Though It Were Written on the Surface of the Moon*, 1967, recalls the photographs sent back to earth by the five lunar orbiters that were launched by the United States between 1966 and 1968 (the neon version, *My Name As Though It Were Written on the Surface of the Moon*, appeared in the latter year). Here again Nauman created a suggestive work by combining widely disparate pieces of information—one of which, about the surface of the moon, had just come into reach. In his essay "Woman in a Mirror," Marshall McLuhan writes that the "artistic discovery for achieving rich implication by withholding the syntactical connection" was stated as a principle of modern physics by A. N. Whitehead, who wrote in *Science and the Modern World*: "In being aware of the bodily experience, we must thereby be aware of aspects of the whole spatio-temporal world as mirrored within the bodily life. . . . My theory involves the entire abandonment of the notion that simple location is the primary way in which things are involved in space-time."[2]

My Name As Though It Were Written on the Surface of the Moon also emanates from an attitude that, as Nauman explains it, "I adopt sometimes to find things out—like turning things inside out to see what they look like." In this case, he said, "it had to do with doing things that you don't particularly want to do, with putting yourself in unfamiliar situations, following resistances to find out why you're resisting, like therapy."[3] A prime example of that attitude is Nauman's photographic work *Flour Arrangements*, 1967. An aesthetic precedent for the activity of arranging flour on one's studio floor has been established by *Dust Breeding*, 1920, a photograph made by Marcel Duchamp and Man Ray in New York of Duchamp's *Large Glass* lying flat, showing "the accumulation of dust in the region of the Sieves," as Arturo Schwarz described it in his monograph on Duchamp. Schwarz also notes that Duchamp had alluded to this collecting of dust in *The Green Box*, 1934: "For the Sieves in the glass—allow dust to fall on this part, a dust of 3 or 4 months and wipe well around it in such a way that this dust will be a kind of color (transparent pastel)." Man Ray's photograph was made in Duchamp's New York studio on Sixty-seventh Street during the dinner hour, by artificial light. Man Ray told Schwarz that "he and Marcel went out for a snack leaving the camera to take a very long exposure; when they came back the photo was ready."[4]

However much Nauman admired the casual, conceptual attitude of Man Ray and Duchamp, with *Flour Arrangements* he wanted to stress

the physical activity involved in being an artist and at the same time test himself, to see if he really was "professional" in his work. For Nauman, being a professional artist entails having "the powerful, almost moral attitude most West Coast artists have, which requires going to the studio every day and doing work." He said in an interview with Willoughby Sharp, "I took everything out of my studio, so that *Flour Arrangements* became an activity which I could do every day, and it was all I would allow myself to do for about a month. Sometimes it got pretty hard to think of different things to do every day."[5]

After a month Nauman selected seven of the most interesting photographs from this project, intending to put them together in a loose configuration on the wall. However, he cropped the fragments carefully because he also wanted each to be a "beautiful aesthetic photograph," in order to transform the project, with its documentary character, into art. That year, after he had made composite photos for *My Name As Though It Were Written on the Surface of the Moon,* Nauman produced *Composite Photo of Two Messes on the Studio Floor,* 1967, a parody of his flour arranging. This time he recorded the debris left over from several sculptures he was working on as evidence of his ongoing activity in the studio. It was also a kind of artistic economy— he didn't want to leave any idea or material unused. In this piece Nauman again uses what does and does not belong to a piece, just as he did in 1966 when he exhibited the plaster mold of the Slant Step in two parts, and, later, when he included a mold in one of his fiberglass pieces. Dislocated from their original context, the remnants of the sculptures are given weight by being turned into photographs, which are arranged in a specific configuration. As Jane Livingston pointed out in 1972 in her essay on Nauman, this work has certain similarities to Barry Le Va's distribution sculptures. But *Composite Photo of Two Messes on the Studio Floor* echoes the acceptance of chance that Duchamp demonstrated in using the crack that developed in the *Large Glass,* as well as the dust that collected on top of it, as part of the creative process. "Duchamp allowed the object to take on a life of its own rather than forcing it to be an illustration of an idea that can't be changed," Nauman said. Another related photographic piece, in which an activity was to be recorded over a period of time, was intended for a show at the gallery of the University of California at Davis in January 1970. A number of artists had been invited to carry out a work on site, within a period of twenty-four hours. Nauman's idea was to record the

activities in a stop-action film, using a camera set up to shoot one frame a minute, but in the end he was unable to complete it.

With *Flour Arrangements* and *Composite Photo of Two Messes on the Studio Floor* Nauman made his first attempt to move away from making static objects. These pieces, which emphasize the remnants of an activity rather than sculptural qualities of objects or artistic photography, were transitional pieces between Nauman's sculptural objects and later works in which the activity itself became the piece. The latter could be arbitrary and absurd—for example, the film *Playing a Note on the Violin While I Walk around the Studio,* 1968; in fact, Nauman did not know how to play the violin. The activity could also be more logical, such as "pacing or rhythmic stamping around the studio." Nauman remembers at the time telling a friend who was a philosopher that he imagined him spending most of his time at a desk, writing. But in fact his friend did his thinking while taking long walks during the day. This made Nauman conscious of the fact that he spent most of his time pacing around the studio drinking coffee. And so he decided to film that— just the pacing. During the winter of 1967–68 Nauman made four black-and-white films of activities carried out in a studio in Mill Valley that he had sublet from his teacher William T. Wiley, while Wiley was traveling: *Playing a Note on the Violin While I Walk Around the Studio*; *Bouncing Two Balls between the Floor and Ceiling with Changing Rhythms*; *Walking in an Exaggerated Manner Around the Perimeter of a Square*; and *Dance or Exercise on the Perimeter of a Square.* The activities recorded in these films and the videotapes Nauman made in New York during the following winter were originally intended as performances. However, at the time there was no situation in which to perform them. Nauman felt that notes were not sufficient to preserve his ideas, so he made these inexpensive short films (each lasting no more than ten minutes) and hour-long videotapes both as a record of his studio activities and as a form of art.

In the film *Dance or Exercise on the Perimeter of a Square,* Nauman performs a simple dance step: starting from one corner of a square formed by masking tape fastened to the studio floor, he moves around the perimeter. He turns alternately into the square and out toward the wall, with either his face or his back turned to the camera (the back view allows more anonymity). His movements are regulated by the beat of a metronome. In the silent film *Walking in an Exaggerated Manner Around the Perimeter of a Square,* a larger square is taped to the

floor outside the first one. With great concentration Nauman, shown in profile, puts his feet carefully down on the line of the outer square, one foot in front or in back of the other; at the same time he shifts weight onto a hip in an exaggerated manner. At times a reflection of this exercise in contrapposto balance, showing the figure from a different angle, can be seen in a mirror leaning against the back wall. From time to time the performer is completely absent from the screen, because the frame cuts off part of the square; at those times Nauman seems to be paradoxically stressing the artist's isolation within the double entrapment of his studio and the frame. Nauman's method of escape from this imprisonment, stepping out of the picture, also takes him out of reach of the viewer, which creates a strong sense of remoteness. This exaggerated dance exercise was the forerunner of another performance, executed only on videotape in 1969, the hour-long *Walk with Contrapposto*. In this work the artist, his hands clasped behind his neck, walks slowly, with his arms and legs akimbo, toward and away from the camera, along an extremely narrow, 20-foot-long corridor. Nauman's exaggerated movements, mostly taking up lateral space, appear cramped within the narrow corridor. The artist explained: "The camera was placed so that the walls came in at either side of the screen. You couldn't see the rest of the studio, and my head was cut off most of the time. The light was shining down the length of the corridor and made shadows on the walls at each side of me."[6]

These three dance exercises are based on a daily activity, walking, but, by breaking it up into detached motions, they distort its ordinariness. For instance, by emphasizing the hip movement. Nauman lavishly covers space, stressing his presence in the corridor; by turning the step into a balancing act he lifts it out of its everyday context. The disjunction of motion into a series of fragments echoes the multiple frames of Eadweard Muybridge's sequential photographs of people and animals in action, causing tension between movement and rest. The use of the square on the floor is somewhat arbitrary—it could have been a circle or a triangle, or the pieces could have been performed around the edges of the room—but it serves to direct the movements and to formalize the exercises, giving them more importance as dances than they would have had if Nauman had just wandered aimlessly. For instance, in taking one convenient step forward in *Dance or Exercise on the Perimeter of a Square*, Nauman reaches precisely the middle of a side of the square. In *Walking in an Exaggerated Manner Around the Perimeter of a Square*, the framing of the image is accentuated by crop-

ping off a part of the square, so that the field of action becomes restricted. The lopping off of the performer's limbs or head serves to objectify the human body.

Nauman practiced these dance exercises extensively before filming them. "An awareness of yourself comes from a certain amount of activity and you can't get it from just thinking about yourself," Nauman stated in his interview with Willoughby Sharp.

> You do exercises, you have certain kinds of awarenesses that you don't have if you read books. So the films and some of the pieces that I did after that for videotapes were specifically about doing exercises in balance. I thought of them as dance-problems without being a dancer, being interested in the kinds of tension that arise when you try to balance and can't. Or do something for a long time and get tired. In one of those first films, the violin film, I played the violin as long as I could. I don't know how to play the violin, so it was hard, playing on all four strings as fast as I could for as long as I could. I had ten minutes of film and ran about seven minutes of it before I got tired and had to stop and rest a little bit and then finish it.[7]

By reading the psychologist Frederick Perls's book *Gestalt Theory,* Nauman was stimulated to place himself in an unfamiliar situation "where you can't relax following resistances," and to turn to the root of one's problems as a way to make art. However, no matter how much Nauman enjoyed reading in psychology, it did not provide a methodology for his performances or the installation pieces he made during the first half of the 1970s. He explained that many laboratory tests have shown that specific physiological changes occur in particular situations, and that we react in certain ways in certain situations. You can set up those situations as if they were experiments, he reasoned, "but I don't think any of my pieces really function that way. They're much more intuitive. . . . It somehow has to do with intuitively finding something or some phenomenon and then later relating it to art. . . . But the approach always seems to be backwards."[8] Nauman never seems "to get there" from knowing the result he will achieve beforehand or from working off a previous experiment. Perls's book provided a rationale for Nauman in his work, and helped clarify what he had been doing in making art from simple everyday activities.

In San Francisco in 1968 Nauman met the dancer-choreographer Meredith Monk. She had seen some of his films on the East Coast, and she assured him that his "amateur" method need not be an obstacle to turning his body awareness into art. This method as well as the spatiotemporal structure of Nauman's performances were suggested in

part by the work of choreographer Merce Cunningham and the composer John Cage: "I guess I thought of what I was doing as a sort of dance because I was familiar with some of the things that Cunningham and others had done, where you can take any simple movement and make it into a dance just by presenting it as a dance. . . . I wasn't a dancer, but I sort of thought if I took things I didn't know how to do but was serious enough about them, they would be taken seriously."[9]

In making use of the tension between professionalism and dilettantism Nauman put into practice what Cunningham had applied, for example, in a group performance at the Brandeis University Creative Arts Festival in 1952; the choreographer had used students with little or no dance training in a performance with dancers he brought from New York. The students were asked to do "simple gestures they did ordinarily," such as washing their hands, filing their nails, combing their hair, and skipping. He commented, in describing this work: "These were accepted as movement in daily life, why not on stage?"[10] The students could execute with confidence those movements they were accustomed to, and thus had little stage fright.

Cunningham tried not "to separate the human being from the action he does, or the actions which surround him, but . . . [to] see what it is like to break these actions up in different ways, to allow the passion, and it is passion, to appear for each person in his own way."[11] In the same way that Nauman believed conventional tools tended to determine how art could be made, Cunningham was suspicious about relying totally on technique: "The danger with acquiring a technique is that it can constrict, *can make you think that's the way* you have to do it." It was Cunningham's experience that "movement is expressive, regardless of intentions of expressivity"; of his dancers he wrote that "in one way or another, what we thought we couldn't do was altogether possible, if only we didn't get the mind in the way."[12] Cunningham's attitudes toward dance indicated to Nauman that he could proceed as an "amateur," working intuitively rather than by aiming for technical perfection. The force of Nauman's performances stems from the tension of operating at the edges of "professionalism," where the warm-up exercises or rehearsals end and "dance" starts, as well as from the continuous threat of collapse, of losing his balance or otherwise failing technically, that comes from his amateur status in a professional field.

In other works Nauman blurs distinctions between music and noise, and again poses the question of where practice ends and performance begins. In *Playing a Note on the Violin While I Walk around the Stu-*

dio, 1968, his original intention was "to play two notes very close together so you could hear the beats in the harmonics. . . . The camera was set up near the center of the studio facing one wall, but I walked all around the studio, so often there was no one in the picture, just the studio wall and the sound of the footsteps and the violin."[13] The sound is fast, loud, distorted, and out of sync, but it is not noticeable until the end of the film. Nauman quietly walks out of the frame in the knowledge that, as John Cage put it, "There is no such thing as an empty space or an empty time. There is always something to see, something to hear."[14] It was again Cage who made Nauman aware of the possibilities of playing with sounds "that are notated and those that are not." In his book *Silence,* Cage explained that "those that are not notated appear in the written music as silences, opening the doors of the music to the sounds that happen to be in the environment."[15] When Nauman steps outside the frame, the viewer's sense of his own environment is heightened, while the action in the film is reduced to "white noise," vaguely present in the background; the involvement of the spectator with the performance is nearly broken.

When he made this film, Nauman did not know how to play the violin, which he had bought only a month or two earlier. "I play other instruments, but I never played the violin and during the period of time that I had before the film I started diddling around with it." A year later, during the winter of 1968–69, Nauman made the videotape *Violin Tuned D E A D.* "One thing I was interested in was playing," Nauman stated in the already mentioned interview with Willoughby Sharp. "I wanted to set up a problem where it wouldn't matter whether I knew how to play the violin or not. What I did was to play as fast as I could on all four strings with the violin tuned D, E, A, D. I thought it would just be a lot of noise, but it turned out to be musically very interesting. It is a very tense piece."[16]

Nauman felt strongly that the important thing in doing these performances was to "recognize what you don't know, and what you can't do," and as an amateur never to allow himself to slip into traditional music, theater, or dance, where he would put himself in the position of being compared with professional performers in those fields. Nauman believed that if he chose the right set of circumstances and structure, was serious enough about his activities, and worked hard at it, his performance would have merit. His intentions and attitude would turn the performance into art. John Cage's *Pieces for Prepared Piano* of 1940 gave Nauman additional insight into the reinvention of how to

play the violin. For this piece Cage had changed the sound of a piano in order to produce music suitable for the dancer Syvilla Fort's performance of *Bacchanale*. First Cage had placed a pie plate on the strings, but it bounced around because of the vibrations. Nails, which he had placed inside the piano as well, slipped down between the strings; however, screws and bolts worked out. In this way, Cage wrote, "two different sounds could be produced. One was resonant and open, the other was quiet and muted."[17]

By playing the notes D, E, A, D, on the violin as fast as he could, Nauman created a rhythmic structure and notational pattern that, because of its repetition, provided a certain monotonous continuity. Because of the frenetic tempo, the performance was very intense; Nauman's screechy manner of playing lacked any melodic inflection, and the sounds picked up by the cheap equipment gave the piece a harsh electronic character. Nauman got the idea of playing as fast as he could from the aleatoric directions in certain musical compositions by Karlheinz Stockhausen, especially his 1955–56 *Zeitmasse* ("Tempi") for Woodwind Quintet. As Peter S. Hansen has written, Stockhausen's Quintet "employs various kinds of 'time.' Some are metronomic (in specified tempi), while others are relative. These are 'as fast as possible' (dependent on the technique of the players); from 'very slow to approximately four times faster' and from 'very fast to approximately four times slower.' "[18] In *Violin Tuned D E A D,* Nauman created a specific kind of environment through sound, and at the same time turned the act of playing the violin into a physical activity that is itself interesting to watch. By turning the camera on its side and his back to the camera, in a static, medium-long shot of the studio, Nauman portrayed himself as an anonymous figure floating horizontally across the screen in defiance of gravity.

The performance in *Violin Tuned D E A D* would have been a continuous activity were it not for the unintentional mistakes, accentuations, and moments of faltering and tiredness that slowed the tempo from time to time. In a similar way, the sound in the film *Bouncing Two Balls between the Floor and Ceiling with Changing Rhythms,* 1968, in which Nauman performs a sort of athletic version of the children's game of jacks, appears at first to be only incidental but turns out to be the focus of the piece, sustaining the structure and rhythm of the performance. In the interview with Willoughby Sharp Nauman recalls:

> At a certain point I had two balls going and I was running around all the
> time trying to catch them. Sometimes they would hit something on the

floor or the ceiling and go off into the corner and hit together. Finally I lost track of them both. I picked up one of the balls and just threw it against the wall. I was really mad, because I was losing control of the game. I was trying to keep the rhythm going, to have the balls bounce once on the floor and once on the ceiling and then catch them, or twice on the floor and once on the ceiling. There was a rhythm going and when I lost it that ended the film. My idea at the time was that the film should have no beginning or end: one should be able to come in at any time and nothing would change.[19]

Rather than attempting to pick up objects while the balls were bouncing (as in a real game of jacks), Nauman stressed physical force by throwing the balls as hard as he could; this made them bounce more unpredictably. He compared the effect to an incident that happened when he was playing baseball as a kid: "Once I got hit in the face, totally without expecting it, as I was leaving the field; it knocked me down. I was interested in that kind of experience you can't anticipate— it hits you, you can't explain it intellectually." In both his films and his videotapes Nauman starts from certain rules he has invented and then lets events take their own course. He waits for chance to come along to change those rules, and when it does he allows the unexpected to take over. As a parallel to his intuitive approach of making up rules and breaking them, he cites the African game Ngalisio, which is played by the Turkana men at any time, with a constantly varying number of players. The men dig two rows of small, shallow holes in the ground, and then place stones in each. The players gather around the holes and squat down, and then one at a time move the stones in different combinations from hole to hole. The objective seems to be for each player to gather as many stones as possible, but no player ever seems to win. The game appears to be not so much about winning as about the act of playing. New rules are made up silently and are adopted or discarded with the understanding and consent of the other players, so that there is never a consistent pattern in the way the men move the stones. In *Bouncing Two Balls between the Floor and Ceiling with Changing Rhythms,* the discontinuous noises which structure both the time of the performance and the rhythm of the film can be heard by the spectators even after they have walked away from the monitor. By using the natural noises resulting from his activities Nauman found a clever way to let sounds be themselves rather than, in Cage's words, "vehicles for man-made theories or expressions of human sentiments."[20]

The first time Nauman gave directions for particular sounds to be incorporated as an element in a sculptural work was in a concept for a

piece that was never executed but is preserved in a drawing of 1966. On it he noted: "Cry to me, cry to me, yellow neon at bottom pile of felt pads with letters cut out—neon light at bottom; if pad is say 5′ or 6′ square, can't see light at bottom except what light shining up from the holes—(could be lead rather than felt); need 7″ of felt, 5/16″ per layer, say 22 layers; if 6 sq. cost $8 for 9 × 12, or $4 per layer, cost $88 for sufficient felt." Instead of presenting a piece of information, he employed an imperative that could be a fragment of a rock 'n' roll lyric, as he had in *Love Me Tender, Move Te Lender,* the pun on the title of the Elvis Presley song. Nauman recalls that at a symposium he attended in Santa Barbara at the time, a sculptor defended her right to use bread as a material, while a well-known critic argued that to do so was unethical since so many people were starving. "This confirmed to me that I could use anything I wanted, whatever was around," Nauman said. "I could use it even if it did not appear to be appropriate to somebody else." Nauman also observed other artists, such as Joseph Beuys and H. C. Westermann, using "poor" materials at the time. In 1966 the publication of Robert Morris's "Notes on Sculpture" stimulated discussions about what sculpture should be. In this piece Morris argued that cubes, pyramids, and simple, irregular polyhedrons, such as beams or inclined planes, are relatively "easy to visualize and sense as wholes." Those simple forms "create strong Gestalt sensations. Their parts are bound together in such a way that they offer a maximum resistance to perceptual separation."[21] Nauman shared an interest in Gestalt psychology, but disagreed with what he felt was Morris's narrowing of its definition. For Nauman, the idea of "completion" meant arriving at a more complex physical and emotional experience through a Gestalt. The use of light, sound, and "poor" materials as sculptural elements became his means of getting away from reductivist statements. His approach is exemplified by the drawing *Cry to Me,* in which he charged elementary geometric forms with strong emotional and evocative content that is reinforced by the title, the hidden light, and the suggestion of the muffled sound buried beneath the pile of felt.

In 1968 Nauman realized a piece with hidden sound and described it in a drawing with this notation: "Tape recorder with a tape loop of a scream wrapped in a plastic bag and cast into the center of a block of concrete: weight about 650 pounds or 240 kg." The theatrical gesture of the muffled scream offsets the minimal form of this piece. The idea shows similarities with Nauman's time-capsule pieces, such as *Storage Capsule for the Right Rear Quarter of My Body,* 1966. A reversal of ex-

pectations occurs as the volume of air enclosing the recorded scream is solidified in concrete, giving the piece a sculptural presence. By sealing off the sound, Nauman forces the spectator to imagine the concept and therefore to think about the piece rather than simply be attracted by its formal qualities. This proposal and another from the same year—for an unrealized stack piece that would conceal memorabilia from his own life, such as photographs and pocket things, between heavy steel plates—bring to mind Marcel Duchamp's *With Hidden Noise,* 1916. This work, made in New York during Easter of that year, is an "assisted" readymade, which consists of a ball of twine sandwiched between two brass plates; inside the ball is a small secret object that rolls around—the "hidden noise" of the title—added by the collector Walter C. Arensberg.

In *Six Sound Problems for Konrad Fischer,* a piece done in the summer of 1968 at the Galerie Konrad Fischer in Düsseldorf, Nauman again set up discrepancies between what one knows and what one sees. This piece mixed recorded sounds with the natural noises of the environment. On the plan for this work (drawn first backwards and then correctly), Nauman noted, "6 sound problems for Konrad Fischer—(6 day week)/ 1. walk/ 2. balls/ 3. violin 4. violin w. walk/ 5. violin w./ balls/ 6. balls w/ walk/ must be short can be very short/ loop 1/ monday/ 2 tuesday/ wednesday 3/ thursday 4/ friday 5/ saturday/ loop 5/ loop 4/ loop 3/ on tape/ recorder/ loop 6/ loop 2/ 11 cm. 1968." Nauman started by repeating his earlier performance activities—walking around, playing the violin, and rhythmically bouncing two balls—which he performed for the occasion in Fischer's gallery, again by himself, making the space his studio. Then he physically cut the tapes to lengths that fit the physical layout of the space. On each of six days a different loop of sound tape was both played and shown in the gallery space. On the first day of the piece, a visitor entering the gallery was confronted with a scene that might have been a stage set for a production of Samuel Beckett's *Krapp's Last Tape*; there was nothing in the space but a chair and a table, placed off center in the room. On top of the table was a tape recorder playing the smallest loop of sound tape. On following days, however, a visitor would find, strung diagonally across the space, ever-longer loops of sound tape, at one end threaded through the recorder head and at the other wound loosely around a pencil fastened to the chair with masking tape. Each day the chair would be located in a different spot, with the tapes eventually forming a radiating pattern.

Six Sound Problems for Konrad Fischer summarized central aspects of Nauman's sculptural and performance activities. In incorporating his own memories and experiences into his sculptural works—as he had also done in some of his 1968 stack pieces—Nauman eliminated the distance between his work and himself, just as Beckett had in the trilogy *Molloy, Malone Dies,* and *The Unnamable,* where one hears the author's voice, as the first-person narrator, alongside the fictional main characters'. Both Beckett and Nauman transform their experiences into anonymous, timeless events. Nauman kept his performances from becoming too autobiographical by distancing himself from his audience through film and video. Through his use of framing and cropping he turned himself into an anonymous, abstract body.

During the winter of 1968–69 Nauman stayed in New York; while there he made several hour-long black-and-white videotapes, among them *Bouncing in the Corner No. 1* and *No. 2, Lip Sync, Revolving Upside Down,* and *Pacing Upside Down.* Then, in 1969, after returning to Los Angeles, he made a set of four black-and-white silent films— *Black Balls, Bouncing Balls, Gauze,* and *Pulling Mouth.* Each of these so-called Slo-Mo films is less than ten minutes long; the four are shown together on one reel.

Nauman had originally intended to show his films from 1967 to 1968 as loops, so that the audience could come in or leave at any time without feeling that they had missed something, but he never screened them that way. He wanted to set up a cyclic time structure because he felt that *Fishing for Asian Carp,* with its beginning and end, was a narrative; as such it became "too much like making movies, which I wanted to avoid, so I decided to record an ongoing process and make a loop that could continue all day or all week."[22] In these films the camera was stationary, placed at a low height and then pointed slightly downward in order to show the floor. The only camera manipulation consisted of the framing, which caused Nauman to be partly in and partly out of the picture as he performed. The technical flaws of the films were included in their aesthetics, as were the imperfections of Nauman's actions caused by fatigue and chance. For instance, Nauman explained that in both *Playing a Note on the Violin While I Walk around the Studio* and *Bouncing Two Balls between the Floor and Ceiling with Changing Rhythms,* he "started out in sync but there again, it is a wild track, so as the tape stretches and tightens it goes in and out of sync. I more or less wanted it to be in sync but I just didn't

have the equipment and the patience to do it."[23] In contrast, Nauman had been able to rent a special industrial camera to make the four Slo-Mo films, which are shot in very slow motion. Speaking with Willoughby Sharp in 1970, Nauman described his process:

> You really can't do it with the available video equipment for amateurs. I'm getting about four thousand frames per second. I've made four films so far. One is called *Bouncing Balls,* only this time it's testicles instead of rubber balls. Another one is called *Black Balls.* It's putting black makeup on testicles. The others are [*Pulling Mouth* and *Gauze*], and in the last one I start out with about 5 or 6 yards of gauze in my mouth, which I then pull out and let fall on the floor. These are all shot extremely close up.[24]

Each film took from six to twelve seconds to shoot, depending on the frame speed, which varied between 1,000 and 4,000 frames per second, depending on how well the area in which the activity staged was lit. "The action is really slowed down a lot," Nauman said. "Sometimes it is so slow that you don't really see any motion but you sort of notice the thing is different from time to time."[25]

In his films from 1967 to 1968 Nauman had objectified his activities through the endless repetition of sound and broken-up movements, and through the cropping of the body by the frame. In some of the slow-motion films, the suspension of time and gravity caused by the slowed filming abstracts the action. The viewer stops looking for recognizable objects; the absence of sound forces one to concentrate even more intently on the nearly arrested motion of the picture. Nauman compares the effect to that of watching silent, slow-motion films of atomic bomb explosions, "where you become fascinated with the weightless cloud formations unfolding like giant flowers. You have to know what the images are in order to understand their morbid implications." In *Bouncing Balls* and *Black Balls* the nearly static images alternately take the form of movie stills, kinetic sculpture, and "stillnesses"—Cunningham's term for static positions held by dancers—stressing not so much the breaking up of motion but of the relationships that exist between movements.

Precedents for these slow-motion works can be found in a film Nauman made in 1967 entitled *Thighing,* and, specifically for *Pulling Mouth,* a series of holograms he produced entitled *Making Faces,* 1968. In *Thighing* Nauman distorted his thigh by pinching and pulling it, while confusing the viewer with a sound track of his breathing loudly. That same year he made a drawing of five poses of unnaturally twisted

lips; they suggest both children's games and aberrant behavior. On this drawing he carefully noted: "Both lips turned out: mouth open, upper lip push[ed] up by right thumb and lower lip pulled down by right forefinger; both lips pulled in tight over teeth—mouth open. As above but mouth open. Both lips squeezed together from the side by the thumb and forefinger right hand." In the series of holograms called *Making Faces,* Nauman contorted, stretched, and pulled his face into exaggerated and formal facial arrangements, ending in absurdity. "I guess I was interested in doing a really extreme thing," he revealed. "It's almost as though if I'd decided to do a smile, I wouldn't have had to take a picture of it. I could just have written down that I'd done it, or made a list of things that one could do. There was also the problem with the holograms of making the subject matter sufficiently strong so that you wouldn't think about the technical side so much."[26] Of the four slow-motion films, *Gauze* is the most ethereal. "When I pulled the gauze out of my mouth, I had no idea what it was going to be like," Nauman remembers. "Watching it afterwards, you are left with beautiful images of falling gauze. All kinds of allusions had slipped in which I had not intended, but certainly had allowed to be there." *Gauze* was filmed with the camera upside down, giving the activity a sense of weightlessness. This quality combines associations that range from the yogi who purifies the digestive tract with a length of wet string, to the magician who pulls a seemingly endless string of handkerchiefs from his mouth.

Both the idea of the suspension of gravity, which reduces the sense of the physicality of the scenes, and the omission of references to scale, which forces the spectator to use his or her imagination, return in Nauman's Film Sets: *Spinning Spheres* and *Rotating Glass Walls,* both 1970, 8 and 16 mm film loops that are projected simultaneously onto four walls. Nauman has described the projects as follows:

Film Set A: Spinning Spheres

A steel ball placed on a glass plate in a white cube of space. The ball is set to spinning and filmed so that the image reflected on the surface of the ball has one wall of the cube centered. The ball is center frame and fills most of the frame. The camera is hidden as much as possible so that its reflection will be negligible. Four prints are necessary. The prints are projected onto the walls of a room (front or rear projection; should cover the walls edge to edge). The image reflected in the spinning sphere should not be that of a real room but of a more idealized room, of course empty, and not reflecting the images projected on the other room walls. There will be no scale references in the films.

Film Set B: Rotating Glass Walls

Film a piece of glass as follows: glass plate is pivoted on a horizontal center line and rotated slowly. Film is framed with the center line exactly at the top of the frame so that as the glass rotates one edge will go off the top of the frame as the other edge comes on the top edge of the frame. The sides of the glass will not be in the frame of the film. Want two prints of the glass rotating bottom coming toward the camera and two prints of bottom of plate going away from camera. The plate and pivot are set up in a white cube as in Set A, camera hidden as well as possible to destroy any scale indicates in the projected films. Projection: image is projected from edge to edge of all four walls of a room. If the image on one wall shows the bottom of the plate moving toward the camera, the opposite wall will show the image moving away from the camera."[27]

In contrast to *Gauze,* the videotapes Nauman made during the winter of 1968–69 record such commonplace studio activities as pacing or walking, and therefore have a more down-to-earth character. Nevertheless, because of Nauman's manipulations of the camera, these tapes are no less absurd or abstract. Here the camerawork has become "a bit more important." Nauman noted: he used a wide-angle lens to distort the image, or he turned the camera on its side or upside down. "As I became more aware of what happens in the recording medium I would make little alterations," he said. For *Stamping in the Studio,* 1968, which records Nauman stamping his feet in different rhythms, the camera was stationary but placed in an upside-down position. The rhythms of the stamping become more and more complex, moving, as Nina Sundell describes it, "from a steady one-two one-two to a syncopated ten-beat phrase. . . . Nauman crosses the studio horizontally and then diagonally, and then moves in expanding and contracting spirals, covering the entire floor area, his path often taking him off-screen."[28] In *Revolving Upside Down,* 1969, the camera is also inverted. The action in this tape is related to that of *Slow Angle Walk*; Nauman complicates and extends the process of getting "from here to there" by making a series of complicated leg movements in a manner that seems alternately logical and illogical, first raising one leg while standing on the other, then revolving a quarter-circle by turning his heel, then completing the step. While Nauman made this sort of multidirectional movement part of his video vocabulary, it had been Merce Cunningham who had emphasized this idea, in applying chance to space: "Rather than thinking in one direction, i.e., to the audience in a proscenium frame, direction could be foursided and upside down," he wrote.[29]

Lip Sync, 1969, in which the camera is again upside down, focuses on Nauman's mouth, chin, and throat as he repeats the words "lip sync" over and over, articulating them in an exaggerated manner. Nauman hears the words through the earphones that he wears, and then repeats them; but the rhythm of the sound track on which he says the phrase is not synchronized with the movements of the lips on the screen—which are made even harder to comprehend because of their inversion. The lips and sound go in and out of sync. In contrast to the grainy, lyrical images of his films of 1967–68, which suggest a visual field on which one is free to impose one's imagination, this video image separates what one hears from what one sees, forcing the viewer to try to match up sound and image.

Nauman did his last live performance in 1969, during the exhibition "Anti-Illusion: Procedures/Materials," held at the Whitney Museum of American Art in New York from May 19 to July 6. For an hour, the performers in the piece—Nauman, his wife Judy, and the dancer Meredith Monk—stood in different corners of the space, facing the audience. Over and over they let themselves fall back, then pushed themselves off the walls of the corner, a foot and a half away, bouncing back to the point where they would nearly lose their balance. The effect of this rigorous, physically exhausting exercise was intensified by the thumping sound it produced. Because the performers could not see each other, they were in varying degrees in and out of sync both with each other and with the pounding sounds they produced. Nauman employed a similar effect in his 1985 neon pieces on sex and power. For instance, in *Mean Clown Welcome,* the sequence in which the various parts of the piece flash on and off is the same for each pair of figures, but they flash at different speeds, going out of phase and back into it over a period of five minutes. Basically the two pairs of figures are programmed to "stand, step forward (hand and arm reach out, limp penis becomes erect penis), and shake hands (when hand is up, erect penis is on, when hand is down, limp penis is on)," as Nauman described it. The figures on the left flash at a rate "about that of a brisk handshake," while the figures on the right flash faster and thus go out of phase, so that the limbs no longer align with each other, creating confusion and complexity. Nauman compares his procedure of taking events in and out of synchronization to the composer Steve Reich's use of a similar technique in *Violin Phase,* 1967, and *It's Gonna Rain,* 1965. In the latter, several sound tracks are played at a slightly different rate so that the phrase, "It's gonna rain," repeated over and over, is altered at the points

where the tracks don't align. This not only causes the cadence to change but also breaks the sequence of the words, giving them a different meaning, somewhat in the manner of Nauman's *First Poem Piece,* 1968, and *Second Poem Piece,* 1969. It interested Nauman, too, that Reich had picked up the phrase from a man voicing his opinion in New York's Central Park. This was in accordance with his own practice of using the titles of popular songs, as in the drawing *Love Me Tender, Move Te Lender,* 1966, and in his neon piece *Suite Substitute,* 1968. In 1972 he took an exhortation, sprayed in red letters about 5 feet high on an overpass in Pasadena, California, for his yellow-and-pink neon piece *Run from Fear, Run from Rear.*

Nauman met Reich in 1968 at the University of Colorado, where he was visiting William T. Wiley. Wiley and Reich were collaborating on a performance they entitled *Overevident Falls,* and Nauman became interested in Reich's working methods while observing him as he recorded over the course of two days. Wiley recalls that Reich suspended a pair of microphones from a swing. Each time the swing passed in front of a set of amplifiers feedback was produced—a shriek, followed by a kind of howling sound when the swing reached the height of its motion before swinging back in the opposite direction. Meanwhile, Wiley poured soap flakes on the swing; these fluoresced under a black light and softly drifted down to form a pile beneath the swing. Later that same year Reich used a similar device for his piece *Pendulum Music,* performed at the Whitney Museum of American Art.

In the winter of 1968–69, before his own performance at the Whitney during the "Anti-Illusion" exhibition, Nauman had made two tapes called *Bouncing in the Corner No. 1* and *No. 2,* based on the same idea as the Whitney piece. These works are more remote and sculptural than the live performance, which was direct and theatrical. In the first tape the camera is held sideways, in the second upside down; in the second tape, one especially perceives an abstract, swaying image positioned carefully at the edge of the frame. Through the repetitious cadence, the dislocating cropping of the image, the apparent defiance of gravity, and the use of reductive black-and-white tones, the performer is changed into a hypnotic, undulating visual field.

Performing at the Whitney Museum with two people made Nauman realize that he could involve others in his performances if he gave them specific instructions. Before this he had found it difficult to carry out a performance even once, let alone repeat it. He figured that he could "make a situation where someone else has to do what I would

do," he could go into the studio and do whatever he was interested in doing, and then "try to find a way to present it so that other people could do it without too much explanation." But he felt he had to set up a "very strict kind of environment or situation so that even if the performer didn't know anything about me or the work that goes into the piece, he would be able to do something similar to what I would do." After the Whitney evening, and throughout the first half of the 1970s, Nauman no longer performed himself but sent specific performance instructions to exhibitions in which he was invited to participate. A typical set of instructions was published in 1970 in *Artforum*:

> Hire a dancer or dancers or other performers of some presence to perform the following exercises for one hour a day for about ten days or two weeks. The minimum will require one dancer to work on one exercise for ten to fourteen days. If more money is available two dancers may perform, one dancer performing each exercise at the same time and for the same period as the other. The whole may be repeated on ten or fourteen day intervals as often as desired.
>
> (A) Body as a Cylinder
>
> Lie along the wall/floor junction of the room, face into the corner and hands at sides. Concentrate on straightening and lengthening the body along a line which passes through the center of the body parallel to the corner of the room in which you lie. At the same time attempt to draw the body in around the line. Then attempt to push that line into the corner of the room.
>
> (B) Body as a Sphere
>
> Curl your body into the corner of a room. Imagine a point at the center of your curled body and concentrate on pulling your body in around that point. Then attempt to press that point down into the corner of the room. It should be clear that these are not intended as static positions which are to be held for an hour a day, but mental and physical activities or processes to be carried out. At the start, the performer may need to repeat the exercise several times in order to fill the hour, but at the end of ten days or so, he should be able to extend the execution to a full hour. The number of days required for an uninterrupted hour performance of course depends on the receptivity and training of the performer.[30]

These performances and a related one about attempting to make the center of the room and the center of one's body coincide are to a large extent mental exercises in which the audience observes no action. In the first place, it is virtually impossible to locate the perfect center of a

room, even with incredibly precise measurements. In these works Nauman again explores the discrepancies between idea and reality, between what one observes and what one theoretically knows. Again, the conceptual process prevails over physical details. In 1969, Nauman had used the idea of finding a center in a sculptural piece, *Dead Center*, in which he cut a hole through the center of a steel slab with a blowtorch. In this case the violence of the act, with its allusion to the deadly precision of shooting through the bull's-eye of a target, is combined with the absurd literalness Nauman had used in other works—for instance, *From Hand to Mouth*. Discrepancies between seeing and knowing return in two videotapes of performances done in 1973, *Elke Allowing the Floor to Rise Up over Her, Face Up* and *Tony Sinking into the Floor, Face Up and Face Down*, forty and sixty minutes long, respectively. For these tapes Nauman instructed each performer to lie motionless on the floor—and had told each one to practice this diligently before the taping. Furthermore, he had told the first performer to imagine that the molecules of her body would mix with those in the floor, and that slowly she would lose herself and become a part of something else. Under the pressure and tension of the actual performance, she lost her sense of time and became frightened; three times she had to sit up because she felt that she was filling up with the molecules of the floor and was therefore becoming unable to breathe.

Nauman intended these performances as mental exercises, the realization of a concept that already was implicit in his slow-motion films. Slowing down the performer's movements in these earlier films made the muscular contractions seem weaker; the performer appeared to be perfectly still. The internal process did not necessarily show on the outside. Thus in 1973 it occurred to Nauman that he could make a tape in which a person who was concentrating very hard would appear the same as someone taking a nap on the floor. In these tapes Nauman's presence is felt behind the camera, something that is not true of the videotapes from 1968–69, where as the performer he was in front of the camera. In these later works, for instance, at five-minute intervals he dissolves between two images of the body, seen from different angles, and he sets up the time structure of the works by panning and moving the camera. By restricting a situation in this way Nauman ensured that whatever variation the performer invented spontaneously would remain within the framework of his instructions. It was through this kind of reasoning that, in the spring of 1969, Nauman hit upon the idea that by creating a sculptural installation in a sufficiently specific manner he

could "make a participation piece without the participants being able to alter the work." Thus he would bridge in one piece his sculptural and performance activities. An example of this is *Performance Corridor,* first used as a prop in his videotape *Walk with Contrapposto* and then exhibited by itself in the "Anti-Illusion" show at the Whitney Museum of American Art. "I began to think about how you relate to a particular place, which I was doing by pacing around," Nauman wrote.

> That was an activity which took place in the studio. Then I began thinking about how to present this without making it a performance, so that somebody else would have the same experience instead of just having to watch me have that experience. The earliest pieces were just narrow corridors. The first one I used was a prop for a piece that was taped. It was presented as a prop for a performance and was called that, without any description of what the performance was. It was just a very narrow, gray corridor, and all you could do was walk in and walk out. It limited the kind of things you could do, because I don't like the idea of free manipulation, of putting a bunch of stuff out there and letting people do what they want with it. I really had more specific kinds of experience in mind, and without having to write out a list of what people should do. I wanted to make play experiences unavailable just by the preciseness of the area.[31]

By giving no instructions, Nauman left it up to the visitor to decide whether or not to enter the corridor and become a performer in the piece. Another piece from that time, *Lighted Performance Box,* 1969, consists of a tall welded-aluminum box, open at the top, to which there was clamped a theatrical light. The idea of this work may be that one is to climb into the box and stand under the bright light. Here again the performer-spectator is made aware of the physical limitations the artist has imposed; for one thing, it is very nearly impossible to enter the box.

In December 1969, Nauman constructed his first Acoustic Wall at the Galerie Ileana Sonnabend in Paris. "It was a large L-shaped piece covering two walls of her Paris gallery," Nauman explained. "It was flush with the wall of the gallery, and had very thin speakers built into it. Two different tapes were played over the speakers: one was of exhaling sounds, and the other alternated between pounding and laughing. You couldn't locate the sound. That was quite a threatening piece, especially the exhaling sounds."[32] The false wall, 9 feet high and 12 feet long on each wing of the L shape, served no support function and so was built roughly to create a sculptural presence in the room.

In most of the Acoustic Wall installations, sound is used not only to disorient but also to impart a psychological impact to otherwise neutral

surroundings. The advantage of using sound in this way is that it does not cover up "true" materials, something that must be done to create a sculptural presence in the gallery. To reinforce both their tactility and their ambiguity—are these false walls art, or are they part of construction work being done in the gallery?—most of these walls are smooth on the inside but rough and unfinished on the outside. In the 1969–70 *Acoustic Wall,* Nauman shifts the emphasis from visual experience to physical involvement. He explained his intent in such works:

> When the corridors had to do with sound damping, the wall relied on soundproofing material which altered the sound in the corridor and also caused pressure on your ears, which is what I was really interested in: pressure changes that occurred while you were passing by the material. And then one thing to do was to make a V. When you are at the open end of the V there's not too much effect, but as you walk into the V the pressure increases quite a bit, it's very claustrophobic.[33]

In her article "PheNAUMANology," published in *Artforum* in 1970, Marcia Tucker writes that "Nauman has pointed out an analogous situation existing in nature, when certain winds or approaching storms can create even minute massive changes in the atmosphere, which are said to account for widespread emotional instability and increased suicide rates in a given area."[34] As hard as it is to measure the impact of "emotional overload" on the participants, it is as senseless, in accordance with Nauman's intent, to attempt to describe the Acoustic Wall pieces, which "rely on words less and less." Already in 1970 Nauman had written that "it has become really difficult to explain the pieces. Although it's easier to describe them now, it's almost impossible to explain what they do when you're there. Take *Performance Corridor.* . . . It's very easy to describe how the piece looks, but the experience of walking inside it is something else altogether which can't be described. And the pieces increasingly have to do with physical or physiological responses."[35] Information from two sources, touching and hearing, disorients and confuses the participants in the Acoustic Wall installations. Sometimes these sources are inseparable; at other times they do not align at all. The artist can then restrict the participants physically, guiding their experiences. On the other hand, the "cooler" the empty spaces become the more emotionally loaded the pieces are, leaving the artist in a vulnerable position as well: "I think when you attempt to engage people that way—emotionally—in what you're doing," Nauman told Tucker, "then it's difficult because you never know

if you succeed or not, or to what extent. In other words, it is easier to be professional, because then you can step outside the situation. When you bring things to a personal level, then you're just much less sure whether people can accept what's presented."[36]

In 1985, after a hiatus of about ten years, Nauman returned to video; he made two videotapes in color, one featuring a man and the other a woman, and together they constitute *Good Boy Bad Boy*. Each performer repeats the same one hundred phrases. In a later interview he explained why he had returned to this medium:

> I think it's because I had this information that I didn't want to put into a neon sign; I didn't know what to do with it. . . . I could write it and publish it, print it or whatever. . . . It took a long time, but I finally decided to do it as a video. I had thought about presenting it as a performance, but I have never felt comfortable with performance. And so video seemed to be a way to do it. It was very interesting for me when we made the tapes—I used professional actors. The man had done mostly live, stage acting, so he was much more generous and open in his acting. The woman had done a lot of television acting, mostly daytime, in commercials and some soap operas. So a lot of her acting is in her face—she didn't use her hands much. I liked that difference. What interests me is the line that exists between others. Because the performers are actors, the material's not autobiographical. It's not real anger; they're pretending to be angry—and they are pretty good at it, but not really convincing. I like all these different levels, not knowing quite how to take the situation, how to relate to it.[37]

Good Boy Bad Boy was conceived as a didactic, moral statement. Both actors address the viewer, looking straight into the camera. They appear in close-up, like news announcers, as each one tries to convince the audience of the truth of his or her message. "It involves you by talking to you—'I was a good boy—you were a good boy!'" Nauman said. "It's not a conversation; you are not allowed to talk. But you are involved simply by virtue of the fact that someone uses that form of address."[38] An artificial relationship is set up not only between the actor and the audience, but also between the man and the woman—although they act and speak at the same time, they do so at a psychological and physical distance from each other, framed within their own separate monitors. Each time they repeat the hundred phrases, both actors become more emotionally intense in their delivery. In the course of going through the phrases five times (during which they are shown in tighter and tighter close-ups), the actors change from inflections that are neutral and cheerful to those that show irritation and anger. Gradually the

emotional differences between the actors (within their methods of acting) begin to show up more and more. Their sentences don't match up any longer, the cadence keeps going out of sync—once more, the scheme of the action breaks down.

Later that same year *Good Boy Bad Boy* returned as part of an installation in Haus Esters, Krefeld, West Germany. In this work Nauman attempted to suggest the atmosphere of his studio, in which one thing leads to another, connecting through a process of free association, taking on a variety of ambiguous meanings. He was working against the atmosphere of the museum, in which works of art tend to be defined hierarchically and to be categorized uncomfortably. In his 1970s corridor installations, Nauman had set up a confusion between works under construction, sculptures, and installation pieces, in an attempt to escape the elimination of possibilities that the act of selection implies. Other ways in which he has attempted to avoid categorization have included putting plaster pieces from two different sculptures together in one work, as in the *Studio Piece* of 1978–79, and reassembling dispersed works again in a new context, as in the *Six Sound Problems for Konrad Fisher*, 1968. Another example of this tactic is the Haus Esters installation of 1985, which combined in three rooms the 1985 neon *Hanged Man*; a sound recording of the text for the 1984 neon piece *One Hundred Live and Die*; and the 1985 video work *Good Boy Bad Boy* playing on two monitors. This installation can be seen as part of Nauman's epos on the themes of war and peace, or perhaps as his version of the medieval dance of death. The *Hanged Man*, flashing on and off in a simple sentence, epitomizes ambiguity. The implicit question of whether it was the "good boy" who made the "bad boy" hang, or vice versa, is left unanswered. In any case, death is the result. Several associations are suggested by this installation, including the hanging of criminals, lynchings by the Ku Klux Klan, and images from such movies as Ingmar Bergman's *Seventh Seal* or John Ford's Westerns— as well as Nauman's own dangling chair pieces in the Diamond Africa and South America series. Once again a reference is made to a children's game—in this case, Hangman, in which one has to guess the letters of a word; when one misses, part of a gallows is drawn. The game continues until one player has either guessed the word or completed a gallows with a hanging figure. In the Haus Esters installation, *Hanged Man* keeps dangling between good and evil, accompanied by the sound of the chanting of the phrases "kill and die" and "kill and live," "fall and die" and "fall and live," and "spit and die" and "spit and live." At

the same time the two actors address us with, "I was a good boy, . . . that was good. I was a bad boy . . . that was bad"; "I don't want to die, you don't want to die, we don't want to die: this is fear of death."

Notes

1. Unless otherwise noted, all quotations from Bruce Nauman in this chapter come from a series of interviews and discussions with the author held between June 1985 and August 1986.

2. Quoted in Marshall McLuhan, *The Mechanical Bride* (Boston, 1967), p. 80.

3. Quoted in Willoughby Sharp, "Nauman Interview," *Arts Magazine,* March 1970, 27.

4. Quoted in Arturo Schwarz, *The Complete Works of Marcel Duchamp* (London, 1969), p. 483.

5. Quoted in Sharp, "Nauman Interview," 24.

6. Quoted in Sharp, "Nauman Interview," 23.

7. Quoted in Willoughby Sharp, "Bruce Nauman," *Avalanche* 2 (Winter 1971): 27.

8. From un unpublished interview with Lorraine Sciarra, Pomona College, January 1972, quoted by Jane Livingston, in *Bruce Nauman: Works from 1965 to 1972,* Los Angeles County Museum of Art, 1972, pp. 16, 21.

9. Quoted in Sciarra interview. It was Jasper Johns who asked Bruce Nauman to make a stage set for Merce Cunningham. Johns recalls meeting Nauman for the first time when they had dinner in a Japanese restaurant after Nauman's first New York show, organized by David Whitney at the Leo Castelli Gallery in 1968. Later, they saw each other several times in Los Angeles, where Johns was making prints at Gemini G.E.L. According to Johns, when he asked Nauman to do the set for *Tread* (first performed in January 1970), Nauman told him to get a lot of fans and put them on a rail across the stage. Nauman's idea was that the Cunningham dance group would not have to carry the fans with them during their tour, but could rent them wherever they went. In a 1968 drawing Nauman had first proposed a kind of scaffolding on wheels, about 4½ feet high, with rows of fluorescent lights on it. The scaffolding was to move back and forth, from left to right, gradually illuminating the stage. The dancers would not only have to work around the patterns of light and dark on the stage but also around the scaffolding itself, which would be moving. However, Robert Morris had already designed a moving light fixture the height of the stage, and it was thought that the designs were too similar. Nauman then came up with the idea of fans, blowing first toward the dancers, then toward the audience.

10. From Merce Cunningham. *Changes: Notes on Choreography* (New York: Something Else Press, 1968), n.p.

11. Ibid., n.p.

12. Ibid., n.p.

13. Sharp, "Bruce Nauman," 29.

14. From *Silence: Lectures and Writings by John Cage* (Middletown, Conn.: Wesleyan University Press, 1976), p. 8.

15. Ibid.

16. Quoted in Sharp, "Bruce Nauman," 29.

17. Quoted in *Empty Words: Writings 1973–1978 by John Cage* (Middletown, Conn.: Wesleyan University Press, 1981), p. 8.

18. Quoted in Peter S. Hansen, *An Introduction to 20th Century Music* (Boston: Allyn and Bacon, 1971), p. 391.

19. Quoted in Sharp, "Bruce Nauman," 28, 29.

20. Cage, *Empty Words*, p. 8.

21. Quoted in Robert Morris, "Notes on Sculpture," *Artforum* 4, no. 6 (February 1966): 44.

22. Quoted in Sharp, "Nauman Interview," 26.

23. Quoted in Sharp, "Bruce Nauman," 28.

24. Quoted in Sharp, "Nauman Interview," 26.

25. Quoted in Sharp, "Bruce Nauman," 24.

26. Quoted in Sharp, "Nauman Interview," 26.

27. From "Bruce Nauman: Notes and Projects," *Artforum* 4, no. 4 (December 1970): 44.

28. Quoted in *Castelli-Sonnabend Videotapes and Films*, ed. Nina Sundell (New York, 1974), p. 103.

29. Quoted in Merce Cunningham, *Changes*.

30. From "Bruce Nauman: Notes and Projects," 44.

31. Quoted in Livingston, *Bruce Nauman: Works from 1965 to 1972*, p. 23.

32. Quoted in Sharp, "Nauman Interview," 26.

33. Quoted in Sharp, "Bruce Nauman," 23.

34. Marcia Tucker, "PheNAUMANology," *Artforum* 4, no. 4 (December 1970): 42.

35. Quoted in Sharp, "Nauman Interview," 25.

36. Tucker, "PheNAUMANology," 42.

37. In an interview with the author, Nauman stated that he did not plan to make a neon of *Good Boy Bad Boy*. Shortly thereafter, however, he changed his mind, and transformed his text, a listing of a hundred phrases, into a multicolored neon sign as well.

38. Quoted in Chris Dercon, "Keep Taking It Apart: A Conversation with Bruce Nauman," *Parkett* 10 (1986): 55, 61.

Regina Cornwell

A Question of Public Interest

At first hearing, *The Center of the Universe* and *Virtues and Vices* sound like the titles of Sunday sermons, but in fact they are works of art by Bruce Nauman. Such odd religious allusions fit, as Nauman has always wittily explored issues of belief and knowledge in and through his art. His is an art based on a relentless questioning of its own possibilities, which in turn causes his audience to question. With such straightforward but surprising titles for these, his second and third permanent public artworks to date, both completed in 1988, Nauman challenges his viewers' assumptions about art within a public domain.

With a seriousness allied to wit and humor, Nauman, who stands to-day as one of America's leading artists, has always been about con-founding his audience, refusing to give simple satisfaction or easy an-swers through his art. There is a frustration that often accompanies looking at and thinking about Nauman's work, since it consistently de-nies closure and thus remains open-ended. But with the frustration comes a pleasure, part of which is in the way he pushes us. He prods us to ask questions about art, about the artist's place or role, about our own positions as perceivers, and about the way we are affected in the world through our experience of art.

While best known as a sculptor, and secondly as a draftsman, since the 1960s Nauman has worked in virtually every medium except paint-ing, which he abandoned after art school. The list includes neon, film, video, photography, holography, performance, sound, and installation. Language is crucial to much of his art, often evident in his choice of ti-tles, as well as in the puns, rebuses, anagrams, and palindromes that he spins. All his pieces, particularly his sculpture and drawings, have an in-

Originally published in *Contemporanea* 3, no. 2 (February 1990): 38–45.

tentionally rough and incomplete look to them, since the artist has always been more interested in process than product, in materials and ideas than in finished objects.

To compare *The Center of the Universe,* made of poured concrete, with *Virtues and Vices,* in neon, one might as well match apples with carrots. Formally different as they are, though, they provide a focus for reflecting on several key themes and preoccupations of Nauman's that have surfaced regularly over his twenty-five-year career.

The two public works share a number of circumstances in common. Not only were they both completed the same year, but the planning for each began five years earlier, in 1983. Both are located in the Southwest, each on a university campus. While they were first conceived as outdoor works for public spaces, each materialized in 1984 as other works in other media in two separate gallery exhibits in the same building in New York's SoHo. The one, executed in stone, is called *Seven Virtues and Seven Vices,* while the other became *Room with My Soul Left Out, Room that Does Not Care.* Like the geometric image of skewed lines of which Nauman is so fond—lines neither parallel nor intersecting—ideas from these two very different public works draw close to and inform each other in a curious way.

The Center of the Universe immediately poses the question: Why here? "Well, why not?" says Nauman. "No one else has said where it is, and this place is as good as any." The sculpture is located on the University of New Mexico campus in Albuquerque and consists of two open intersecting passages or corridors and one vertical column that rises up from the intersection, each segment 50 feet long and 10 feet square. The column at the center looks like an awkward, overweight chimney gripping for the sky; it descends below to a pit covered with a metal grating. When the poured concrete construction was built on location, Nauman instructed that its rough and unfinished appearance be left as is in keeping with the industrial look common to his other sculpture. The stubby, mysterious space is completed by six sodium-vapor lamps, one burning in each chamber leading out from the center—to the sides, above, and below. Day and night they cast their yellow urban and industrial glow. On the grating at the center a plaque announces the name of the sculpture.

While Nauman wryly lays claim to the center of the universe, we notice that on the inner walls of one entrance are the remains of washed-down graffiti depicting Gothic stained-glass windows, while another wing bears the classical aspirations of a fellow malcontent whose

scrubbed-down drawings of Doric columns and architrave are still visible on the walls. Both sets of images echo a longing for simple traditional satisfaction, envisioned in comfortable and familiar symbols. Clearly, *The Center of the Universe* won't provide this. Its 1984 predecessor, *Room with My Soul Left Out, Room that Does Not Care*—truncated, with one less arm, in Celotex with bright light—created an atmosphere of unease, discomfort, fear, and sadness. Its gentle and plaintive title reinforced the black attitude of the sculpture. The strong emotional reaction that it evoked brought it a little closer to something familiar than does its outdoor relative.

The Center of the Universe stands bluntly sandwiched between two modern pueblo-revival buildings on the campus, with a park to the north and to the south a street ending in a cul-de-sac directly in front of the sculpture, marked by a small wooden barricade and a stop sign off from the center. Eventually a pedestrian mall will replace the dead-end street, but that won't alter the east-west squeeze between the buildings.

Nauman submitted an earlier proposal to the university called *Abstract Stadium*, consisting of bleachers placed in an open space in front of the library. While it would have been infinitely more prominent on the campus, the project was turned down. Later the proposal for *The Center of the Universe* was approved as Nauman put his ideas into place in this singularly lackluster location for a work by a major artist.

The Center of the Universe's urban-looking, chunky passages contrast sharply with its nonurban setting, with duck ponds off to the north in the park. Its hard industrial materials and yellow lights summon up the feeling of a subway passage or wartime bunker; the pit below, a torture chamber; and the whole, the ovens of Nazi concentration camps with only the smoke missing. Its New Mexican site also brings to mind associations with laboratories for the testing and development of the atomic bomb.

At the same time, Nauman's eccentric construction makes allusions to the body of his other works—for instance, his corridor video installations of the 1970s and his tunnels of the 1970s and 1980s, including *Three Tunnels Interlocking, Not Connected* (1981) and *Model for Tunnel* (1978). More important is the notion of centers and centering examined in his *Floating Room* (1973), *Cones and Cojones* (1974–75), and *Dead Center* (1969), among other pieces, and the linking of the center with the concept of perfection, as in *Perfect Door/Perfect Odor/Perfect Rodo* (1973).

With centering comes the analysis of public/private, inside/outside divisions that also constitute a large part of what *The Center of the Universe* is about. These themes recur in a number of his works, including the corridor installations and early sculptures from the 1960s, which focus on Nauman, wondering in public what it means to be an artist and what consequences this has ethically and morally. He has posed these questions with considerable wit, as in his three self-portraits—the two photographs of 1966–67, *Self Portrait as a Fountain* and *The Artist as a Fountain,* and the 1967 drawing *Myself as a Marble Fountain,* preceded by the 1966 text, "The true artist is an amazing luminous fountain"—all of which provide suggestive, quirky answers to the question. Nauman later said that in some sense he believed this, as well as the verbal legend of his neon piece entitled, *Window or Wall Sign*: "The True Artist Helps the World by Revealing Mystic Truths." A continuous thread connects Nauman's work from the 1960s, with his studio tasks and investigation of art's essence, to his 1970s concern with the role of the perceiver, puzzling over the body revealed and concealed through the manipulation of video cameras, and finally to his more socially conscious works of the 1980s, including the sculptures of the *South American* series and the *Diamond Africa with Chair Tuned DEAD* (1981). The line in his work continues through the decade's video installations and neons, to his self-conscious and self-reflexive, yet public work.

Nauman's playful title makes a tongue-in-cheek reference to a basic tenet as defined by Einstein. Known as the cosmological principle, it states roughly that there can be no privileged position in the universe where the laws of physics do not operate—no "center" or area of *primum mobile.* In a relativistic universe, anywhere can be regarded as a center—its own center. Nauman, as artist-explorer, has laid claim to one center of the universe; absurd as it is, conquest makes the site acceptable. We shift to the perceiver. The mythogeographical conquest works hand in hand with a psychological and perceptual claim. Both children and the very elderly see themselves, in psychological terms, as the center of the universe. The adult who stands in the middle of the Nauman is neither inside nor outside but exposed on all sides, naked, vulnerable, attempting to find a center, in a space that continually alludes to other locations, other circumstances. And below the center, the pit is an emblem of precariousness. *The Center of the Universe* can be read as an open-ended allegory about our place as perceivers in the construction of identity and meaning in and

through a work of art, as Nauman shifts the responsibility of locating ourselves to us.

At the same time, the sculpture is formal and abstract. The severity of the structure, with its squares and the hard industrial sodium-vapor light, contrasts with the generally softer buildings surrounding it. Sunlight coming through the top and sides is cut at hard angles. At night the yellow glow makes it look ominous, both from a distance and close up. Paradoxically, but in keeping with Nauman, *The Center of the Universe*'s abstract and formal shape is precisely what gives it its many concrete references. It is also, as Peter Walch, director of the University of New Mexico Art Museum, points out, a perceptual chamber for touch, with its cold walls, and for sound, with its echoing sides and hollow center, perhaps as much as for sight.

The title of the work, then, takes us back both to Nauman and his role in art-making and to ourselves as participants in the viewing process. He forces us to work hard. As his art is perhaps less about aesthetics and more about being in the world, Nauman provides us a space in which to think of our own place amid these allusions to the outside of the center of the universe.

And we work just as hard, if not harder, with *Virtues and Vices*. In this, the largest of Nauman's works to date, a stark text written in giant neon letters takes morality for its theme but is nether moralistic nor didactic. Confounding in its simplicity, it brings to mind Nauman's assertion: "Sometimes it is important to state clearly something which is apparently quite obvious." Completed in October 1988, *Virtues and Vices* is a neon frieze running along the top of the Charles Lee Powell Structural Systems Laboratory on the University of California San Diego campus in La Jolla. It is a recent addition to the Stuart Collection, privately endowed by the foundation of the same name and supplemented with additional NEA funding. The Nauman is now one of eight permanent sculptures that have been commissioned so far for the expanding collection on the 1,200-acre La Jolla campus.

The Powell Lab looks as if it had been designed with Nauman's neon in mind. A research facility for analyzing large-scale structural components and systems, its special equipment for testing simulated seismic loads makes it the only laboratory of its kind in the United States and one of the largest in the world. Resembling a tall box, the plain building is 60 feet high; its vast open interior space allows for the construction and testing of a five-story building. Capped by a 10-foot clerestory, its wall surfaces are otherwise unbroken except for doors.

On the clerestory stand Nauman's 7-foot-high neon letters spelling the names of the seven virtues, set in regular fonts, with the seven vices in italics superimposed, one over each virtue. All fourteen words appear in two of eleven colors: green and blue for "Envy," purple and yellow for "Charity," and turquoise and sky blue for "Fortitude," among others.

Activated by a computerized photosensitive cell, the virtues and vices begin their dance nightly at dusk and carry on until 11:00 P.M. The virtues flash clockwise around the building, taking three seconds per word, with a cycle beginning again every seven seconds. At a slightly faster rate of two-and-a-half seconds per word, the vices flash in sequence counterclockwise, with a new cycle beginning just less than every six seconds. The two sequencing patterns result in overlaps, a vice shining over a lighted virtue; sometimes several overlaps occur at once. What appears initially as random orchestration is in fact not. Periodically, for ten-second intervals, all of the vices blaze on together; separately, all of the virtues do the same. The scale of this $240,000 project is impressive: the eighty-eight letters, each with its own switcher, constitute nearly a mile of neon.

"The piece makes a list" is how the artists describes his work. Contrary to what Nauman says, what seems obvious isn't always so. This is a list that is for the most part ignored these days. When the artist first conceived of his project, neither he nor any of his associates could name the list of vices and virtues, and as others were queried, this proved to be more the rule than the exception. Once the piece was installed, many university students confessed that they were totally unaware that something called the vices and virtues existed.

Yet the idea of the virtues and vices goes back to classical antiquity and beyond, and the inventory has changed contingent upon the predominant values and attitudes of each period. Nauman's list contains the most common ones: the three standard Christian theological virtues of faith, hope, and charity, along with the four cardinal virtues of justice, temperance, fortitude, and prudence—the result of a marriage between Christianity and Neoplatonism. The vices selected here are those familiarly known as the seven deadly sins. In Nauman's work, lust, is superimposed over faith, envy over hope, and sloth over charity on one side of the building, with avarice/justice and gluttony/temperance on the opposite side; pride/prudence is situated at one end, and anger/fortitude at the other. Nauman chose his colors without adhering to convention, although some color matches are traditional, such as the pairing of red with anger and green with envy.

Although the virtues and vices were once depicted as statuary in and outside churches, the former overpowering the latter in moral tales composed of dramatic and symbolic imagery, Nauman overlooks both this, theater, and literature in presenting them, restricting their content to the symbolic level of words. In his 1984 *Seven Vices and Seven Virtues,* Nauman chose to carve the words on seven granite plaques, using superimpositions of vices over virtues as in the later neon work. Displayed on the floor and propped along the gallery walls, they looked like gravestones, the letters hard to distinguish from each other, so that the vices and virtues nearly canceled each other out while the viewer struggled to read them. Neoclassical, somber, foreboding, with a religious aura, they played well off the walls of the gallery space; given the context, Nauman was tempting us to read a moral allegory into the exhibit.

Virtues and Vices is somehow lighter, serious but humorous, and spiced with irony, given the scale and position of the work atop the Powell Lab. Uncharacteristically, the 1984 work made use of a traditional sculptor's material, stone, with all its connotations of solidity and permanence. By contrast, neon—an ephemeral, time-bound medium used by Nauman throughout his career—is still associated more with advertising and signage than with art and ideas, more with beer and cigarette ads and red-light districts than with elegance. For over two decades, Nauman has presented serious messages in neon about what it is to be an artist, about politics, sex, violence, death, and now about the vices and virtues, as if reminding the culture that they still exist in some form. Instead of virtues outmuscling vices, as we might imagine in larger-than-life postmodern statuary, Nauman's words blink, overcome one another, return, and remain unresolved, only to repeat themselves in different phased sequences. Occasionally one sees a new word take shape, as when "Faust" seems to appear out of a blending of faith and lust. As the list dances on, new alliances between the vices and virtues are formed and then broken.

In fact, Nauman suggests, the virtues and vices are not really fixed or stable quantities. Anger can be seen as wholesome and healthy, pride as essential to the ego, and lust as a confusingly relative term unless one is adhering to monastic rules. Prudence may backfire, and fortitude can lead to self-destruction. Various interpretations are hinted at as the neon display continues to trigger the imagination.

Pay Attention is the title of an earlier neon piece by Nauman. "Pay attention" seems to be what *Virtues and Vices* is saying through the

drama and theatricality of its size and scale. Controlled by a computer clock, the colors are altered by dusk, clouds, fog and haze; the words are read differently depending on the light and weather. When the neon snaps on at dusk, the words are faint. Gradually, as the sky becomes heavier and darker, the letters brighten and seem to float. It is startling to see them cut off so abruptly at 11:00. It feels like a loss.

The Powell Lab was not the original site proposed for *Virtues and Vices*; the first was a new theater building on a hill on the edge of the campus, which would have made the work visible to the larger community but virtually invisible to the daily life of the university. Opposition from neighbors and two residents to the old but still strong associations of neon, combined with a less-than-enthusiastic theater department, prompted the chancellor to call for a change. As ideal as the Powell Lab is structurally and formally for hosting the Nauman, unfortunately, because of the building's location, views of *Virtues and Vices* are largely confined to the campus. It can only just barely be seen from a few places outside the university and not at all from the nearby freeway, where a larger public might experience it. It is a trade-off—atop the right building but seen by a smaller audience. The Powell Lab with its Nauman sculpture is destined to become an anchor building on a planned pedestrian mall which, when completed, will be the center of the university campus.

Beautiful is a description one applies with hesitation to Nauman's work, since it intentionally questions and even eludes the conventions and conditions of the category. But beautiful can be used to describe his neons—especially this one. *Virtues and Vices* will eventually stand over the center of the campus to perplex us, draw our focus—a neon monument with no answers, only a list that beckons our attention.

Both of Nauman's public works from 1988 are more private than public, placed where small but serious audiences are likely to be found and nurtured. And, finally, both are as much about the interior life, the life of the perceiving self, as the life outside, engaging their viewers in questions about how the experience of art can change their experiences in the world.

Brooks Adams

The Nauman Phenomenon

Bruce Nauman may well be *the* artist for the lean, mean 1990s. Ever since the late 1960s, this 49-year-old California sculptor (who now lives in New Mexico) has captivated the international art world with his ominous corridors and cages, his punning neon word games and his pornographic figurative neon signs, blinking on and off in *Kama Sutra* positions. His cryptic hanging sculptures on the theme of South American torture, his strangely narcissistic films and photographs, not to mention his masterful video installations, often make a nasty first impression. There are works of his that are unforgettably brilliant—video installations like *Clown Torture,* 1987, which literally stole the show at ARCO, the Madrid contemporary art fair, in 1989. This S&M, mixed-media piece, with its grating audio and raunchy footage of a clown sitting on a toilet, can blast just about any painting off the wall. Indeed, a neighboring dealer reportedly tried to sell the piece, without a commission, out from under Donald Young, the Chicago dealer, so that its aggressive reverberations would finally be silenced.

On the other hand, it must be said that there are some Nauman installations that have been rather less successful, for example, his triple show in New York last spring at Leo Castelli, Sperone Westwater, and 65 Thompson Street. To be sure, it struck a number of critics with quite some force, but these undeniably gruesome sculptures of animal carcasses and severed human heads cast in wax, foam, and aluminum reminded one of just how tried-and-true this kind of imagery had become in 1980s art. Most notably, his *Animal Pyramid,* a colossal pileup of deer carcasses cast in foam, looked like yet another symbol for 1980s conspicuous consumption.

Originally published in *Art & Auction* 13, no. 5 (December 1990): 118–25.

Now, in the newly austere 1990s, Nauman's place promises to be-
come ever more prominent. His work will definitely loom large in the
next "Documenta," the prestigious international show of contempo-
rary art that convenes every five years in Kassel, Germany, to be held in
1992. The organizer of the show, Jan Hoet, director of the Contempo-
rary Art Museum in Ghent, Belgium, says: "I would like the next
"Documenta" to be based on the body. And Nauman takes a global
view of the body, not a linear view. His art teaches us how to deal with
desperation, how to go through the desperation and find a compensa-
tion for nihilism. The complexity of his work certainly inspired me in
the articulation of the 1992 'Documenta.'"

A major overview of Nauman's work is also being planned by the
Art Institute of Chicago for 1994, with other venues to include the Mu-
seum of Contemporary Art in Los Angeles as well as East Coast and
European institutions. But this will be no simple retrospective, because
Nauman doesn't like the term and also because his multifaceted oeuvre
doesn't have a clear stylistic progression. As Kathy Halbreich, the newly
appointed director of the Walker Art Center in Minneapolis, who is
organizing the show with Neal Benezra at the Art Institute, puts it:
"Nauman has never believed it was necessary to establish a formal sig-
nature. But his voice is distinct, and that ties the work together across
many mediums. The elevation of content, especially social or political
content, is always the anchor. From the body to the body politic, that's
how I trace his development."

This fall, one could see a healthy sampling of Naumans in Europe.
In Paris at the Musée d'Art Moderne, eight Nauman corridors and
rooms, once owned by Count Giuseppe Panza di Biumo, were recon-
structed; in many cases, these works had existed only on paper and had
never been built before. The Naumans were recently bought by the
Solomon R. Guggenheim Museum in New York, along with other
treasures by the minimalist and conceptualist generation, but have yet
to be seen there. In Basel, Switzerland, at the Contemporary Art Mu-
seum, there was an overview of Nauman's sculptures and installations
from 1985 to the present, based in part on the museum's awesome Nau-
man holdings. As Jorg Zütter, the curator who organized the show,
comments: "We started early with Nauman in Europe. Konrad Fischer
in Düsseldorf has shown him since 1968, and there are great collections
of Nauman in Switzerland, Germany, and Holland. Now it's very dif-
ficult to do a show. It's hard to get the wax works. No one wants to
lend them. I got the *10 Heads Circle* piece owned by [California col-

lector] Eli Broad on loan. But there are not enough works, and everyone wants one." In assessing the recent work, Zütter feels that "the foam animals are more important than the metal ones, because there you see how he works, gluing and changing the legs." (The foam pieces are also lighter to ship.) This show will also be seen in Frankfurt next summer, as part of the provisions of the Max Beckmann Prize that Nauman was awarded in 1990.

Needless to say, all this public esteem is reflected in the marketplace. The triple show in New York last spring sold out. The top price paid was reportedly $850,000 for the *Animal Pyramid*, which Leo Castelli sold to a German collector, with the hope that it would be shown in the Nationalgalerie in Berlin. (What better symbol of unification!) According to Castelli, director Thomas Krens wanted it for the Guggenheim, but didn't have the money. A large video installation, *Shadow Puppets and Instructed Mime*, shown at Sperone Westwater last spring, is in the process of being bought by the Basel Contemporary Art Museum, for between $500,000 and $1 million, according to Angela Westwater. Other prices at Castelli ranged from $500,000, for the large *10 Heads Circle/Up & Down* sculpture, down to $125,000, for two-headed sculptures in wax such as *Andrew Head–Julie Head*, and $50,000 to $100,000 for photocollages. According to New York dealer Larry Gagosian: "Lesser talents are selling for a lot more. Nauman could seem like a good deal. But his true value has yet to be realized. Even greedy people wouldn't sell them now." Gagosian says he has sold some of British collector Charles Saatchi's Naumans, but "we have more." He also claims to have sold one Nauman sculpture for over $1 million.

Many date Nauman's market surge to the evening of November 10, 1986, when, at Sotheby's New York sale of the Ethel Redner Scull collection, a Nauman sculpture of two folded wax arms and rope (*Untitled*, 1967) brought a winning bid of $220,000 from Swiss dealer Thomas Ammann—and incredulous looks and vocal expressions of amazement at the price from the salesroom audience. The contemporary art boom was on. A more recent Nauman record was set, also at Sotheby's New York, in May 1989, when a colossal hanging sculpture, *White Anger, Red Danger, Yellow Peril, Black Death*, 1984, estimated at between $150,000 and $200,000, made $429,000. This May, a drawing, *Fevers and Chills, Dryness and Sweating, North, South, East, West, Over, Under, Up, Down*, 1984, estimated at $100,000 to $150,000, made $407,000. And in the same sale, another drawing, *Seated Stor-*

age-Capsule (for Henry Moore) of 1966, estimated at between $80,000 and $100,000, made $330,000.

In the old days, Nauman's prices were rather more modest. Joseph Helman of New York's Blum Helman Gallery, who bought several works out of Nauman's first show, at Leo Castelli in 1968, recalls, "I was one of Bruce's few early collectors." Helman remembers giving away Nauman drawings as presents to friends in the late 1960s and in the 1970s. Today, he still owns the wax-cast body piece *From Hand to Mouth*, 1967, which he feels "is one of the real icons of the late 1960s, perhaps Nauman's most famous piece." Helman remembers that he bought it for $800 or $900 in 1968. Asked about its current value, he refuses to speculate. Clearly, the market for these late 1960s body-fragment pieces remains to be determined.

Castelli, who has shown and collected Nauman from the outset, tells a little story about the wax version of *Henry Moore Bound to Fail*, 1967, which he still owns. Castelli lent it to New York dealer Tony Shafrazi's opening show last spring. Shafrazi called to say he had a client who was interested in the piece. "I don't sell it," Castelli told Shafrazi. "Not even for an astronomical price?" Shafrazi pressed. "How much?" Castelli queried. "One million dollars," Shafrazi answered. "That's very fine. I still don't sell it," Castelli replied.

Not everyone is so convinced about Nauman. Ivan Karp, now owner of the O.K. Harris Gallery in New York and Castelli's director at the time of Nauman's first show, takes a contrary view of the artist's worth: "There were six to eight pieces in that first show, and only three to four of them were fulfilled conceptually. The show was considered disruptive and offbeat. The works had a curious, caustic, hostile presence, and they didn't sell well at first, although we sold a couple. Not until Nauman reverberated in California was there a consensus about his work. He's not a remarkable artist. His work is spotty, and it's utterly received wisdom that Nauman's so great." Of the most recent show at Castelli, Karp opines, "The craftsmanship was quite sound, but I found them appalling as objects. It's all psychodrama and personal pain. He doesn't have a unified point of view. He doesn't have a face in the world. Certain things do come off, but the work doesn't measure up to his notoriety."

Village Voice critic Peter Schjeldahl, on the other hand, who is one of Nauman's most ardent supporters, remembers that "Nauman's first show was amazing. But I resisted it. I was a New York chauvinist who felt you couldn't do all that stuff. There were enough ideas in that first

show for twenty careers." Schjeldahl recalls that after Nauman's early retrospective (he was 31) at New York's Whitney Museum of American Art in 1972, "his career went into the trash can. In the 1970s, he was totally out of fashion. He didn't make a public career. He holed up and never accepted his shamanistic celebrity. He made no money and survived on a stipend from Castelli. Finally he tried to cut it off, because he felt he could never pay it back. Now the work is Fort Knox, it's gold, and everything else was paper money."

Schjeldahl says his response to a new Nauman is "always 'Oh no, Bruce, don't do it.' Then by the third time I've looked at it, it's become classical. There's nothing to coast in on, or groove on, just this absolute fact. You don't ascend to Bruce's work. You descend to it. There's something dumb, primitive, matter-of-fact about it. Stylistically, the stuff is frazzled, it's comfortless and zero-reassuring. There's a masochistic quality to the work and the man. He's very funny, completely unassuming and not given to minimalist swagger."

Critic Adam Gopnik waxed hyperbolic about Nauman last May in *The New Yorker* magazine. Speaking of Nauman's early 1980s colossal hanging sculptures inspired by Jacobo Timerman's firsthand account of official torture in Argentina in his book *Prisoner Without a Name, Cell Without a Number,* Gopnik wrote: "Nauman's 'South America' chair pieces are perhaps the strongest single images of torture in modern art, conveying through the stark, spare means of Dada assemblage the essential experience not merely of pain but of being removed into a floating, timeless realm of isolation, silence, equidistance, and impersonality." Gopnik went on to say that "for the past decade, American art has been trying to find a way out of irony, and, in retrospect, Nauman seems to have been the unwitting leader of the expedition."

Similarly, Richard Flood, director of New York's Barbara Gladstone Gallery, remembers seeing the impressive array of Naumans at the Halle für Neue Kunst in Schaffhausen, Switzerland, and thinking, "Here was the spine of American art. I got a kick in the stomach. The way you are asked to physicalize yourself in relation to the work really knocked me out." Flood included *Skewed Tunnel and Trench in False Perspective,* 1981, a plaster cast, burlap, and wood circular sculpture, in a group show at Gladstone's in 1987. "I didn't understand these pieces at first," he says. "But a few years later, it looked as if it had been unearthed and was waiting for time to catch up with it. It was a rude, crude, jerry-built thing that suggest a sort of American, wagons-west, let's get-it-done feeling." The piece was sold by Gladstone to New York

collector Elaine Dannheisser for $150,000. Dannheisser recalls, "I could have bought something for less money from the same genre, but this was a better piece."

Nauman's work, like much of the minimalist and conceptual art that emerged in the 1960s and 1970s, brings up special problems of authenticity and replication. One tricky area is the neon signs. Castelli points out that he has so many requests for loans by museums for one spiral neon of 1967, *Window or Wall Sign (The True Artist Helps the World by Revealing Mystic Truths)*, "that I made an agreement with Bruce to reproduce it for exhibition purposes only."

Brenda Richardson, deputy director of the Baltimore Museum of Art, who organized the first retrospective of Nauman's neons in 1982, had many neons refabricated to the artist's specifications for the show. "Neons are easier, cheaper, and safer to make locally than to pack and ship," she explains. "They're as tricky as any piece of glass, but even more so, because they are tubular and fragile. Except most artworks can't be refabricated if you break them. In Nauman's case, we're talking about commercial fabrication in the first place. There was no handiwork involved. It's not as if you're capturing Rauschenberg's hand. The neons are programmed and mechanical."

Donald Young showed Nauman's sexually explicit figurative neons of naked men in Chicago in 1985, as did Leo Castelli. "People were so surprised," Young says. "Nothing sold at first. Finally, Charles Saatchi bought one a year later. The first figurative neons were probably in the $40,000 to $50,000 range at the time." (Now such works would be more likely to sell for approximately 10 times that amount.) About the late 1980s video installations like *Clown Torture,* Young notes, "People didn't know how to deal with it. I had a lot of trouble convincing them it was as important as any object." Some were shown in LA, New York, and Chicago, but none were sold. Finally, *Clown Torture* went to a Spanish collector, who recently resold it to the Lannan Foundation in Los Angeles.

Nauman's reputation, always strong in Europe, seemed really to gel in America in about 1988, when suddenly there began to be a widespread revival of interest in art of the 1970s. His popularity coincided with the emergence of a new generation of young artists known as the neo-conceptualists, many of whom revere Nauman almost as a demigod. Ashley Bickerton, known for his wild and crazy wall reliefs covered in commercial logos, included one of Nauman's mystical spiral neons in "Ideal Collection II," 1988. Similarly, the work of young

LA sculptors such as Liz Larner, who makes mean-looking, chain-link fence installations as well as more organic multimedia works, would be unthinkable without Nauman's example. Nayland Blake's cagelike sculpture *Feeder,* 1990, on view this fall at New York's Petersburg Gallery, seems like a direct Nauman clone.

In the late 1980s, Nauman's dealers and collectors began reconstructing (or building for the first time) corridors and video installations first designed in the late 1960s and 1970s, many of which had existed hitherto only on paper. According to Westwater, an early corridor piece "would go for $300,000, but you can't get them now. We have a 1970 corridor that is on view at the Temporary Contemporary in Los Angeles. It's called *Going Around the Corner Piece,* and it's a video surveillance corridor."

Suddenly, all Nauman's seemingly ephemeral production is beginning to assume an enormous historical resonance. Donald Young opines that "Bruce Nauman was greatly undervalued in this country until recently. All through the 1970s, the support system came from Europe. American collectors prefer their art more straightforward. His work was always difficult and strange." Young points out that "the big increase in prices came only in the last few years. But it's not just Nauman—look at Brice Marden's prices or Robert Ryman's. For years, it was so reasonable. Nauman was so overlooked before."

Gerald S. Elliott is a Chicago collector who bought his first Nauman from Young in the early 1980s. "It is a fiberglass piece from 1965. It's very strange. It goes up the wall, and down the floor," he says. "Many times I've wanted to return it. I had it in my law office, but they didn't like it. It looked very ugly even twenty years later. But I kept it, and it grew on me. Now it's in my apartment." Elliott also owns three large video installations. "People always say, 'Where are you going to put them?' I have the *Chambres d'Amis* video-and-neon piece in my home." (It depicts, among other things, a neon hanged man with an erection.) "It looks worse than it actually is. You just plug it in. I have a *Run from Fear, Fun from Rear* neon piece up in my dressing room. I only put it on when people want to see it. I also commissioned drawings for stone tablets through Angela Westwater. I own the tablets, and you put them on the floor at the side of the room. They all deal with the word 'yourself.'"

When Elliott's collection was shown at the Art Institute of Chicago last summer, Nauman's work was clearly the centerpiece. According to Neal Benezra, who curated the show, "with Nauman's work, it is cru-

cial to have a sense of menace in the space, to have the walls close in on you. With Elliott's collection, I installed them in as confined a manner as possible to create an off-putting feeling. There was a big Monet exhibition at the same time. The shows were so close to each other that you could see them both in an hour. People loved the contrast.

"Nauman's earlier photographic self-portraits from the 1960s could be considered some of the first postmodern works," Benezra observes. "His *Self Portrait as a Fountain* makes me think of Cindy Sherman. And Jenny Holzer's word pieces would not be possible without Nauman. Moreover, there's been a psychological development in Nauman's work as he's matured, a new directness. It's like late Guston or Picasso. As they get older, they start pushing things aside, cutting through to the essentials."

Jorg Zütter

Alienation of the Self, Command of the Other

Last fall's exhibition of sculptures and installations by Bruce Nauman at the Museum für Gegenwartskunst in Basel showed this artist setting out once more to exemplify the central confrontations between human individuality and modern mass society. When Nauman slices animal bodies apart, then slaps them together into Horsemen of the Apocalypse and arranges them in static or gyrating groups, it is not his primary intention to offer a critique of genetic manipulation and its attendant perils. He is not moralizing; he is using the plastic foam bodies for experiments of his own, carrying to extremes the alien and artificial nature of these naked stereotypes. Where, in all this, is the viewer's threshold of pain?

In his installations from 1985 on, Nauman reverted to a theme that had concerned him in his performance pieces of the 1960s: the exploration of the nature and scope of the artist's self-presentation. The clowns who constantly appear on monitor screens and wall projections in the 1987 installations stand for the dramatic crisis point at which amusing antics mutate into the terrors of the absurd. Since 1989, the central theme, or shall we say the subject of the experiment, has been the human being in all his helplessness. The illusory nature of the electronic image, and the breathtaking violence of the mangled animal bodies, have given way to wax life-casts of human heads, which present realistic and unnervingly direct individual likenesses. Suspended from the ceiling in pairs, either side by side or one above the other, these monochrome heads pose the issue of human individuality at a moment when the omnipresence of the electronic media seems to have abol-

Originally printed in *Parkett*, no. 27 (1991): 155–58, translation David Britt. Reprinted with permission.

ished all frontiers between the private and public realms. The viewer stands, ominously, in between. The earlier encounters with mangled animal bodies placed the viewer in a hyperreal situation, in which, even so, a certain degree of detachment could still be maintained; these heads confront him with a set of realistic effigies in which every wrinkle, every pore, every hair turns out to be identifiable.

In these works, Nauman is not pursuing the tradition of sculptural portraiture. Nor is he setting up a monument to any person, or indeed to art itself. He constantly redeploys the same wax casts—of three models in all—to convey the impression of a finite group. Hung on wires at eye-height, they create an uncanny succession of encounters. The lack of bases may at first make them seem elusive and intangible, like people in a dream. But appearances deceive, for these realistic waxen physiognomies remind us of death masks. There are formal parallels with those fragmentary plaster casts of antique statues, or of human bodies, that were used in academic art teaching. However, in contrast to this neoclassical view of art, which is based on a holistic, idealized image of the human body, Nauman sets up a human image deduced from present-day reality; its strongest affinities are with the techniques of reproduction and presentation employed in such late-nineteenth-century anatomical collections as the "Grand Musée Anatomique" assembled in Paris by Dr. Spitzner.

Nauman's dismemberment and reconstruction of the human and animal body, in defiance of the laws of anatomy, also cast a contemporary light on the assemblages of Auguste Rodin; and, from today's standpoint, their physical immediacy becomes more striking than ever. The contemporaneity of Nauman's art lies not so much in a critique of the subjective body-image—a critique of the kind practiced under psychoanalytical influence by the surrealists—as in the direct impact of the spatial experience on the viewer.

Nauman's works evoke the urban environment in all its anonymity and unconnectedness. In the early 1970s he was constructing virtually inaccessible corridors; in the early 1980s he built fragile model tunnels out of fiberglass or plaster, in such a way that their spatial proportions could be grasped only in the imagination. Again and again, he confronts the viewer with labyrinthine models that are never as innocuous as they seem. The video installation *Learned Helplessness in Rats* consists mainly of a flat, transparent Plexiglas maze that was used, when the video was being shot, as a cage for rats. With the aid of monitors placed up against this yellow enclosure, and of a wall projector, the an-

imal experiment is reenacted and presented as an object lesson in acquired helplessness.

In the installation *Shadow Puppets and Instructed Mime* (1990)—recently purchased by the Emanuel Hoffmann Foundation and placed in the Museum für Gegenwartskunst on permanent loan—the maze moves out from its central position in the rat work and takes over the entire exhibition space. The question implicit in Nauman's wax heads—to what extent can authentic information be conveyed by artistic means, and to what extent can emotions still be expressed?—has inspired the artist to videotape the shadows cast by wax heads dangling in space, swinging and crashing into one another, and to incorporate the tape in the installation *Shadow Puppets and Instructed Mime.*

The video images are projected onto two screens that serve to demarcate two spaces, diagonally opposite with each other, in which, respectively, one and two white wax heads are suspended. These enclosures serve to reconstruct the situation that existed while the tape was being made at Nauman's studio in Pecos, New Mexico. The artist had taped the fishbowl scene for *Clown Torture* in an identical cell. In the new installation, as the video image is projected onto two screens, it is visible in two directions at once. A switching device regulates the phased projection of the images on screens, walls, and monitors in turn. The image material is recorded on four tapes in all, two for the wax heads and two for the mime performer. In the actual projection, however, this quantitative ratio is obscured by crossovers and double images.

This is the installation with the most logical distribution of video images across the available exhibition space. The static and neutral quality of the location is disrupted by the fragmentation of the images, and especially by their circular motion and 180-degree turns. In the video installations of 1988, the sculptural elements were clearly visible in the center of the space, where they restricted the viewer's freedom of movement; here a new situation prevails, whereby the video monitors and the projections are so arranged as to prevent the viewer, however much he shifts around, from ever taking in the structure of the installation as a whole.

Nauman has reinforced the fragmentation of the image on the walls by spreading the piece out across the entire expanse of the floor. The monitors and projectors are placed approximately knee-high and make it difficult to walk around. There is no point at which the visual information can be assimilated in its totality. The floor area is dominated by

the monitor images, which point in a total of three directions. The four projected video images define the overall aspect of the installation through their size alone, and represent clear landmarks toward which the viewer tends to gravitate. The time-lag repetition of all phases of the action, in large and small formats, carries the disturbance of visual perception to an extreme.

The viewer is treated to a lesson in human compliancy by the mime performer, who carries out acrobatic motions affecting only her own body and its immediate surroundings, in response to commands from a male voice-over: "Put your foot on your hand on the chair, your hand in your mouth, your head on the table," or, "Put your foot in your mouth."

In this work, by contrast with the *Clown* installations, an artistic statement is not being obscured or alienated but minutely dissected. The private sphere—always ultimately detectable in the earlier installations—here seems to have been eliminated once and for all. The mime performer creates the illusion of a succession of complicated and painful actions carried out in total submission to verbal instructions. The voice has only to order her to "Lie down" or "Lie dead," and she does so with the implicit obedience of a trained dog. Here, helplessness and the fight for survival coincide.

The two corner spaces can be interpreted additionally as fictive exits from this maze of images. The subjugation of the living body, as imposed on the mime performer, and dominion over the world of objects, have clearly not been attained without a sacrifice: the body has surrendered its head, and nothing has changed. On the genesis and significance of the shadow projections, Nauman has said: "I think it was in V. S. Naipaul's book *Among the Believers*—I'm not sure where I read this—but he is talking about some civil war or another and some Hindus who didn't believe in killing anybody, so when they did executions they hung a sheet and put a fire behind the sheets so that the shadow was cast on the sheet. And then they would shoot at the sheet, shoot at the shadow and, of course, the person that is there gets killed too. But this way they were only shooting the shadow, they were not shooting the person. It is such a perversion of this classical shadow theater and yet so straightforward." In this installation, the human alienation of self and command of the other are thus endowed with all the rational perfection of the absurd.

Neal Benezra

Raw Material

In 1990, Bruce Nauman made a group of three video sculptures, each of which comprises pairs of stacked monitors and a related wall projection. In one he hums the consonant *m* in a continuous, closed-eye meditation; in another he pours forth a flurry of "ok"s; and in the third he shakes his head furiously as the sound "brrr" spills out. Unshaven and a bit haggard, Nauman's head is cropped and bathed in alternating shades of icy green and blue. When the three videos—*Raw Material*—"*MMMM*," *Raw Material*—"*OK, OK, OK*," and *Raw Material*—"*BRRR*" (all 1990)—were exhibited for the first time at the Daniel Weinberg Gallery in Los Angeles, they were striking for a number of reasons. Although not as complex as some of the video installations of the late 1980s, the three "raw material" pieces were filled with ideas consonant with his current work. Conjoined, suspended heads, continuously spewing forth the same sounds and phrases ad nauseam, recall both the cast wax heads and numerous video installations made in the late 1980s. There were also numerous links to many of Nauman's early ideas and works, with themes of masking, the repetitive performance of isolated tasks, the presentation of inverted imagery, and the infusion of disconcerting color all resonating throughout the work. Finally, while Nauman's early pieces are filled with self-images, this was only his second appearance as a performer in his own work since the late 1960s.[1]

Then there is the title. Throughout his career, Nauman has employed titles in a scrupulously descriptive and objective manner, and he has seldom, if ever, used a suggestive phrase such as "raw material" in his work. A clue to the title exists in Nauman's biography and the ac-

tual process he followed in making these works. The three "raw material" pieces came at an important moment of transition in Nauman's life and work: in 1989 he married the painter Susan Rothenberg and the next year the two artists completed the construction of a new home and studio complex near Galisteo, New Mexico. At precisely this time, Nauman was evolving the ideas that would underlie the "raw material" works, and yet for the moment he was unsure how to give form to these concepts and images.

Material for Younger Artists

Seeking to guard the privacy that his new studio afforded him and feeling incapable of clearly directing actors until he had clarified his intentions, Nauman decided to explore these new ideas by employing his own body as source material, and to perform these actions himself, videotaping them in his studio.[2] When he exhibited one of the three works, *Raw Material—"MMMM,"* at the Whitney Biennial in the spring of 1991, Nauman was simultaneously pressing ahead, having replaced himself with the actor Rinde Eckert. In the process, Nauman's introspective words and actions were replaced by Eckert's unforgettably fearsome head, half-singing, half-chanting the words, "feed me, eat me . . . help me, hurt me . . . ," words that Nauman "wanted to use . . . but didn't sound good coming out of [his] mouth."[3] In short order, the "raw material" works evolved into Nauman's most powerful pieces of the early 1990s: *Anthro/Socio (Rinde Facing Camera),* dating from 1991 and exhibited in "Dislocations" at the Museum of Modern Art in 1991–92; and *Anthro/Socio (Rinde Spinning),* completed in 1992 and shown at "Documenta 9" in 1992.

At the time the "raw material" works were made, Nauman's influence was reaching its zenith. Museums enthusiastically collected and exhibited his work, artists in Europe and the United States sought it out wherever possible, and the commissioner of the 1992 "Documenta," Jan Hoet, announced his intention to focus extensively on Nauman in Kassel. If this gesture reminded many of the way Joseph Beuys had been deified previously in "Documenta 8," Hoet's gesture, while grandiose and ill-advised given Nauman's penchant for privacy, nevertheless accurately reflected his prominence and stature. Simply stated, no artist of his generation can rival Nauman in the breadth or degree of his influence, in both the ideas he has pursued and the variety and quality of the objects he has made—and no artist's work appears so fresh and insistently challenging. For all these reasons, Nau-

man's work and his example have provided "raw material" for younger artists.

If Nauman's influence upon subsequent artists remains indisputable, its nature has been difficult to pinpoint in any substantial way.[4] On one level, Nauman's importance to his contemporaries and younger artists unquestionably stems from his decision to imbue his work with ideas, a determination that has encouraged him to embrace several media almost simultaneously. The first museum exhibition of his work, organized in 1972 when he was 31, included drawings, films, holograms, installations, neons, photographs, prints, proposals for installations, sculptures, and videotapes. By establishing the principle that the idea must prevail over its formal realization, Nauman became fluent in these many media and could select the one most appropriate to the expression he sought. In the course of this development, he was reversing a practice that has predominated throughout the modern period, if not much of the history of art, for rather than falling back on a set vocabulary of form or a preferred material and manner of working, Nauman has pressed ahead on many fronts simultaneously and reasserted the value of ideas in art.

Nauman was not alone in inventing and exploring these concepts. The assumptions that underlie conceptualism and process art had their basis in the widespread antiformalism of the late 1960s. However, most of the major figures of the period have narrowed their approach in recent years, pursuing a given idea to a point of personal and creative stasis, and—ironically—formalizing art forms originating in the antiformal processes of thought and activity, rather than in the production of refined objects.

Nauman's method—or rather his lack of one—has made it exceedingly difficult for him to establish any sort of daily studio routine. His emphasis on process and determining the most effective manner to pursue an idea has often proved painstaking, and at times he has been unable to work as he tries to settle upon the best way to proceed. Early on he recognized that his manner of working was "always going to be a struggle." As the artist puts it, "I realized I would never have a specific process; I would always have to reinvent it over and over again. . . . On the other hand, that's what is interesting about making art, and why it's worth doing: it's never going to be the same, there is no method."[5] Unable simply to walk into his studio and pick up where he left off the previous day, Nauman has survived numerous dry spells when his in-

terests in reading and, most recently, horse training have taken priority over the daily feeling of obligation to enter the studio.

While Nauman guards his privacy with zealous care, in fact, one seldom finds work in the studio. Indeed, although there are usually drawings or blueprints in evidence, Nauman's studio is actually dominated by the cast-off detritus that has survived previous work. Numerous makeshift chairs are in evidence and these allow one to view or preview—albeit uncomfortably—videos in progress. In every way Nauman's studio surroundings suggest flux, in either the form of tentative beginnings or recent conclusions. Here, the course that Nauman followed in bringing the "raw material" ideas to fruition is telling. In undertaking this body of work at a moment when his personal life was in transition, Nauman nevertheless managed to retain his privacy while engaging himself as an actor. His new studio remained largely off-limits to casual visitors and potential actors alike, and when he resolved the visual and audio ideas to his satisfaction, he absented himself from the work completely.

Public or Private

As a result, Nauman's influence is to be found in other, perhaps more subtle aspects of contemporary practice. Just as he has avoided the temptation to concentrate on a single medium or process, or to formalize his work, so has he redefined the position of the artist in relation to his work, his studio, and his public. Here again comparison with Joseph Beuys is striking. In a large measure, Beuys placed himself at the very epicenter of his work—making his persona indispensable to its presentation and meaning—and his example predominated in the 1980s, as the charismatic public presence of the artist seemingly became an essential component of contemporary art. In contrast, by his very reticence, along with the geographical and psychological distance he has maintained from the centers of contemporary art, Nauman has established quite another model. Whereas Beuys was a quintessentially "public" figure, with his every action as a teacher and an artist witnessed and documented, Nauman sees himself in a different role: "When I give a public presentation of something I did in the studio, I go through an incredible amount of self-exposure which can also function, paradoxically, as a defense. I will tell you about myself by giving a show, but I will only tell you so much."[6] While he has often employed his own body as "raw material," he has also taken great care to

mask his presence psychologically and to bring emotional power to his work through a variety of surrogates that confer moral force and integrity. Even when Nauman admits us—metaphorically—into his studio, it is a visit filled with paradox and dislocation. Two relatively recent works allude to this. In *Shadow Puppets and Instructed Mime* (1990), Nauman surrounds us with sculptural elements in the form of props, videos, monitors, projectors, packing, and electrical equipment. Even though the highly organized disarray of this environment suggests the artist's own studio, in *Green Horses* (1988) Nauman's presence is both explicit and elliptical. In this work—in which Nauman appears, seen from a distance riding a horse—we also have a surrogate for the artist in the form of an empty chair from his studio. Nauman has included chairs repeatedly in his work, and as is often the case, in *Green Horses* the chair performs a complex function, acting as a substitute for the artist while also beckoning the viewer to watch the piece in which Nauman performs. Whether applying makeup to his face and body, employing chairs as surrogates, or engaging clowns, mimes, or other actors, Nauman consistently surprises with his ability to confound our expectations of both his art and his conception of the world, while still retaining his distance. Even as his work has grown exceptionally theatrical, with its bright lights, vast scale, thundering volume, and often bewildering complexity, the artist has remained offstage and far from the public spotlight. In the course of this evolution, Nauman has managed to avoid the self-indulgence that has characterized the art world in recent years, creating work which has grown increasingly forceful with the passage of time.

In recent years Nauman has focused as well on the ultra-fine line dividing the public and private spheres, and on the narrowing distinction between human behavior and social and public implication. It is here that Nauman's influence is most obviously felt, for the distinction between public and private is densely interwoven throughout the fabric of contemporary art. Nauman's work has been seen as often in Europe as in the United States and, in a fascinating way, artists on either side of the Atlantic have pursued the public/private issue toward clearly different ends. While generalizations are difficult, I would argue that Nauman's resolute privacy in the studio and the degree to which his private activity possesses implications for public discourse has helped to reshape contemporary European art. Rather than taking up the explicitly public purposes of an artist's behavior—as postulated by Joseph Beuys—younger European artists generally have concentrated on a

more suggestive, allusive, personal, and creative presence, and retained their distance from direct public disclosure. In this respect, Nauman himself has worked in two directions, masking his body, for instance, both literally and metaphorically by applying makeup to his face and upper torso in his early *Art Make-Up* films (1967–68); or employing his body as a type of living prop as in the recent "raw material" videotapes. Jan Vercruysse has explored similar ideas in a group of self-portrait photographs set in his studio in 1984, in which he posed accompanied by a variety of time-honored and symbol-laden attributes—hourglasses, chessboards, and theatrical masks—to veil his presence and disguise his persona. If Vercruysse's studio is, like Nauman's, a refuge from public exposure, for Reinhard Mucha the studio floor often acts as a surrogate for the artist, suggesting both his presence and his detachment. On occasion, Mucha has disassembled his studio floor and displayed it, perhaps most notably as part of his installation *Mutterseelenallein* (1989) at the Museum für Moderne Kunst in Frankfurt. For this piece, Mucha uprooted the floorboards of his Düsseldorf studio and mounted them, along with photographs of chairs, on the wall behind glass. The use of glass acts, paradoxically, as both window and barrier, on the one hand providing visual access while casting the viewer in his own reflection and rendering the work impenetrable. By metaphorically displaying his studio in this manner, Mucha admits limited, even paradoxical, access to his private space while ultimately offering a taciturn self-expression. Although Beuys's vitrines and other works have obviously been important to Mucha, the younger artist's work ultimately offers only momentary insight into his activity and life in the studio, whereas Beuys's sculptures function as narrative traces of his public actions. Both Vercruysse and Mucha share Nauman's feeling for the absolute privacy of the studio, and both would doubtless subscribe to his commitment to using "the tension between what you tell and what you don't tell as part of the work."[7] Implicit here is a doleful loss of faith in contemporary culture and a wary recognition of the harm that can result from an overexposed self.

The Poetry of His Materials

A similar, quite disconcerting feeling of fragmentation and isolation inhabits many of Nauman's more evocative sculptures and projects, in which imaginative possibility plays a particularly prominent role. These works are among Nauman's most literary and their themes resemble those of Samuel Beckett and Alain Robbe-Grillet. I

am referring here to Nauman's model plaster tunnels and pieces incorporating video and audio equipment for the purpose of surveillance. In this way, the oddly conjoined and metaphorically endless plaster passageways of *Model for Tunnel Made Up of Leftover Parts of Other Projects* (1979–80) are meant to suggest the desperate isolation of an inescapable maze fraught with existential hopelessness and despair, while in *Audio-Visual Underground Chamber* (1972–74), the closed-circuit audiovisual surveillance of an empty concrete chamber, broadcast live to observers in another location, is a devastating, if understated, allusion to the realities of political torture and the observation of frightening human misdeeds. Works such as these resonate strongly in the sculpture of Rachel Whiteread and Miroslav Balka, as well as the photographs of Sophie Calle. Whiteread has made powerfully evocative sculptures, casting the interiors of private spaces and the undersides of domestic objects, imbuing them with a presence that is at once poetic and despairing. *Untitled (Yellow Bed, Two Parts),* which dates from 1991, presents a bed that, stained with use, abandoned, and propped unceremoniously against a wall, preserves traces and memories, yet reveals nothing more than silence and absence. In Balka's wall-mounted, open metal chambers, or his stone floor slabs, prone and silent as grave markers, one senses a similar, unspoken memory. The apparent minimalism of his work is belied by the poetry of his materials, the pairing of his sculptures, and the continual reference to his own body in the scale of the work. And Nauman's interest in surveillance as a means of analyzing the public implications of private actions is everywhere present in Sophie Calle's voyeuristic observations of human behavior, as she follows individuals through the streets of Paris, or observes the private habits of hotel guests by posing as a chambermaid in Venice.

Interestingly, at a time of emphatic social and political change in Europe, each of these artists has pursued his or her work with a determined privacy, emblematic of a distrust of excessive disclosure or public pronouncement. The careful balance these artists have established between the private impulse which drives their work and its public expression forms one response to Nauman's model, and it diverges diametrically and dramatically from the impact he has had in the United States. In short, whereas European artists have favored the more introspective, private, and conceptual aspects of Nauman's oeuvre—the masking, the observation, and the restraint—many younger American artists have gravitated toward Nauman's more explicitly public expres-

sion in video and neon, media appropriate, if not ripe, for unequivocal public commentary.

In part, this specifically American reading of Nauman's work is a response to the very different political and artistic climate of the United States today, in which politics and art seem inseparably joined. Indeed, at a time when individual values and public behavior are under ceaseless scrutiny, when private life seems perilously close to disappearing altogether, Nauman's most aggressive images are quintessential statements on the lack of intimacy and the public implications of private behavior. As he has recently noted, "There's a conflict between our animal instincts and how we're socialized to behave, and a lot of my work has played on the tension between these two drives."[8] Among the many works in this vein are, for instance, *American Violence* (1981–82), with its plainspoken title and invocation to "stick it in" and "rub it on," and *Violent Incident* (1986), in which scenes of domestic violence are videotaped in the manner of daytime television and are presented via banks of monitors aping department store display.

Perhaps the first artist to address this very different element of Nauman's work was Jenny Holzer. Just as Nauman has employed the traditionally cool medium of neon signage to broadcast hot messages, Holzer has also employed public language—in the form of posters, plaques, engraved stone benches and sarcophagi, and, most importantly, LED signs. Recognizing the importance that public language can have and its potential for pernicious effect, Holzer, like Nauman, has turned the advertising medium on its head, placing bold, purposefully aggressive, and politically assertive language in situations formerly reserved for the seamless phrasing of the flack.

Nauman has narrowed the boundaries once separating public and private even further in various video installations focusing on body imagery. This is particularly evident in *Clown Torture* (1987), in which one series of video projections shows a clown waiting to defecate in a public restroom. Theatrical and, at times, grotesque images involving the body in the public display of private behavior have abounded in American art in the past several years. Whereas Nauman's work is often infused with an absurd humor, artists such as Matthew Barney, Mike Kelley, and Kiki Smith are generally more emphatic and explicit. Kelley is perhaps the most insistent here, as his body of work recalls a tenacious and unrelieved Lenny Bruce monologue. In works such as *Eviscerated Corpse* (1989), Kelley draws heavily on popular culture in

order to hold up to ridicule all manner of social convention, in particular the pernicious impact of family life and the socialization of children. By contrast, Barney and Smith have focused more specifically on the conventions underlying gender stereotypes and representation. Barney's complex video actions, especially *Blind Perineum* (1991), delve into male stereotypes concerning strength, determination, athleticism, and aggression, while works such as Smith's *Tale* (1992) shift the traditional focus from an outwardly attractive female appearance to the body's all-too-human interior functions, anatomical processes that are conspicuously absent from the often idealized presentations of the female body in both the media and art.

It is important to note as well that Nauman's movement away from the early exhibition of his own body in films, videotapes, and performances toward his more recent use of surrogates has also had an impact in the United States. This is apparent in the career of Mike Kelley, who began as a performance artist, but has now largely abandoned this aspect of his work. It is perhaps most noticeable in the work of Cindy Sherman, whose development has followed a parallel course. Sherman's early photographs found the artist both in front of and behind the camera; however, in recent years she, like Nauman, has largely absented herself from her work in favor of various surrogates and studio setups, increasing at the same time the pictorial and theatrical tension of her imagery and the power of her work.[9]

All this is not to suggest that the work of Bruce Nauman is the sole influence on the current generation of younger artists. Europeans, of course, look to Joseph Beuys, as well as Marcel Broodthaers, Dan Graham, and numerous others, while American artists have turned to Vito Acconci and Chris Burden. And yet, Nauman's example may be unique, for it offers sustenance to a great breadth of artistic impulses. As suggested above, to ascribe Nauman's influence purely to the range of his media and the antiformal nature of most of his work would be to understate a very complex situation. The fact that Nauman's most plainspoken works, pieces in which form and content seem to speak with a single, clear voice, have had their greatest resonance in the United States indicates perhaps that culture's need for questions with answers, a civilization disinclined toward ambiguity. On the other hand, Nauman has also created an enormous body of work that is fraught with ambiguity and questions, and this work has found a willing audience in Europe, a continent that, in Peter Schjeldahl's words, is "less reluctant to face inescapable dilemmas."[10]

The breakthroughs made by Jasper Johns and Robert Rauschenberg in the 1950s have long been characterized as explorations of the "gap separating art and life." Ultimately, it may be Nauman's probing examination of human behavior and psychology, and the narrowing separation of public and private life, that mark his own achievement and complex legacy.

Notes

1. The other work is *Green Horse* (1988), which is discussed later in this essay. I am indebted to Amada Cruz, Maria Makela, Juliet Myers, and Joan Simon for their ideas and suggestions.

2. Nauman in conversation with the author, Kathy Halbreich, and Juliet Myers, May 28, 1993.

3. Nauman quoted in *Dislocations* (New York: Museum of Modern Art, 1991), 6.

4. See, for example, the article by Adam Gopnik, "Death in Venice," *The New Yorker*, August 2, 1993, particularly p. 69ff.

5. Joan Simon, "Breaking the Silence: An Interview with Bruce Nauman," *Art in America* 76, no. 9 (September 1988): 144.

6. Nauman quoted in Ian Wallace and Russel Keziere, "Bruce Nauman Interviewed," *Vanguard* 8, no. 1 (February 1979): 16.

7. Simon, "Breaking the Silence," 147.

8. Nauman quoted in "Bruce Nauman: Dan Weinberg Gallery," *Los Angeles Times*, Calendar, January 27, 1991, p. 84.

9. I am grateful to Amada Cruz for her thoughts here.

10. Peter Schjeldahl, "Profoundly Practical Jokes," *Vanity Fair* 46, no. 3 (May 1983): 89.

Peter Schjeldahl

The Trouble with Nauman

I feel in a quandary, faced with writing about the gruelingly magnificent Bruce Nauman retrospective that opened in Madrid in December and has begun a high-profile tour of the United States. I think he is the best—the essential—American artist of the past quarter-century. No other contemporary artist means as much to me. And none so discomfits me. I rely on him for pleasures of a formal economy that is like manifested sheer intelligence—mind-made matter—and for a laconic humor that subtilizes amazingly upon reflection, becoming laughter ineffably knowing and wise. I have learned also to expect from him a lonely, painfully self-conscious state of soul that affects me rather like that most respected and least welcome human faculty, conscience: peremptorily, implacably, often harshly. I hesitate to recommend Nauman's work to anyone innocent of it. Why promulgate anguish? I prefer to imagine that I am writing for the already afflicted.

Talking about his work with fellow Nauman fans, I note a peculiarly flat tone of voice infecting statements of sincere praise. I diagnose it as a strain of spiritual laryngitis that strikes the heart all but speechless, caused by art that engages deep physiological mechanisms and psychic contents in ways thoroughly impersonal and demythicized. In this art there is abundant communication, but no communion. Enthusiasm finds no nexus of sympathy with the artist to feed on—not even the shady complicity of a Marcel Duchamp or the melancholy compunction of a Jasper Johns, to name two important influences on Nauman. (Nauman cites Man Ray's defiant eclecticism as even more decisive for him, while also doing without the hook of that artist's cavalier panache.) The question of "liking" Nauman or not seems impertinent. Con-

Originally published in *Art in America*, April 1994, 82–91.

fronted with his work, the rational mind is extraordinarily clarified, and emotional responsiveness, stricken, falls in a hole. Consider *Clown Torture* (1987), a raucous environment of video monitors and projectors showing clowns trapped in no-win situations. You "get the joke" at once, but the joke won't stop. Those clowns are telling the same circular stories, getting bopped by the same water bucket, and monotonously screaming "no! no! no!" as you read this. They do so for eternity. Nauman makes us squirm, and by "us" I mean fans. What he makes others do, in my observation, is glaze over, tense up, and flee.

As installed by Neal Benezra and Kathy Halbreich in a sort of pharaonic maze at Madrid's Reina Sofia, where I saw it, the Nauman retrospective gave no whiff of "development." It was a labyrinth of situations, each discrete and as present-tense as an emergency. It began with the famous 1967 neon spiral *Window or Wall Sign,* whose silly and/or profound message—"The true artist helps the world by revealing mystic truths"—affects the mind like a pestering insect you can hear but not see. The show ended with *Shit in Your Hat—Head on a Chair,* a complex work that incorporates a video of a winsome mime being put through torturous poses by an offscreen voice—one of a 1000 series of videos that, I think, strip bare some eerie and stirring imports of the verb "to perform." The mime's determination to obey, in high mime style, the voice's humiliating instructions makes the work's sadism a victimless crime, perhaps—and may induce a shocking reflection on the unpleasant things we all do every day, as well as we can and even with pride and joy, at the behest of unsympathetic powers. In between, there were worlds of enough meaning to exhaust anybody's capacities for absorption many times over. Emerging from the show on each of the several times I saw it, I felt exalted and beaten up. After twenty-five years of following Nauman's work, maybe I should be used to this feeling, but I never am.

On the retrospective's evidence, Nauman was never not Nauman. At least from the moment in 1965 when he arrived in San Francisco from the Midwest and ended a brief involvement with painting, he has made only "mature" work. Perhaps he exhausted his growing pains in the disciplines, pursued before he switched to art, of mathematics and music. What, by the way, is the significance for his art of that early training? Only someone equally adept in math, music, and art itself—and throw in Nauman's lifelong vigorous involvement with animals and the outdoors—could say for sure. Our culture seldom produces such people.

This artist routinely disrupts the settled expectations and predictable manners (bad manners included) of art-schooled art. He forbids us conditioned responses. He makes us start repeatedly from scratch: from our individual resources, such as they are.

Things don't evolve in Nauman's work. They happen. Early on, in the 1960s, an incredible profusion of things happened. Nauman's early production had an abbreviated representation in Madrid, but the variety of what was on hand still flabbergasted. There was one of his loaf-shaped fiberglass sculptures that splits the differences between minimalist form and the human body; a wax cast of folded arms joined, with conceptually intoxicating effect, to knotted lengths of heavy rope; a video monitor that, as you turn a corner, gives you a glimpse of your body disappearing around the corner; a film (transferred to video, with recorded film projector clatter) in which the artist gravely covers himself in layers of white, red, green, and then black pigments (sumptuous images that can seem somehow to say all that needs saying about painting); a series of high-production-value color photographs literalizing wordplays and morphological japes (*Waxing Hot, Self Portrait as a Fountain*); rather terrifying holograms (still the best work I have ever seen in this medium) of the artist in hellishly lighted, polymorphously grotesque poses; and a room in which a menacing voice growls and shouts "get out of this room, get out of my mind!" (If you stand in the exact middle of that room, by the way, the voice seems to come from inside your head.)

These and other early pieces—a concrete cast of the space under a chair; a hanging collection of glowing neon tubes formed to one side of the artist's body; at intervals during the exhibition, an inconspicuously clothed dancer performing a subtly odd walk ("as though the ceiling were 6 inches or a foot lower than his normal height"); a video of the artist incessantly sounding a violin whose strings are tuned D, E, A, and D; a tape loop draped across the length of a room and broadcasting the sound of someone walking in the room; and so on—the total of these inventions suggests a like number of artistic careers that the young Nauman, or somebody, might have embarked on. Looming from nowhere and returning there, the works are like flaring candles that a mysterious wind blows out. The nature of that extinguishing wind may be the crux of Nauman's art, found not in the works themselves but in the space around and the time between them. Such seems one, or perhaps the sum, of the artist's "mystic truths," whose sense was given by the philosopher most influential on Nauman, Ludwig

Wittgenstein: "What can be said at all can be said clearly; and whereof one cannot speak thereof one must be silent."[1]

Nauman's art is positively oriented to the inexpressible; always smack up against it, abutting silence. His inclination toward what cannot be said recalls a remark of Wittgenstein's apropos ethics, to speak of which is "to run against the boundaries of language. This running against the walls of our cage is perfectly, absolutely hopeless. . . . What [any discourse on ethics] says does not add to our knowledge in any sense. But it is a document of a tendency in the human mind." Each work of art by Nauman documents a tendency in the human mind. It also documents the "perfectly, absolutely hopeless" fix—the linguistic dead end, the virtual aphasia—that befalls the tendency every time. Nauman realizes as phenomena what can only be dreamed of, because unutterable, in anybody's philosophy.

Nauman's art sets the mind on tiptoe and knocks the heart sprawling. When one has been exposed to enough of it, the effect is a sort of rapturous ennui. What possible utility is there in such experience? One could answer by asking what utility there is in any experience at all that increases our apprehension of existing in the world. But this second question merely postpones an admission that there is no answer. We will or will not seek experience for its own sake. Neither option brooks argument. Nauman illuminates the fundamental arbitrariness of any intention to comprehend life—a theme also of one of his favorite authors, Samuel Beckett—by taking a blind will-to-experience to preposterous lengths, creating situations that could only be willed because too irksome to be wanted. This burden of work reached a peak with environmental sculptures of the early 1970s that I remember hating very much when first subjected to them: variously oppressive constructed walls, corridors, and enclosures with highly specific Gestalts, including such things as a double cage (not in the retrospective) that yields the remarkable sensation of being trapped "inside" and "outside" at the same time.

A 1973 triangular room shown in Madrid raises and immediately settles the question of why architects do not regularly give us triangular rooms. Made fiercely bright within by yellow neon lights that minimize the attractiveness of any other viewers present, the room proves conclusively that it is impossible to stand anywhere in a triangular space without feeling cornered. Now, why couldn't we just be told the bad news about triangular rooms? Why should we want to learn it at

all, for that matter? Who cares? Why use up so much institutional floor space merely to stimulate a recherché misery? The occasional Skinner-box aspect of Nauman's work can trigger such resentful questioning. One rebels at feeling cast as a guinea pig—as also in corridors barely wide enough to squeeze through, let alone pass someone coming the other way. (Nauman's architectural works can give rise to awkward social situations.) To submit requires faith that one is in good hands and that the grimmer phases of Nauman's process are not dispensable to its purpose, which is to render the condition of being alive more fully, sharply real. To submit or not is of course entirely optional. No one is obligated to be conscious.

A payoff for those who do undergo the rooms and corridors may be a heightened appreciation of the 1988 installation *Learned Helplessness in Rats,* comprising an empty Plexiglas maze and a video projector showing, in alternation, rats negotiating the maze, the maze scanned in real time by a surveillance camera, and a punk rock drummer beating a loud, repetitive tattoo. (It helps to know that Nauman, as he told me, came across the title phrase in a science magazine *after* making the piece.) I lingered often with this work in Madrid. Its content of wild impulsion and maddened futility became very strangely soothing to me. Here Nauman's fascination with experiences of entrapment is not imposed but confessed, made the shared subject of a zone of contemplation. The three alternating video tracks cause different configurations of consciousness: detached and scientific-analytical (the rat behavior); helplessly and immediately implicated (the surveillance scan); and more or less transcendent (music's comprehension of regimented time as an at once physical and spiritual pleasure, figured in the drums' catchy, incantatory din). The experience is definitively Naumanesque; self-consciousness intensified to a pitch of impersonal enlightenment, whereby the real existence of the body and some real working of the mind are held in a lofty, lucid regard.

This is a noisy retrospective, beautifully so. In Madrid one passed sound sources and the lap dissolves—fading behind, swelling ahead—between them as on an aural conveyer belt. The sources could be as ferociously loud as the drums of *Learned Helplessness* or the shouts of *Clown Torture.* (The intention of such pieces plainly includes ensuring that you cannot hear yourself think.) Or the sources could be as incidental as the humming and clunks of neon-light hardware. Those soft noises give dispassionate accompaniment to the social-anthropo-

logical burlesque of *Mean Clown Welcome* (two sour-faced clowns salute each other with random combinations of bowings, extended gloved hands, and penises leaping to attention) and to the great, blazing, wall-sized paean to the possibilities of existence, upbeat or downbeat according to association with living or dying, of *One Hundred Live and Die*. The soft scrape along the floor of *Carousel*'s cast-aluminum taxidermist animal forms, hung from slowly rotating beams, persists in memory as a song of unutterable sadness. The literally silent majority of the works in the show profited from the ambient aural soup, their hush becoming a kind of sound in itself that tacitly said, in the words of a drawing in the show's second room, "PLEASE PAY AT-TENTION PLEASE." Then there was the pregnant silence of the open microphone that along with a video camera was buried underground outside the museum in a coffinlike concrete box. A closed-circuit monitor broadcast what was happening in the box, which was what you would imagine. (This work is *Audio-Video Underground Chamber*, 1972–74.)

The haunting joke of the buried box, previewing the ultimate lodging that awaits us all, epitomizes Nauman's penchant for themes of death. The themes are a practical expedient, in a way. They open the most direct possible route to "mystic truths." Certainly they get a viewer's attention. *Violent Incident* (1986), a wall of twelve video monitors playing variant tapes of a loud male/female spat that leads inexorably to mutual homicide, tests the effect of repeating a cartoonish death scenario. (So does the neon *Hanged Man*, 1985, with its stick figure from the game of hangman repeatedly subject to a travesty of the lethal instant: body jerking, tongue out, penis erect, eyes replaced with Xs.) *Incident*'s battle of the sexes is absurd, with an actor and an actress trading roles from tape to tape in the piece's stagy choreography. But the idea of death—here as a consequence of hostile feelings hardly uncommon in male/female relations—can be kept at an amused remove for only so long. The longer the idea is present to the mind, no matter how artificially and archly, the more dangerous it becomes to equanimity. At last even the most trivial things are contaminated with the dire seriousness by association to it. *Incident* offers a chance that you may or may not opt to stick around for: to witness the flowerlike blooming in your mind of pure horror.

More than one person in Madrid wished out loud that there were more "sculpture" in the show—meaning things that stand still and somehow

reflect on traditional forms and functions of sculpture. So extravagant are Nauman's gifts for this art that we tend to forget how little pure sculpture he has made—an opus as relatively small, perhaps, as Wittgenstein's output of systematic philosophy. Very much like Wittgenstein, Nauman pointedly conveys the strict insupportability of the métier that constitutes his job description. The sculptor's preponderant antisculptures are like the "language games" with which the philosopher, by imagining cultures with rules of grammar radically different from our own, attacked faith in any language's ability to capture the essence of anything. At issue is no mere exercise of iconoclastic glee, but a tragic skepticism that poisons anything savoring of tradition. Nauman has managed some series of sculpture only by a fierce straining of his imagination, a sort of dreamlike trance. Such is the charge of his *Models for Tunnels* (floor-hugging, jury-rigged plaster mockups of impossible underground chambers, visceral elaborations of solitude) and of the hanging chairs surrounded by eye-level metal bands, such as *South America Triangle,* which allegorize political torture. All these works display the physical appeal of Nauman's startling frugality of materials and labor: everything only and exactly substantial and finished enough to serve. Rough craftsmanship underlines the artist's all but crippling doubt about sculpture's capacity "to mean." Still, a will-to-meaning clings about the works' crumbly plaster edges and brusquely wire-trussed components.

Likewise forced, and of interest to me as a work that has always given me special difficulty, is *Consummate Mask of Rock,* a 1975 room-girdling array of eight pairs of low-lying stone cubes in two sizes: the larger cube to the right of the smaller in all pairs but one, where the reverse obtains. The overall look of the piece and its trick variation have seemed to me acutely boring—rousing unhappy memories of "site-specific" sculpture in the 1970s with its imperatives to "define the space" and "energize the space." (Nothing happened to the space at all, of course.) In Madrid I stayed with my boredom to see if something would grow in it as in a petri dish, and something did: a sense of failed sculptural metaphor as a deliberately emphasized matter of fact. The rhythmically arrayed cubes "yearned" for circle-dance-like "wholeness" by means of internal asymmetry, except for the pair that "yearned" to assert "independence" by means of symmetry with its neighbors. Something like that. (The story doesn't matter.) This hopelessly jejune drama unfolded all around me and so could not be held in view. It insisted on commandeering my mind.

Does Nauman make his own problems the viewer's problems? Or, like a scientist testing a new serum on himself, does he incur problems of significance to everyone? Whatever the case, a willing viewer receives a revealed sense of the problematic as a true state of affairs attendant on, and maybe definitive of, being alive. This revelation seems to me the ultimate action and possible value of Nauman's art. The action can be completed only if valued, only if granted a viewer's self-interested participation. You must have a personal use for Nauman's work if the work is even to exist for you. Otherwise you will be overwhelmed by tedium and will want to be away from this thorny, importunate stuff. Nauman does not add to my own experience of art so much as cast it in an unflattering light, and even plunge into tormenting doubt, the generality of that experience. He gives me a sullen sense of knowing less than I thought I knew and a sinking feeling that what I do know may depend on flawed, perhaps sentimental assumptions. I come away from his work with less confidence of all kinds than I bring to it, but with a whetted appetite for whatever in the world may be genuine.

Bruce Nauman is a great artist. There is no other kind or degree of artist he could be. The material, technical, and formal (or antiformal) range and mastery and, most of all, the philosophical density of his work demand that he be admitted to art's first rank. The alternative would be to exclude Nauman from art altogether. This could almost be argued. One might suggest, putting it nicely, that he is overqualified to be an artist. He can indeed seem to mistake art for something more difficult and substantial—more intellectually rigorous, more ethically urgent, at once more developed in thought and raw in feeling—than our surface-happy visual culture has any sustainable uses for. He more than ignores our appetites for esthetic satisfaction. If Nauman has a single overriding subject, it is frustration. Certainly he poses a steep problem for the "art lover": no love, only a guarantee of practically barbaric integrity. The problem has no solution. Sometimes, though, in the charmproof vicinity of the work the problem disappears, replaced by the fact of an illumination that, call it what one will, is like being newborn to the real.

Note

1. This famous line is the concluding proposition in Ludwig Wittgenstein, *Tractatus Logico-Philosophicus* (London: Routledge & Kegan Paul, 1921), 74.

Kathryn Hixson

Nauman: Good and Bad

If the only facts we can believe in are the fact that we live and the fact that we die, and if, after disease and natural disaster, the most likely cause of death is murder by our fellow human beings, and if the social contract that staves off mutual murder is our most controllable defense against death, and if death is the most feared fact of our lives, then Bruce Nauman's art is about the fear of death. We can solicitously discuss the fineries of noble death, comfortable death, dignified death, "which completes the process of being alive,"[1] but the fear of a personal losing of consciousness in death is an inconsolable fear.

Co-curators Kathy Halbreich and Neal Benezra offered an opportunity to trace Nauman's morbidity in a retrospective of 67 works ranging from his earliest performances for film to a 1994 state-of-the-art video projection. This show premiered at the Reina Sofia in Madrid (paralleling interest in Nauman's career, which took off in Europe before it was accepted on his home turf), and opened in the States at the Walker Art Center[2] in Minneapolis. In Halbreich's catalogue essay, she points out that, "More than twenty sculptures by Bruce Nauman refer directly to dying and include in their titles the words death or dead."[3] This central preoccupation can be observed in many manifestations throughout this artist's career, from his early, highly individualized existential self-tortures, through the more metaphorical clown- and animal-torture work of his mid-career that address social and political interaction, to the most recent mature, or maturing, examinations of Nauman's own mortality. Nauman seems to have always understood the limits of the self in terms of existentialism and art-historical influence, and has continued to wrangle with those limits by virtue of find-

Originally published in the *New Art Examiner,* December 1994.

ing and then transgressing them.[4] His work addresses many issues, but, at the risk of reductive simplicity, in the retrospective the fear of death is so overt and powerful that it is crucial to blatantly label it as a central driving motivation for Nauman's art-making.

Boundaries of Art

Nauman's early works crossed many lines in terms of art-making genres. His films, performances, sculptures, and installations were exemplary of his generation and now well serve art historians who teach this epoch. Much has been made of Nauman's self-examination of his own art-making: What does a young man do after shrugging off de Kooning, having been affected by Modern and Minimalist sound and dance, while reading a lot of Beckett, and taking classes from William Wiley and Robert Arneson? Extensive and intensive soul-searching, it would seem. The typically impoverished art-guy came up with a lot of radical invention, and along with the rest of his generation, managed to develop art-smart strategies that produced, for example, a photograph of the artist-as-fountain spewing water from his mouth referencing Duchamp's fifty-year-old *Fountain,* which would be revivified twenty years later by Tony Tasset in his own self-portrait spew. To be sure, Nauman's art is about art.

Over the years, Nauman has directly addressed the work of other artists in ways that are not dismissable as derivative, but function more as journalistic commentary on previous or contemporaneous work. In his *Henry Moore Bound to Fail (back view)* from 1967 (among other allusions to Moore and H. C. Westerman), he simultaneously unsettles his own heritage of traditional object-sculpture and offers up the heroic status of the predecessor against which successive generations could rebel. Many of Nauman's works could be interpreted as homages to Jasper Johns's sign-paintings, Joseph Beuys's fat corners, Marcel Duchamp's fountain, Michael Heizer's masculine earth-movings, or Dan Flavin's fluorescent light tubes. Each forerunner is respectfully quoted, but the remarks are twisted to Nauman's personal existential purposes. If the historical nature of Harold Bloom's "anxiety of influence" can be separated from that author's desire to maintain a conservative status quo, Nauman embraces that fear-of-the-father anxiety as one of many concerns that compel him to wrangle with existing ideas while tweaking them with a personal irony or terror. A satisfying example is Nauman's 1994 *Poke in the Eye/Nose/Ear 3/8/94 Edit,* a huge super-slo-mo video projection of the artist performing the actions of the title upon

himself. I would speculate that this piece is a direct comment on the elaborate video installations of Gary Hill, or more pointedly those of Bill Viola, which have been overwhelming art audiences in recent years with their spectacular—bordering on fascistic—visual feasts. In Nauman's acknowledgments to the shifting trends, either of older generations or in contemporaries' work, is the reluctant acceptance of the passage of time, another fact, which is the nemesis of wishes for transcendent immortality.

The weight of recent art history is always heavy on the shoulders of the practicing artist, producing anxieties akin to those that cause one to rebel against the parent, or continually dis the siblings (while stealing their LPs or lipstick). Nauman's project incorporates these feelings by setting up personal activities and aspirations, which work against dictatorial extrapersonal forces: in effect, art against life, and life against death. (His glib visual pun *From Hand to Mouth*, a wax cast of the parts of the artist's body described by the title, is a literalization of a figure of speech that characterizes a life just barely kept alive, like the artist who nearly starves, yet continues to make art in the face of a market or culture that ignores it.) The dictates of parental authority, which are as impossible to fulfill as death is to avoid, are painfully illustrated in *Shit in Your Hat—Head on a Chair* of 1990. A suppliant mime acts out the commands of an authoritarian male voice, but she(?) can never quite seem to keep up with his increasing speed, or is horrified at his often mean and nasty demands: "Shit in your hat. Put the hat on your head. Sit on your hat." As a metaphor for life as well as art, this piece positions the individual as always failing to please the parent, the market, the audience, the critics, while doing exactly what they want. This continual failure to achieve mirrors the ultimate failure of mortality.

The Disappearance of the Body

Nauman's corridor and tunnel pieces from the 1970s also illustrate physical constraint, which can sometimes be paradoxically liberating. In some corridor pieces, the participating viewer is disappeared by misquoting video surveillance cameras (one monitor plays a prerecorded tape of the perused empty space, and another just catches the image of the viewer leaving a previously traversed space). Nauman dismisses the bodily "completion of the work" by the viewer, while basically letting him or her be absent from it: freed of responsibility, dead and gone. *Room with My Soul Left Out . . .* , shown in the exhibition in model form (making it seem dangerously romantic), is a triple shaft of

intersecting rectilinear spaces that ache with emptiness and refusal. Nearby was *Get Out of My Mind, Get Out of This Room,* an audio installation in a small room that commands viewers—early-Acconci-style—to do just that, to leave him alone: and the most alone thing one can do is die.

The tunnel pieces are intersecting circular or angular, usually messy plaster casts, like poorly made, but elaborately designed architectural models of complicated underground passageways, possibly inspired by Henry Moore's tunnel drawings from World War II. Nauman's tunnels do not, however, invite protection and succor. Instead, they map paths that lead to nowhere. The openings either fail to connect properly to other sections, or are left yawning into the void. Like the maze in *Learned Helplessness in Rats,* the tunnels are symbolic of the futility of circular movement, or of the frustration of the always-already-there-unto-death self-referentiality of art, and of living.

It is somewhat interesting that Nauman's tunnel-structures never quite make it as sculpture. Their dramatic formal presence and almost painterly surfaces and colors make them rather curious, but in the end, dull. It is only when the mental switch is flipped—turning them into symbolic models—that the mind finds satisfaction: the imagination shrinks to a tiny size and runs raucously through the vast circular sweeps, jumping wildly off an edge into oblivion. This goes to show that Nauman is at his best when he directly confronts the living body and mind about to die.

The most dramatic example, and some may say cheapest-shot, of the fear of death in Nauman's oeuvre is the 1972–74 *Audio-Video Underground Chamber.* A box, approximately 2½ by 3 by 7 feet in size, is buried 8 feet underground outside (in the sculpture garden). A video camera and microphone jut into the box, sending image and sound to a monitor inside (in this case in the Walker gallery). The viewer gets to stare at the screen and ponder: So this is what it feels like to be buried alive!

The Social Contract

At a certain point (graciously outlined in the catalogue)[5] Nauman switched from existential solipsism and symbolic loneliness to the examination of the social contract. Through his use of material—neon, vernacular speech, and the rather vague architectural models—he traversed the territory from personal to social. He effected this transition through the employment of seemingly logical word combinations and children's games, which are perhaps two sides of the same coin. In *One*

Hundred Live and Die, a culmination of years of work with texts writ-
ten in light, lines of neon words flash such things as "FEAR AND DIE,
FEAR AND LIVE, RED AND DIE, RED AND LIVE, PAY AND DIE, PAY AND
LIVE." What would seem to be bland verbs are thrown violently from
glorious optimism—LAUGH AND LIVE—to depressing fatality—LAUGH
AND DIE. In the end, the dichotomies set up between "live and die" are
perhaps as arbitrarily nonsensical and logically unsettling as the litany
periodically recited in the high-volume six-channel video installation
Clown Torture. "Pete and Repeat are sitting on a fence. Pete falls off.
Who is left? Repeat. Pete and Repeat are sitting on a fence. Pete falls
off. Who is left? Repeat. Pete and Repeat . . ." Meanwhile, on other
screens, a clown is trying to shit, another clown is a victim of a stupid
sight-gag, while a third is having a temper tantrum (screaming "NO NO
NO NO"). This piece is purportedly popular with two-year-old viewers,
because it perfectly describes their universe, one exemplary of Nau-
man's project. This is when the primary conflicts between socialization
and the individual begin to take place—between shitting in your pants
and shitting in the socially acceptable place of the toilet.

In the Walker exhibition the cacophony of *Clown Torture* was
satisfyingly set up between the almost heinous repetition of the tones
D-E-A-D played by the musically untrained artist on a specially tuned
violin videotaped in 1969, and the groaning carousel of animal taxi-
dermy forms in a draggingly perverse merry-go-round of cadavers. The
aural assault of this section made many visitors run for safety. The hos-
tility of Nauman's work, like the spectre of death, continually demands
attention to its message, in other words, to quote a 1973 collage, the
viewer is exhorted to "PLEASE PAY ATTENTION PLEASE."

Shitting in Your Pants

In a Wittgensteinean sense, discussing the social contract—
say, speaking of a merry-go-round as a fun ride and not an abstraction
of dead animals circling endlessly for no good reason except to posit
our own aliveness—is a way to agree on definitions of that contract. In
Good Boy Bad Boy,[6] two people, a black man and a white woman, ex-
hort: "I was a good boy, you were a good boy, we were good boys, that
was good. I am an evil woman, you are an evil woman, we are evil
women, this is evil. I live the good life, you live the good life, we live
the good life, this is the good life. I have work, you have work, we have
work, this is work. I play, you play, we play, this is play. I'm bored,
you're bored, we're bored, life is boring." Here are the tenuous agree-

ments that rule our world and define our existence, or rather form the definitions of social interaction that then rule our lives. They are simple agreements that ultimately are arbitrary, like in the children's game rock, paper, scissors—which Nauman included in the enigmatic text section of his 1975 *Consummate Mask of Rock*—in which rock crushes scissors, scissors cut paper, but paper covers rock. Who makes the rules?

Sex and Death/Violation

Another fun aspect of Nauman's work is his preoccupation with sex. The 1985 neon *Hanged Man* is especially wonderful in its cartoon depiction of a kid-drawn hanged man suffering the ultimate fate, the ultimate transgression, by not only dying, but getting a hard-on as he lurches toward nothingness, the proverbial chair being kicked out from under him, sex = death. As brutal as this piece is, it is in turn rather mundane in its cruelty, for it lets the viewer off the hook, walking away with a satisfied chuckling voyeuristic impulse. In his more complicated scenarios, most notably the clown pieces, Nauman turns grotesqueries into pleasing aesthetics in order to invite voyeurism or to deflect feeling, then aggressively thrusts onto the viewer a complicity in the violence depicted, turning fun into guilt. In the work that scores the highest in the queasiness-causing category, Nauman never allows the viewer an easy exit. In the aforementioned *Shit in Your Hat—Head on a Chair* it is impossible to identify completely with the poor mime, because it is too sickeningly fun to side with the evil master voice.

Playing on the viewer's gleeful, and embarrassed, participation in such cruelty is Nauman's 1986 video installation *Violent Incident*. Here, a man and a woman transgress simple social rules: They alternately pull the chair out from under each other, throw drinks in each other's faces, kick one another in the groin, and finally kill each other. Nauman, like playwright David Mamet, pits these actors against each other in an abstraction of violence. In the footage, which cycles around twelve stacked monitors, he includes a "rehearsal" take, wherein the actor and actress, seemingly bored with the whole project, go casually through the scripted motions. This serves as a pivotal moment in the piece: without the conventional "theatrics" the activities become heinously real, and therefore more scarily close to mundane reality.

Bad Nauman

At points in Nauman's work, and in that of his apologists, its ethical component lapses into a didactic harangue. When the artist or

critics start to unironically believe that *The True Artist Helps the World by Revealing Mystic Truths* (a neon piece from 1967), a quaint political message results that forgets art may very well serve as an idealistic model or raise public consciousness, but rarely does it effect direct political change. The worst examples of this lapse in faith in abstraction are Nauman's hanging-chair pieces from the mid-1970s, which are purported to be exposés of the terrorism and torture of South American military regimes of the time. Their metaphors are obvious, flat, and a disservice to any liberal cause. Alongside these artistic banalities are Halbreich's epiphanies that seek to reinstate the artist's role as mystic: "If by mystic . . . mysteries of faith are best understood through moral allegories or symbols, then Nauman's wavering [and] questioning . . . place him in the center of the mystic's creative dilemma of representing faith."[7] This quasi-religious high-falutin' claim that art and the artist can transcend the everyday moral and ethical codes through some ersatz spirituality is not really necessary to understanding Nauman's work, and is apt to erroneously lionize the art personality as inordinately saintly. Nauman is at his best when he directly expresses the failure of this tendency, as in his *Failing to Levitate,*[8] a doubly exposed photograph from 1966 in which his body is seen rigid, then falling, stretched between two regular folding chairs that hold, then release, his head and feet.

Good Nauman

I wish to believe that Bruce Nauman's work is more about shitting in your pants than about mystical transcendence. I would agree with Adam Gopnik's assertion in a *New Yorker* review of the last Venice Biennale Aperto[9] that a lot of lame work has been championed, or at least allowed (much of Damien Hirst's, for instance) because of precedents set by Nauman, but I also think that Nauman's brand of annoying transgression harbors a healthy antagonism, which continually insists on direct confrontation with the fear of death.

At the root of this basic emotion is the fear of losing control of body and consciousness, of losing control of the social rules that the intellect knows how to follow, and again shitting in your pants. Also, fear of death is the fear of losing the boundaries that separate the individual from the rest of the world, anticipating that the body will decay into the undifferentiated void of matter.[10] At his best Nauman baldly presents us with these fears, setting up games that are just on the verge of going out of control, ethical rules about to explode into amorphous vi-

olence. Although easy to understand intellectually, the work continues to fascinate, whorling around in the never-never regions of pure emotion. His *Poke in the Eye/Ear/Nose* is a most elegant, and completely frightening, manifestation of transgression of social games and the body. In painful slow motion, blown up to gargantuan size, the artist performs the simple childish gesture, poking himself in his orifices, the points at which our bodies merge with the void everyday, his finger going deeper and deeper, deeper than you ever thought possible into those holes. Horrific yet irresistibly enchanting, *Poke* . . . insists that we join Nauman in confronting our imminent demise. Fear of death will never go out of style.

Notes

1. Kathy Halbreich, "Social Life," *Bruce Nauman* (Minneapolis: Distributed Art Publishers, 1993 [exhibition catalogue]), p. 86.

2. "Bruce Nauman" exhibition schedule: Museo Nacional Centro de Arte Reina Sofia, Madrid, November 30, 1993 to February 21, 1994; Walker Art Center, Minneapolis, April 10 to June 19, 1994; the Museum of Contemporary Art, Los Angeles, July 17 to September 25, 1994; Hirshhorn Museum, Washington, D.C., November 3, 1994 to January 29, 1995; Museum of Modern Art, New York, March 1 to May 3, 1995.

3. Ibid., p. 89. This catalogue also includes very helpful and insightful essays by Benezra, Robert Storr, and Paul Schimmel, and the hardcover version includes a catalogue raisonné of Nauman's work. This document is a critical and crucial addition to discussion of late-twentieth-century art-making in Europe and the States. This essay is indebted to this catalogue and to the monograph by Coosje van Bruggen, *Bruce Nauman* (New York: Rizzoli, 1988).

4. Madeleine Grynsztejn, in conversation, 1994.

5. In the essays by Storr and Halbreich.

6. One of three parts of *Chambres d'Amis (Krefeld Piece)*, 1985, *Good Boy Bad Boy* is in one small room, between two others. The room to the left is empty of objects, and the words of *One Hundred Live and Die* can be heard played on audiotape. The room to the right is dark, and houses the neon *Hanged Man*.

7. *Bruce Nauman*, p. 105.

8. *Failing to Levitate* was not in the retrospective, but is reproduced in the catalogue, p. 104.

9. Adam Gopnik, "Death in Venice." *New Yorker*, August 2, 1993, pp. 61–71.

10. Laurel Frederickson, in conversation, 1994.

Neal Benezra

Surveying Nauman

From the outset, Bruce Nauman's work has eluded easy characterization on the basis of medium, style, or content. Initially a painter, Nauman questioned and eventually abandoned the medium. He soon turned to sculpture as the cornerstone of his work, extending the practice by making sculptural installations animated by spoken and written language, film, video, dance, and performance. Beyond this, Nauman's installation work has ranged from environments that include a wide variety of nonart materials to settings that are entirely free of objects, in which perceptual and psychological suggestion and response constitute the sole content.

Although the challenging nature of this body of work suggests an iconoclast, Nauman, particularly as a young artist, looked to the history of art for direction. In so doing, he bypassed most contemporary American art of the early 1960s, which was dominated by the clear, decisive formal statements of pop art and minimalism. Searching farther afield, Nauman focused on Man Ray, whose career epitomized the breadth of activity he sought. Here was an artist who was a painter, sculptor, filmmaker, and photographer: yet he earned his income as a fashion photographer and thereby ensured his independence as an artist. Ideas governed Man Ray's work rather than matters of medium or style, and it was this quality that Nauman particularly appreciated: "To me Man Ray seemed to avoid the idea that every piece had to take

Originally published in the catalogue for the touring exhibition, "Bruce Nauman," Museo Nacional Centro de Arte Reina Sofia, Madrid; Walker Art Center, Minneapolis; Museum of Contemporary Art, Los Angeles; Hirshhorn Museum and Sculpture Garden, Smithsonian Institute, Washington, D.C.; Museum of Modern Art, New York, 1993–95. *Bruce Nauman* (Minneapolis: Walker Art Center, 1994), 13–46.

on a historical meaning. What I liked was that there appeared to be no consistency to his thinking, no one style."¹

While Nauman has great respect for and an admitted debt to the Dada tradition, he simultaneously considers art to be a type of research endeavor. Having studied mathematics as an undergraduate at the University of Wisconsin in the early 1960s, he has commented: "I didn't become [a mathematician], but I think there was a certain thinking process which was very similar and which carried over into art. This investigative activity is necessary."²

If Nauman's intellectual commitment to art as an area of investigative activity is strong, he is also firmly dedicated to the moral and ethical purposes of art. Born to a middle-class Midwestern family, he believes strongly in the value of labor.³ This work ethic presses him into the studio every day, and through the years it has evolved into a powerful political commitment. Here Nauman credits his art professors at the University of Wisconsin, many of whom had come of age during the Depression and had worked under the auspices of the Works Projects Administration. "They were socialists," he says, "and they had points to make that were not only moral and political, but also ethical . . . people who thought art had a function beyond being beautiful . . . that it had a social reason to exist."⁴

This is a complex and wide-ranging mix of influences and attitudes: a nearly encyclopedic array of contemporary media and materials; an engagement with Dadaist irony and paradox; an interest in art as a form of research; and a growing commitment to the political responsibility of the artist. Uniting the disparate threads of Nauman's work is an ongoing devaluation of traditional formal considerations—"making the thing itself less important to look at," to use his phrase⁵—in favor of a prolonged examination of both the ideas that underlie the object and the role of the artist in contemporary society.

When Nauman was graduated from the University of Wisconsin in 1964, he received a bachelor's degree in science with a minor in painting. In seeking an independent direction for himself, he studied the work of numerous modern masters. He focused on the painting and example of Willem de Kooning, for he appreciated the complex interaction between figuration and abstraction in his work, as well as the challenges he faced in his art.

He's a beautiful draftsman and a powerful artist—and also somebody who was struggling. Artists from that generation, and even after that, had to struggle with Picasso. Their problem was basically how to get beyond Pi-

casso. De Kooning finally found a way, and so I trust him in his choice of how to proceed.[6]

While Picasso and de Kooning have remained important touchstones for Nauman, the young painter questioned, fairly quickly, more recent and more formal work in the medium, particularly as represented by Frank Stella.

I think where I finally ran into trouble was at Frank Stella, someone a little bit ahead of me in time. I was very interested in his early paintings because I saw incredible possibilities in the work of how to proceed as an artist, but then it became clear that he was just going to be a painter. And I was interested in what art can be, not just what painting can be.[7]

Nauman's decision to study art on the graduate level at the University of California, Davis, was a fortuitous one because many of the attitudes he was developing were already being explored by artists teaching at Davis. His principal professors were Robert Arneson and William T. Wiley, each of whom espoused an informal approach to art rather than one based on medium or style. Both artists' work involved healthy doses of irony and humor, a wide variety of nonart materials, often whimsical compositions, and punning titles. Yet these artists' ironic wit and humor masked the altogether serious nature of their teaching and work. In particular, Wiley's open-ended approach to teaching encouraged the young artist's critique of formalist art.

Nauman's paintings of these years often included welded steel elements that were incorporated into abstract or landscape compositions and then painted. Others, such as *Untitled* (1964–65), are shaped canvases and convey his engagement with then-current aesthetics. This painting—tall and slender like the artist himself and painted in tan, brown, and blue acrylic bands—is Nauman's last canvas. For it was in the antiformalist environment of Davis that he determined to abandon painting. As he noted, "I loved moving the paint and the manipulation of materials. It was very serious, but it also got in the way. I still don't trust any kind of lush solution, which painting was, and so I decided—it was a conscious decision at some point—that I was not going to be a painter. The decision was hard, but I was young enough that it wasn't *that* hard."[8]

It is important to note that while Nauman discarded paint at this early moment in his career, he did not abandon color. In fact, color plays a remarkably important role throughout his work, and from the time he stopped painting Nauman has consistently invented ways in

which to integrate it into his art.[9] Perhaps the earliest example of a more conceptual engagement with color is his *P.P.G. Sunproof Drawing No. 1* (1965), an appropriated industrial color paint chart, transferred to blueprint and presented in sepia tone, which is rotated on its side and signed by the artist. Unlike the color-chart paintings Gerhard Richter began in 1966, in which bars of color are presented and displayed undescribed and unadorned, Nauman's color chart is based on a found object; but it is one in which the ironic absence of color whimsically defies our linguistic expectations.

When Nauman stopped painting he explored a number of media virtually at once. In 1965 and 1966 he made nine films (six of them collaboratively), simply using the camera as a recording device. The best known of these is *Fishing for Asian Carp* (1966), in which he filmed the painter William Allan attempting to catch a fish. While the project parodied traditional notions of narrative and duration in film, ultimately, it depended on a linear story line, a device that Nauman avoided in subsequent films. For *Revolving Landscape* (1965–66), Nauman employed a mechanical device in order to rotate the camera continually while filming. The chance effects he achieved were similar to those realized by Man Ray, who in 1926 threw a camera in the air while filming *Emak Bakia*.

Nauman also presented two performances while at Davis. In the first, which would form the basis for a later videotape, *Wall-Floor Positions* (1968), he performed an untitled piece

standing with my back to the wall for about forty-five seconds or a minute, leaning out from the wall, then bending at the waist, squatting, sitting and finally lying down. There were seven different positions in relation to the wall and floor. Then I did the whole sequence again standing away from the wall, facing the wall, then facing left and right. There were twenty-eight positions and the whole presentation lasted about half an hour.[10]

In the second performance, which later became the videotape *Manipulating a Fluorescent Tube* (1969), Nauman worked with artificial light, moving an 8-foot-long fluorescent tube into varying positions in relation to his body. In both works, he treated his body as a type of theatrical sculptural material, assuming a number of allusive and even suggestive poses and then holding them for extended periods of time.

The human scale and slim proportions of Nauman's last paintings and the evocation of his own body in the films and performances also formed the basis for the artist's first sculptures. Rather than producing

durable objects in plaster or bronze, he focused on the process of *making* itself by analyzing the venerable tradition of casting. In 1965 and 1966 he completed a number of fiberglass sculptures in which a pair of forms were cast from the same plaster mold, with pigment added to the polyester resin. Many of these elongated forms were mounted on, or lean against, a supporting wall. As a group they seem willfully eccentric: they possess neither front nor back, neither inside nor outside. Most troubling for sculpture purists, Nauman made no attempt to refine the finished surfaces: remnants of the casting process often remain prominent in the completed work. In short, his first sculptures defy the tradition of sculpture in almost every regard. They are constructed of nonart materials, and their unorthodox and casual appearance places them at odds with the history of the medium.

Nauman's first sculptures have much in common with the early work of Walter De Maria, Robert Morris, and Richard Serra (all of whom, it is interesting to note, either grew up or studied in the San Francisco Bay Area). In the mid-1960s these artists were pressing beyond the rigorous geometry and seamless fabrication of minimalism by employing industrial materials such as fiberglass, lead, and plywood and by allowing their labor to remain prominent in the final work. Nauman made works such as *Untitled* (1965–66), in which he explored gravity as a sculptural principle by simply hanging lengths of latex rubber on the wall, while simultaneously suggesting a figure by virtue of the composition. In other works he parodied the minimalist obsession with the formal organization of space. *Shelf Sinking into the Wall with Copper-Painted Plaster Casts of the Spaces Underneath* (1966), for example, consists of objects lying casually on the floor as though they had simply dropped after being cast by the underside of a now-sloping shelf, which seems to sink into the wall. In the case of *Platform Made Up of the Space between Two Rectilinear Boxes on the Floor* (1966), Nauman eliminates the ostensible mold altogether and simply presents a fiberglass representation of the space separating two illusory boxes.

Elaborate, fully descriptive titles such as these now become ubiquitous in Nauman's work, signaling both the artist's disaffection with the formalism of his initial cast sculptures and a desire to load his work with ideas.[11] Nauman was influenced here by the writings of Ludwig Wittgenstein, particularly the *Tractatus Logico-Philosophicus* (1922) and the *Philosophical Investigations* (1953). The titles Nauman employed at this time suggest Wittgenstein's "picture theory of meaning," which holds that language consists of propositions that image the world. This

notion served as a foundation for language-based artists such as Joseph Kosuth and Lawrence Weiner and influenced Nauman's early titles as well. Yet if we compare his *My Last Name Exaggerated Fourteen Times Vertically* (1967), one of the artist's first works in neon, with Kosuth's *Five Words in Blue Neon* (1965)—in which object, title, and the language used to describe them are as one—obvious distinctions arise. While Kosuth's neon is conceived and formed analytically, Nauman's employs language as one of several means to enrich and complicate his work. Nauman remains committed to the formal appearance and the linguistic transformation of his objects as well as to the process of generating both simultaneously. Beyond this, he has continually questioned his own identity as an artist. In *My Last Name Exaggerated Fourteen Times Vertically,* this led him to exaggerate his own signature, as he simultaneously parodied the time-honored notion of artists developing a "signature style."

At the time, Nauman became especially interested in Wittgenstein's *Philosophical Investigations* and, in particular, the way in which the philosopher pursued

an idea until he could say either that it worked or that life doesn't work this way and we have to start over. He would not throw away the failed argument, but would include it in his book.[12]

The notion of displaying one's processes and failed notions in a completed work provided an armature for Nauman's early sculptures, and he now tested these ideas in an apparently more public context. In 1966 he borrowed the phrase "a rose has no teeth" and made a small lead plaque. When complete, *A Rose Has No Teeth (Lead Tree Plaque)* (1966) was mounted temporarily on a tree, with the expectation that the growth of the tree would subsume both the words and the plaque. Implicit here is Nauman's skepticism concerning the fixed meaning of language, as well as a critique of the Earthworks movement, for he disagreed with the heroic gestures then being made in nature by Michael Heizer, Robert Smithson, and others.[13] Nauman took the phrase directly from the *Philosophical Investigations* and followed Wittgenstein's pursuit of an illogical premise to its self-evident and absurd conclusion.[14] The piece subtly reveals both Nauman's debt to the philosopher and the artist's iconoclastic view of public sculpture, with its tradition of permanent placement, monumental scale, and ennobling purpose.

When Nauman was graduated with a master's degree from the Uni-

versity of California, Davis, in the spring of 1966, he moved his studio into an abandoned grocery store in San Francisco. Although he began to teach that fall at the San Francisco Art Institute, he felt isolated:

> I didn't know many people there, and being a beginning instructor I taught the early morning classes and consequently saw very little of my colleagues. I had no support structure for my art then . . . there was no chance to talk about my work. And a lot of things I was doing didn't make sense so I quit doing them. That left me alone in the studio: this in turn raised the fundamental question of what an artist does when left alone in the studio. My conclusion was that [if] I was an artist and I was in the studio, then whatever I was doing in the studio must be art. . . . At this point art became more of an activity and less of a product.[15]

Nauman's confrontation with himself was not unlike that faced by many artists who experience sudden isolation after leaving graduate school. Yet his situation was exacerbated by his emphatic early decision not to work in established media. Having determined that "painting is not going to get us anywhere, and most sculpture is not going to either,"[16] he now found himself in a terrible bind. Isolated in the studio, with little money for materials and no clear direction, he determined to trust himself and his instincts by exploring the very problem of being an artist and his own activities inside the studio and out.

The window of the San Francisco grocery storefront in which Nauman lived and worked displayed a beer sign. He was captivated by the clear, concise, utterly unproblematic advertising logo in glittering neon, a logo that nevertheless was illegible when seen from inside the studio.[17] Characteristically, he determined to explore this tension and two works resulted. In 1966 he purchased a Mylar window shade and around the edges printed the words "The true artist is an amazing luminous fountain." While functionally reminiscent of Jasper Johns's *Shade* (1959), an opaque, painted window shade mounted on canvas and revelatory of the older artist's penchant for concealment, Nauman's shade displayed his doubt publicly. The artist installed it in the window of his storefront studio and, alongside it, mounted a spiral shaped neon, *The True Artist Helps the World by Revealing Mystic Truths (Window or Wall Sign)* (1967), composed of the titled words.[18] Nauman was responding to his circumstances with idealism and irony in roughly equal measure. Although he possessed a youthful belief in himself as an artist hoping to follow in a great tradition, he already had come to doubt and even reject important elements of that tradition, as well as to question his own position and activity.

Rather than abandoning sculpture altogether, however, Nauman began working with one of the most hallowed of sculptural subjects, making casts of body forms and, in the process, parodying his own insecurity. Three works from 1967, all of which were included in his first solo exhibition in New York at the Leo Castelli Gallery the following year, are particularly important here: *Untitled,* a thick length of double-knotted rope above a pair of folded arms; *Henry Moore Bound to Fail (back view),* a wax cast of a human back bound with rope; and *From Hand to Mouth,* in which the title is made literal by the fragmentary human form. Although Nauman scarcely knew the work of Marcel Duchamp at this point, the spirit and essential character of pieces such as *With My Tongue in My Cheek* (1959), were conveyed to the young artist indirectly by Jasper Johns. Nauman was fully conversant with Johns's work: pieces such as *Target with Plaster Casts* (1955), with its small, fragmented body parts, were of great importance for him. While Duchamp is often credited as a crucial influence on Nauman, the light-hearted intellectual gamesmanship of the French artist was, in fact, much less important than the restrained psychological tension underlying Johns's work at this point.[19]

Also close to the spirit and content of Nauman's body casts are several of Walter De Maria's early sculptures. His *Boxes for Meaningless Work* (1961), a pair of simple wooden boxes, bears the inscriptions: "Boxes for Meaningless Work. Transfer things from one box to the next box back and forth, back and forth, etc. Be aware that what you are doing is meaningless." A taut, self-conscious humor prevails in both artists' work, as well as an obsession with art as a highly subjective, personal activity that need not yield objects or have any public meaning whatsoever.[20]

Nauman's mock-expressionist commentary assumed similar forms in other media. After seeing a Man Ray retrospective at the Los Angeles County Museum of Art in 1966, he made a group of eleven photographs. Several of these strike at the heart of his continued self-absorption in the studio. The bound artist also appears—this time without the reference to Moore—in *Bound to Fail* (1966–67); and *Self-Portrait as a Fountain* (1966–67) finds Nauman stripped to the waist in a darkened room in the guise of a self-generating fountain, parodying both the tradition of public sculptors engaged with the heroic male nude and his own youthful preoccupations.

Photography, and soon, film and video, provided Nauman with new media for his ideas. The camera offered a seemingly straightforward

means to document activity without aesthetic or narrative impulses entering the process. When Nauman found himself obsessively pacing in the studio, he began to consider how his behavior might be documented. As a substitute for public performance, he filmed, and later videotaped, a variety of these apparently mundane activities. He made some twenty-five films and videotapes in the late 1960s; these involve walking, pacing, stamping, jumping, bouncing balls, and playing the violin. The actions were always performed before a stationary camera that was placed so that Nauman often disappeared offscreen as he performed. On occasion he mounted the camera upside-down or sideways so that the resulting film would further disorient the viewer. Throughout, Nauman explored the problem of physical self-awareness: "I thought of them as dance problems without being a dancer, being interested in the kinds of tension that arise when you try to balance and can't."[21]

Nauman found confirmation for these ideas in his reading—specifically, in the plays and stories of Samuel Beckett and the novels of Alain Robbe-Grillet. While Robbe-Grillet describes nuances of behavior and environment in minute detail in *Jealousy* (1957), Beckett's plays are full of characters who engage in obsessive behavior. Nauman was particularly interested in the activities of Beckett's character Molloy: "transferring stones from pocket to pocket. . . . They're all human activities, no matter how limited, strange, or pointless, they're worthy of being examined carefully."[22] In 1968 Nauman actually invoked Beckett's name in titling several works, among them a drawing, *Untitled* (Study for *Slow Angle Walk*) also known as *Beckett Walk Diagram II,* and a corresponding videotape, *Slow Angle Walk (Beckett Walk).*

In addition to these literary sources, Nauman's work at this time benefited from his awareness of recent developments in dance and music. In 1968 he met the dancer-choreographer Meredith Monk and the composer-musicians Steve Reich, Terry Riley, and La Monte Young. All were committed to transforming the chance effects that John Cage and Merce Cunningham had explored into planned compositions that nonetheless incorporated process as an integral element. Monk, as well as Ann Halperin, Steve Paxton, and Yvonne Rainer, often worked with untrained dancers who performed task-oriented or simple motor movements in which purposeful repetition played a prominent role. Similarly, Reich, Young, and Karlheinz Stockhausen (whose work Nauman also knew) explored the relationships of duration and repetition, boredom and intensity, creating "pieces of music that are, literally, processes,"

in Reich's phrase.[23] All employed tape recorders in their work—Stockhausen to introduce new forms of tempo and discontinuity, and Reich to create new forms of pacing with both word and sound.

Nauman knew Reich's *Violin Phase* (1967), in which "one basic pattern is played simultaneously by several violinists in a variety of different phase relationships."[24] This piece, and Stockhausen's experiments with fast-paced tempi, had a particular impact on the two works of the period in which Nauman employed both music and dance: the film *Playing a Note on the Violin While I Walk around the Studio* (1967–68) and the videotape *Violin Tuned D E A D* (1969). For both of these Nauman purposely chose an instrument with which he was unfamiliar in order to "set a problem, where it wouldn't matter whether I knew how to play the violin or not. What I did [in the video] was play as fast as I could on all four strings with the violin tuned D-E-A-D."[25] The latter piece no longer simply records Nauman's activity: the work now suggests an element of fear and violence, both in the title and in the unnerving combination of sound and image.

Nauman's work of the late 1960s culminated in two installation pieces: *Six Sound Problems for Konrad Fischer* (1968), shown at the Galerie Konrad Fischer in Düsseldorf in 1968; and *Performance Corridor* (1969), included in the exhibition "Anti-Illusion: Procedures/Materials," which was held at the Whitney Museum of American Art the following year. In both cases the artist was suddenly absent from the work.

Six Sound Problems consisted of audiotapes based on six of his recent films and videotapes, which Nauman rerecorded in the Fischer Gallery and presented individually over a six-day period. As Coosje van Bruggen has noted, the gallery resembled a set for Beckett's 1958 play *Krapp's Last Tape:*

> there was nothing in the space but a chair and a table, placed off center in the room. On the top of the table was a tape recorder playing the smallest loop of sound tape. On the following day, however, a visitor would find, strung diagonally across the space, ever larger loops of sound tape, at one end threaded through the recorder head and at the other wound loosely around a pencil fastened to the chair with masking tape. Each day the chair would be located in a different spot, with the tapes eventually forming a radiating pattern.[26]

Performance Corridor began as a prop for Nauman's videotape *Walk with Contrapposto* (1968). The artist wanted to record himself walking

back and forth in a narrow space, so he constructed two freestanding walls, each 8 feet high and 20 feet long. When placed 20 inches apart with the ends abutting a wall, they formed a closed and quite narrow corridor. He remade this makeshift corridor for the Whitney, with the implicit invitation to viewers to enter and experience the cramped space. Indeed, the critic Peter Schjeldahl described *Performance Corridor* at the time as "ruthless," a "somber corridor" that induces "claustrophobic discomfort."[27]

Walk with Contrapposto, the videotape that Nauman had made in the corridor, was not included in the Whitney exhibition, but it, too, suggested the adversarial nature of space in the artist's new installations.[28] The videotape shows the artist in the guise of a prisoner, his hands clasped and implicitly bound behind his head, monotonously pacing in the tightly circumscribed corridor space. Nauman placed the camera in an elevated position, suggesting that it no longer simply recorded mundane studio activity but now acted as a surveillance device.

Surveillance would become an important theme in Nauman's work in the early 1970s, with numerous installations utilizing video equipment to record and represent the movement of visitors. For an exhibition at the Nicholas Wilder Gallery in Los Angeles in 1970, he constructed *Corridor Installation (Nick Wilder Installation),* a series of walls dividing the space into six passages, only three of which were passable. Three live video cameras were mounted at the top of the walls, and corresponding monitors offered images of empty corridors as well as of any visitors who might enter, always seen from behind. The claustrophobic effect Nauman had achieved in *Performance Corridor* was now escalated. *Los Angeles Times* critic William Wilson noted his feelings of "dread" and "invisibility," as well as the very notion of being under video surveillance, causing "the back of your neck to prickle slightly as if someone were watching."[29]

In other cases Nauman found that he could achieve equally compelling and disorienting effects by altering lighting conditions or the configuration of his spaces. In *Green-Light Corridor* (1970–71), he left both ends of the corridor open, encouraging the intrepid to traverse its entire length. Claustrophobia was nonetheless induced, both by the narrow width and exaggerated length of the corridor, and by the eerie light cast by green fluorescent tubes that ran its length. For *Yellow Room (Triangular)* (1973), Nauman flooded the triangular room with a particularly disconcerting yellow light. The shape of the room added to the discomfort: "I find triangular spaces really uncomfortable, disori-

enting kinds of spaces. There is no comfortable place to stay inside them or outside them. It is not like a circle or square that gives you security."[30]

All traces of Dadaist wit and irony, integral to the earlier work, were replaced in these audio and architectural installations by a fascination with phenomenology and behaviorism and, in particular, with Gestalt psychology and the exploration of human behavior in anxious or uncomfortable situations. In a set of "Notes and Projects" published in the December 1970 issue of *Artforum,* Nauman set out his new concerns under the heading "Withdrawal as an Art Form." By his own account, he was now experimenting with "sensory manipulation and overload" and the "denial or confusion of a Gestalt invocation of physiological defense mechanisms. Examinations of physical and psychological response to simple or even oversimplified situations which can yield clearly experiencable phenomena."[31]

Nauman's phrase "withdrawal as an art form" is indicative of this shift. While on the one hand the phrase refers to sensory deprivation, it also suggests his withdrawal as a subject of his own work. Earlier Nauman had prepared the way for his departure in four *Art Make-Up* films (1967–68), in which the artist sequentially applied different colors of makeup to his face and upper body, self-consciously masking, and even erasing, his identity.

If Nauman's work was aided to some extent by his readings in Gestalt psychology, his processes were far more intuitive, and he often found parallels in literature as well as science. Robbe-Grillet's aforementioned *Jealousy,* for example, is the story of a husband's meticulous surveillance of his wife, while his *In the Labyrinth* (1959) is filled with images of a soldier's movements through mazelike streets and interiors filled with stark and disorienting colored light. In 1970 Nauman read Elias Canetti's *Crowds and Power* (1962), a study of human behavior patterns in a variety of physical and spatial environments. As its title suggest, Canetti's book is a meditation on the profound impact that context has on behavior and the resulting implications for political and social control. By removing himself as a subject, Nauman effectively turned his work away from his personal concerns in the studio and delivered it, quite literally, into the public realm.

The changes that took place in Nauman's work of 1968–73 coincided with the artist's move to southern California in 1969 and with the widespread exhibition of his work in the United States and Europe. As noted above, his first solo exhibition in New York was at the Leo

Castelli Gallery in 1968, and he was also included in several important group shows, among them "9 at Leo Castelli," organized by Robert Morris, also in 1968; the aforementioned "Anti-Illusion: Procedures/Materials" at the Whitney in 1969; and "Information," held at the Museum of Modern Art in 1970. Interest in his work was even stronger in Europe. Following close on the heels of the 1968 Galerie Konrad Fischer show, his work was included in "Documenta 4" (1968); "When Attitudes Become Form," held at the Kunsthalle Bern in 1969; and "Op Losse Schroeven," organized by the Stedelijk Museum in Amsterdam, also in 1969. All of this activity culminated in late 1972, when an extensive survey of Nauman's work was organized by Jane Livingston and Marcia Tucker for the Los Angeles County and Whitney museums; this show toured widely in the United States and Europe.

Nauman's emergence as an important young artist yielded a flurry of opinion among artists, critics, curators, and collectors. Whereas a number of curators in Europe and the United States alike immediately gravitated toward his work, many American critics rejected him from the outset. In part, their critique stemmed from a peculiar but still pervasive denigration of California artists by New York critics. But there were seriously considered rejections as well. Typical was Robert Pincus-Witten's review of the 1968 Castelli show, in which he heaped abuse on Nauman's work with the figure ("infantile narcissism") and with language ("seeks comfort at the bosom of Rrose Sélavy").[32]

When Nauman began to involve the viewer as both subject and audience in 1972, Pincus-Witten was equally critical, dismissing these environmental pieces as "a tired idea."[33] If Pincus-Witten held a pervasively negative view of Nauman's work, at least he was engaged in his criticism. In reviewing the touring exhibition in 1973, *New York Times* critic Hilton Kramer simply dismissed the artist out of hand: "Mr. Nauman's exhibition is no easier to describe than it is to experience, for there is pathetically little here that meets the eye—a few sculptures of no sculptural interest, a few photographs of no photographic interest, a few video screens offering images that somehow manage to be both boring and repugnant."[34]

This is not to say that Nauman had no defenders among American critics: from the outset Peter Schjeldahl took note of the challenging and paradoxical nature of the work, and Marcia Tucker, two years before the touring exhibition, wrote about the importance of the artist's shift from punning self-reference toward an engagement of the viewer.[35] These assessments notwithstanding, from the beginning Nau-

man's reputation in the United States was modest in comparison to the nearly universal respect he was accorded by the European art world. The influential critic and curator Germano Celant devoted a 1970 article to Nauman;[36] there was widespread discussion of the work among European artists; and the majority of his pieces were entering European—not American—public and private collections. While Nauman's reputation among artists in the United States has fluctuated, he quickly achieved a position of lasting prominence and influence among European artists that is exceeded perhaps only by that of Joseph Beuys.

There are several reasons for this. While American critics such as Kramer rejected the antiformal nature of the artist's work, in Europe the pioneering example of Beuys and the Italian Arte Povera group (both scarcely known in the United States around 1970) created an atmosphere in which formal concerns were suspect. The collector Giuseppe Panza di Biumo touched the pulse of European taste for contemporary art at the time when, in a 1972 interview, he noted his disinterest in formalist painting with its "systematic way of working."[37] Panza, who quickly developed a definitive collection of Nauman's early works, recognized their "disturbing" nature as well as the subtlety with which they addressed "the relationship between the perceiver and the environment, the reality around man, and his reaction to this reality."[38]

Nauman's antiformalism was embraced in Europe, as were the presence of the artist and his ideas, which were not considered narcissistic there. Whereas American critics such as Pincus-Witten found fault with Nauman's employment of his own body as a vehicle for his ideas, in Europe Nauman's admitted early debt to Man Ray, Duchamp, and Johns was of secondary concern to the manner in which he transformed the Dada tradition in his work with neon, film, and video. Indeed, Nauman's use of alternative media held greater interest in Europe than did his early sculpture. If post–World War II Europe has been generally suspicious of charismatic politicians, it often has embraced artists such as Beuys. While Beuys's dynamic personal presence was indistinguishable from his work throughout his career, Nauman's early work with his body, signature, and recorded presence also found a ready audience. And yet, the shift away from using his own body that occurred around 1970 resulted in a much more discrete profile for the artist in both Europe and America in succeeding years.

Ironically, just when Nauman had shifted his attention from generalized private concerns to more public issues, the artist found *himself* beneath the microscopic lens of art world attention, much of it critical.

An intensely private man, he suffered from the exposure that the round of exhibitions, especially the 1972 Los Angeles County–Whitney show, brought him. In retrospect, he feels

> it made it really difficult to go back to work and led to the longest dry spell I've ever had. That was pretty frightening. I guess I was inhibited by the fact that I felt expectations around my work were so high; plus I think that show made me examine my work in a way that probably wasn't good for me.[39]

Having produced a flood of work between 1966 and 1972, Nauman reduced his output to a trickle through the mid-1970s. A tenuous balance now developed between the understatement of the corridors and rooms, and a voice, plaintive and angry by turn, that was discernible in the language Nauman used in his prints, drawings, and neons. Phrases such as "Please/Pay Attention/Please" and "Placate My Art" found their way into the work, as the artist vented feelings of frustration and anger. On several occasions he wrote lengthy texts to accompany and elucidate his exceedingly subtle sculptural installations.

Consummate Mask of Rock (1975) is perhaps the most important of these installations. Consisting of eight pairs of sandstone blocks with one block in each pair slightly larger than the other, the installation produced an unusual sense of dislocation in which the floor no longer seemed flat. Both Man Ray's *Rebus* (1938) and Robert Morris's *Voice* (1974) also consist of ground planes filled with stonelike forms. The subtly disconcerting spatial perceptions that are central to all three works are, in Nauman's case, however, almost secondary to his emotionally loaded text for the installation. Here, for the first time, he employed references to a children's game—"rock/paper/scissors"—and crafted his words to the cadence of the nursery rhyme "The House That Jack Built."

These games and rhymes, in Nauman's hands, are transformed into elaborate, meandering exercises in veiled revelation. In *Consummate Mask of Rock,* one section of the text begins:

1. This is my mask of fidelity to truth and life.

2. This is to cover the mask of pain and desire.

3. This is to mask the cover of need for human companionship.

and concludes:

16. This is the distortion of truth masked by my painful need.

17. This is the mask of my painful need distressed by truth and human companionship.

18. This is my painless mask that fails to touch my face but floats before the surface of my skin my eyes my teeth my tongue.

19. Desire is my mask.
 (Musk of desire)

20. Rescind desire
 cover revoked
 desire revoked
 cover rescinded

21. PEOPLE DIE OF EXPOSURE

Nauman's difficulty here, and in other, similar works of the mid-1970s, was one of integrating such compelling words with his much more opaque sculptural objects.[40] In several of these language-aided installations of the mid-1970s, we sense that the environments functioned in part as masks to conceal words and feelings. Nauman had made the mask a subject of his work previously, in his *Art Make-Up* films of 1967–68, for example; and yet *Consummate Mask of Rock* bears none of the direct, quite physical "masking" of the earlier piece. In the work of the 1970s, he often created a tenuous balance between expression and concealment. As he would state in 1979: "Whenever I give a public presentation of something I did in the studio, I go through an incredible amount of self-exposure which can function, paradoxically, as a defense. I will tell you about myself by giving a show, but I will only tell you so much."[41] In fact, language was Nauman's most powerful and sustaining medium at the time, representative of a body of thought too potent and personal to be integrated effectively into the corridors or room environments. Although he had previously employed short, emphatic phrases such as "Raw War" or "Eat Death" in his neons, their brevity suggested public slogans rather than the private narrative implied above. Ultimately, if the absence of his physical presence in the work of the early and mid-1970s made this the artist's most difficult body of work to date, his disembodied voice was, nonetheless, never absent.

As Nauman struggled to integrate his voice into his work, he also sought—throughout the mid-1970s—a sculptural form that might amplify it in a more directly public way. Whereas the corridors and

room installations traced individual behavior, Nauman now conceived works that "were really about a certain kind of frustration and anger—creating uncomfortable spaces and shapes even on a very large scale for lots and lots of people."[42] These included *Double Steel Cage* (1974), a 7-foot-high steel-fence prison, as well as models for fantastic underground shafts and trenches. Although he had made drawings for these latter structures as early as 1972, the first "model tunnel" sculpture, *Model for Trench and Four Buried Passages,* was not made until 1977.[43] While the piece is quite large—more than 30 feet in diameter—Nauman nonetheless considered it a "model" for something much larger. In fact, he used this subliminal tension between the size of the piece itself and the scale of the ideal conception as a psychological tool:

> The information about scale gives you two kinds of information: visual and physical information as well as the intellectual information which indicates that the sculpture is only a model. Immediately you begin to imagine what it would be like and how you would respond to it at the proper scale.[44]

Nauman began to construct paradoxical physical relationships in order not to lay bare the work. By withholding information, or by introducing a contradiction as he does here, he at once enriches the work and demands a more complex response from the viewer.

If the discrepancy between physical fact and imaginative possibility served Nauman as a point of creative tension, so, too, is his manner of making the works. Because he wanted the "model tunnels" to be without place—possibly buried, conceivably floating in an indeterminate space—Nauman developed new methods of construction and presentation. The model tunnels, in fact, do everything except sit securely on the ground: some are lifted inches off the floor by small blocks of scrap wood, some hang by wire from the ceiling, and some are both raised and hung, as is the case with *Model for Trench and Four Buried Passages.* All of the model tunnels are constructed roughly of plaster, wood, wire, glue, and any other material that Nauman had in the studio, and all are thrown together as if to suggest that they are, in fact, models and not finished works.

Nauman's unorthodox sculptural methods and his inventiveness with scrap materials are both conspicuous here. Often direct in revealing his processes and then in employing descriptions of these as titles, he called one of these sculptures *Model for Tunnel Made Up of Leftover Parts of Other Projects* (1979–80). Surviving from his studio is a maquette for another, similar work, *Model for Underground Tunnel* (1981), in

which the artist simulated the hollow tunnels by tying and taping together discarded mailing tubes, paper-towel rolls, and various packing materials.

Here Nauman's studio methods bear an uncanny resemblance to those employed by Pablo Picasso decades earlier. His inventiveness with cast-off materials suggests Picasso's own dexterity as a sculptor throughout his career. In fact, Nauman's cardboard, wall-mounted *Model for Underground Tunnel,* with its allusion to head, arms, and torso, recalls nothing so much as Picasso's assemblages. *Figure* (1935), for example, is a remarkable sculpture in which wood, string, a ladle, and two rakes are tied together, literally, and transformed into a rugged figurative presence.

Rugged construction and industrial materials occupied Nauman in the late 1970s, as did the possibility of composing a sculpture entirely of suspended elements. In contrast to Alexander Calder, whose mobiles are characterized by their playfulness and grace, Nauman's hanging sculptures are deliberately heavy-handed and refer to the world outside the studio. They are infused with metaphor, dominated as they are by inverted chairs, which serve as explicit surrogates for human victims. Although Nauman had worked previously with the chair as an abstract form—in particular, in *A Cast of the Space under My Chair* (1965–68), which was built exactly as the title suggests—he now had in mind images of electric chairs or chairs in which suspects are seated while being interrogated. "I thought of using a chair that would somehow become the figure: torturing a chair and hanging it up or strapping it down."[45]

In order to demarcate a space for the suspended chair, Nauman made a triangle of three steel I-beams and then hung the overturned chair within the surrounding triangle roughly at eye level. *South America Triangle* (1981) was the first of several "suspended chair" sculptures, and within a year he made two other works, similar in title, form, and content—*South America Square* and *South America Circle* (both 1981)—as well as variations on the theme, among them: *Diamond Africa with Chair Tuned D E A D* (1981), a reprise of the video *Violin Tuned D E A D,* now with the legs of the chair (and not the strings of the violin) tuned to these notes; and later, *Musical Chairs: Studio Version* (1983), a thoroughly slapdash construction of scavenged materials involving three chairs, a circle, and a triangle—yet one of his most compelling sculptures.

The political implications of Nauman's work now came to the fore as these sculptures provided an unmistakable critique of totalitarian

regimes in South America and of apartheid in South Africa. Just as his sculpture had become more explicitly political, so had his reading habits. In the late 1970s, when he made the model tunnel sculptures, he found support in books such as Beckett's *The Lost Ones* (1971), which describes, as Nauman put it, "a large number of people in a very strange, very accurately and clearly described space. . . . A greenish yellow light, circular space with no top to it. . . . When I read this, a very powerful connection to a lot of the work I had done before encouraged me in the direction of the 'tunnels' and the kind of oblique comment they make on society."[46]

The evocative, existential Beckett was supplanted, around 1980, by nonfiction accounts of contemporary oppression and terrorism. "I was reading V. S. Naipaul's stories about South America and Central America, including 'The Return of Eva Peron' and especially 'The Killings in Trinidad.' . . . Reading Naipaul clarified things for me and helped me to continue. It helped me to name names, to name things."[47] The other influential book was the Argentine newspaper publisher Jacobo Timerman's *Prisoner without a Name, Cell without a Number* (1981), the writer's autobiographical account of his 1977 imprisonment and torture at the hands of the Argentine military. While the book is replete with wrenching descriptions of the author strapped in a chair and tortured with electric shocks, equally important for Nauman was Timerman's indictment of the malicious use of language in the service of political control and repression.[48]

Given the directness of Nauman's sculpture in the early 1980s, it is hardly surprising that his use of language evolved correspondingly. He now made his first important neons in nearly a decade, among them, *American Violence* and *Violins Violence Silence* (both 1981–82). Whereas the earlier neons were simpler in form and content, Nauman now employed far more provocative and complex language patterns, as well as a blinding array of color and programming effects. Words appear suddenly and surprisingly—in the shape of a swastika in *American Violence* and read backward as well as forward in *Violins Violence Silence*. While muted mechanical sounds characterize the earlier neons, these pieces buzz and hiss, underscoring the reference to violins and silence, as well as to violence. Nauman had been attracted to neon in part because of advertising signs he had seen in the 1960s: in 1984 he made a billboard-size neon. *One Hundred Live and Die* consists of four nearly 10-foot-high columns of sequentially changing words relating to life and death. Comprising a staggering barrage of color and light, the words are by

turns poetic and vulgar, representing an encyclopedia of human expression and activity.

By the early 1980s, the dry spell that Nauman had undergone in the early and mid-1970s had definitely ended: the understated corridor pieces and text-driven installations were now exchanged for neons and sculptures that were aggressive in form and more obviously narrative in content. Whereas the work of a decade earlier was often perceived to be too elliptical, particularly for an American public, the early 1980s work was simply too dynamic to ignore. Nauman had no fewer than six solo exhibitions in museums and galleries in the United States and Europe from 1982 to 1984, and the breadth of their subject matter and visual effect attracted a new audience.[49] The early 1980s were the heyday of neo-expressionism—a time dominated by enormous paintings bearing images derived from earlier art as well as popular culture. Although Nauman was never considered a neo-expressionist, the heightened theatricality and political reference of his new neons and "suspended chair" sculptures seemed to parallel prevailing taste; and American collectors, in particular, now sought to acquire the work.

While this sudden popularity produced greater public awareness and increased sales, ironically, within the context of Nauman's development, it often yielded a misunderstanding of the work. For if his works of 1981–84 possess the same large scale and theatrical presentation of neo-expressionist painting and sculpture, their plainspokenness masks a deeper layer of paradox and contradiction. One need only look again at the South American and South Africa sculptures, with their references to "tuned chair legs," and to the children's rhymes and "musical chairs" games to sense the idiosyncrasy of Nauman's enterprise. Peter Schjeldahl put it best when he described this gap between idea and object in Nauman's work: "The idea will not mesh with the physical facts. The objects, allusions, and real and implied spaces cling to their separate orders of experience. One yearns to resolve them in vain.[50]

This is not to cast doubt on the sincerity of Nauman's political commitment, which since the late 1970s has often been expressed quite directly in both his work and his published interviews. However, his rather unsettling detachment and compulsion for paradox remain firmly in place. Perhaps because of the low point his career reached around 1974, he developed a distrust of simple solutions to complex issues. Perhaps his move to New Mexico in 1979—where he still lives self-consciously apart from the art world—allowed Nauman to make his unique form of political work in the early 1980s, a decidedly non-

political moment in American history. Whatever the case, despite the renewed interest in his work at this time, Bruce Nauman continued to stand apart.

Since 1984, Nauman has pursued a wide variety of social themes. And yet, rather than "naming names" as he had done in the South America and South Africa sculptures, he has now developed a more universal commentary. Continuing to invent new means for presenting ideas, he also has revisited a number of options explored previously—a working method that is possible because, like Duchamp, Nauman, throughout his career, has addressed ideas without exhausting them.

In 1988, for example, after a hiatus of nearly two decades, Nauman resumed his work with cast objects. Rather than casting abstract spaces or human forms, however, he now turned to ready-made molds—taxidermy forms used in molding stuffed animals. He found these strangely unnatural, featureless polyurethane foam models—including deer, wolf, bear, fox, and others—in a taxidermy shop in New Mexico and developed several ways to incorporate them into his work. Returning to a formal device he had used previously, he suspended the animal forms in midair. In *Carousel* (1988), Nauman employed a mechanical device to rotate the hanging animals. While the piece is reminiscent of a merry-go-round, he intended that the animals drag across the floor, thereby calling forth a more visceral allusion to a slaughterhouse. Following *Carousel*, Nauman pressed the animal molds in two distinct directions. On the one hand, he was interested in them sculpturally and used them as raw anatomical material, dismembering and reassembling them, often in violent defiance of anatomical correctness, as in *Untitled (Two Wolves, Two Deer)* (1989). More traditionally, he used them as ready-made maquettes, as in *Animal Pyramid* (foam version) (1990), the full-scale sculpture of which was commissioned and installed outdoors by the Des Moines Art Center.

Pursuing the idea of anatomical casting even further, Nauman made several "suspended head" sculptures in which wax heads cast from life supplanted the chairs and animals and were suspended plaintively from wires. While such works as *Ten Heads Circle/Up and Down* (1990) might be seen as evidence of Nauman returning to a traditional sculptural idiom, he also included the cast heads and animals in other, recomplicated installations. For example, in *Hanging Carousel (George Skins a Fox)* (1988), he included a video monitor as an additional suspended, rotating element. With the video we see—and, above all, hear—a hunter methodically skin a fox, a process that is simultaneously

mundane and grotesque and which evokes the daily labor of butchers as much as it does the many art-historical representations of the flaying of Marsayas.

Equally compelling as the multivalent content of the work is Nauman's integration of video monitors and sculpture. Video had been conspicuously absent from his work from 1973 until 1985, when he returned to it as perhaps his principal medium, especially as a component of his sculptural installations.[51] The first of these more recent videos is *Good Boy Bad Boy,* which Nauman made in 1985 as part of a three-room installation at the Museum Haus Esters in Krefeld, Germany, which has come to be known as *Chambres d'Amis (Krefeld Piece).* The *Good Boy Bad Boy* room was bare except for two monitors mounted at head height on pedestals. Seen on each was the frontal view of an actor—a black man on one, a white woman on the other—reciting one hundred phrases, which, like those in the neon *One Hundred Live and Die,* admit no ambiguity: "I am a good boy; You are a good boy; We are good boys," and so on. Superficially, the monotonous repetition suggests grammar-school recitation; and yet the onslaught of two competing voices repeating the same cycle of phrases five times each suggests indoctrination rather than education. Added to this is the eye contact that the actors make with us and the steadily increasing intensity of their delivery throughout the course of the videos. The woman becomes more agitated than the man, taking longer to complete the task. This throws the performance out of synchronization, and in the process creates an effect that recalls the phased pacing in the music of Steve Reich.[52]

The aural intensity of the piece carries over into the two adjacent rooms of *Chambres d'Amis:* in one we hear—emanating from a separate audiotape played in an otherwise vacant adjoining room—the phrases from *One Hundred Live and Die* repeated in a fiendishly paced, singsong manner, and in the other we see Nauman's installation of his first full-figure neon, *Hanged Man* (1985). This last derives from the children's game in which incorrectly spelled words result in the delineation of a stick figure who ultimately dies by hanging. Nauman's customary transformation of a children's game into an object of tension is exacerbated here by the erection that appears when the man is finally hung, an apparent allusion to Beckett's *Waiting for Godot* (1954), in which the characters Vladimir and Estragon discuss such matters while contemplating suicide.[53]

Aggressive, mean-spirited games and language that escalate to vio-

lence characterize the video installation *Violent Incident* (1986) as well. Here the subject of the videotapes is domestic violence: in a contrived domestic setting, a clumsy joke transforms a romantic dinner into violent conflict. As a couple seat themselves, the man pulls the chair away, causing the woman to fall. They exchange insults, and the situation quickly turns from angry words to violent action as they struggle for a knife. The pace, as well as Nauman's direction of the text and actors, is critical. As he describes it: "Now this action takes all of about eighteen seconds. But then it's repeated three more times: the man and woman exchange roles, then the scene is played by two men and then by two women. The images are aggressive, the characters are physically aggressive, the language is abusive."[54] Following on *Good Boy Bad Boy*, with its implications for racial as well as gender conflict, *Violent Incident* concentrates on the latter, specifically, the shifting roles of men and women and the escalation of aggressive words to violent action. The effect is multiplied by the presentation of these actions in four different videotape versions on twelve monitors (three rows of four). Besides staggering the pacing, Nauman introduces dramatic changes in color, slow motion, and, in an interesting reprise of his early cast-fiberglass sculptures (in which remnants of the process remain visible in the completed piece), he even includes preliminary rehearsals in the finished work.

While Nauman introduced numerous variations into these new videotapes, for the moment he maintained a traditional mode of presentation with the monitors either mounted on or placed against a single wall. In 1987 he began to place the monitors on three sides of a room, adding a sculptural component and making his installations still more compelling. The breakthrough work here is the installation *Clown Torture* (1987). On entering an enclosed room we encounter videotapes projected in large scale directly onto the two lateral walls, as well as two pairs of stacked monitors placed frontally on pedestals. Only two of the four monitors are correctly oriented: one is upside-down, one is turned on its side. The large-scale projected images are similarly displaced and therefore disorienting to the viewer. The five sequences—*Clown Taking a Shit; Pete and Repeat; No, No, No, No; Clown with Goldfish Bowl;* and *Clown with Water Bucket*—play simultaneously and create a cacophony of image and sound emanating from three sides of the room. The content replays a number of characteristic Nauman themes: surveillance (one observes a clown using a public toilet); untenable physical situations (clowns unable to balance goldfish

bowls and buckets of water); torture and interrogation (a clown repeatedly screaming "no" under the threat of an unseen antagonist); and absurd word games (a clown repeating the story: "Pete and Repeat were sitting on a face, Pete fell off: who was left? Repeat. Pete and Repeat were sitting on a fence . . .").

For Nauman—who had masked his own likeness in his *Art Make-Up* films of 1967–68—the clown provided a step beyond the artifice of actors. Although we expect humorous behavior from clowns, Nauman emphasizes that vaudeville and circus clowns often behave cruelly, with their costumes lending them a necessary shield of anonymity and providing an additional level of unreality for the viewer. Although he did incorporate several different costumes—"the Emmett Kelly dumb clown; the old French Baroque clown; one is a sort of traditional polka-dot, red-haired, oversize shoed clown; and one is a jester"[55]—as historical references, this did not differentiate them. The range and tempo of the different videos—as in a circus where actions take place on many levels simultaneously—is simply too fast-paced and continuous, making them all but impossible for the viewer to follow. Whereas Nauman's early corridor and room installations had been discomforting due to the deprivation of sensory information, *Clown Torture* overloads the senses, making it difficult to remain for long in the installation. This is not merely a matter of the sheer bombardment of sounds and rush of images: the combination of violence and innocence, of absurd situations and behavior, leaves the visitor thoroughly unnerved.

In more recent installations, Nauman has explored new ways to integrate video and sculptural elements while continuing to renew themes from previous work. The focus of *Learned Helplessness in Rats (Rock and Roll Drummer)* (1998) is a yellow Plexiglas maze placed in the center of a darkened room with video images projected on the wall. These projections alternate between a rat coursing through the maze and an untutored rock drummer pounding away on a set of drums. (His amateurish efforts remind us that Nauman was a musician as a youth, and that he had played the violin in his early videotapes.)

In a related work, *Rats and Bats (Learned Helplessness in Rats II)* (1988), Nauman retained the maze and the videotaped images of the rat but now replaced the drummer with a man noisily beating the unknown contents of a duffle bag with a bat. A third segment is included as well: images of the viewer standing in the space as filmed by a panning closed-circuit camera. In order to disorient the rats while making the videotapes for both works, Nauman had directed monitors bearing

these images at the Plexiglas maze. He had similarly bewildered visitors to the Wilder *Corridor Installation* by the disparity between what was seen on the video monitors and what was actually experienced in the corridor. In both cases, either human or animal was made "helpless" by the experience.[56]

The intensity of these recent video installations is pressed further still in *Shadow Puppets and Instructed Mime* (1990). In a darkened room, Nauman installed a wide array of video equipment, creating a futuristic minefield of technological hardware. The room is dominated by two impressions. One is of cast-wax heads, which hang in three corners of the room and are also seen in video projections on sheets of linen hanging nearby. Whereas in previous works he hung the heads motionless, in these video images he now shows them rotating and being beaten.[57] The second set of impressions derives from video images of a mime, who is compelled by a loud, authoritative voice to assume a series of convoluted positions—many of them in relation to a chair. Silently, sadly, she attempts to comply. The poses she strikes and holds seem a powerful allusion to Nauman's own first performances as a student, the series of twenty-eight unorthodox postures that he later recorded in the videotape *Wall-Floor Positions*. The inclusion of the chair as an illusionistic prop enriches the relationship to earlier works, whose suspended chairs had served as surrogate figures. The mime now, however, acts as an apt and quite helpless victim. Beyond these references to previous works, the informal arrangement of *Shadow Puppets and Instructed Mime* suggests the artist's studio: everywhere we see projectors and monitors resting atop the packing boxes in which they had been transported. Electrical tape holds wiring in place, and we walk timidly through it all as though we are trespassing in the artist's darkened studio.

Yet while Nauman here creates what may be the ultimate process sculpture by recreating the immediacy, as well as the confusion, of various works simultaneously in progress in the studio, we sense something more bleak, more profound. Throughout the recent video installations—beginning with *Clown Torture* and continuing through *Shadow Puppets and Instructed Mime*—there is a visceral sense of foreboding. Because he places the monitors and other objects in our space—indeed, in our path—the images we see and the sounds we hear are inescapably frightening. Particularly in the case of *Shadow Puppets,* the utter darkness of the room, the eerie images emanating from the floor, walls, and corners, all press us well beyond the boundaries of stat-

ic, two- and three-dimensional art. Seldom in the history of art has the experience of looking at objects and images in public been so fraught with challenge and emotion. At this point the multipart installation begs comparison directly with film and theater. We recall Nauman's model tunnels and the artist's suggestion that we visualize the gargantuan yet claustrophobic spaces at inhabitable scale. We no longer need project ourselves intellectually into these "model tunnels"; we now inhabit this Beckett-like world ourselves.

Notes

I am indebted to Nancy Owen for her research assistance, and to Barbara Bradley, Kathy Halbreich, Maria Makela, and, in particular, Joan Simon and Bruce Nauman, for their careful readings of this essay.

1. Nauman in Coosje van Bruggen, *Bruce Nauman* (New York: Rizzoli, 1988), p. 14. In 1966 Nauman saw and was impressed by a Man Ray retrospective organized by the Los Angeles County Museum of Art.

2. Nauman in Ian Wallace and Russell Keziere, "Bruce Nauman Interviewed." *Vanguard* (Canada) 8, no. 1 (February 1979): 16.

3. Nauman in conversation with the author, September 30, 1991. See also Joan Simon, "Breaking the Silence: An Interview with Bruce Nauman." *Art in America* 76, no. 9 (September 1988): 143.

4. Nauman in Simon, "Breaking the Silence," p. 143.

5. Nauman in Joe Raffaele and Elizabeth Baker, "The Way-Out West: Interviews with 4 San Francisco Artists." *ARTnews* 66, no. 4 (Summer 1967): 75.

6. Nauman in Bruggen, *Bruce Nauman*, p. 8.

7. Ibid.

8. Ibid., p. 7. For Nauman's relationship to the Davis environment, see Thomas Albright, *Art in the San Francisco Bay Area, 1945–1980* (Berkeley: University of California Press, 1985), p. 120; Brenda Richardson, "I Am My Own Enigma," in *William T. Wiley*, exh. cat. (Berkeley: University Art Museum, University of California, 1971), p. 10; and Neal Benezra, "Empowering Space: Notes on the Sculpture of Bruce Nauman," in *Affinities and Intuitions: The Gerald S. Elliott Collection of Contemporary Art*, exh. cat. (Chicago: Art Institute of Chicago, and New York: Thames and Hudson, 1990), pp. 58–61.

9. This discussion owes to Joan Simon who, in the course of her research on Nauman, has recognized the important role of color in his work. While color plays an obvious role in his neons, its importance has been much less apparent in the work in other media. In large part this can be explained by the fact that Nauman's work is often large and difficult to install: for that reason good color photography is often lacking, with black-and-white photographs dating to the moment the work was completed in the studio serving as the only record.

10. Nauman in Willoughby Sharp, "Nauman Interview." *Arts Magazine* 44, no. 5 (March 1970): 26.

11. To some extent, Nauman was influenced here by Jasper Johns, whom he considered "the first artist to put some intellectual distance between himself and his physical activity of making paintings." See Bruggen, *Bruce Nauman,* p. 23. It is noteworthy that several minimalist sculptors, in particular Donald Judd, have not titled their sculptures; Nauman may have opted for lengthy, descriptive titles as part of his reaction against formalism.

12. Nauman in Bruggen, *Bruce Nauman,* p. 9. See also Nauman's comments in Jane Livingston, "Bruce Nauman," in Jane Livingston and Marcia Tucker, *Bruce Nauman: Work from 1965 to 1972,* exh. cat. (Los Angeles County Museum of Art, 1972), p. 13.

13. Nauman in conversation with the author and Kathy Halbreich, November 3, 1992.

14. The passage is: "'A newborn child has no teeth'—'A goose has no teeth'—'A rose has no teeth'—This last at any rate—one would like to say—is obviously true! It is even surer than that a goose has none—And yet it is none so clear. For where should a rose's teeth have been?" (Ludwig Wittgenstein, *Philosophical Investigations,* trans. G. E. M. Anscombe [1953: repr. New York: Macmillan, 1958], p. 221e).

15. Nauman in Wallace and Keziere, "Nauman Interviewed," p. 18. Early in his career, Johns came to a similar realization: "Before, whenever anybody asked me what I did, I said I was going to become an artist. Finally, I decided that I could be going to become an artist forever, all my life. I decided to stop *becoming,* and *to be* an artist" (Michael Crichton, *Jasper Johns* [New York: Harry N. Abrams, 1977], p. 27).

16. Nauman in Jan Butterfield, "Bruce Nauman: The Center of Yourself." *Arts Magazine* 49, no. 6 (February 1975): 55.

17. Nauman in conversation with the author and Kathy Halbreich, November 3, 1992. See also Brenda Richardson, "Bruce Nauman: Neons," in idem, *Bruce Nauman: Neons,* exh. cat. (Baltimore Museum of Art, 1982), pp. 19–20; and Bruggen, *Bruce Nauman,* pp. 15–16.

18. The composition of *Window or Wall Sign* recalls *Anemic Cinema,* the film made by Duchamp, with the assistance of Man Ray and Marc Allégret, in 1925–26, in which punning phrases were displayed in a spiral format.

19. Nauman in conversation with the author and Kathy Halbreich, November 3, 1992. Nauman was still an undergraduate at the University of Wisconsin at the time of the major Duchamp retrospective organized by the Pasadena Art Museum in 1963, and most of the major English-language publications on the artist did not appear until the early 1970s.

20. In valuing the activity rather than the product, Nauman here approaches Fluxus attitudes toward art. See La Monte Young, ed., *An Anthology* (New York: La Monte Young and Jackson MacLow, 1963), which included De Maria's theory of "meaningless work." In addition, see Michael Kirby, "The

Activity: A New Art Form," in *The Art of Time: Essays on the Avant-Garde* (New York: E. P. Dutton, 1969), pp. 153–70.

21. Nauman in Willoughby Sharp, "Bruce Nauman." *Avalanche*, no. 2 (Winter 1971): 27.

22. Nauman in Bruggen, *Bruce Nauman*, p. 18. Nauman read *Jealousy* and *In the Labyrinth* in 1967, and he discusses Robbe-Grillet in Butterfield, "The Center of Yourself," p. 55. See also Bruggen, *Bruce Nauman*, p. 112, and Livingston, "Bruce Nauman," p. 24.

23. Quoted in Thomas DeLio, "Avant-Garde Issues in Seventies Music," in Gregory Battcock, ed., *Breaking the Sound Barrier: A Critical Anthology of the New Music* (New York: E. P. Dutton, 1981), p. 257. Reich's use of tape recorders to create "phased" pacing, as well as sound that hovers between music and speech, has been particularly important throughout Nauman's career. See Emily Wasserman, "An Interview with Composer Steve Reich." *Artforum* 10, no. 9 (May 1972): 44–48. For Nauman's comments on music, performance, and dance, see Sharp, "Bruce Nauman."

24. DeLio, "Avant-Garde Issues," p. 261.

25. Nauman in Sharp, "Bruce Nauman," p. 29.

26. Bruggen, *Bruce Nauman*, p. 233. *Six Sound Problems* bears comparison with Robert Ashley's *Chair* (1963), in which the artist provided a set of instructions for the alteration of a chair to be carried out over a period of six days. See Kirby, "The Activity," p. 159. In effectively making sound visible, Nauman here approaches Fluxus attitudes both in regard to intermedial work and to the idea of placing the viewer at the center of the process of making. See Peter Frank, "Fluxus Music," in Battcock, ed., *Breaking the Sound Barrier*, pp. 13–19.

27. Peter Schjeldahl, "New York Letter," *Art International* 13, no. 7 (September 1969): 71. During the course of the "Anti-Illusion" exhibition, Bruce Nauman, Judy Nauman (his wife at the time), and Meredith Monk staged a performance, Nauman's last to date. See Sharp, "Bruce Nauman," pp. 25–26.

28. The term *adversary* was used by Carter Ratcliff to describe a number of works included in "Documenta 5" (1972), among them, Nauman's *Kassel Corridor: Elliptical Space* (1972). See Carter Ratcliff, "Adversary Spaces." *Artforum* 11, no. 2 (October 1972): 42–44.

29. William Wilson, "Bruce Nauman's Unsettling Art Given a Masterful Touch." *Los Angeles Times*, March 23, 1970, sec. 4, p. 6.

30. Nauman in Simon, "Breaking the Silence," p. 147.

31. Bruce Nauman, "Notes and Projects." *Artforum* 9, no. 4 (December 1970): 44. He had read *Gestalt Therapy: Excitement and Growth in the Human Personality* by Frederick Perls, Ralph F. Hefferline, and Paul Goodman (New York: Delta, 1951) in 1968, and although the films and videotapes he made at the time reveal an awareness of Gestalt, around 1970 the artist began to con-

centrate on behavioral observation almost exclusively. See also Nauman's comments in Livingston, "Bruce Nauman," pp. 16, 21.

32. Robert Pincus-Witten, "Bruce Nauman: Leo Castelli Gallery." *Artforum* 6, no. 8 (April 1968): 63.

33. Idem, "Bruce Nauman: Another Kind of Reasoning." *Artforum* 10, no. 6 (February 1972): 31.

34. Hilton Kramer, "In Footsteps of Duchamp." *New York Times,* March 30, 1973, p. 28.

35. Marcia Tucker, "PheNAUMANology." *Artforum* 9, no. 4 (December 1970): 38–44.

36. Germano Celant, "Bruce Nauman." *Casabella* (Italy) 345, no. 34 (February 1970): 38–41.

37. Bruce Kurtz, "Interview with Giuseppe Panza di Biumo." *Arts Magazine* 46, no. 5 (March 1972): 42.

38. Ibid.

39. Nauman in Kristine McKenna, "Bruce Nauman: Dan Weinberg Gallery." *Los Angeles Times,* January 27, 1991. "Calendar," pp. 4, 84.

40. Nauman originally entitled this work *The Mask to Cover the Need for Human Companionship,* prior to its first installation at the Albright-Knox Art Gallery, Buffalo, New York, in 1975. Other works in this vein are *Flayed Earth, Flayed Self: Skin Sink* (1974) and *Cones Cojones* (1973–75). See Bruggen, *Bruce Nauman,* pp. 193–96.

41. Nauman in Wallace and Keziere, "Nauman Interviewed," p. 16.

42. Nauman in Bob Smith, "Bruce Nauman Interview," *Journal* 4, no. 2 (32) (published by Los Angeles Institute of Contemporary Art) (Spring 1982): 36.

43. See *Bruce Nauman: Drawings 1965–1986,* exh. cat. (Basel: Kunstmuseum Basel and Museum für Gegenwartskunst, 1986), cat. nos. 260–264.

44. Nauman in Wallace and Keziere, "Nauman Interviewed," p. 16.

45. Nauman in Simon, "Breaking the Silence," p. 147. In this interview, Nauman discusses the implications of the chair in some detail, making reference to the Shaker practice of hanging chairs on walls and to Joseph Beuys's *Fat Chair* (1964). Numerous artists have employed chairs in their work, notably, Robert Rauschenberg, *Pilgrim* (1960), and Jasper Johns, *According to What* (1964).

46. Nauman in Smith, "Nauman Interview," p. 36.

47. Nauman in Simon, "Breaking the Silence," p. 147.

48. Timerman's book includes numerous references that have importance for Nauman's work. The writer rails against the irresponsible public use of language ("Newspapers write virtually in code, resorting to euphemisms and circumlocutions, speaking in a roundabout way, as do leaders, politicians and intellectuals") and cites a number of Peronist slogans ("Violence from above engenders violence from below"), the meanings of which are intentionally ambiguous. In addition, he analyzes the dynamics of torture and interrogation in

considerable detail ("The police . . . have orders from their superiors to shout all the time in order to intimidate and confuse prisoners. Therefore, whenever they talk, they shout, which adds to the puzzle."). See Jacobo Timerman, *Prisoner without a Name, Cell without a Number* (New York: Vintage Books, 1981), pp. 23, 24, 83, respectively.

49. In addition to being the focus of gallery exhibitions, Nauman's neons were the subject of an exhibition organized by Brenda Richardson for the Baltimore Museum of Art in 1982. In conjunction with that exhibition, an enlarged, horizontal version of *Violins Violence Silence* was commissioned for the facade of the Baltimore museum and was later acquired by the institution.

50. Peter Schjeldahl, "Profoundly Practical Jokes: The Art of Bruce Nauman." *Vanity Fair* 46, no. 3 (May 1983): 93.

51. In 1973 Nauman made the videotapes *Elke Allowing the Floor to Rise Up over Her, Face Up* and *Tony Sinking into the Floor, Face Up and Face Down.* These were the first instances in which Nauman employed actors, a practice that became common when he returned to the medium in 1985.

52. For Nauman's comments on *Good Boy Bad Boy,* see Chris Dercon, "Keep Taking It Apart: A Conversation with Bruce Nauman." *Parkett* 10 (1986): 54–61.

53. Simon, "Breaking the Silence," p. 147.

54. Nauman in ibid., p. 148. See also Dercon, "Keep Taking It Apart."

55. Ibid., p. 203.

56. Nauman has disclosed that the phrase "learned helplessness in rats" derived from an article that he had read in *Scientific American.* The article is E. Collins, "Stressed Out: Learned Helplessness in Rats Sheds Light on Human Depression." *Scientific American* 257, no. 5 (November 1987): 30. See Antje von Graevenitz, "Geloof en twijfel in het werk van Christo en Bruce Nauman: Rituele aspecten in het existentialistisch perspectief." *Archis. Maanblad vor Architectuur, Sledebouw. Beeldende Kunst* (the Netherlands) 6 (June 1990): 28.

57. Nauman recalls the source of this image in V. S. Naipaul's *Among the Believers* (1981), in which the author describes executions being carried out in an unusual manner. "When they executed someone, they hung a cloth up and lit a fire behind it. They placed the victim between the fire and the cloth so that his or her shadow fell on the cloth. Then they shot at the shadow, whereby the person behind it was naturally shot, too." See Jorg Zütter, "Human Nature, Animal Nature: Videoinstallationen und Skulpturen von 1985–1990," in *Bruce Nauman: Skulpturen und Installationen 1985–1990,* exh. cat. (Basel: Museum für Gegenwartskunst, in association with DuMont Buchverlag, Cologne, 1990), pp. 71–72.

Arthur C. Danto

Bruce Nauman

Ludwig Wittgenstein began to talk about "language games" in the late 1930s, and conceived of these as very primitive forms of language that went with correspondingly elementary forms of life. Wittgenstein conjectured that these games "are the forms of language with which a child begins to make use of words," but he meant to use them as tools for analyzing what goes on when we engage in linguistic interchange: "When we look at such simple forms of language, the mental mist which seems to surround our ordinary use of language disappears." In *Philosophical Investigations,* he offers an example of a language game used to serve for communication between a builder, A, and an assistant, B. They use a language consisting only of the words "block," "pillar," "slab," and "beam." Here is play: A says "Slab" and B brings a slab. So in addition to a vocabulary, the game consists in commands—clearly "Slab" here means "Bring me a slab"—and compliances, which are nonvocal. Bringing a slab is as much a move in the language game as uttering the word "slab." Hence the language game is made up of words and actions.[1]

A great deal of the work of Bruce Nauman consists in issuing commands, and since Wittgenstein's views on language are said to have had a marked influence on Nauman's art, it is perhaps helpful to consider those works as having at times the framework and logic of language games—which means, since the commands are often directed at us, that we are meant to do something in response. That is to say, by contrast with works of art that evoke only an aesthetic response, Nauman's are conceived to require something more strenuous, and in a way more active, on our part. Designed as plays in language games, they address us

Originally published in *The Nation,* May 8, 1995.

less as viewers than as participants. To experience a Nauman is to interact with it in some way that goes beyond appreciating it as a work of art.

Let's begin with a special kind of command, one that the "assistant" has no power to resist, once the command is understood. (This is clearly very different from one of Wittgenstein's primitive scenarios in which A calls out "Slab" and B brings it, and where although such contingencies rarely arise in these reduced scenarios, it is within B's power to say to hell with it and walk off the job.) As in baseball, striking is a way of not playing the game. So I am thinking of what we might call strike-proof games, where it is, as continental thinkers like to say, "always already" too late to refuse to do what one is asked. "Read this sentence!" is perhaps a case in point: To read the sentence is ipso facto to have satisfied the obedience conditions it lays down. Alongside such commands one might think of logically non-nondisobeyable ones, like "Don't look!" (Oops, too late!) or "Don't read this sentence!" (ditto). The next time conversation flags, you might try to think of some examples of your own. The point is that such commands contrast with the typical orders and directives of everyday life, like "Open the window," where one must do something in order to refuse or comply with the command, other than merely understand it.

Nauman has come up with a nondisobeyable command and fashioned it into a work of art that his devotees admire extravagantly: PAY ATTENTION! Well, this in fact comes in more than one version. There is a lithograph in which "PAY ATTENTION MOTHERFUCKERS" is printed backward, one word per line. Of this the critic John Yau writes: "By describing both our experience and our specific existence, 'PAY ATTENTION . . .' successfully integrates our awareness with our sensation. We do what we see." This work is not in the show of Nauman's work at the Museum of Modern Art (which runs until May 23), but a kinder, gentler version in: PLEASE PAY ATTENTION PLEASE, a collage this time. Of this, the show's curator, Robert Storr, writes, "By reading the words on this collage, one automatically grants their plaintive request. Much of Nauman's work . . . draws the viewer into its constructs and often controls the way it is absorbed, either by demanding feats of concentration or imagination or by limiting the viewer's movements." Paul Schimmel, a co-curator, similarly writes: "Throughout Nauman's career he has baited, controlled, bored, infuriated, scared, insulted, angered, imperiled, experimented with, and manipulated us—his viewers—into experiencing his work within his parameters. . . . The meaning of the piece is what it does to us."

I am struck by the persistence of the word "viewer" in these glosses, which implies a greater continuity between normal museum experience and the rather more peremptory demands upon us that these works are praised for making. We "do what we see," remember. And our so doing is "the meaning" of the work. So "viewing" is but a stage in our response, and the rest is something the philosophical cross-examiner will force us to admit was an action. Admittedly, a fairly mild and tepid action, even if, once in front of the work, we could not help performing it. We did pay attention.

It has often, in the history of art, been hoped that works would entail effects that went beyond mere aesthetic gratification. The great ecclesiastical art of the Roman Baroque, for example, was specifically commissioned to strengthen the faith of those who viewed it. So artists were instructed to represent Christ and the martyrs as suffering, and it is reasonable to suppose that the tremendous expressiveness of these representations was calculated to arouse feelings of compassion in the viewers that could not help but strengthen the latter's bonds with those subjects of torture, humiliation, and crucifixion. I have deliberately lapsed into the idiom of "viewers," but of course those upon whom these works were to have had the desired effects were first of all Christians, and then too were usually engaged in some religious activity like praying before an altarpiece when they experienced it. The altarpiece was composed in such a way as to enhance the bond between the saint prayed to and the supplicant. Whether or not this worked out was a matter of how astute Baroque psychology was and then how manipulative Baroque artists were capable of being. But the hope was something religious art often and political art always aspires to: that some change of state would be induced by seeing the work. And certainly that happens sufficiently often that only against a formalist aesthetic would it be remarked upon at all. We approach works of art as viewers but leave them as altered beings, whether the alteration was something calculated in or not.

Still, this alteration is something that may happen or not; it is not something *entailed*. Like the ordinary game of command and obey, in which there is space for insubordination, the soul may not respond: the work looks too contrived, or too cold, or one is simply not in the mood. How grateful the Baroque patrons would then have been for a form of response that cannot go wrong, where simply to view the work is to be in the altered state, however one may want or try to resist— where resistance is, strictly speaking, unthinkable. To see "Pay Atten-

tion" is to pay attention. Still, the question cannot but nag as to what, beyond having been trumped in a forced language game, has been achieved. What have we been paying attention to? To the command and to nothing else. The moment we pay attention to the lettering, to whether the lettering goes forward or backward, to whether the command is plaintive or ugly, we are no longer in compliance with the directive but rather are attentive in the ordinary way in which we regard works of art in galleries—we are outside the horizons of the language game. So the artist's victory is fairly trivial. It is a kind of joke. Like writing "Behold!" when there is nothing to look at but the imperative itself.

PAY ATTENTION may seem a rather minor work for this degree of critical examination, but it typifies the Nauman corpus. It is peremptory, invasive, aggressive; it uses coarse language (in its lithographic version); it straddles (in the collage version) the boundary between a work of art and a poster—an admonition on the wall of the machine shop to watch what one is doing—and hence raises the deep ontological questions that have been with us since at least Duchamp; it similarly straddles the boundary between writing and image that has come to define an entire genre of art-making; and it uses (again in the collage version) unprepossessing, even proletarian materials, which defined the minimalist movement with its various ideologies and established an aesthetic axis between American art in the late 1960s and such European art movements as *Arte Povera,* which gave Nauman a widely appreciative audience on the Continent. (PAY ATTENTION was borrowed from an important Italian collection for the MoMA show.) All this has made Nauman the cynosure—the focus of rapt attention, to make an internal connection between artist and work—of our advanced curatoriat. Four outstanding curators have collaborated in bringing this exhibition to their respective institutions.

Critical opinion is by contrast considerably more divided, and I must admit to a certain division within myself. I have seen works by Nauman that seemed to me simply tremendous. One was the monumental *Anthro/Socio. Anthro/Socio* exhibited at MoMA in 1991, in which the head of a rather fierce bald man is projected on various scales and in various orientations—he is sometimes upside-down—chanting, Hare Krishna style, over and over, in unison with himself, "Feed me/Eat me/Anthropology. Help me/Hurt me/Sociology." Standing in the vast gallery among these talking heads, one felt moved and powerless, and in some crazy way the chanter's seemed to be the Voice of Humanity. In a show of works on paper at MoMA the following year,

called "Allegories of Modernism," there was a photomontage of animal forms called *Model for Animal Pyramid II,* as well as a drawing of what looked like a suffering animal that was delicate, beautiful, and, in its own way, as moving as *Anthro/Socio.* . . . There is, in the catalogue to the present show, a photograph of *Animal Pyramid,* a kind of acrobatic formation of animals (Nauman uses taxidermy forms for these), with deer at the base and smaller animals as one ascends. I have no idea of the intent behind that piece, but it conveys a sense of overwhelming meaningfulness, and I must say, on the basis of these works, that I was prepared to regard Nauman as a very major artist indeed. When asked to write a citation to go with a major prize to be awarded him, I wrote, in part, "He is an avant-garde artist whose theme is the human condition, and whose aim is to make us conscious of our limits and our needs."

Not one of these works, save for the photomontage, is in the present show, which is in the aggregate so inconsistent with the above appraisal of Nauman as an artist that I am constrained to ascribe this to a division in his own artistic persona, between the humanist I believed him to be and the smartass perpetrator of aesthetic practical jokes in which this noisy, awful exhibition consists. Either that or there is a division between the curatoriat, who seem dazzled by the artist who made these works, and me, who is repelled by them. It is possible that the revulsion, which made me want to flee the museum, was compounded by the high expectations I had had, based on partial evidence. That evidence had also caused me to explain away a number of other Nauman works I had seen—a chain-link cage, a constricting passage between walls, and some jejune wordplays in neon—rather than to construct a more realistic picture of his achievement.

The pièce de résistance at MoMA is Nauman's celebrated *Clown Torture* of 1987, which, like *Anthro/Socio . . . ,* is made up of a number of video images, although the spirit could hardly be more different. The images are of clowns doing, with one exception, fairly clownish things, like holding goldfish bowls against the ceiling with broomsticks and making a lot of racket. Whatever they do, they do over and over, so that repetition is as thematic here as in the chant of *Anthro/Socio.* . . . Part of the cacophony consists in a tiresome joke one clown tells as his routine, a joke with a certain logical kinship to *PAY ATTENTION.* It goes: "Pete and Repeat were sitting on a fence. Pete fell off. Who was left? Repeat. Pete and Repeat were sitting on a fence. Pete fell off. Who was left? Repeat. . . ." the joke never comes to the point—or its not coming

to the point *is* the point, but the clowns never learn. (If they allegorize the human condition, as can be argued, human life is the same thing over and over, and *we* never learn.) Another part of the racket comes from a clown who, lying on his back, waves his feet furiously in our direction, crying out, as if he were about to be tortured, "No! No! No! No! No! No! No! . . ." And finally there is "Clown Taking a Shit," on a large screen to one's left as one enters the clamorous, shrieking, clanging alcove where the repetitions take place on different screens.

I am uncertain what the iconography of the clown in the toilet stall is, although one may get a hint of its meaning in a large work called *One Hundred Live and Die,* which is made up of that number of paired fatalistic sayings, written in neon tubing, which flash on and off at different intervals, and of which "Shit and Live" and "Shit and Die" are but two. (Others are: "Speak and Die," "Laugh and Die," "Cry and Die"—the whole repertory of basic human doings on the left, and alternatively "Die" and "Live" on the right.) We live or die, and the regularity with which we move our bowels is invariant to the difference between life and death, like the regularity with which we eat or drink or sleep or make love. The overall feeling of *One Hundred Live and Die* is distantly Kierkegaardian: "If you marry, you will regret it; if you do not marry, you will also regret it; if you marry or do not marry, you will regret both; whether you marry or do not marry, you will regret both." "My life is absolutely meaningless," the narrator in *Either/Or* states at one point, and perhaps from the perspective of life and death, everything we do is meaningless. Something like that is the intended implication of the incantatory declarations of *One Hundred Live and Die.* Robert Storr recalls that when he first saw the work, two girls, in complete spontaneity, began chanting the words, "Feel and die. . . . Fuck and live. . . ."

On the other hand, this may be a rather more exalted interpretation of the clown in the toilet than Nauman intended. The artist communicated to Storr the thought that the times when it is difficult being an artist are very like the times when one is constipated. "Then the image of a clown taking a shit (not in a household bathroom but in a public restroom—a gas station, an airport—places where privacy is qualified or compromised) can show a useful parallel," Storr notes. (So how, to continue the parallel, are we to think of the art that comes out after the difficulties are resolved? Asking a rhetorical question is also a kind of language game. So you said it, I didn't! The parallel in any case is not mine. But what view can an artist have of his art if his favored image for artistic blockage is constipation?) There is in any case a certain cal-

low consistency between this image, which is a somewhat unfortunate metaphor, and a set of images from the late 1960s in which Nauman photographs mostly himself enacting certain charades, where the picture is to be understood—is to be "solved"—with a cliché. Thus he shows his feet covered with clay, which means—you guessed it—"feet of clay." Or we see the artist eating some bread cut out in the shapes of letters which spell out w-o-r-d; it is titled *Eating My Words.* Or he applies wax to the cutout letters h-o-t, painted red, which is *Waxing Hot.* Or he photographs some drill bits ranked in their holder and gives it the title *Drill Team.*

In 1967 Nauman made a cast in waxed cloth of a region of his body that included his hand, arm, part of his neck and chin, and his mouth, which has the inevitable title *From Hand to Mouth.* That very year, he made a cast of his crossed forearms, cut off at the biceps, out of which some heavy ropes extend that are knotted at the top. This one, in the spirit of the charade, is entitled *Untitled,* meaning we are to find the cliché, which is, I would guess, "Knotted Muscles." These, too, I suppose, are in the nature of language games, or at least a certain sort of wordplay, in that we are to understand the image by finding the cliché that fits it. Storr writes of *Eating My Words* that it "transforms a worn-out phrase into a powerful one-liner," but I find the transformations limp and pretty silly. And it is difficult to see what has been achieved by finding a visual pun for "From hand to mouth," which, as a cliché, does not refer to a stretch of the body, where the hand is at one extreme and the mouth at another, but to a condition of marginal existence where the hand and mouth are in contact because the person of whom it is true has little to show for his expenditure of energy but the food he puts in his mouth. At the very least Nauman's transformations seem to show a certain blindness to meaning or a will to subvert it.

There is another way of looking at it, perhaps, which refers us to certain views of language considerably more primitive than anything Wittgenstein had in mind by language games. In *The Interpretation of Dreams,* Freud writes as follows:

> The dream-thoughts and the dream-content are presented to us like two versions of the same subject-matter in two different languages. Or, more properly, the dream-content seems like a transcript of the dream-thoughts into another mode of expression, whose characters are syntactic laws it is our business to discover. . . . The dream-content . . . is expressed as it were in a pictographic script, the characters of which have to be transposed individually into the language of the dream-thoughts.[2]

Often, in classical dream analysis, one goes from dream-thought to dream-content by finding the pun that makes one the transform of the other in a way that makes no sense until the double entendre is found. A psychoanalyst I know told me that when she undertook her training analysis in German, her analyst asked her what she had dreamt the night before. She said she remembered dreaming about a fresh rose, and was told that she had dreamed about her neurosis. What can the connection have been? Only the German pun between *neue Rose* (new rose) and *Neurose* (neurosis). As with puns always, it only works in the language(s) in which the sounds are interchangeable. Someone dreaming of a fresh rose whose language was French would be dreaming of something else. Freud's interpretations, like Lacan's, are often like solving rebuses, and indeed Freud explicitly talks of dreams as "picture puzzles." Nauman's pictures and sculptures in any case stand in this kind of relationship to one another, with this difference: solving them takes us nowhere. PAY ATTENTION: The solution opens nothing up.

The above assessment can be extended to the other primitivism I find in Nauman's wordplay. The ancient Sanskrit thinkers used to try to elicit the secret of things by cracking open words. There is a lot of fairly crazy wordplay in the Upanishads, for example, that since the word for chant—*saman*—contains *sa* (she) and *ama* (he), chants themselves must somehow connect men and women. The inference goes from the shape of the word to some deep truth about the universe. The shape *saman* also contains the shape *sama*, which means "equal," and hence the chant is said in the Upanishads to be equal to the world. "He who obtains intimate union with the Saman, he wins its world," the Upanishads proclaim, as if something had been discovered. In general, the argumentation proceeds as it would were one to observe that "he" is contained in "she" and deduce from that the truth that there is a masculine side to femininity. It is a very old kind of verbal magic, but at least the pundits (as they were called) had a theory that they were doing things by finding words within words and (hence) things within things. Nauman proceeds this way as well. Thus he finds the word "EAT" in "DEATH." Or he finds that "EROS spelled backward is "SORE." He discovers shapes within the shapes of words or expressions, and presents them to us as if they mean something beyond the fact that one shape occurs in another. One genre of his work consists in neon signs, in which, for example, we are to join him in seeking the connection between VIOLINS and VIOLENCE and SILENCE, to refer to a work of 1981–82. Is there a connection?

Other, that is, than at the level of sound? How about at the level of meaning? There could be, I suppose. Someone in ACT UP could say that SILENCE = VIOLENCE if indeed SILENCE = DEATH. But would this follow from the phonemes being what they are?

There is a work from 1988 entitled *Learned Helplessness in Rats (Rock and Roll Drummer)*, which shows, among other things, videos of rats in a maze and of a drummer. the concept of "learned helplessness" initially had reference to what happens to rats in an inescapably painful situation. Shocks are administered in such a way that there is nothing the rats can do to keep them from happening. The rats are rendered helpless for the duration of the conditioning period, by contrast with rats in a control group who are in a more manipulable environment and thus are capable of learning to avoid the shocks. In subsequent experiments, the helpless rats learn much more slowly than the others, and, whatever the connection, show an elevated level of steroids in the blood. Some years ago, "learned helplessness" was generalized to humans to refer to pathologies believed to be the result of an individual's diminished capacity to control his or her environment. Depression, for example, was considered a form of learned helplessness, in at least some cases, and possibly this indicated a therapeutic direction.

Whatever the current state of that discussion, I somehow felt that the situation of the visitor to the Nauman show was a kind of learned helplessness, in that we are subjected to a certain series of shocks over which we have no control except that, unlike the laboratory rat, we can leave—after we pay attention, undergo torture, and so on. Our learned helplessness may be a metaphor for the human condition, as suggested by *One Hundred Live and Die*, with its fifty pairs of conditions that, although in our power, nevertheless leave life and death as independent variables over which we have no control. So the show may imply a kind of philosophical meaning grander than that carried by the works creating the sense of helplessness, although this is probably too charitable a view. The show is aggressive and nasty, cacophonous and arrogant, silly and portentous. It made me feel, overall, that I had better not think too much about those works of Nauman I really have admired, lest they too slip into language games, sophomoric puns, or the artistic correlative of whoopee cushions and gongs: clown torture.

Notes

1. Ludwig Wittgenstein, *Philosophical Investigations* (New York: Macmillan, 1953).

2. Sigmund Freud, *The Interpretation of Dreams* (London: Hogarth, 1953).

Robert Storr

Flashing the Light

in the Shadow of Doubt

This is a time of great public uncertainty in America; why is a matter of debate. Unquestionably, signs of unease are rife, especially in the arts, which have rarely before been the focus of so much popular attention or been so embattled as they have become over the past decade. Disquieted by the rapid social and political changes going on around them and dismayed by what they see as the frivolity or insularity of much of contemporary culture, people of all kinds are calling for a return to art of high seriousness that is consonant with the gravity of our predicament. Those who mean it should look hard and long in the direction of Bruce Nauman.

On first or even repeated encounters, Nauman's disconcerting sculptural riddles and nerve-jangling challenges to the ear and mind may exacerbate one's sense of a world out of joint. In part that sense is due to simple unfamiliarity; until now, relatively few people in this country have had the chance to follow the growth and development of Nauman's work over the thirty years of his career. This is because he belongs to a type of rigorously experimental artist that America breeds but only grudgingly nurtures. Moreover, he is a member of a particular generation of artists who came into their full powers in the late 1960s under the brilliantly looming presence of abstract expressionism and pop art. As a result, during the past two decades, many people have missed out on some of the best talents at work in their own backyard. Like Robert Ryman, whose retrospective at the Museum of Modern Art in 1992–93 offered the American public the first overall view of the painter's work since 1972, Nauman (whose last comprehensive mu-

Originally published by the Museum of Modern Art, 1995.

seum show in the United States also took place in 1972) is better known and more highly regarded abroad than in his homeland.

The pairing of these two artists is more than circumstantial; its roots lie in the near-total opposition of their aims and approaches. While Ryman has pragmatically devoted himself to an art of consistent procedure, apparent simplicity, and total serenity, Nauman has turned his equally methodical talents to the creation of formally disparate, visually hypnotic, profoundly disturbing, and frequently difficult to grasp images. In the context of widespread loss of faith in the possibility of finding unalloyed beauty in a strict modern manner, Ryman's paintings keep their matter-of-fact promise of aesthetic transcendence. Against the same skeptical current, Nauman's multimedia art recasts the tragic in our own unheroic, even laughable image. Reminding us that tragedy is the drama of limitations, he specifies the extreme consequences of common flaws in character, and the common intellectual and perceptual lapses that condemn us to mutual misunderstanding and self-deception. Rather than reassuring us of certain values, Nauman's seriousness is proven by his systematic doubt. That critical attitude is complemented by the belief that similar doubts harbored by his viewers are the sufficient (although imperfect) grounds for communication among people who, if they cannot entirely overcome their solitary bewilderment, can at least recognize their obsession with basic but unknowable truths as a shared human trait.

This sounds like a tall order, and it is. Nauman's genius lies in the rendering of such philosophical questions into plain American English or its visual equivalent. As with most truly serious men—including such influential kindred spirits as artists H. C. Westerman and Marcel Duchamp and writer Samuel Beckett—humor plays a crucial role in Nauman's thinking. Initially, his early work seemed almost whimsically offhand. For example, *Eleven Color Photographs* (1966–67/1970) consists of a group of staged images illustrating a series of gestures, actions, and verbal clichés. In *Eating My Words,* Nauman spreads jam on letters cut out of a loaf of white bread; *Feet of Clay* shows his feet covered in clay; and *Bound to Fail* shows his arms tied behind his back. *Coffee Spilled Because the Cup Was Too Hot* depicts precisely what its title describes. At first glace, these pictures seem like simple, indeed simple-minded visual puns. However, such obviously obvious wordplay answers the question it raises—is this art?—with a cheeky insistence—yes, it *is* art!—that borders on the aggressive. The sources of that aggression are traceable to the pathos in some of the situations por-

trayed. Stupidly spilling coffee whose temperature one misjudged equals frustration; clay feet translate into the ludicrous exposure of one's defects; being tied up equals helplessness. Each image is a comic metaphor for larger, possibly disastrous mistakes or inadequacies. In the wax sculpture *Henry Moore Bound to Fail* (1967), the impotence portrayed in the photograph is explicitly linked to futile artistic struggle. At the same time it signals the end of the monumental tradition represented by the British sculptor that was brought about by the rise of Nauman's cohort of conceptual artists.

Nauman's reference to Moore, who was very much alive and active in the 1960s, was less a claim of youthful triumph over old ways than a candid recognition that the vocabulary of form had undergone a radical change. The new materials available to artists included not only synthetics such as fiberglass and latex, which Nauman employed in his early abstract wall and floor pieces of 1965–66 and later works of the 1970s, but also neon, video, sound, and holography, the use of which Nauman helped pioneer. Yet if "the medium is the message," as Marshall McLuhan claimed in reference to such technological innovations, Nauman's principal medium has been the body, his own or that of surrogates and even members of the public. The body meant all the faculties humans possess, especially movement and speech. *Hand to Mouth* (1967) defines this expressive range with stunning economy. Relying once again on the hidden meanings of a trite turn of phrase, this sculpture not only alludes to the precarious livelihood of artists but also constitutes an aesthetic equation relating the work of the hands to the workings of language, the manipulation of matter to that of words.

From the outset, Nauman has thus been preoccupied with what can be said and what cannot, with meaningful utterance, patent nonsense, and the uncommon sense that lies between them. His texts can be confrontational but rhetorically ambiguous, as in the combined plea and demand *PLEASE PAY ATTENTION PLEASE* (1973)—in either case, whether plea or demand, he gets and holds our attention. On more than one occasion they mix Alice-in-Wonderland anagrams and all-boy wisecracks, as in the neon *Run from Fear/Fun from Rear* (1972). Or they may invoke metaphysical attitudes, as in another early neon *The True Artist Helps the World by Revealing Mystic Truths* (1967).

This last piece was made as a substitute for a beer sign that had occupied one of the windows in a space Nauman rented as a studio. Nauman's replacement was inspired by mixed feelings about the truth of the statement it made, and by his corollary assumption that the only

way to test such a belief in art's mystic powers was to assert them, and find out what it was like to live in the presence of such a claim. Rather than employing commercial neon technology to take a distanced or ironic stance toward the statement's almost romantic conviction, as the pop artists might have done, Nauman used it to advertise his own ambivalence. Honky-tonk signage thus becomes an emblem of vatic illumination; a question without a question mark replaces a slogan with an implicit exclamation point.

In Nauman's environments, texts become sounds, while the installations' carefully calibrated confines frame and dictate motion. Situationally transposed and amplified, the defiant note in his early graphic and photographic works becomes at times unbearably insistent, if not downright hostile. In one instance, two small speakers on opposite walls of a claustrophobia-inducing white chamber bluntly tell the unwary intruder, "Get out of my mind. Get out of this room." This is art that does not love the art-lover back. However, the motive for the rebuff is something other than mere irksomeness or contempt for the public. Correlating architecture and mental space so that physical access is granted on the one hand but psychic access is denied on the other, the piece makes the viewer privy to the outwardly suppressed terror of artists (not Nauman per se), for whom making contact with the public through their creations is tantamount to letting strangers freely enter their most secret refuge. From Vincent Van Gogh to Jackson Pollock, museum-goers have been encouraged to equate expression with self-revelation. No less inclined to cut to the spiritual and emotional core of things than they, Nauman is perhaps clearer about the cost. The barrenness of the white cube and the anxious, asphyxiating rasp of the disembodied voice testify to the speaker's naked vulnerability. Nevertheless, the viewer's prolonged presence establishes a compact with the room's alter ego. In this as in a number of his other installations, if one can endure the rejection and contagious panic, a strange intimacy develops. One's thoughts gradually fall under the spell of the breathless chanting, which Nauman, a former guitarist, composed with an ear to the rhythms, harmonies, and dissonances of contemporary vanguard music. What was first a violation of someone else's domain is transformed by duration into an echo chamber where one's fear of exposure throbs and distant brain squalls resound in one's head.

When Nauman admonishes the public to "Pay Attention," he intends above all that they heed their own evolving and perhaps conflicting responses to the varied stimuli that he provides. As much as any of

his mediums, including his own persona, his audience's reactions constitute part of the raw material of his art. These reactions may range from complete identification with a gesture, look, or word, through puzzled fascination with a shape, surface, or optical illusion, to horrified amusement or frightened recoil from noise, flashing light, or possible physical entrapment. These responses all contribute to the work's meaning, and few occur without the complications added by implicit contrary readings. Before one can "get" Nauman, one must first consciously register all the unconscious or semiconscious resonances of the images and effects he creates. The best access to his thoughts, therefore, is through a close examination of one's own feelings.

Although installation has always played a major part in his output, the artist's growing emphasis on this genre derives from his increasing focus on the problem of how to make the viewer see himself or herself as the involved subject, rather than the detached object, of address. As uncomfortable as one usually is in the situations he sets up, Nauman's work is all about being there. Although he himself may engage in metaphoric actions, or one of his neons or videos that depicts the war between the sexes may have its origins in his personal experience, Nauman eschews the confessional mode. What obsesses him instead are universal conditions of existence, and the dynamics of confrontations in which conventionally distinct roles are, under close scrutiny, uncannily interchangeable. In the winner-take-nothing game of alienated affections, anybody can play—and sooner or later everybody does. The twelve-screen video *Violent Incident* (1986) shows a man and woman progressing from formal courtesy through puerile spite to bloody murder in the space of a few short minutes. These changes are run through in a checkerboard alternation: on one monitor the man plays the aggressor, while on another the woman spits obscenities and wields the knife. This is strong stuff, but it is emphatically theatrical, a mini-drama of domestic abuse staged as a round-robin of pointless vengefulness and victimization.

Other video installations are broadly slapstick, but it is slapstick that can be excruciating to watch or hear. *Clown Torture* (1987) is just that, a painfully funny exercise in humiliation and frustration enacted by a cross between an upbeat Bozo, a downbeat Emmett Kelly, and a regressive deadbeat out of Stephen King. On all sides of the video projection room, this stereotypical and alarming character engages in infantile tantrums, acting out scenes of absurd powerlessness, constipated indecisiveness, and hopelessly repetitive confusion that compete for

our divided attention. A single-screen video, *Shit in Your Hat—Head on a Chair* (1990), incorporates the tongue-twisting voice-over commands of a director instructing a silently bemused but obedient mime to perform the self-debasing ritual named, while we are made complicitous to the sadomasochistic exchange.

Proceeding from one room of such installations to the next is like wandering through a monstrous fun house, the cumulative effect of which is both wrenching and enthralling. Loudness, rudeness, and humor of this kind and degree are generally unexpected in art museums, which many consider places of quiet appreciation and reflection. For these people, Nauman's temporary occupation of the Museum of Modern Art may come as an unsettling surprise. However, the contemplativeness of Ryman's paintings that graced the third-floor galleries last year is, as I suggested at the outset, only one of art's manifold dimensions. While the elegantly erotic and scatological tracery of Cy Twombly canvases, recently on these same walls, demonstrates the middle term, Nauman represents the darker side of the aesthetic equation.

Nauman belongs to a long tradition within the modernist canon that reaches back to the oldest tragicomic strains of Western art. The washed-up buffoons Lucky, Pozzo, Vladimir, and Estragon in Samuel Beckett's deadpan passion play *Waiting for Godot* are close cousins of Nauman's hapless and nameless fools, who also descend laterally from Max Beckmann's sideshow performers, Pablo Picasso's saltimbanques, the *commedia dell' arte* creatures of Francisco Goya and Giovanni Battista Tiepolo, and the antique race of Greek and Roman grotesques whence they ultimately came. Times have changed, though, and the kitschy aura of the iconic "sad clown," who is also an ancestor, lends Nauman's beleaguered Everyman (and woman) a still more pathetic air while at the same time signposting the inappropriateness of any maudlin reading of the artist's intent. Like the tormented clowns, moreover, the flayed animal forms in *Carousel* (1988) and related works also personify humanity's reflex cruelty. The raucous video installation *Learned Helplessness in Rats (Rock and Roll Drummer)* (1988) is predicated on the notion that our claims of superiority are tenuous at best. A print not included in the current exhibition, entitled *Learned Helplessness From Rats* (1988) [underline mine] suggests instead that behavioral psychology, counted upon to improve on nature, may easily be turned against us. The repeated inability to learn from mistakes is a constant issue for Nauman; no design for betterment or punishment for failure changes the odds against error. Pain is a poor teacher—or

perhaps we are Suffering's dunces. The flashing lights of *One Hundred Live and Die* (1984) catalogue the hard and immutable facts of life and death, while the parallel video monologues of *Good Boy Bad Boy* (1985) conjugate a similar litany of instinct, rage, and moral ambiguity. The grammatical progression from "I" to "You" to "We" links the video's separate speakers to the individual viewer, and the viewers to each other. Nonetheless, the semantic bond it establishes is totally devoid of fellow-feeling or consolation.

Unsentimental and unpreachy, Nauman speaks to each about the longings, miseries, and follies of all. His subjects are the big subjects of art and life. His diverse and frequently disorienting means of expression are, however, so unusual that outside the realms of literature and the theater it is easy for those unaccustomed to such a visual discourse to miss the largeness of his purpose and the fundamental directness he strives for. He has acquired the international stature he presently commands precisely because of the unique scope of his work. In regard to Nauman, Americans, although steeped in the history of modern art, have some catching up to do. The successful cultural assimilation of modernism's early phases has, to a considerable extent, blurred the mysterious and often antagonistic qualities that upset and stymied the public when such works first appeared, whether they were postimpressionist, Cubist, Dadaist, surrealist, or abstract expressionist. These qualities too often missed or taken for granted remain embedded in that work even now. Each genuinely advanced form of art must possess a measure of defiant strangeness if it is to offer a fresh perspective on fundamental poetic or philosophical problems.

The modernist credo "make it new" has meaning if and only if the "it" is substantial and the novelty announces an original and far-reaching way of seeing and thinking. The real challenge, therefore, is not to leapfrog previous styles, but to dislodge our convention-determined acceptance of unexamined realities. Aurally, visually, and in every other way, Nauman has "pumped up the volume," rearranging the syntax of the several artistic languages he uses in order to achieve this goal. If his work initially seems more to exemplify our current confusions than to offer a cure for them, this is because we are so little prepared for the very thing we crave: an art that communicates in the idiom of our day, asks the hard questions, and refuses facile answers. Nauman has broken the artistic mold to apply himself to the most enduring of themes. It will take time for the implications of what he has done—and is still doing—to fully sink in. Already, though, he has had a crucial impact on

his peers as well as on countless younger artists in America and abroad. For those who have been lucky enough to follow his zigzagging over the years, this exhibition is the first opportunity in over twenty years to examine the puzzle he has laid out as an integrated entity. For those just getting acquainted, the pieces of that puzzle may seem daunting or unaccountably perverse, but in the end they will provoke a radical but profoundly worthwhile reimagining of what modern art is and does.

Ingrid Schaffner

Circling Oblivion / Bruce Nauman

through Samuel Beckett

Vladimir: What do we do now?
Estragon: Wait.
Vladimir: Yes, but while waiting.
Estragon: What about hanging ourselves?
Vladimir: Hmmmm. It'd give us an erection.
Estragon: (highly excited) An erection! . . . Let's hang ourselves immediately!

—Samuel Beckett, *Waiting for Godot,* 1948

To paraphrase the toastmaster, these works are gathered here today in honor of a great artist, a major talent of the twentieth century, the recipient not only of the prestigious Aldrich Prize, but also of the 1994 Wexner Prize and the 1993 Wolf Prize. His work has been the subject of countless exhibitions, publications, and dissertations. (I myself wrote a graduate paper on his "slo-mo" films of the 1970s.) We welcome Bruce Nauman, who is standing at this imaginary reception in front of one of his recent drawings, entitled *Eating Boogers.*

The artist thanks the assembled guests, takes up his glass, and offers a few words. He says that he has always wanted to make work "that didn't give you any chance . . . like getting hit in the back of the neck (with a baseball bat)—you never saw it coming, it just got you, it just knocked you down and you never knew where it came from or what to do with it. I like that idea very much of that kind of intensity that doesn't give you any choices about whether you're going to like it or

Originally published in *Bruce Nauman, 1985–1996: Drawings, Prints, and Related Works* (Ridgefield, Conn.: Aldrich Museum of Contemporary Art, 1997), 15–31.

not like it or whether you should leave before things get too heavy duty. They're heavy duty before you have a chance to decide."[1]

We, in turn, appreciate the fine technique, the rigorous conceptual relationship between the artist's drawings and related works that rarely admit a moment's false speculation. This creates a dazzlingly circular effect among drawing as a proposal, sculpture as execution, and drawing as record of Nauman's ideas. It's so easy to get from *Elliott's Stones* on sheets of paper to *Elliott's Stones* on slabs of granite. The drawings could practically serve as instructions to the masons who chiseled the sculpture, which read: ABOVE YOURSELF, BESIDE YOURSELF, AFTER YOURSELF, BENEATH YOURSELF, BEFORE YOURSELF, BEHIND YOUR-SELF. Turning drawing into document, Nauman is also known to make studies after the fact, revisiting completed sculptures and installations. "Yes, I work that way a lot, where there are drawings, and then the work, and then there are more drawings to figure out what I've done, to help me resolve what I'm in—as opposed to what I thought I was doing when I got started."[2]

Considering his art of the past ten years—plus one—we recognize a history of challenging antecedents. Over the past thirty years Nauman has evolved an aesthetic based not on the production of beautiful objects, but on the experience of works that are, for lack of a better word, often "ugly" in their unelaborated explicitness. We credit his drawings for having created a common denominator for virtually every contemporary medium in which he works—save painting—including film, video, holograms, environmental installations, cast sculpture, neon wall pieces, prints, and photographs. All of which tend to function less like conventional works of art than behavioral models, forcing participation from the viewer and provoking a response.

We look closely at these particular drawings, comparing them to what came before in the 1965–86 survey (organized by the Museum für Gegenwartskunst, Basel), and posit subtle new signs of painterliness. Granted, this impression may be exaggerated due to certain subject matter. Only recently returned to Nauman's work after years of absence, the figure inherently implies traditional practices and pleasures, such as solving tricky representational problems (the positions of *Three Hands* [1993], seen from rotating perspectives), composing forms (*Heads on Fingers* [1989] balanced elegantly in relation to one another and to the paper's negative space), or just drawing for drawing's sake (probing an impossibly free-floating wound in *Finger Poking* [1989]). There are even signs of pictorial excess, such as the drips running off

the legs of *Marching Figure* (1985), the elegance of the washes laid over the *Heads on Fingers* (1989), and, in an untitled lithograph of 1994, lurid line and color, which turn a simple handshake into a wildly lascivious expressionist encounter.[3]

And having now granted the experiential imperative of Nauman's art, without any further ado, it's time to experience and assess an exhibition of works whose imagery threatens to transform all previous discussion into polite circumlocution, in that it is so extreme and abject as to defy further comment.

Drawings for neon sculpture propose these blinky scenarios. A *Marching Figure* (1985) pops an erection with each stride. A pair of men attack each other with weapons, a knife and a pistol, wielded like a pair of dicks. When the men crumple down dead, their penises grow erect. *Human Sexual Experience* (1985) is reduced to a crude gesture, one hand poking the other hand (described by the artist as "the beautiful stuff of curves and colors and sign language—kid's sign language, innocent, funny, simple").[4] In sculpture, there is the colorless version of the same, cast in bronze from adult arms linked in a monumental circle of obscene signs. *Seven Hanging Animals* (1989) are aptly referred to in the generic, since they've lost all signs of specieshood, mutilated by having assorted limbs jammed at odd angles into their leg sockets. For levity there's a clown taking a shit.

Subjected to these images I'm reminded of a short film, which also inevitably ends in confrontation. Shot in black-and-white, an eyelid fills the screen, popping open onto the action of an old man scurrying along a narrow street. Seen from behind, he's wearing a loose raincoat, baggy pants, and a crushed hat with a scarf underneath, tied around his head. Strangers stop to stare, recoiling in reproach and horror. He darts into a building, where an old lady descending the staircase drops dead upon sight of him. He takes his own pulse in the passageway before entering an apartment, triple-locking the door behind him. The room is bare except for a dog, a cat, a parrot, a fish, a bed, a chair, a mirror, and on a grimy plaster wall, a printed reproduction of an ancient mask—a bearded god with staring eyes. In fact, all eyes seem to be upon the man, who performs a slow, tortured slapstick, putting out first the cat, then the dog (a chihuahua), with each pet returning in turn, until finally both are evicted. Pacing, he covers the mirror, the birdcage, the fish bowl; he tears down the print and settles into the rocker and rips up his family photographs. As he rocks and drifts into abstraction, the camera—which has until now maintained a respectful distance—creeps

around for a front view of none other than Buster Keaton, who wakes as though electrified. Like the strangers in the street, he starts, in what can only be recognition of himself, and claps his hands over his eyes. The screen goes dark. The title and credits roll.

Written in 1963 and shot in New York in 1964, this short is *Film*, the only movie that Samuel Beckett ever made. It succinctly and silently (except for one "Shhh") encapsulates what the novelist and playwright had evolved over the past thirty years of published work: a world pared down to absurd essentials populated by characters who cannot elude the self-perceptions that incriminate them into being. Operating in as tightly conceived quarters, where narrow margins enforce identification among artist, spectator, and cruel spectacle, is Bruce Nauman. Early in his career Nauman acknowledged Beckett's influence, along with that of Malcolm Lowry, Vladimir Nabokov, and Alain Robbe-Grillet, all writers famous for having played hard with language and against traditional forms of narrative. And it's Nauman's own love of language, on similarly unconventional terms, that first led him outside the usual realms and expectations of art, when, as he says, "I couldn't get enough of what I was interested in into paintings. For example, language. Rather than something else I did like reading, I wanted it to be in the work."[5]

As the works in this exhibition demonstrate, Nauman's language is active and direct, communicated for the most part through primary colors, simple outlines, basic gestures. And it's the bluntness of his art—nouns, verbs, no modifiers—which makes it so hard to consider, and which might have us, as viewers, half-trying to elude it, to run away, shield our eyes, like Buster Keaton attempting to escape the camera in Beckett's film. Returning to the artist's own early identification with the writer, I propose taking a closer look at Bruce Nauman in terms of Samuel Beckett. This approach generally allows for the fact that an artist's influences might play out over time and, more specifically (and somewhat ironically), that it's easiest to learn to appreciate what's difficult in Nauman when taken at an oblique angle, through something other than his own terribly straightforward work. By no means to suggest that Nauman "studied" Beckett (or illustrates him), this discussion will take the form of a loose exchange between two mature bodies of work, whose most conspicuous common feature is the clown.

To an almost uncanny degree, Beckett's *Film* anticipates themes and imagery in Bruce Nauman's contemporary art: rooms and corridors make for oppressive constructs of "mental space" (as Nauman dubbed his own abstractions of the 1970s); the inescapable feeling of being

watched (even if only by one's own self); animals sadly attendant upon humans; men, women, and clowns performing vaudevillian slapstick and pratfalls, prone to frailty, violence, and cruelty; and a sense of the abyss. So mutual are their affinities, in fact, that one can hear the grotesque voice that pants and wheedles inside the empty room of one of Nauman's early installations as if it were the voice-over to Beckett's *Film*, "Get out of this room. Get out of my mind."

In turn, one can imagine Beckett answering a work by Nauman, a video entitled *Slow Angle Walk* (1968), which shows the artist expending undue exertion ambulating around his studio. He shoots a straightened leg high into the air, where it seems to stick, while he swivels his whole body in a half turn before jackknifing at the waist to plant his foot to the floor. Starting the next step, the other leg shoots up into the air, to repeat the whole process; as the artist concurs, "[i]t's a tedious complicated process to gain even a yard."[6] Watching him, one hears Beckett's line "I can't go on, I'll go on."[7]

Nauman actually subtitled this video "Beckett Walk," explaining that it "has to do with a description by Beckett of travelling to someone's house."[8] The artist told Jane Livingston in 1972, "My problem was to make tapes that go on and on, with no beginning or end. I wanted the tension of waiting for something to happen, and then you should get drawn into the rhythm of the thing. There's a passage in Beckett's *Molloy* about transferring stones from one place to another, the pockets of an overcoat, without them getting mixed up. It's elaborate without any point."[9]

It's also repulsive. (Although perhaps not so repulsive as *Eating Boogers*.) The stones in question are "sucking stones" and one nearly feels and tastes them, as Beckett describes: "Taking a stone from the right pocket of my greatcoat and putting it in my mouth, I replaced it in the right pocket of my greatcoat by a stone from the right pocket of my trousers, which I replaced by a stone from the left pocket of my greatcoat, which I replaced by the stone which was in my mouth, as soon as I had finished sucking it." This continues for eight pages, with the stones making the rounds between pockets and mouth, knitting the reader into a discomforting loop of pointless activity. Likewise, Nauman's painfully slow *Beckett Walk* was also intended to elicit a physical reaction from the viewer. Impressed by an account by John Cage of how painfully the dancer Merce Cunningham would rehearse each movement toward committing it to anatomical memory, he applied this kind of intensity to his walk. "If you really believe in what you're

doing and do it as well as you can, then there will be a certain amount of tension" translated to the audience as "a kind of body response, they feel that foot and that tension."[10]

What keeps time throughout these prolonged performances is repetition. The opposite of progress, repetition literally keeps time from passing. One is stuck in the moment. As Robbe-Grillet sees it, this is one of the typifying experiences of avant-garde literature. "Instead of having to deal with a series of scenes which are connected by causal links, one has the impression that the same scene is constantly repeating itself, but with variations."[11] Using language alone, Nauman deploys this technique to great effect in works based on traditional forms of wordplay. In a drawing of 1972, "La Brea Tar Pits" breeds "La Brea Art Tips" and splits into "Tar Pits Rat Spit." A neon flashes between DEATH and DEATH, RAW becomes WAR. Doubling "NO" back on itself, "ON" overrules resistance with action, implying echoes of: onward, move on, on and on, on top of. But the line always switches back to: NO.

With such limited means it's a mechanical form of exchange, which makes Nauman's use of flashing neon seem especially apt. These words can never develop into more than passing quips, as Beckett routinely proves in his dialogues:

Vladimir:	They make a noise like wings.
Estragon:	Like leaves
Vladimir:	Like sand
Estragon:	Like leaves
(Silence)	

"To restore silence is the role of objects," Molloy thinks, while contemplating a policeman's nightwatch stick. Likewise, in a series of drawings, Nauman constructs a triangle of words: VIOLINS, VIOLENCE, SILENCE. And silence very much suits another form Nauman's wordplay takes—the tombstone-like sculpture, those inscribed slabs of metal or rock, such as *Elliott's Stones*.

Mechanically lobbed back and forth, words exchanged by repetition and variation dismantle language's power to produce linear progress, action, or meaningful discourse. Instead, sense turns back on itself, returning to enclose its own beginning in an alternate structure of meaning, in nonsense, whose form is the circle. Beckett's *Watt* is a circular tale that begins with the protagonist venturing on a journey and ends with him buying a ticket for "the end of the line." Nauman's work of the 1970s features a series of giant circles, which the artist envisions on

an even larger scale, as being plugs cast from tunnels. Thus to partici-
pate fully in one of these formally elegant abstractions really entails
imagining oneself buried underground, endlessly circling around and
around, inside its infinite structure—conceptually, at least, close to
death. On an ostensibly lighter note, Nauman presents another image
of infinity with a work of 1987. His voice breaking with tension and
tiredness, a clown is telling the classic joke, "Pete and Repeat were sit-
ting on a fence. Pete fell off. Who was left?" "Repeat." "Pete and Re-
peat were sitting on the fence. . . ." Caught, the clown races to get to
the end of the joke, only to find himself tricked into repeating it again.
He's chewing his hair and gibbering his words in frustration. Part of a
larger installation, including *Clown Taking a Shit,* the work is collec-
tively entitled *Clown Torture.*

Commensurate to Nauman's clown on the toilet is Beckett's Krapp.
Coincidental to both their work, although implied practically from the
start, clowns as full-blown circus figures only emerge late in Beckett's
work and lately in Nauman's. Beckett's first published short story,
Dante and the Lobster, 1932, involves preparations for lunch with the
kinds of clownish deliberations that would endlessly sidetrack all of
Beckett's characters to come. In another story, the only thing Mr.
Nixon can remember about Watt, who has owed him 5 shillings for the
past seven years, is that "He had a huge big red nose." Molloy's loose
coat and many pockets certainly suggest a clownish retinue. And Beck-
ett's characters are always joking around: "Estragon (voluptuously):
Calm . . . calm . . . The English say cawm. (Pause.) You know the story
of the Englishman in the brothel?" But in Beckett's 1958 one-act
Krapp's Last Tape, Krapp's costume and makeup are specifically de-
scribed: "Rusty black narrow trousers too short for him . . . sleeveless
waistcoat, four capacious pockets . . . Surprising pair of dirty white
boots, size ten at least, very narrow and pointed. White face. Purple
nose. Disordered grey hair. Unshaven." Krapp's first act on stage is to
slip on a banana peel.[12]

In Nauman's work, initially, it was the artist himself who was clown-
ing around: in 1968 *Making Faces,* for a series of holograms, playing a
Violin Tuned D E A D in a video, or covering himself in face-paint in
Flesh to Black to White to Flesh. In this last video Nauman devotes a full
sixty minutes to making himself up, taking his time just as a good
clown should, according to a circus manual which reads: "Apply the
make-up with as much care as you possibly can. A good job will take
time, perhaps 40 minutes or more."[13] But when actual clowns first ap-

pear in his work of the late 1980s, they are played not by the artist, but by hired performers. And—although not exclusively—they are frequently dressed like Krapp, in the red nose, white face, baggy pants, and big shoes that characterize Auguste. In traditional Western circus, there are three clown types: the pathetic "sad clown" Charlie; the cunning, immaculately dressed Joey; and the half-witted, pratfalling Auguste, who also happens to be the most modern clown, invented by an American acrobat, Tom Belling. Grounded during a performance in Germany, Belling was hamming it up behind the curtain when he accidentally stumbled on stage in a wig and baggy clothes. The crowds jeered "auguste" (an old slang word for silly or stupid), baptizing him on the spot.

True to the Auguste type, Nauman's clowns often bear the brunt of cruel pranks and the embarrassment of their own distress. Another sequence in *Clown Torture* involves a clown coming through a door and upsetting a pail of water. It comes first splashing, then crashing down upon his poor naked pate in a noisy cascade. The scene is a clip that repeats over and over and over, with the clown getting knocked down and standing up each time to take it on the head once more. But clowns are like that. Possessed of superhuman strength, they endure what no right-minded person would tolerate, since they themselves aren't quite right in the head. And they're lucky that way, given what they have to put up with. In *Waiting for Godot*, Pozzo instructs Vladimir to revive Lucky (Pozzo's companion) his way, "Well to begin with he should pull on the rope, as hard as he likes so long as he doesn't strangle himself. He usually responds to that. If not he should give him a taste of boot, in the face and the privates as far as possible." The even harsher realization comes in knowing that the only reason Lucky keeps hanging around the monstrous Pozzo is that he doesn't seem to know any better. Sadly, in life, sometimes this is reason enough.

Animals don't have a choice, which makes them especially vulnerable. In the work of Nauman and Beckett, animals exist like a fringe group, whose callous or appalling treatment by humankind throws a dark look back on society as a whole. Nauman's carousel of carcasses cast from foam taxidermist's forms slowly turns, sometimes dragging the sculpted bodies on the floor, leaving a concentric skid over time. In a video installation based on a scientific study, a rat scurries around inside a maze, agitated into helpless action by the auditory overload produced by a poundingly loud rock 'n' roll snare drum tattoo. Beckett's Molloy runs over a dog with his bicycle, "an ineptness all the more un-

pardonable as the dog, duly leashed, was not out on the road, but in on the pavement, docile at its mistress's heels." (Although Molloy may have been distracted by his earlier musings on the death of lambs, "fallen, their legs shattered, their thin legs crumpling, first to their knees, then over on their fleecy sides, under the pole-axe . . .") *Dante and the Lobster* ends with the lobster, having "survived the Frenchwoman's cat and his witless clutch. Now it was going alive into scalding water. . . . Well, thought Bellacqua, it's a quick death, God help us all. It is not."

Both the inevitability and toleration of cruelty motivate Nauman's art. He says, "My work does come out of being frustrated about the human condition, how people refuse to understand other people, how people can be cruel to other people. It's not even that I'm interested in thinking that I can change that but it's such a frustrating part of the human condition because it's in human history that these things go on."[14] So to watch *Clown Torture* is to participate in it: what is at first funny soon becomes unbearable. It fast takes on a rhythm—bang, crash, scream, splash, boom/bang, crash, scream, and so on—that mechanizes the scene. It makes the violence tolerable, turns the clown into a cheap player, torture into art, and the viewer into an accomplice of the artist—whose intent in the first place was to torture his audience with the truth of their own tolerance for cruelty, all in one concise circle of experience.

The word "circus" means "circle" and was first used in this context in 1782 by Charles Hughes, who called his show the Royal Circus. (This is also the period when visits to Bedlam—never far from view in Beckett's landscapes—provided a related form of entertainment, at the expense of the asylum's inmates.) And in a very significant way, the circus provides a context for cruelty, expressed in the audience's pleasure at the clown's distress and their amusement at the physical deformities displayed by sideshow "freaks." After the show, as one lion tamer's memoirs describe, the nineteenth-century circus traveled in a wake of brawls: "The town gang was always the loser. If it had not been the circus could not have stayed on the road long. Black eyes, bloody noses, bruised heads, and broken bones were common. Often there were more serious injuries and sometimes a man was killed."[15] Life under the contemporary big top (called a "mud show") offers this pathetic detail: "The clowns were given two buckets a day, one to wash in, the other to rinse in. If you spill your pail of water you have to stand in mud all day, so you learn to be careful. . . . Life isn't easy in a mud show."[16]

The province of clowns, the circus is a circle of nonsense, inside of which clowns entertain through their absurd actions, meaningless dialogues, jokes, gibberish, fights, and falls. All are routines and as such comprise a form of behavior not only for the performers, but also for the viewers, who participate, however passively, in an exchange of identification and abstraction that begins with the clown's costume. The clown's baggy clothes render him formless, just as the makeup renders his face a mask. At the same time that he's perceived as an "other," the clown is known to be excessively familiar. By way of exaggeration, all of his motives and actions—however base, lewd, stupid, crude, violent, cruel, or silly—are perfectly recognizable. (The big red nose, for example, signifies that the clown is also a jolly, disgusting drunk.) We are enfolded into imaginative identification at the same time we are repelled. And, by extension, we are invited to experience through our identification with the clown and clownish nonsense not just a silly lack of sense, but the more subversive potential of things actually failing to make sense.

We cannot fail to recognize this same potential in Beckett's writings and in Nauman's art: their nonsense and little cruelties, the repetitions and variations that subvert meaning, and a small battery of clowns—all encompass a vision of abjection that rings of the abyss.

Notes

I would like to thank Geoffrey Batchen for his assistance and Jim Zivic for his encouragement and comments.

All Samuel Beckett quotes from Richard W. Seaver, ed., *I Can't Go On, I'll Go On: A Selection from Samuel Beckett's Work* (New York: Grove Press, 1976).

1. Nauman quoted from an interview with Joan Simon in *Four Artists: Robert Ryman, Eva Hesse, Bruce Nauman, Susan Rothenberg,* a film by Michael Blackwood Productions, Inc., New York, 1987.

2. Nauman in conversation with the author, unpublished telephone interview, May 1986.

3. It's interesting to note that these hints of pictorial pleasures and the reemergence of the figure in Nauman's work coincide with his meeting in 1985 his future wife, the neo-expressionist painter Susan Rothenberg, who is famous for images of horses as surrogates for the human figure. (One of the giveaway features are the hooves, which stick out almost like feet in profile.) In another series, of the mid-1980s, she painted dreamy homages to Piet Mondrian, whose painted compositions are the subject of Nauman's drawing *Mondrian's Frames,* 1996.

4. Joan Simon, ed., *Bruce Nauman,* The Walker Art Center (Minneapolis: Distributed Art Publishers, 1994), catalogue raisonné, no. 340, p. 296.

5. Nauman quoted in Grace Glueck, "Artnotes," *The New York Times,* April 1, 1973.

6. Nauman quoted in exhibition catalogue essay by Jane Livingston, *Bruce Nauman: Works from 1965–1972* (Los Angeles: Los Angeles County Museum of Art, 1972), p. 26.

7. Another inadvertent dialogue between Beckett and Nauman: when Nauman says he wants his art to be like getting hit on the head with a baseball bat, Beckett says of his writing, "My work is a matter of fundamental sounds . . . and I accept responsibility for nothing else. If people have headaches among the overtones, let them. And provide their own aspirin" (Beckett to Alan Schneider quoted in Seaver, p. xiv).

8. Nauman quoted in Livingston, p. 29.

9. Ibid.

10. Ibid.

11. Robbe-Grillet quoted in Susan Stewart, *Nonsense: Aspects of Intertextuality in Folklore and Literature* (Baltimore: Johns Hopkins University Press, 1978), p. 175. This book was invaluable to my research about forms of nonsense in literature.

12. The whole piece is a stripped-down hybrid of circus, theater, and performance art with Krapp in a pair of monologues—one taped, the other his conversation with the tape, which he interrupts, speeds forward, and rewinds, like the past played back through memory.

13. Bruce Fife, ed., *Creative Clowning* (Bellaire, Tex.: Java Publishing Co., 1988), p. 37.

14. Nauman quoted in the film *Four Artists . . . ,* 1987.

15. Harvey W. Root, *The Ways of the Circus. Being the Memories and Adventures of George Conklin, Tamer of Lions. Set down by Harvey W. Root* (New York: Harper and Brothers Publishers, 1921), p. 233.

16. Phyllis Ashbridge Rogers, *The American Circus Clown* (Princeton University, Ph.D. dissertation, 1979), p. 14.

Jean-Charles Masséra

Dance With the Law

In the late 1960s and early 1970s, Bruce Nauman's work seemed to be marked by one of the last modern utopias: that of constructing a subject cut free from all psychological, social, and historical determinisms. Conceiving a subject outside the sound and fury, in the abstract space of the studio or the white cube; exhibiting a neutral, transhistorical body. The symbolic space and the historical dimension of experience were repressed. Since the early 1980s, Nauman's installations have incorporated a historical dimension of experience, particularly through their insistence on certain processes of the body's instrumentalization and the subject's negation.

"Law-Off" and the Reduction of Thinking Time

1990. *Shit in Your Hat—Head on a Chair.* An offscreen voice, settled, steady, and neutral: "Put your hat on the table. Put your head on your hat. Put your hand on your head with your head on your hat." On a hanging screen, an androgynous mime docilely executes the orders. "Sit on your hat, your hands on your head. Shit in your hat. Show me your hat. Put your hat on your head." No sign of suffering or humiliation on his face as he must successively shit in his hat, show it, then put it back on. Contrast between the nature of the orders and their assiduous execution. The will to submit is even more stupefying

Originally published in the catalogue for the touring exhibition, "Bruce Nauman," Kunstmuseum, Wolfsburg; Centre Georges Pompidou, Paris; Haywood Gallery, London; Nykytaiteen Museo, Helsinki, 1997/1999. *Bruce Nauman* (London: South Bank Centre, 1998), 20–33. A revised version of this essay has also appeared in *Amour, gloire et CAC 40, Estétique sexe, enterprise, croissance, mondialisation et médias* (Paris: P.O.L., 1999), 59–60, 193–217. Translated from French by Brian Holmes.

than the nature of the abasement. Make one's body a gift to power. 1975. *Salò or The 120 days of Sodom:* the abasement of the victims staged by Paolini is comparable in nature, but here the torturer (the power) has a name and a face: a duke, a bishop, the president of a tribunal, a banker. "The face or body of the despot or god has something like a counterbody: the body of the tortured, or better, of the excluded," remarked Gilles Deleuze and Félix Guattari.[1] *Shit in Your Hat—Head on a Chair:* the body of the tortured is no longer a counterbody because the despot and God were stripped of their power long ago. The orders now come from elsewhere. The site of enunciation is offscreen. A voice-off.

And if the body of the tortured is still a current theme, the exercise of power has become more cerebral, no longer marking bodies. The body reduced to slavery (to nudity) by political, religious, legislative, or economic power, exposed in *Salò or The 120 days of Sodom,* has been replaced by the body employed for the execution of highly precise tasks, in specific working garments (the mime's clothing). The face has lost the marks of torture. Emancipation has erased its very traits with cosmetic powders. A white face, ready for use. Power (the voice-off) can write on it, impose its desires, without leaving its mime the least possibility of representing what he desires. The mime is no longer the master of his gestures. He gives form to speech which is not his own. His androgynous body carries out a statement (a desire) of which he is not the subject, but the instrument. A body dispossessed of its sex and its desires.

1935. *Modern Times* [Chaplin]. The division of labor deactivates the full range of possible bodily functions, using only one for each body. The chain-structure of the assembly line dispossesses Charlie of his body, specializes it for the tightening of bolts. The body takes the form of its function and lives to the rhythm of that function's execution. But the reduction of a body to a function is only possible by stepping up the pace imposed by the factory director, whose face appears on the section leader's control screen: "Workshop 21: Maximum speed." The pace of task execution takes possession of the bodies. The reduction of break time transforms the subject into a tool of economic rationality. Longer breaks between bolt-tightening sessions would have allowed Chaplin to become conscious of what growth in productivity really means (the labor-organizing phase). Slower and more varied movements would have allowed him to regain awareness and possession of his body (access to leisure activities). The speed of command sequences

and the lack of breaks prohibit any rise in the mime's consciousness. After a certain speed of enunciation (of task execution) the absurdity and abjection of the commands are no longer legible. Pacing as a mode of the subject's execution.

For Chaplin, the rationality of self-dispossession has a face: the face of the boss who appears on the screen of the section leader. If "the face is a veritable megaphone," if "a language is always embedded in the faces that announce its statements and ballast them in relation to the signifiers in progress and subjects concerned,"[2] what then shall we make of these commanding words broadcast from nowhere? For the mime, the rationality of self-dispossession has no face. The master's law has been replaced by a law-off.[3]

Servile, Services, Severity: Normal Desires

When the body is no longer a counterbody (martyr or slave), when it is no longer the mechanical arm of an assembly line (blue-collar worker), then it takes back its senses in order to enjoy the products that were formerly forbidden (consumer). 1985. *Porno Chain:* seven neon silhouettes form a horizontal chain carrying out all the possible varieties (product lines) of sexual intercourse. Whoever does not feed the chain with offers and demands—whoever does not feed off it—is invisible. Produce pleasure and reproduce it, or blink out. Consumer logic. Pasolini saw *Salò* as "a visionary representation which, via sexual relations, becomes a metaphor between power and subject. The sadistic relation is nothing other than the commodification of the body, its reduction to a thing."[4]

Today the abstract economic *machine* has beheaded the Prince (the single subject of enunciation). Power can no longer be located (off-camera) because it is fragmented, diluted in an interweave of networks and interests.

1982. *Sauve qui peut (la vie)* [Godard]. Seated at his desk, a boss organizes a pornography chain whose departure and arrival point is himself. The system's functioning rests entirely with him. Each body must carry out a task (lick, suck, penetrate) at the moment when the preceding body in the chain gives the sign (a foot on the breast, fellatio, and so forth).[5] The bodies are employed to produce the supply (the pleasure) to which they enchain themselves. *Porno Chain:* the commodified bodies are dissociated from the command sequence that sets them into

place and determines their function. Godard's pornographic system reconstructs the meaning and the symbolic chain that links economic agents to their directives. The economic machine has beheaded the Prince, but its agents still need to represent, indeed, to embody, the power that is exerted upon them (to put a face on the command). Thus the last link of the chain receives the command to "put some rouge" on the pale, dispirited face of the boss (the service director), as though the boss had to produce an image of his power ("Okay, the image'll do," he blurts out while putting it all together). As in *Shit in Your Hat—Head on a Chair*, the absurdity of the orders reveals the naked exertion of power on the bodies and their reduction to things. Bodies employed in the service of a law-off, and dispossessed of their free will.

Speech and the forms it produces all flow along a one-way traffic route through the bodies of the mime, the employees, and the neon silhouettes. They blink and flow in us until we are nothing more than the desire for the product: *Hanged Man*, 1985. The life and death of a man hanging from norms. Three phases: waiting for the message (only the gibbet is lit), reading the message (the man lights up), consumption-consummation (erection and orgasmic possession of the product). The totality of this man's body is occupied by the message. The mass destination of the supply entails standardization of those who demand. The neon silhouettes refer less to individuals than to types. Consumption disfigures (they're all platinum blondes) and the consumers take on the forms of the things they consume. The reign of statistics denies interiority and individuation. Successful distribution calls for nothing but reflexes or programmed behavior. The mechanicality of desires replaces the mechanicality of production (*Modern Times*). The neon man has no individual features because the economic machine only produces the habits and reflexes of consumption, which deny any possible individualization of experience. The machine offers combinatory possibilities, arrangements of goods and services. Just let yourself be shown around. *Normal Desires*. If you're not turned on, you're invisible.

All this places the demander in a posture of immediate consumption: the flashy, attractive color pages of our advertising, the rhythm of our fashion parades, the absence of causes and reasons in favor of sheer effects (porn star Traci Lords always moans when she meets someone). *Masturbating Man, Masturbating Woman*. The distributed model and the model economic agent fuse together in neon. The effect that the message provokes in the man becomes the message to switch on an-

other neon man. To be turned on by a product, to be hot for it—or not to be. Light up for a product or just blink out—without feeling the pleasure.

Only actions come to light (the active population): marching, getting a hard-on, in *Five Marching Men* . . . Greet, suck, kill, and commit suicide in *Sex and Death by Murder and Suicide.* The neons are a chain of states, positions, reactions, and effects without pauses or connections, reflecting nothing but demand (the movement of growth). The blinking signals and the hypnotic repetition of the postures are like promises of an event that never comes (a TV viewer in suspense until the next episode). The speed of the blinking and the assembly of the phases are the events. Never leaving one's seat, satisfaction with the pure clash of images (channel hopping). Don't be the subject of your desires, just satisfy them, right now. You can be sure to pick up your program wherever you left off.

Dance With the Law

A word or message becomes effective when it circulates through bodies. Whatever the future ways of instrumentalizing bodies, the movements of the future mime or the future hanged man will necessarily melt into the motion of their chains or networks (keeping up with the times). The law is a cadence, a rhythm that circulates through bodies. The more your drives are synchronized to the rhythm of the law, the easier the execution of the task. Let feeling make a word effective. Help us feel pleasure at the effectuation of a message. 1968. Two loudspeakers set in the walls of an empty room, addressing any visitor who happens by: *Get Out of My Mind, Get Out of This Room.* A few footfalls, then those two injunctions repeated ceaselessly in tones that make you want to run when they are throaty or even mucous, but also to linger when the rhythm shifts: a ritornello, a bouncy little jig that makes you want to dance. The spectator is led to acquiesce to a discourse, to dance to words he no longer hears and that reject him (get out of my mind, get out of this room . . .). Slip into the cadence of your own eviction. The inscription of the law is a matter of feeling. Like a room left free so that a subject—the spectator in this case—might come to actualize a text. *Dancing in your head. . . .*

The chain of behaviors and reactions that the boss tries to put into motion is slow to produce the desired image, because the employees have to learn as they go along. But the mime's execution is immediate, the image of the hanged man is composed in a flash, because the first

has been trained and the second has been programmed. Michel Foucault speaks of schoolchildren's training: "All the activity of the disciplined individual must be punctuated and sustained by injunctions whose efficacy rests on brevity and clarity; the order does not need to be explained or formulated; it must trigger off the required behaviour and that is enough. From the master of discipline to him who is subjected to it the relation is of one signalling: it is a question not of understanding the injunction but of perceiving the signal and reacting to it immediately, according to a more or less artificial, prearranged code."[6] Four columns of affirmative, imperative phrases written in neon on the wall: *One Hundred Live and Die.* Some fifty attributes and action verbs combined with the words "live" and "die," blinking on and off in binary patterns: "SHIT AND DIE . . . SING AND LIVE . . . SMILE AND LIVE . . . SMILE AND DIE. . . ." An empty room big enough for a group of people (learning process): the same proposals are chanted in a welter of childish voices. An invitation to turn in circles. Once learned, these obsessive combinations will turn us into the mimes and hanged men of tomorrow. Tables or chants designed to "place the bodies in a little world of signals to each of which is attached a single, obligatory response: it is a technique of training, of *dressage,* that despotically excludes in everything the least representation, the smallest murmur."[7] The mime and the hanged man are nonrepresentations. The mime is just the representation of the spoken word; the hanged man's erection is a reaction triggered off at the proper time.

The content of the command can be read immediately. The structure of *One Hundred Live and Die* is generative. It proposes formations of possible phrases (actions)—formations into which one could insert other verbs, other qualities. Once the jig has been assimilated, once the melody is on your mind, not only does it become difficult to shake it off (to think of anything else), but more important, the most absurd, indeed, the most dangerous contents can be absorbed and broadcast by this obsessive little jig, without the subject even batting an eye: "YELLOW AND DIE . . . KILL AND LIVE." The pause in which consciousness—critical thinking—could react is reduced to zero; no time to say "no" or not follow orders (refuse to join the dance). How many listeners or TV viewers have the time (the consciousness) to realize the incoherence of certain pieces of information strung together in a single phase? 1991. "According to Pentagon sources, the tonnage of bombs dropped in the past few hours is one and a half times greater than that of the bomb dropped on Hiroshima; according to Pentagon sources,

twenty-three civilians have died." This montage of two pieces of contradictory information broadcast by the media during the Gulf War forces our assent (just say "yes"). Media metrics skip all transitions (no ordering of the factors at the origin of the event). It beats time without analyzing, hollows a void around the salient facts of the day. The event is an inflection (numbers without the matching story). The chain of selected facts is pulled by too quickly, and the over-explanatory, over-lengthy articulations—the ones that could imperil the transformation of the public into true believers—have been edited out. Media metrics call for dancers who can be made amenable to the pursuit of operations. The image hits hard but ricochets away. The commentaries of our special reporters as modes of structuring our collective behavior. The break in the beat, the halt of the cadence means critique (opposition journalism).

Whether command ("HEAR AND LIVE"), commercial ("YOUNG AND LIVE"), warning ("FUCK AND DIE"), or educational diatribe (*Good Boy, Bad Boy*), the messages gain in effectiveness when they merge into a simple binary rhythm, easy to grasp and hang on to: "We are segmented in a *binary* fashion, following the great major dualist oppositions: social classes, but also men-women, adults-children, and so on. . . . It is a particularity of modern societies, or rather State societies, to bring into their own duality machines that function as such, and proceed simultaneously by biunivocal relationships and successively by binarized choices."[8] As though all the possibilities that punctuate existence had their contrary (good and evil, integration and exclusion, right and left, etc.). As though they fit together in a logical chain necessarily linking cause and effect: ("FUCK AND DIE"). As though each situation implied a choice between two contradictory possibilities (refusal or acceptance, success or failure). Our reflexes and decisions respond to a binary logic: yes or no—drink or drive. But each choice has its consequence (the right choice, the wrong choice) and its sanction ("KILL AND DIE"). Punish or reward.

In Foucault's description of the society that emerged after the collapse of the ancien régime, the art of punishment had to be "as unarbitrary as possible." It rested on "a whole technology of representation": "an art of conflicting energies, an art of images linked by association, the forging of stable connections . . . it is a matter of establishing the representation of pairs of opposing values, of establishing quantitative differences between the opposing forces, of setting up a complex of obstacle-signs that may subject the movement of forces to a power rela-

tion."[9] This society is now being replaced by one which eliminates quantitative differences in favor of a game based on the arbitrary. "When I take the game, I take it out of context and apply it to moral or political situations."[10] *Musical Chairs:* the slowest one is left standing (learning to compete). A kid's game becomes an adult pastime. *Hanged Man:* whoever gets it wrong wins an erection. The game as structure of our imaginary. The cruelty of an imaginary structured by the taste for business ventures, the taste for risk, the pleasure of exclusion. But in this adults' game "the parts of the figure are put into place without you."[11] The hanging doesn't follow from your difficulty at spelling a word—it's just in the programming.

The very restricted freedom afforded the spectator in Nauman's most recent works corresponds to the restricted freedom that power gives the subject. 1996. *World Peace (Received):* five monitors, each playing back the words of a sincere-looking speaker. They're set in a circle around a chair (do sit down), they address you with an aggressive drone—"I'll talk, you'll listen to me"—while assuring you they're listening: "You talk, I'll listen to you. They'll talk, we'll listen to them." Just try to slip a word in edgewise. The TV talks to you (talks for you). Stymied promises of dialogue.

It remains to decide if one can be satisfied with this demonstration of the processes whereby the subject is negated and reduced to a machine. If you agree that Bruce Nauman's works have something to say, then no doubt—at that very point, you have to admit that they say nothing else. Yet each exhibition confronts you with a choice: accept or refuse the way the works work on you ("STAY AND DIE/LEAVE AND LIVE").

No

1987. *Clown Torture. Clown Taking a Shit.* Must we accept the cacophony of what the clowns tell us ("Pete and Repeat were sitting on a fence. Pete fell off. Who was left? Repeat. Pete and Repeat . . .") and the cacophony of what they don't want to tell us ("No! . . . No! . . . No! . . . No! . . .")? Why remain caught in the vicelike grip of a low-ceilinged room amidst a profusion of monitors and wall projections showing us one clown having a jar of water poured over his head, another stamping "no no no" with his feet, a third taking a shit? Their torture becomes ours. Looking and listening become impossible and unbearable, just as they were on the chair surrounded by the five droning monitors. Unable to say anything to us, these installations attack

us. The neat little jig (*Get Out of My Mind, Get Out of This Room*) has disintegrated into a cacophony, but the effect is only magnified. As soon as you get in you have to get out.

1991. For the exhibition "*DISLOCATIONS*," a gallery at MoMA is plunged into semi-darkness. *Anthro/Socio (Rinde Facing Camera):* close-up on a shaven-headed face projected on three walls and six monitors, screaming with deafening intensity: "Feed Me/Eat Me/Anthropology . . . Help Me/Hurt Me/Sociology . . . Feed Me, Help Me, Eat Me, Hurt Me." The installation turns into a demonstration of strength. The gallery acts like a sounding box that amplifies the scansion of the cries. Sensurround. A process that surprises us "like getting hit in the back of the neck. . . . The kind of intensity that doesn't give you any trace of whether you're going to like it or not."[12] Creation of a three-dimensional acoustic ambience bringing a sensation of depth to the chanted phrases. The repetition of the imperative inflections and the simplicity of the injunctions obsess us. The alterity of the piece forces contact upon us. Reach out or reject. The neon silhouettes can suck each other, kill each other, but they don't concern us directly. Rinde's face becomes inescapable, compelling us to recognize his demand. Feed him and feed off him, help him and do him harm. Confused feelings of attraction and repulsion. *Get Out of My Mind, Get Out of This Room:* the tone and rhythm make us enter the dance that rejects us. "Feed Me, Help Me," calls the chant, "Eat Me, Hurt Me": it circulates inside us, to the point where our hearts beat to the pulse of the other's destruction. Embody the output of the chant (beat to the rhythm of the text). Let yourself be swept away by speech that reduces you to silence. The amplification system and the dimensions of Rinde's shaven head refer to other faces, other commanding words. Linkages of hammered commands that call for an impulsive response. Unlike *Clown Torture, Clown Taking a Shit,* or *World Peace (Received),* the installation no longer appears to be addressed to a single person or to a small group of persons, but to a crowd—to the social body. Stadium logic. Bass-note logic, dispossessing us of the desire for any other thing except this chant. Let yourself be fascinated by the spectacularization of power, or leave. *RUN FROM FEAR.*

The mix between the fascination of power and the aggressive force of the decibels raises a question that Bruce Nauman formulates with respect to certain earlier works: "how does normal anger—or even hating someone—evolve into cultural hatred? At what point does one decide it's OK to wipe out an entire race? How do you become Hitler? Where

does it stop being something personal and turn into the abstract hatred that leads to war?"[13] No doubt the moment when this obsessive chant (this rhythmic beat) is imprinted in us—the moment when we enter the dance—is the moment when we pass over to the stage of adherence (alienation). A discourse becomes effective when it penetrates bodies. Michel de Certeau: "The *credibility* of a discourse is what first makes believers act in accord with it. It produces practitioners. To make people believe is to make them act. . . . Because the law is already applied with and on bodies, 'embodied' in physical practices, it can accredit itself and make people believe that it speaks in the name of the 'real.' "[14] Rhythm as a means of structuring an opinion. Nauman's installations never name the nature of power. The only things shown are the forms of its application to bodies and the conditions in which the subject becomes a *believer.* At what point are we dispossessed of our own free will? At what moment do we become the objects of power?

Confiscated Bodies

1988. *Learned Helplessness in Rats (Rock and Roll Drummer).* An improvised installation, almost ridiculous. On the ground, an empty perspex labyrinth scanned by a video camera. Against the wall: video images of a terrorized rat seeking to escape from the same labyrinth (document), images of a drummer launching into a wild solo (clip), images of the labyrinth scanned by the camera (live). In the early 1970s, the combination of constraining spaces for the body and the use of closed-circuit video surveillance was inscribed in the field of pure aesthetic experience. Enter a first corridor to follow your own progress on a control screen; go out, then enter a second corridor to observe the comings and goings of those who are still in the first one. The relative control of the spectator is replaced by the total control of the laboratory animal. Ambiguity of the title: who is put in a situation of helplessness? The rat because it has no chance to get out of the labyrinth, or the spectator because he can do nothing but look?

Bruce Nauman: "My work is basically an outgrowth of the anger I feel about the human condition. The aspects of it that make me angry are our capacity for cruelty and the ability people have to ignore situations they don't like."[15] Let yourself be seduced by the rock rhythm or become conscious of the violence done to the lab animal. Although the title of the piece can imply that the rat is terrified by the drummer, nothing in the installation proves that anybody was drumming while the rodent's movements were filmed. The alternating playback of the

three image sources seems to deny the possibility of simultaneity. What's more, the speed of the rat's movements does not necessarily mean it has been placed in a situation of distress. . . . The association of these two images (the editing) would then be no more than the projection of a fantasy: watching the rodent's movements in the labyrinth exhibited at our feet. The installation exposes and blends voyeurism (the empty labyrinth), pleasure (the solo), and compassion (the rat). The guinea pig is not where you think it is. The installation's object shifts. The second version of the piece—*Rats and Bats (Learned Helplessness in Rats II)*—renders the hypothesis of the suffering rat still more unlikely: a baseball player has replaced the drummer, while the labyrinth, now spread over four stories, has taken on grotesque proportions. The aggressivity inherent in numerous other installations fades into derisiveness here. The images lose their force. The sound takes hold of the body and separates it from judgment. Headless body.

After having sacrificed it to power (the slave and the conscript), then to industrialization (the blue-collar worker), the subject is now separated from his body (the consumer). Giorgio Agamben: "the process of technologization, instead of materially investing the body, was aimed at the construction of a separate sphere that had practically no point of contact with it: what was technologized was not the body, but its image. Thus the glorious body of advertising has become the mask behind which the fragile, slight human body continues its precarious existence."[16] *Porno Chain, Five Marching Men, Sex and Death by Murder and Suicide:* conductive body for commodified behavior simplified to extremes (greatest common denominator). The behavior can be outdated (marching in time), reprehensible (murder), emancipated (sex), or social (greeting each other). The sexualization and spectacularization of an organless body. The programmed linkage of sequences and the repetition of certain bodily postures deny the event, the gap, the existence of desire. Technologization and commodification as processes for the devitalization of bodies.

1986. *Violent Incident:* twelve monitors forming a video wall, four video decks. Twelve key moments in a candlelight dinner which begins with someone pulling away the chair as the other sits down (practical joke) and ends with two knife thrusts. All in eighteen seconds. The multiplication and repetition of the images and sounds prohibit any linear reading (or comprehension) of this domestic drama. A trivial story that leaves only a few peaks of intensity in the mind. The narrative and reasons for the dispute disappear beneath the insults, screams,

toppling chairs, and sounds of fighting bodies. We rediscover the media logic that links violent actions in a chain, eliminating the transitions and the order of causal factors. The televised event is an inflection, a flow. But here, the splintering of the scenario leaves us at a respectable distance: the blasé TV viewer. This distance confirms the constitution of an exclusively spectacular body and the development of a sphere and a temporality which have been entirely separated from the subject (exclusion).

Shit in Your Hat—Head on a Chair: hanging in front of the screen on which the mime's body loses all dignity (all will), is the green cast of a head with its eyes closed, lying on a chair. A head severed from its body and its activity. An activity that unfolds on the screens or in the neons. An activity severed from the subject. Where certain activities of the early 1970s "force you to be aware of your body"[17] the later installations seem to deprive the subject of his body of experience. The shrinking corridors acted to heighten the awareness of the senses and the sentiment of self. The acoustic and visual juxtaposition opposed by the simultaneous functioning of the monitors and mural projection in *Clown Torture, Clown Taking a Shit* puts our bodies in a situation of hyperesthesia. It's the paradox of a hearing test that denies the spectator even the slightest room for reflection. Hyperesthesia turns into sensory deprivation.

Touch and Sound Walls (1969): two walls 12 meters apart. By touching the first, the spectator produces a sound that the second wall echoes after a slight delay. Self-consciousness depends on the experience of delay (hearing oneself think). The *retrospective* awareness of one's own bodily activity. *Anthro/Socio (Rinde Facing Camera) . . . World Peace (Received):* a room with a chair that invites us to have a seat, faces that address us and let us know that we are considered the actors of a process, that we have access to speech. . . . But these spaces of free being and speech prove limited. These faces (sounding boxes) give us an illusory consciousness of ourselves. By eliminating the delay (the step back) that is necessary for comprehension, the intensification of speech flow imposes an immediate reception that bars any possible access to consciousness. The time of the subject (the time of understanding) is interstitial and silent. The time of media speech is continuous. Severed temporalities.

1989–91. Return to silence. Other heads, hanging from threads at eye height: *Hanging Heads . . . Ten Heads Circle/In and Out . . . Ten Heads Circle/Up and Down . . . Four Pairs of Heads . . .* Confiscation of a

body. Clear yourself a path through couples and communities of heads. Monochrome casts of wrinkles, expressive mouths, and eyelids. Frozen interiorities. Subjects without a body of experience. Subjects disembodied of their individual history. The hanging of these heads at eye height reveals the ground and the empty space at the base of the necks. A space that the installation invites us to occupy, underscoring the frail and fragile presence of our own body, its precarious existence. The wax, the monochromy, and the hanging as a fragilization of our own field of experience. The closure of faces (private experiences) imposed by continuous, deafening speech. *One Hundred Live and Die:* the verbs and attributes do not articulate in any particular experience (generative grammar). 1985. *Good Boy Bad Boy:* two actors—a man and a woman, each on one monitor—link together a few commonplaces of existence in various intonations, from persuasive inflections to aggressivity: "I'm bored. You're bored. We're bored. Life is boring/I like to drink. You like to drink. We like to drink. This is drinking." Playback of an "I" which is not a particular case, of a "you" which is hypothetical, of a "we" which denies any possible singularity. The media don't tell us anything; they base their generalities on the sum total of the subjects of generic experiences (listening/viewing public). Subjects and verbs without complements (specific experiences). Faces without histories.

In the late 1960s and early 1970s, a number of minimal sculptures and performances worked toward the construction of a subject of experience and enunciation. In the years that followed, the installations of some of Bruce Nauman's contemporaries integrated the psychological, social, anthropological, cultural, or even political conditions of subject-formation that had been repressed until then by modernism. In Nauman's recent works, the subject is neither neutral, nor embodied in a specific figure; instead, the subject is exposed to processes of instrumentalization and negation of exactly that which constitutes it as a subject. Since the mid-1980s, the relations we maintain with certain installations are power relations. With the spectacularization of media forms, the activation of imperative language, the recourse to certain allegorical figures and constrictive systems, we are confronted—or thrust violently up against—the experience of a threshold, a turning point: at what moment does the pressure exerted on us become unbearable? At what moment do we move from the state of subject to that of a *target* for certain types of speech? And when the pressure eases off, when the installation offers us breathing spaces, room to move, then the critical attitude (dis-

tance) becomes an alternative to rejection (dissidence) or acceptance (the docile body). Make the links between the symbolic tenor of the dislocated objects (a chair, a head, etc.) and the language played out. Imagine the latter's context of enunciation and field of effectuation, and inductively reconstitute (retrace) the chain of assigned roles. Work back from the facts to the law-off.

Notes

I would like to thank Vincent Labaume and Pierre Leguillon for their precious help.

1. Gilles Deleuze and Félix Guattari, *A Thousand Plateaus: Capitalism and Schizophrenia*, tr. Brian Massumi (London: Athlone Press, 1988), p. 115.

2. Ibid., p. 179.

3. In French I play on words: "law-off" (or "command-off"), a translation of "loi off," is a made-up expression that comes from "voix off" ("voice-off" or "offscreen voice"). I mean that it's impossible to know where the command comes from. You can hear the command but you don't know where it's coming from. In Bruce Nauman's piece *Shit in Your Hat—Head on a Chair*, the mime hears an offscreen voice (an "offscreen command") and the viewer doesn't know who gives the commands. On the contrary, Chaplin knows where the command comes from. The command has a face (the one of the director, which appears on the control screen). The command of Nauman's mime is faceless—it is separate from the hanging screen on which the mime executes the commands.

4. Pier Paolo Pasolini, *Une vie future* (Rome: Associazione 'Fondo P.P. Pasolini'/Ente Autonomo Gestione Cinema, 1987), p. 306.

5. "The boss—You Nicole, lay on your back, there . . . Thierry, put your thing in her mouth. Isabelle, come on over here. . . . Bend over.

The assistant—I lick her ass?

The boss—I haven't said a thing yet . . .

The assistant—Excuse me boss.

The boss to Isabelle—Okay, you're going to put make-up on me but only when he licks your ass. And you Thierry, you lick the crack of her ass only when she blows you. . . . And you, you start the blow job each time I touch your tits with my feet. So let's try it. . . . Okay, the image'll do, now we're going to work on the sound. When I touch your tits with my shoe you say 'Ahh!' and you blow him. Go ahead: 'Ahh!' You, Thierry, when she sucks you, you say 'Ohh!' and you lick her crack. Let's do it: 'Ahh!' . . . 'Ohh!' . . . And you, when he eats your ass, you go 'Ayy!' And don't respond if he's not on target. Go for it Thierry: 'Ayyyyy!' And then you put a little make-up on him, just once. And if I ever smile at you, you kiss me. So let's do it: 'Ahh!' . . . 'Ohh!' . . . 'Ayy!' . . ."

6. Michel Foucault, *Discipline and Punish: The Birth of the Prison,* tr. Alan Sheridan (New York: Vintage, 1995), p. 166.

7. Ibid.

8. *A Thousand Plateaus,* pp. 208–10.

9. *Discipline and Punish,* p. 104.

10. Interview with Joan Simon, "Breaking the Silence," *Art in America* 75, no. 9 (September 1988): 140–49, 203.

11. Ibid.

12. Ibid.

13. Quotes excerpted from a text by Kristine McKenna, "Bruce Nauman: Dan Weinberg Gallery," *Los Angeles Times,* January 27, 1991, pp. 4, 84, reprinted in *Art Press* 184 (October 1993): 21–23.

14. Michel de Certeau. *The Practice of Everyday Life,* tr. Steven Randall (Berkeley: University of California Press, 1984), p. 148.

15. Cf. note 12.

16. Giorgio Agamben, *The Coming Community,* tr. Michael Hardt (Minneapolis: University of Minnesota Press: 1993), p. 51.

17. Interview with Willoughby Sharp, "Body Works," *Avalanche* 1 (Autumn 1970): 14–17.

II Reviews

Peter Schjeldahl

Only Connect:

Bruce Nauman

For a while there in the late 1960s Bruce Nauman was one of the most abundantly inventive artists anyone had ever seen. It is interesting to remember this—on the occasion of Nauman's current two-gallery show (January 9–January 30, 1982) at Castelli's 142 Greene Street space and, upstairs, at Sperone Westwater Fischer—because the late 1960s are squarely in the blind spot of present art consciousness. During those years the force of earlier "big styles"—abstract expressionism, pop, minimalism—was beginning to spread itself, deltalike, toward the tranquil gulf of the 1970s, but it still had momentum. More to the point, there was still, at least in principle, a readiness in the art audience to value the "difficult" in new work, especially work by artists perceived to be pushing the frontiers of aesthetic possibility. In today's eager but negligent atmosphere that time seems long ago.

Artists in the late 1960s were optimistic about the aesthetic potential of technologies and systems, and Nauman played with most of them—video, film, photography, light, sound, language, mathematics, holography, and more—to memorable effect. His work was Duchampian in its wit and insolence, in its teeming paradoxes, puns, and other forms of mental short-circuitry. It reminded some people also of Jasper Johns for the way it invested brainy art gestures with a psychological charge—an air of withdrawn, self-involved emotion only obliquely revealed in each piece. Like Duchamp and Johns, Nauman seemed to spin art out of sheer self-consciousness. An adept sculptor, craftsman, and all-

Originally published in the *Village Voice*, January 20–26, 1982. Also published in *The Hydrogen Jukebox: Selected Writings of Peter Schjeldahl, 1978–1990* (Berkeley and Los Angeles: University of California Press, 1991), 105–8.

191

around showman, he was a Barnum of introversion, embodying anxious or hostile states in broad jokes and spectacular displays. Typical of his bottomless facetiousness was a spiral of writing in neon that read, "The true artist helps the world by revealing mystic truths." Typical of his capacity to unnerve was an empty room in which a recorded voice hectored, "Get out of my mind! Get out of this room!"

What was really inconveniencing about Nauman, however, was his work's skewed relation to the various dialectics that defined "advanced art" in the late 1960s. He seemed always to be entering the scene from some informed but eccentric angle, and living mostly in California had something to do with it. It cost him critically. Robert Pincus-Witten, who invented the term *postminimalism* and used it as a procrustean bed for many artists (with consequent amputation of the odd limb and meaning), taxed Nauman with "narcissism," then still a dirty word. And Nauman ran into definite trouble with New York audiences when he started showing austere "behaviorist" environments—a corridor so narrow it could be passed through only sideways, a suspended "room" whose walls stopped at mid-shin level—that induced physical self-consciousness and mild sensory deprivation. Nervous urbanites (including me) found such work conducive less to mind expansion than to anxiety attack.

Nauman's disconcerting presence wasn't the only thing that felt marginal in the art world of the 1970s. After a last burst of artifice and hysteria in conceptualism and so-called body art—most of whose practitioners owed something to Nauman—the idea of an avant-garde mainstream dissolved. Art in general started to feel marginal to the commercial, professional, governmental, and alternative institutions that "supported" it not wisely but too well. A new audience appeared whose attention span could be measured in milliseconds, and a new consumer criticism emerged to serve it. Although slow in registering, these changes inexorably affected the reputations of many art stars whose work had been geared to the tight, centered situation of the 1960s. They weren't dropped from prominence—in the new art world nothing actually failed—so much as defused, their impact deadened by incurious acceptance.

Nauman's fate through all this was at once harder, in terms of worldly success (he lacked regular patronage, except to some extent in Europe), and less undermining, because he had always been a lone wolf. In a way, Nauman's work since the late 1960s—forbidding, puzzling, and tentative as some of it is—has revealed, to those few contin-

uing to care, an artist more significant and valuable than the modernist cowboy of the late 1960s. He has kept alive the avant-garde "antiart" impulse not as an ideological program or art-cultural game but as a personal predilection, a mode of conscientiously being in the world. If his relation to the changing art audience and market has become ever more attenuated, his commitment to his own peculiar slant of vision has correspondingly deepened. Both the emotional content and the open-ended, almost oriental, detachment in the presentation of his work have intensified.

The lovely, vaguely haikulike, title of Nauman's double show—*Violins Violence Silence*—is a reminder that unlike many artists who toy with language, he has a poet's ear. "Violins" is an obscure reference to a late-1960s videotape in which Nauman, untutored in the instrument, played a violin whose strings were tuned D, E, A, and D. This morbid musical pun recurs in one of his new sculptures, called *Diamond Africa,* in which the legs of a suspended cast-iron chair sound the same notes when struck. "Violence" is a political allusion, to torture in South America. The three sculptures at Sperone—cast-iron chairs suspended within circular, triangular, and square eye-level corrals of steel bands, each roughly 14 feet across—are collectively entitled *South America.* "Silence" might be an injunction of a piece of advice on how to encounter these pieces—these shaped columns of space-containing chairs, tilted at unsittable angles, which seem mute testimony to some anonymous catastrophe. In context, "Silence" suggests no rhetoric, no sentiment, no conclusion—and no evasion.

"Silence" also jibes with the effect of two new sculptures—crude plaster elements roughly wedged and braced together on Castelli's floor in configurations, one circular and one indescribably irregular, respectively about 23 and 12 feet across—from Nauman's series called *Models for Tunnels.* The concept is of vast underground tunnel networks (going nowhere) for which these sculptures are rough sketches. The coarseness of execution appears intended to direct attention away from the pieces toward the imaginary, although scarcely imaginable, projects they prefigure. It doesn't seem to matter much to Nauman whether any such project is eventually realized. These homely metaphors of subterranean grandeur are self-sufficing—generating, with some effort of the viewer's imagination, a psychological state of isolation, refuge, silence.

Trying to explain for myself the uncanniness of Bruce Nauman's recent work, I think again of Duchamp and Johns. All three are artists of self-contradicting, radical skepticism directed against assumptions of art

experience and even of experience generally. They make self-canceling signs—like the dumb public emblem given intense subjectivity by color and brushwork in Johns's *Flag* paintings or, vice versa, derisively objective models of subjectivity, as in any of Duchamp's works involving the erotic. But to say all this is to say very little about the impact of such artists; it is merely to describe thought structures easily analyzed and aped by others.

Less comprehensible about Duchamp, Johns, and Nauman is the personal drive that keeps running them into the brick wall of their own intelligence, as if, with some mixture of amusement and despair, they never cease to be amazed by the futility of it all. For the integrity of these artists—their ironic, lonely dignity—consists in observing and being true to a "failure to communicate" built into every language, every style. Such artists haunt the mind with a sensation like that of being in a remote, supposedly secret, place and suddenly feeling that someone else is there, too. This presence, a small pressure somewhere in consciousness, feels neither friendly nor unfriendly, neither "good" nor "bad." It is intimate without being in the least personal. Trying to confront it is like trying to bite your own back.

In the late 1960s there was a fleeting notion that this sensation could be made the basis for a conscious "criticality," an ideology of change. But, as Nauman seems instinctively to understand, the sensation signifies an irony of existence that cannot be directed or contained and certainly cannot be handed down as a tradition. Each true instance of it is terminal. D, E, A, D. It can be tracked only by a solitary individual, and its track can be registered only by another solitary individual. This recognition made Nauman rather a spoilsport then. In the frenzied sociability and revived political fantasies of today, he is doubly an unwelcome guest. But his work and example, like the fact of human solitude they apostrophize, can afford to be patient. Time is on their side. Time *is* their side.

Nancy Goldring

Identity: Representations of the Self

Few artists have resisted the impulse to make a self-portrait—
to produce a likeness of themselves, to conjure their own presence
through mark or symbol. There arrives a moment when his/her glance
falls upon his/her own image or turns inward upon itself. At this in-
stant the artist becomes the obvious, logical, and, more important, the
necessary subject of the work of art. Traditionally relegated to the sta-
tus of subcategory within portraiture, self-portraiture has resulted in an
extraordinarily wide range of images—from the *Pietà* of Santa Maria
del Fiore, in which Michelangelo appears as Nicodemus, to the many
autobiographical paintings by that chronic self-portraitist, Rembrandt.
Chameleon-like, this mode has assumed many guises—altering with in-
dividual, style, and period. For although self-portraiture is essentially
"transhistorique," as Michel Beaujour puts it, it has always served as a
reflection of its time.

"Identity: Representations of the Self" makes only a modest attempt
to explore this complex genre, which has persisted unobtrusively since
its inception in the early Renaissance. According to the curators—Julia
Blaut, Luke Dodd, Tom Folland, Eric Nooter, and Erika Wolf—this
exhibition's goal is specifically to investigate the artist's search for an
identity as recorded in self-portraiture of the past twenty-five years.
But, unfortunately, what the show does offer is only a smattering of
conceptual icons, tempered by a selection of tamer, standard pho-
tographs, rounded off by a sampling of recent art stars.

A comprehensive or discerning study of the strain of images that
proliferated in the late 1960s and 1970s juxtaposed with equivalent ones
from the 1980s would have proven instructive indeed. While qualifying

Originally published in *Arts Magazine* 63, no. 7 (March 1989): 85.

as self-portraits, these earlier pieces (such as those by Bruce Nauman, Vito Acconci, Eleanor Antin, William Wegman, and Dennis Oppenheim) moved beyond motivations that typically impel representations of self—for example, reflection, narcissism, self-examination, self-preservation against the ravages of time, and declaration of self: "I paint therefore I am." For behind these anguished, wry, sardonic, didactic, and even silly images was the desire to provoke new definitions of art. And in the process the artist was furnished with an "identity," or at least a raison d'être. Self-portraiture was, therefore, only a by-product of a search for new forms and new meanings. The camera and video served as instruments to capture what was a kind of Pygmalion transformation in reverse, in which the awakening artist came to life, reincarnated as objet d'art. For an instant Bruce Nauman literally becomes the fountain, thereby linking art and artist in a temporary, documented (if fictive) gesture.

A comparison of these conceptual works with the overtly media-inspired images of the 1980s reveals a dramatic shift in cultural priorities. Cindy Sherman, who is well-represented in the show, repeatedly inserts herself into ready-made cinematographic clichés. Her transvestisms do not, however, confer meaning; but rather the proliferation of personas attests to the futility of the search for an authentic self in the contemporary art world.

The Whitney curators have avoided any such revelatory contrasts by failing to identify the specific parameters of their subject or establishing its relation to photography. We are given false clues by the inclusion of Jasper Johns's *Skin,* an imprint from 1975, and Robert Rauschenberg's *Autobiography,* an offset lithograph from 1967, which seem to promise other hybrid forms or even "pure" paintings. But from Chuck Close they have selected only a medium-sized polaroid; and, sadly, they have omitted altogether such artists as Arnulf Rainer. Missing in general are the many European artists whose participation would have disrupted the provincialism of the show. Instead, the curators have generally retreated into a safety-zone of pure photography with Lee Friedlander and the inevitable Robert Mapplethorpe. Although admirable in themselves, these works cloud the sense of the exhibition to the extent that no clear basis for inclusion emerges from the sequencing.

The exhibition has also over-simplified complex feminist issues by reducing them to what the curators have called "role playing to expose the effects of patriarchy." If they wished to expose an essential difference between the nature of the male and female search for identity,

they might have included such pieces as Mierle Laderman Ukeles's *Maintenance Art* from 1969, which would have made an effective complement to Martha Rossler's marvelous deadpan video *Semiotics of the Kitchen*, or Vito Acconci's *Conversions* of 1971, in which he hides his penis between his legs to create the illusion of a sexual transformation, or even Duane Michal's dramatic explorations of sexuality. But in the Whitney show the examination of race, class, and gender remains tentative and superficial.

What the exhibition does afford is a most welcome chance to re-view certain major works from the 1970s which are now known mostly through reproductions in black-and-white publications on conceptual art. (Indeed, many were surprised to find the Bruce Nauman series in color.) Further, it has afforded the possibility of considering Jasper Johns's earlier, autobiographical *Souvenir* in relation to his current, intimate, self-referential paintings. And, finally, it offers a kind of closure on the original conceptual works. Most of the early practitioners have moved on to other themes. Second and third generations only repeat the original postures, reducing what was a literal playing with life-and-death matters to a mere question of style. To find the genuine descendants of conceptual representations of self, one must look to such artist/photographers as John Coplans, again lamentably omitted, whose serial body-works would have provided a connection to the earlier pieces. But the exhibition stops short, like an inconclusive quiz show; and we are left wondering about the true identity of today's artist.

Jerry Saltz

Assault and Battery,

Surveillance and Captivity

Bruce Nauman's art has often been a deliberate assault on the senses, aesthetic and otherwise. He seems to want to throw us off balance visually, psychologically, physiologically, and socially in order to make us painfully aware that art, in the words of Joseph Beuys, "is approached by all the senses—and human beings have a lot of senses." In this way, Nauman continuously challenges the viewer to reexamine expectations, exposing a kind of parallel universe that exists, ghost-like, alongside the one in which we feel comfortable.

Although Nauman has, rightfully, been linked to Duchamp and Johns, it is useful to add Beuys to this list. Despite its irritating and anarchic qualities, Nauman's art has, surprisingly, something in common with the humanist values that are especially clear in Beuys's pronouncements about art. Perhaps more than any other artist of his generation, Nauman emphasizes that creativity is not just some isolated and casual activity, but rather a primary and essential characteristic of being alive.

This past fall was a high-profile time for Nauman. Two new installation pieces, *Hanging Carousel (George Skins a Fox)* and the variant *Carousel (Stainless Steel Version)*, were unveiled. The first was seen in a show at the Sperone Westwater Gallery in New York that also included two early 1970s video corridor pieces; the second was in the Carnegie International in Pittsburgh. These pieces are violent and intriguing and they suggest new directions in Nauman's work. Featuring polyurethane casts of animal carcasses suspended from large rotating merry-go-round structures, they address man's relationship to his natural environment and his use and abuse of animals.

Originally published in *Arts Magazine* 63, no. 8 (April 1989): 13.

In November 1988, Nauman exhibited another new installation piece, alongside new works by Jasper Johns and David Salle, at the Leo Castelli Gallery. Entitled *Rats and Bats (Learned Helplessness in Rats II)*, it was especially powerful, dramatically pulling together and encapsulating many of the basic concerns and elements of Nauman's art. His penchant for wordplay, for relentlessly repeated sounds or actions, for spatial dislocation and socially unacceptable behavior, all play a role in this new piece. Even more important in *Rats and Bats*, however, is that Nauman continues openly to explore the fundamental and complex relationship between the making and the seeing of art.

While considering the meaning of *Rats and Bats*, it might be useful to keep in mind two other "rooms." The first is Marcel Proust's study, lined with sound-absorbing cork. This is the epitome of the darkened womb—an environment all but hermetically sealed off from the noise of everyday existence, where creation takes place in total secret. The other is Beuys's 1985 installation entitled *Plight*, consisting of a felt-covered piano placed in a felt-lined room. It is a room filled with a sense of the imagination's potential and "that which might have been." The silenced instrument and the muffled walls evoke a deep yearning for creativity, which has been denied by the very warmth of the protective but confining material. Nauman has something completely different in store for us in *Rats and Bats*.

In *Rats and Bats*, Nauman confronts the viewer with several futile situations, both in real space and through video. The piece is encountered in a small, darkened room measuring approximately 12′ × 20′, which Nauman had built in the gallery. Upon entering this room, one's attention is immediately drawn to a large advent video screen with its disturbing sound and image: a man clad in blue jeans and T-shirt is beating with a baseball bat on what appears to be a homemade punching bag (it looks like a large duffle bag stuffed with rags or sand). In front of the screen is a compartmentalized transparent cube, about 5 feet on a side, made of yellow Plexiglas—it is a multileveled maze that recalls and condenses the effects of Nauman's corridor and tunnel pieces. Six video monitors press in on the maze, one to a side (even the bottom), their lighted screens causing the yellow Plexiglas to glow eerily. Finally, up in the corner, near the ceiling, is perched a small TV camera (pointing down at the cube), scanning slowly, back and forth.

Nauman has said he wants to "sabotage the hegemony of information." In *Rats and Bats*, the viewer is conscious of losing power over the situation, of being changed from passive observer to participant and

witness, if not target. This produces apprehension but also a sense of freedom and pleasure at being given a new set of circumstances to navigate. One experiences something akin to a countertransference vis-à-vis the piece: the feeling that "it" wouldn't be "it" without you. As Nauman strips away all the usual support of rules and expectations, the viewer begins to empathize, to act along with the artist and play with the situation, short-circuiting the initial helplessness.

For example, the title of the work yields a number of verbal permutations and wordplays, all reflecting some aspect of its possible meaning. Wordplay, it should be remembered, has no rules, no right, no wrong, no winner or loser, only the process of "doing it" and seeing what is hidden. It is not by chance that children love to rhyme. It is a way of empowering oneself, of feeling a sense of mastery over things. Rhyming, punning, and anagramming all provide fleeting glimpses of underlying significance, creating also the feeling of control and pleasure. They're all ways you can have fun with a situation, amuse yourself, or engage in fantasies, without risk.

Think of all the incredibly loaded phrases or sayings that the words "rat" or "bat" figure into: a bat out of hell, rat race, bats in the belfry, like a rat leaving a sinking ship, the bat of an eye, or blind as a bat. In addition, a rat is a bat without wings. The two words are both nouns and verbs. If you beat on (bat) someone long enough they will rat, or "spill the beans." Finally, using anagrammatization (as Nauman always has) *Rats and Bats* can become *star and stab, arts and tabs,* etc., and the word *rats* two times (and it is used twice in the title) can be rearranged into *art stars.*

The gamesmanship in *Rats and Bats* causes us momentarily to drop our pretentions and inhibitions. We are presented not only the picture but the experience of creativity itself, with its pleasure and pain. The viewer is in close proximity to the artist (the man with the bat, or the rat in the maze), alone in the studio, going through the intensely isolated, repetitious, uncomfortable, humiliating, and infuriating process of "making something," and then placing this "thing" in public, for scrutiny. Nauman welds the public and the private, the making and the showing of art, into one inseparable process.

This piece is like several versions of Chinese water torture at once. Over and over the man whacks the bag with crushing force. The sound bores into you until it is almost unbearable. Meanwhile, the TV monitors that surround the cube each beam in three different images (in sequence): the man with the bat; a live image of the room (this comes

from the surveillance camera and means that the viewer can be part of the piece); and, finally, a tape of rats in this very same, now empty, maze. Just like the viewer, they are being subjected to his horrible, nerve-racking pounding, trying to escape or at least to hide—stopping, starting, being frightened to death, standing paralyzed, becoming helpless.

The first impression on entering this room is that somehow you've actually stumbled into Hell. The first words of Dante on his passing through the Gates of Hell do well to describe the initial experience of the Nauman installation:

> Here sighs and cries and wails coiled and recoiled
> on the starless air, spilling my soul to tears.
> A confusion of tongues and monstrous accents toiled
>
> in pain and anger. Voices hoarse and shrill
> and sounds of blows, all intermingled, raised
> tumult and pandemonium that still
>
> whirls on the air forever dirty with it
> as if a whirlwind sucked at sand.
>
> —*Inferno*, Canto III (tr. by John Ciardi)

Although there are no voices here, there is such an incessant racket, such relentless violence, such a sense of "forever dirty" air that you begin to feel nauseous. You want to get out as fast as you can, but you don't. Nauman has sprung the trap, using confusion and tumult, chaos and dread, to draw you in further. An inexplicable feeling arises that you have passed from the normal world into one where everyday rules and regulations are suspended, and hidden laws and meanings are to be discovered. It is as if you have really entered Rauschenberg's "gap between art and life," and discovered it to be a kind of Twilight Zone.

Cantankerous and obstreperous, on one level *Rats and Bats* can be understood both as an unusual experiment and a model of everyday life. It illustrates the "rat race" we each endure while being exposed to abuse and stress that wears us down, confusing us and making us feel helpless. This race leaves us no place to hide, no place to exercise creativity or control. Our humanity is eroded by each blow of the bat, each sweep of the surveillance camera, and every thwarted attempt to escape the maze. The man with the bat, meanwhile, mindlessly and mechanically repeats an empty act of rage. Trapped in a maze of his own devices, he underscores the deeply infernal nature of this piece.

In *Rats and Bats* he portrays two immutable conditions of creativity. First, that sometimes you have to beat the crap out of yourself (or your surrogate self) in order to "make something." Second, that each time you enter into this process there's a moment, no matter how brief, when you think you have lost your way and will never find it again. Terror and rage, exhilaration and joy, drive this process, and force one to return to it over and over again in order to experience one of the most profound feelings in life—creativity.

HPL Central
MON–THU 9-9; FRI-SAT 9-6; SUN 1-5

Customer ID: **********209**

Title: Bruce Nauman / edited by Robert C. Morgan.
ID: R0124985633
Due: 12-07-08

Title: Bruce Nauman : raw materials.
ID: 33477004644796
Due: 12-07-08

Title: Bruce Nauman, 25 years / Leo Castelli ; edited by Susan Brundage ; design by Smart Florence.
ID: R0100660945
Due: 12-07-08

Total items: 3
1/23/2008 2:17 PM

PL Central

David Pagel

Bruce Nauman

If Jasper Johns's grids of numbers and letters began, in the late 1980s, to disengage the smallest units of signification from their social roles, Bruce Nauman's word-images, from the past two decades, piece together these fragments to form puzzling utterances in which the rearrangement of a few letters usually transforms the meaning of a deceptively innocuous phrase into a startling, often hostile imperative. Across the top half of *M Ampere* (1973), for example, Nauman has inscribed, in reverse, the name of the French physicist credited for formulating the unit measure of electrical current. Underneath these block capitals, he has arranged the seven letters to spell, also in reverse, "RAPE MME." By retarding the speed of the act of reading, Nauman forces his readers/viewers to return to the ways they learned their language. Like schoolchildren, his audience must slowly sound out the strangely arranged yet familiar symbols until their message becomes clear. By reconfiguring a man's name into an ugly command, Nauman's ostensibly nonsensical three-word phrase teaches that although meaning is predicated on the play of linguistic difference, language's real force derives from the claim it makes on embodied speakers. The bottom line's doubled *M* suggests that the speaker of this perverse request stutters when the play of signification suddenly and violently implicates his body. Indeterminacy returns to Nauman's malevolent anagram when its last three letters are read as the abbreviation for the French word *madame*. Although this shift in reference prevents the speaker from requesting his own victimization, it does so only by transferring this fate to an anonymous woman. According to Nauman's

Originally published in *Art Issues,* no. 8 (December 1989/January 1990). © 2000 The Foundation for Advanced Critical Studies, Inc. Reprinted by permission.

dark lithograph, language's permutations are not formal exercises in which signs are substituted and reused in an abstract realm of deferral and uncertainty, but are part of a potentially threatening game that has grim consequences for the bodies of its participants. Another black-and-white lithograph from 1973, also in reversed block capitals, admonishes and insults its audience: PAY ATTENTION MOTHERFUCKERS." Using the crude language of bathroom graffiti, Nauman constructs an image modeled on the most subtle plays of sophisticated linguistic theory. The power of this simple imperative lies in its invisibility. Once the graphic message is recognized, the formal beauty of the paper's surface is defeated and a response, alternating between defensiveness and paranoia, grips the viewer; any reader capable of engaging the piece's purpose snaps to attention only to realize that there is nothing, in Nauman's picture, worthy of that sort of concentration. Before this absence in the field of vision, the viewer instantly alerts himself to his surroundings and wonders: what am I missing, in the world, when I focus on this matter-of-fact sign-like art? Nauman's reductive object thus denies its status as a powerful presence in order to point to that which is absent. As indeterminate as it is threatening, *PAY ATTENTION* works by suggesting that whatever deserves one's scrutiny is just beyond one's vision.

Where Johns took fundamental reference points of American culture—the flag, the numbers from 1 to 10, the letters of the alphabet, the target, the map of the United States—and painted them over with the flamboyant brushstrokes of abstract expressionism to make some of the most tragically romantic paintings of the past thirty years, Nauman takes the violence underlying these official versions of culture and infuses its threat into simple studies of basic phrases to make some of the most menacing prints of the past twenty years. In the work of Johns, the symbols of order (intellectual, perceptual, geographical, or civic) seem to be vanishing within his treatment rather than being recorded or given presence by his melancholic paintings. Effaced or silenced as they become the basis for beautiful works of art, these fundamental ordering systems sink out of sight as though they were as temporary as any other cultural code. In Nauman's work, however, these experience-grounding orders return to assert their claim over the most basic forms of human experience—fear and anxiety, dread and malaise, bodies and politics. In Nauman's prints, rebukes replace refusals: Johns's disquieting silence breaks into a rude cacophony of jeers and indictments, threats and misrepresentations. Language collides, in Nauman's inele-

gant world of televisions, clowns, defecation, and neon, with its referents, just as Johns's poignant meditation on muteness and incommunicability gives way to the vengefulness and manipulation of Nauman's diabolical projects. *Studies for Holograms* (1973), four photographic prints of Nauman's face being poked, pulled, pinched, and probed by his own fingers, summarizes Nauman's impatience with the resounding silence implied by Johns's poetic rumination on language's diminished potential and lost powers. Resembling an idiot's scrutiny of his lips, teeth, mouth, and throat, Nauman's prints ignore language's abstract play in favor of trying to locate its bodily source. Grounded in sound, Nauman's words always implicate the corporeal forms of their speakers and readers: they exploit their subjects' vulnerability to find the ground where bodies and signs collide in a struggle to make sense of madness.

Andrew Winer

Bruce Nauman

Mallarmé wrote that the perfect object is never an extension of you, it has to change you. This assertion fittingly describes an exhibition of new work by Bruce Nauman, in which Nauman continues to utilize his body to explore subjectivity—and, more often than not, it is the human body being subjected. Suspicious of explanations, Nauman presents objects and video installations which refuse ordinary models of causality and map a new set of coordinates which lie outside social critique, where morals are unlocatable and Nauman's own stance remains cunningly undefinable.

In choosing video, Nauman embraces a form one might expect to conflict with the content of his work, putting forth double-edged artworks which assault us upon viewing and haunt us after leaving. No longer a fresh, unexplored medium, video now has an established position in art history, associated with cheap movie rentals and kitschy home-video television shows. Reading Nauman's video works within this framework, a layer of domesticity is revealed, with its associations of hidden violence, torment, and both physical and emotional states of being. Our awareness that *Raw Material—"OK, OK, OK,"* for example, was taped in some private location (perhaps Nauman's home), displaces the work from its context in the gallery and reinforces the sense of privacy implicit in the art. In addition to expressing Nauman's recurring theme of the desperation of human processes, his urgent and pleading "OKs" produce a proliferation of references to modes of domestic violence ever-present in the social conscience of our time. There is a sense of paradox in the relationship between the digitally encoded

Originally published in *Art Issues,* no. 17 (April/May 1991). © 2000 The Foundation for Advanced Critical Studies, Inc. Reprinted by permission.

videotape and our bodies, in Nauman's utilization of a cold electronic box to deal with the fleshy and vulnerable body in its pain and suffering.

The resonance of Nauman's art results from his avoidance of an interpretive/descriptive methodology, whereby viewers acknowledge the work and nod their heads in either agreement or disagreement. Instead, his work creates what Gilles Deleuze calls "the line of flight." Nauman creates himself in and through his work, producing ruptures in the social matrix which codifies our expectations. We neither agree nor disagree: we are hit by a train. Nauman confronts us with disturbing models rather than literal critiques or complaints of social and urban ills. Well aware of his own implication in such ills, Nauman escapes the smugness found in weaker political art by using representations of himself in his work.

Nauman's refusal to be consumed by his environment depends on the multiplicity of contradictions inherent in the work. The forced intimacy of the heads in *Andrew Head/Andrew Head Reversed, Nose to Nose,* and the resulting seductiveness of their colors and waxy surfaces, directly conflict with their gruesome references to decapitation and mutilation (disembodied tongues are forced back in the mouths). These heads, placed on pedestals, perform an historical trope by reinserting references to ancient Greek and Roman busts into contemporary art practice, with a twisted sense of humor. Similarly, one is drawn to the elegance of the aluminum *Fox Wheel* once one realizes it is made of taxidermal casts of foxes and that, furthermore, the foxes are biting each other's legs. The video installation *Raw Material—"MMMM,"* placed in a dark room and depicting Nauman humming, conjures up an image of a body in meditation. This transcendental reading is then confused by the nagging rotation of the isolated head and the artificiality of the video image. The strength of this work lies in its ability to create a sense of horror and uneasiness while invoking humor; we don't know whether to laugh or be disturbed. The truth is we have no choice but to do both.

Michael Kimmelman

Space Under a Chair,

Sound from a Coffin

You are walking down a narrow corridor toward a video monitor that, when you get close to it, displays your image, observed from the back by a surveillance camera you didn't notice when you entered the corridor. You are in a room, empty except for two loudspeakers implanted in the walls from which a man's voice assaults your ears, insistently demanding that you leave. You are standing beside a carousel and the riders are cast-aluminum forms of dead animals strung up by the neck or feet, scraping along the floor as they're dragged by the rotating beams.

Where are you, and how can you get out of there? You are in the Bruce Nauman retrospective here at the Walker Art Center, and if you are like most people, the urge to flee is strong. Mr. Nauman's goal seems to be to knock you out rather than win you over. His work is aggressive, paranoiac, ridiculous, and loud. In fact, this must be the loudest show in years.

It is also powerful stuff, if you permit yourself to break through the barrier of outrage. The critic Andrew Porter once wrote about passing the point of rebellion at the "needle stuck in the groove" quality of "Einstein on the Beach" and succumbing to Philip Glass's score. No surprise that Mr. Nauman has been influenced by minimalist composers or that his work provokes much the same love/hate reaction their music does.

Taxing is one word that describes this retrospective of sixty-six works (here through June 19, then in Los Angeles, Washington, and, in March 1995, at the Museum of Modern Art). Other words are memo-

Originally published in the *New York Times,* April 24, 1994. Copyright © 1994 by the New York Times Co. Reprinted by permission.

rable, important, artfully choreographed (by Kathy Halbreich of the Walker and Neal Benezra of the Hirshhorn in Washington), and overdue, considering Mr. Nauman's influence.

At 52, he may be the most influential American artist around, which can sound grandiose, not to say surprising, considering that the last full-dress retrospective of his work in the United States was held more than twenty years ago, when his career was less than a decade old. But his art has traveled almost every highway and byway of the contemporary scene, beginning with postminimalist sculpture and including performance, environmental, installation and process art, conceptual art, photography and video, political art, and even holography. The list of those who have followed him down one or another of these roads is long.

His signature style is the lack of one. He once praised Man Ray because "there appeared to be no consistency to his thinking, no one style." Even more than with Gerhard Richter or Sigmar Polke, you begin to understand Mr. Nauman only once you see the eclecticism. He has made a giant stick figure out of latex and cloth; turned wordplay into neon signs ("RAW = WAR"); built models for imaginary underground tunnels; placed a microphone and video camera in a coffin; filmed himself poking a finger into his eye; and made, out of a chair, steel beams, and cables, a sculpture meant to decry the torture of political prisoners in South America.

What ties all these works together? For one thing, Mr. Nauman's willingness to experiment, maybe to fail. Far more than most artists, he doesn't seem to be afraid to try out new ideas in public and see how they fly (his openness has been especially liberating for younger artists). Sometimes the ideas fly; often they don't. Many of the pieces from the 1970s, for example, are dry, dead-end conceptual exercises, implacably boring. But even when his art doesn't work, you admire the probing spirit behind it.

Almost despite himself, he's a gifted draftsman. His early sculptures made out of odd materials, cousins of those by Richard Serra and Eva Hesse, look good here. But his career has mostly been about getting away from traditional art objects, even when these objects are as untraditional as the body-cast sculptures of the mid-1960s.

Mr. Nauman was born in Fort Wayne, Indiana, and studied art in California with William T. Wiley and Robert Arneson, two artists whose anarchic and punning sensibilities affected him considerably. Other influences included Jasper Johns, Samuel Beckett, Alain Robbe-

Grillet, Meredith Monk, and Steve Reich. What came out of that stew is Mr. Nauman's deadpan, slapstick, ironic, downbeat, purposefully repetitious art—repetitious in the way that Ms. Monk's dances and Steve Reich's music are (and deadpan like Mr. Johns's art, but much more confrontational).

A prime example is *Clown Torture*, deafening video installation repeatedly showing clowns in embarrassing, discomforting situations, one of them screaming "No, No, No," so that you eventually wonder whether the title means the clowns are being tortured or you are (the answer is both, I think). Futility is a consistent theme in Mr. Nauman's art. *Learned Helplessness in Rats* with its videotape of rats frantically navigating a maze to the pounding sound track of a punk drummer, derives its title from a *Scientific American* article about rats made helpless by auditory stress.

Futility, abuse, family conflict, and death: it's possible to see Mr. Nauman as the ultimate dysfunctional teenager on the basis of his morbid obsessions and dumb jokes and back-of-the-garage concoctions.

But that may be to underestimate the effects, auditory as well as visual, not to mention the irony, that he calculatedly builds into his work. Consider the low, ominous sizzle and the blinding burst of light, like a flashbulb's, that accompany the neon sculpture *Violins Violence Silence*. Or the just-off colors of the suspended wax heads in *Ten Heads Circle/Up and Down*. Or the incantatory rhythms of the chanting voices in *Good Boy Bad Boy* and *Get Out of My Mind, Get Out of This Room*. Or the weirdly hypnotic, even soothing, super-slow-motion ballet of himself, moving like a whale rising out of water, in the video *Poke in the Eye/Nose/Ear*.

Mr. Nauman's art is about heightened awareness, awareness of spaces we usually don't notice (the one under a chair, out of which he made a sculpture) and sounds we don't listen for (the one in a coffin), awareness of emotions we suppress or dread.

There is something about this that puts me in mind of the critic Harold Rosenberg's famous reference to the canvases of New York School painters as arenas for action. "In this gesturing with materials, the esthetic . . . has been subordinated," he wrote. "What matters always is the revelation contained in the act. It is to be taken for granted that in the final effect, the image, whatever be or be not in it, will be a *tension*."

He could have been describing Mr. Nauman's art. What separates it, in the end, from that of so many conceptualist epigones is this tension—his embrace of the subjective, the antididactic, qualities that

nowadays can make him seem almost like a throwback. It may seem funny to think of an inveterate iconoclast like Mr. Nauman that way, but after all, his heroes include Beckett, who belonged to the same generation as Rosenberg's Action Painters (and Rosenberg, for that matter).

Little wonder, anyway, that he inspires reverence or loathing, as this show is bound to do. It's hard to feel indifferent toward work like his.

Peter Plagens

Return of the Galisteo Kid

If there were ever an exhibition to provoke a museum guards'
strike, the Bruce Nauman retrospective at Minneapolis's Walker Art
Center is it. Day after day (through June 19), those laconic, uniformed
heroes, without whom no museum could display its art, will not only
have to field more questions than usual from a puzzled public, but
they'll have to bear up under the dissonant din of Nauman's video in-
stallations. Into one ear will come the shouts of "No! No! No!" from
Clown Torture (1987), while into the other will ricochet the racket of
Learned Helplessness in Rats (Rock and Roll Drummer) (1988). Guards
could turn in their badges like Kojak being taken off a case.

The casual visitor should have an easier time of it—only partly be-
cause two hours of modernist cacophony is endurable. The real
amenity of Nauman's show (which will travel to Los Angeles, Wash-
ington, D.C., and New York) is that it's an excellent survey of perhaps
the most influential American in the international art world today.
(Nauman won the $100,000 Wolf Prize for sculpture, awarded in Is-
rael, in 1993 and is this year's Wexner Prize recipient.) Europeans in
particular take to Nauman's aw-shucks Duchampism like vacationing
arbitrageurs to their inner child. Nauman is enigmatically conceptual
enough to tantalize the critics, but he's also facile enough to seduce big-
time collectors like Count Panza and Eli Broad. Underlying all of Nau-
man's work is a fluency in drawing—a "wrist"—that renders his art sur-
prisingly kind to the eye. The touch is in everything he does. It's there
in his mid-1960s "antiform" fiberglass sculptures and austere videotapes
of him seeing how many positions he can assume with his own body
and a fluorescent light fixture. And it's still around in the recent ani-

mal-cast sculptures like *Carousel* (1988) and the super slo-mo videodisc *Poke in the Eye/Nose/Ear* (1994).

That doesn't mean Nauman, 52, is an easy artist to figure out. The Fort Wayne, Indiana, son of an engineer, Nauman attended the University of Wisconsin as a swimmer and science student. After being soundly beaten in several races, and discovering that using calipers and a calculator for nose-volume-measuring contests in the dorm was more interesting than physics, he switched to art. Nauman pursued graduate study with Bay Area funksters William Wiley and Robert Arneson at the University of California, Davis. The school gave him a studio cubicle and said, in effect, stay in it, kid, and make some art. With logic straight from Occam's razor—the philosophical rule that says limit your premises to what's absolutely necessary—Nauman made art about hanging out in the studio figuring out what to make art about. His early work includes the wax cast of a roped torso called *Henry Moore Bound to Fail* (1967) and, the videotape of a silly *Slow Angle Walk* (1968) that presaged John Cleese's fictitious minister by two years.

The 1980s Nauman proceeded with the guileless imagination of a boy playing pirate on an orange-crate frigate. According to Walker director Kathy Halbreich, the wistful 1983 sculpture *Musical Chairs: Studio Version*—an aluminum circle, wooden beams, and three tilting chairs suspended from the ceiling—was concocted out of refuse Nauman scavenged while wandering around Cologne to come up with something for a gallery show. Coming up with something is what Nauman does best. He takes Jasper Johns's famous dictum—"Take an object, do something to it, do something else to it"—one Nike step further: he just does it. If the work turns out to be spookily interesting (like the 1968 audiotape *Get Out of My Mind, Get Out of This Room*, which growls through speakers hidden in walls) or just fun to look at (like the untitled 1967 sculpture of two crossed arms topped by an anthropomorphic knotted rope), fine. If not, Nauman goes on to something else.

These days, Nauman lives on a Galisteo, New Mexico, ranch with his wife, the painter Susan Rothenberg. Flintier and wiser than the kid who once photographed himself spitting out water and called it *Self-Portrait as a Fountain*, he's now into horse training. That seems about as far from a power position in the art world as one could get. But Nauman has always done things his own way, and relied on the good-natured conundrums in his objects to win people over. It's always worked with collectors and critics. Maybe it'll carry the day with security guards, too.

Kenneth Baker

Nauman Was the Man to Watch

For best museum exhibition of 1994 there are worthy con-
tenders. "Prince of Dreams: Odilon Redon" at the Art Institute of
Chicago and "Willem de Kooning: Paintings" at the National Gallery
and New York's Metropolitan Museums jump to mind.

The survey of paintings and drawings by R. B. Kitaj now at the Los
Angeles County Museum of Art (through January 8) is a revealing, en-
ergetic event, too, as was—in very different terms—the fall's survey of
early French photographs by Edouard Baldus at the Met.

Is it fair, or even possible, to judge such diverse, successful, high-
caliber projects against each other?

The art event of the year does not settle this question but simply
blots it out. It is the retrospective "Bruce Nauman," on view through
January 29 at the Smithsonian's Hirshhorn Museum and Sculpture
Garden in Washington. For surprise, intensity, pertinence, and restless
inventiveness, nothing in recent memory competes with this show.

(I have not seen "Bruce Nauman" at the Hirshhorn, but did catch it
at its two previous American venues in Minneapolis and Los Angeles;
each presentation has involved logistical adaptations.)

Not a household name, and not likely to become one, Nauman is a
53-year-old American artist who has worked in just about every
medium, from photographs, performance, video, and recorded sound
to steel, wax, concrete, neon signage, and interior architecture.

In the late 1960s, Nauman was considered a conceptualist because ma-
terials and techniques seemed to interest him only for their convenience
in materializing his ideas. The retrospective revises this view twofold.

Originally published in the *San Francisco Chronicle Datebook*, December
25–31, 1994.

It presents Nauman as a sculptor who, although always focused on the spells ideas cast, cares plenty about the physical detail and historical echoes of what he fabricates. It also shows him to be an unflinching performer-director determined to expose the invisible vectors of power that structure the making and viewing of film.

Visitors who enter Nauman's show seeking or expecting a contemplative experience are likely to leave feeling disappointed or even abused. (They include several professional critics, I'm told.) The abrasive aspects of Nauman's work—in imagery, language, and noise level —can send people away cringing.

The Nauman show stages many confrontations.

If art is presumed to be therapeutic in a society sick with its own contradictions and the denial they incite, then Nauman's art might be described as homeopathic.

He challenges the assumption that to be critical of the ambient culture, art must masquerade as its opposite. For instance, his video pieces that appear to respond to implicit and explicit violence in Hollywood entertainment are themselves punishing to watch.

His multichannel 1987 piece *Clown Torture* shows on several monitors a man in a clown suit and makeup subjected repeatedly to various mild torments, not least of which is the performance itself.

These include walking through a door above which a bucket of water is poised to fall and reiteration of a "Pete/Repeat" joke that never ends because "repeat" is always taken as a cue to continue rather than as a silly homonymic pun.

With vaudevillian crudeness, *Clown Torture* makes us experience afresh the sort of split-minded sophistication we exercise unselfconsciously (and therefore, sooner or later, unconsciously) as we watch everything from Calvin Klein commercials to *Pulp Fiction*.

Simple, absurd, and repetitive as it is, *Clown Torture* restores immediacy to the process of taking in a mediated entertainment, opening like forgotten wounds the gaps in logic, alertness, and sympathy to which editing and other conventions have anesthetized us.

The neon piece *Violins Violence Silence* (1981–82) alternately flashes these three words in several colors, overlapped to form a loose triangle. It links the cynical simplifications of the shop sign with a sense of society, such as we might get from news media, as an alternation among the violins of official culture, the violence of the streets, and the silence of an isolated private life.

As a career retrospective, "Bruce Nauman" draws a zigzag line from

early pieces in which his own body was both subject and work area to recent ones such as *Ten Heads Circle/Up and Down* (1990), in which five pairs of cast-wax male heads hang from the ceiling.

As so many of his works do, *Ten Heads Circle* . . . arranges a collision between literal meanings or crude puns ("going head to head") and more elusive or intolerable readings, such as the heads' hint of being trophies of torture or combat.

That double-edged quality is apparent even in many of Nauman's quietest, most low-tech pieces, such as *Hand Puppet* (1990), where a glove's shadow on glassine is a signature of both artistic authorship and possible moral disintegration.

How we grasp and tolerate what we are doing to ourselves and what we see done to each other, how we feed on complications to keep ourselves numb: These are themes that make Nauman's work seem like the most necessary art being made today.

Paul Richard

Watch Out! It's Here!

Bruce Nauman is the ultimate *pay-attention!* artist. There are cutting mental dangers, traps and swift reversals in his edgy retrospective, which goes on view today at the Hirshhorn Museum and Sculpture Garden. Be alert, his art insists. Watch out. Stay alive.

His videos and neons, his wax heads and his holograms, offer no consolations. Nauman is an artist who, to use his phrase, distrusts the "lush solution." His sculptures—made of Styrofoam, felt, sound, or grease—never let you bask in transcendental loveliness. He'd rather show up in your thinking space—and club you from behind.

"From the beginning," Nauman told an interviewer in 1988, "I was trying to see if I could make art that . . . was just there all at once. Like getting hit in the face with a baseball bat. Or better, like getting hit in the back of the neck. You never see it coming; it just knocks you down."

Nauman's flashing neons—for example, "Run from Fear, Fun from Rear," the one about one pursuit from 1972—tend to grab you all at once in the jaws of a pun. There's no time to protect yourself: you read and you are caught. His claustrophobic corridor—with television monitor and concealed surveillance camera—is equally efficient. It lets you glimpse your body only as you're leaving, but it gets you every time. You thought that you were watching it. But it was watching you.

Nauman's retrospective is balanced on that sort of switch, that turning of the tables. You may enter his retrospective, as you would another's, expecting to discover the artist's personality, the mode of thought, the signature, that ties—or fails to tie—his diverse works together. His signature is there all right (sometimes stretched out into

Originally published in the *Washington Post,* November 3, 1994. © 1994 The Washington Post. Reprinted with permission.

"bbbbbbrrrrrruuuuuuuccccccceeeee), but the artist remains hidden. The more you think, the more you look, the less you see of Nauman and the more you see of you.

The first Nauman one encounters is hanging in the lobby. *The True Artist Helps the World By Revealing Mystic Truths* is a sign in spiraled neon from 1967. He has said that he conceived the piece when looking, from the back, at the discarded beer sign hanging in the window of a storefront studio he had rented in northern California.

"The most difficult thing about the whole piece was the statement," he observed in 1971. "It was a kind of test—like when you say something out loud to see if you believe it. Once written down, I could see that the statement, 'The true artist helps the world by revealing mystic truths,' was on the one hand a totally silly idea and yet, on the other hand, I believed it. It's true and it's not true at the same time. It depends on how you interpret it and how seriously you take yourself."

Do you believe it? Is there holiness or nonsense or perhaps a bit of both in that neon sign? As with most of Nauman's works, the answer's up to you.

Nauman is an artist as much at ease with absences as he is with objects. His *Neon Templates of the Left Half of My Body Taken at Ten-Inch Intervals* (1966), with its flickering purple flames and glowing lines of green, is a thing of real beauty. And he is as comfortable with performances as he is with objects. Who else would film himself playing a violin tuned D, E, A, D? His materials vary widely. Sometimes he makes sculpture-puns, sometimes he makes portrait heads just the size of life. One of his best pieces is a noisy empty room.

The walls are white, the floor is bare. The only thing that's there is the artist's voice growling animalistically, slowly, and incessantly from a pair of speakers buried in the walls: *"Get . . . out . . . of . . . the . . . room,"* the voice demands. *"Get . . . out . . . of . . . my . . . mind."* The experience is uncanny, and it is precisely that experience—of banishment, rejection, and thrown-back curiosity—that's the subject of the art. "Nauman makes us squirm," writes critic Peter Schjeldahl, "and by 'us' I mean fans. What he makes others do, in my observation, is glaze over, tense up and flee."

"Get . . . out . . . of . . . the . . . room. Get . . . out . . . of . . . my . . . mind," despite its germ of humor (and there is a smile in it, as in lots of Nauman's art), is just about unbearable. The artist, 52, acknowledged a few years ago that it's "really frightening." Still it's easier to take than is his screaming clown.

Now, clowns are there to make us laugh. When they fall down on their fannies, or get bopped on their heads, it's supposed to be a joke. The clown in Nauman's video piece—*Clown Torture* (1987)—is writhing on the floor, wagging his big shoes, saying, "No, No, No." But his voice keeps getting louder, and his terror more authentic, until your smile freezes and you feel yourself encased in horrified concern. When did your empathy take over? What flipped the switch?

"I got interested in the idea of the clown first of all because there is a mask, and it becomes the abstracted idea of a person. It's not anyone in particular, see, it's just an idea of a person. And for this reason, because clowns are abstract in some sense, they become very disconcerting. You, I, one, we can't make contact with them. It's hard to make any contact with an idea or an abstraction."

Yet if we can't make contact with that video image until our armor falls away, how are we to feel the real pain we see almost every night in newscasts on TV? That Nauman keeps insisting on such nondidactic questions, and cares about the answers, is what holds his art together. Never for a moment does one doubt the man's integrity in this anxious and unsettling knockout of a show.

Although he claims he prefers Man Ray, and says he has learned more from Jasper Johns, Nauman is a sort of American Marcel Duchamp. Like Duchamp he loves puns. And films, and casts of body parts, and disparate materials. And like the Frenchman he insists that his art be aimed beyond the shudder of the retina, that its crucial work take place in the observer's mind.

But Duchamp was a mandarin of high and distanced elegance. Nauman, who was schooled at the University of Wisconsin, and then at the University of California, Davis, is another sort of guy. Duchamp was a wondrous wit. Nauman is a humanist, as well as a proctor. Duchamp enjoyed playing master-level chess. Nauman raises beef cattle and trains quarter horses on his ranch in New Mexico.

And he makes his own knives.

His is not a show for cowards. His exhibition bruises. A number of his latest works—suggestive of a place where slaughterhouse meets merry-go-round—are made from the life-size forms, of wolves and deer and caribou, that taxidermists use to mount the trophies hunters kill.

What are we to picture when looking at such objects? Marsyas the satyr flayed in Titian's canvas, or the skinless horses Thomas Eakins used to bring into his drawing class, or the demarcations between inside and out? But no sooner does your mind start flitting toward such

memories than Nauman tugs it back—to grueling and implacable thoughts of life and death.

The man is highly thought of here (in part because such curators as Jane Livingston and Walter Hoops and Baltimore's Brenda Richardson have long been Nauman fans), but not until this show did we have a chance to see how fierce he really is. The Nauman retrospective was organized by Neal Benezra of the Hirshhorn and Kathy Halbreich of the Walker Art Center, Minneapolis. See it and you'll have no doubts: Nauman blows away such pale post-Duchampians as disappointing Robert Morris and the friendly flakes of Fluxus. His scary yet exalting vision is the real thing.

Joan Hugo

Bruce Nauman

In Bruce Nauman's early work from the 1960s, one glimpses
shadows of the work of his teachers at UC Davis: Robert Arneson's vis-
ual puns and William Wiley's penchant for amusing and lengthy titles
(as well as pages borrowed from Man Ray, one of his acknowledged in-
fluences). Under their tutelage, Nauman quickly developed a distinc-
tive, economical style that efficiently layers multiple meanings and in-
terjects wry subtexts that mock formalist concerns. The selection of
sixty-seven works in his MOCA retrospective, organized by Neil
Benezra of the Hirshhorn Museum and Sculpture Garden and Kathy
Halbreich of the Walker Art Center, documents performances that uti-
lize Nauman's own body as raw material, and trace the development of
an increasingly complex response that has come to encompass a more
political dimension, finally to invoke a classic metaphor: the clown/
jester/mime presented in ambiguous situations of pain, torture, and vi-
olence. This recurrent trope is saved from romantic cliché by its deeply
ironic edge, which avoids all sentimentality and draws the viewer into
the work.

This edge is present at the outset. The concrete-block *A Cast of the
Space under My Chair* (1965–68) refers to a remark by De Kooning, but
also echoes the human body and makes literal the idea of negative
space. The photograph *Self Portrait as a Fountain* (1966–67/1970), one
in a series of visual puns, introduces bodily functions as a frequently re-
curring theme in Nauman's art, and in effect completes Duchamp's
own *Fountain*. The videotape *Manipulating a Fluorescent Tube* (1969)
can be read as a document of one of Nauman's many studio perfor-

Originally published in *Art Issues*, no. 35 (November/December 1994). © 2000.
The Foundation for Advanced Critical Studies, Inc. Reprinted by permission.

mances as well as a formal exploration of manipulating a volume in space—or as an aside to Dan Flavin. The four films that constitute *Art Make-Up* (1967–68)—in which a deadpan Nauman covers himself successively with white, pink, green, and black body paint—can simultaneously be understood as a projection of the self through paint onto a surface, as in abstract expressionism, or as a perverse commentary on color theory.

Whether using his body as a template, distorting his face in a series of holograms, or performing esoteric tasks in his studio, Nauman's use of his body and its surrogates (his signature, his voice, a cast head, a chair) is consistent. With the first of his corridor pieces in 1970, however, Nauman shifts the emphasis from his own body to the viewer's. Nauman asks viewers to "perform" the work through an interaction with surveillance cameras, which play back unsettling, out-of-sync versions of the viewer's own trajectories while navigating the space. As Nauman explored this aesthetic territory further in the 1980s, the tone of his work shifted menacingly toward more violent images and abusive situations, suggesting a heightened social awareness and a greater aesthetic desperation. One of Nauman's most chilling installations, *South America Triangle* (1981), is part of a trilogy that suggests the brutality of life in the Third World. In each of the three works, a chair is suspended at eye-level at an unnatural angle. Again, the viewer is implicated; steel beams form a circle, square, or triangle, and what appear to be merely formal concerns become politically charged.

The roles of the artist and the viewer, each implicated as both victim and perpetrator, become dislocated in works like *Clown Torture* (1987). In this twenty-minute, multiscreen video and sound installation, clowns undergo the tortures of seemingly impossible or humiliating tasks endlessly repeated, all filmed from disconcerting visual angles and with an assaultive volume. In various scenes, a clown holds a goldfish bowl against the ceiling with a broomstick; opens a door which triggers a bonk on the head from a bucket filled with water; reads, talks, and shits in a public toilet; recites a version of a Pete and Re-Pete joke; and gives a highly agitated performance of "No! No! No!" The intensity and repetition are highly abrasive, and ultimately raise the questions, Who is the Clown? Who is being tortured?

Shit in Your Hat—Head on a Chair (1990) positions the artist, represented by a plaster-cast head on a suspended chair, as a relentless taskmaster barking absurd instructions—"Shit in your hat. Put your hat on your head. Put your hat on the table. Put your head on your

hat."—to an eager-to-please mime, who may also represent the artist. Like the clowns, the mime submits to a torturous ritual, bullied into obedience. Coming full-circle with the retrospective's most recent piece, *Poke in the Eye/Nose/Ear 3/8/94 Edit* (1994), Nauman returns to his own body. The viewer winces as the artist performs, in silent slow-motion close-up, an excruciatingly literal version of the work's title. The self-inflicted torture by and of the artist/clown provides a wince of ironic self-recognition.

Paul Mattick

Bruce Nauman

Everybody who counts likes Bruce Nauman's work. But why should this be? His retrospective is filled with loud noises, offensive words, boring or ugly images. An early piece sets the tone: *Made in 1968*, it consists of a small room lit by a bare bulb and containing nothing but two speakers set in a wall from which the artist's voice endlessly repeats: "Get out of this room, get out of my mind." Is this bad faith? After all, Nauman has set this room up for us to enter; if it's only to drive us out again, that's an unpleasant thing. On the other hand, it leads to interesting questions about the relation of artist to audience, and about what sorts of pleasure art is supposed to give.

"Get out . . ." sets the tone for the works in this show not only in the strain it puts on the relation between artist and audience, but also in the conflicting relation between its means and content. Much of Nauman's art employs cool (in McLuhan's sense) media like video, neon, and canned sound to carry messages about intensely hot matters, of bodily experience and social relations. This is hardly a unique procedure but it's carried out here with great ingenuity and imaginative variations, and is more a matter of spirit than specific materials. In the 1966 *Neon Templates of the Left Half of My Body Taken at Ten-Inch Intervals*, for instance, the body is present only in its absence, evoked by the ghostly glow cast by a vertical array of horseshoe-shaped greenish neon tubes that make a fractured contour map of the physical self. As with most of the neon pieces, the dangling wires and transformer that power the work place the technology employed, the machinery of metaphor, squarely within its visual substance. If art preserves experience by replacing it, this involves loss as well as survival.

Originally published in *Trans* 1, no. 1 (1995).

Nauman can derive similar effects from materials closer to a sculptural tradition. *Carousel* (1988), for instance—a large motorized contraption that drags aluminum casts of a dead bear mother and cub, two wolves, and a deer around a surface on which they leave a circular track—plays the dull metallic character of its parts and the ungainly shape of the object, against its heart-rending imagery. The image of the mechanized destruction of nature expands to encompass the human holocausts of modern history. Such a theme would be disfigured by beauty; Nauman has found a mode of harshness which, freed of aesthetic quality, is not titillating either.

Nauman's earlier productions derive directly from the modernist artist's focus on the self and on art-making in particular. We are shown the artist's name in various forms, his image on video and in holograms, the space under his chair (cast in concrete, it is at once an homage to and a parody of Minimalism), the shape and size of his body. A sort of climax to such explorations comes with the 1966 *Art Make-Up* videos, which project colossal images of Nauman smearing pink, white, green, and black make-up on his face and torso in a spectacular farewell to painting, the high art of the self. A later video, *Black Balls,* in which he applies black make-up to his testicles, mocks the gender of modernism's heroic artist, as does the slow-motion masturbatory *Manipulating a Fluorescent Tube* a *reductio ad absurdum* of minimalist machismo.

In contrast, the high-walled portable corridors Nauman began to construct for exhibition spaces in 1969, like the uncomfortably shaped yellow-lit triangular room of 1973, allow others, in the artist's words, "to have the same experience instead of just having to watch me have that experience." A particularly thorough example of this strategy has the visitor approaching his or her own image, filmed from the back by a video camera at the corridor's entrance, on a monitor placed at its other end. The viewer thus becomes part of the spectacle he or she is viewing, a reflexive experience from which the only escape is, once again, to get out of the room, and this time out of his or her art-viewing mind.

A 1985 video installation similarly embraces the viewer: its text, read simultaneously on two monitors by a woman and a man, begins: "I am a good boy. You are a good boy. We are good boys. I am a bad boy. You're a bad boy. We are bad boys . . . I am a good girl," progressing through a list of qualities, actions, and states that enumerate the elements of a human-scale worldview. This is related thematically to *One*

Hundred Live and Die (1984), a four-column array of neon signs nearly 9 feet high by 11 feet wide. Individual lines flash on and off like barroom advertisements, ranging from KISS AND DIE through PISS AND LIVE to YELLOW AND DIE and YELLOW AND LIVE. At the end of the cycle they all go on at once in a blaze of pink, black, yellow, blue, red, and white, testimony to the richness as well as the limitations of life's possibilities.

Nauman's embrace of the spectator has involved a move from the tedium of his earlier videos—artily low-rent records, in black and white, of bodily movements within the studio—to more visually gripping uses of action and color transcending the world of art. The 1987 installation *Clown Torture,* simultaneously repellent and fascinating, like a souped-up Warhol film, makes reference to the theme of the artist's condition, evoking as it does the long-used figuration of the artist as clown. Pagliacci wept inside his "mask" while the audience laughed; Picasso's saltimbanques and harlequins acted as roles of grace and sensitivity on the margins of bourgeois society. Nauman's four clowns, shown on monitors or wall projections, are pathetic, repulsive, aggressive; trapped in repeatedly unfunny jokes, as unpleasant for the gallery visitor as for themselves. Their very wretchedness, their lack of grace, expands their reference from artist to everyman.

Such a decisively dark view of contemporary existence has the ring of truth about it, in tune with any day's newspaper or walk around the block. The art world's embrace tends to neutralize the reality effect Nauman works so hard to achieve with unaesthetic media and imagery. Art acts to incorporate the darkest vision into the world of commercial high culture. The artist, like anyone, can only do his best; if Nauman's outlook is bleak, it's one from which others are not excluded.

Ronald Jones

Bruce Nauman

I'm meandering. "Pay Attention Motherfucker!" the barker sneered as I strolled through the muddy carnival streets of the historical sideshows and critical freak shows that rolled into town and set up shop just outside the Modern. These sagging tents will be there, along 53rd Street between Fifth and Sixth Avenues, for the duration of the Nauman retrospective. If you walk over to the carousel and jump up on one of the horses spinning round it seems everybody's pitching the fast ball, talking about: Wittgenstein, Beckett, Robbe-Grillet, the usuals. I suppose I could do that, but for now my thoughts are wandering off in another direction. Before these tents were pitched, I began thinking about Bruce Nauman in ways I've always reserved for Martin Scorsese, Stanley Kubrick, Francis Ford Coppola, and more recently, young Quentin Tarantino. Fassbinder too. Perhaps you sense what I'm getting at. Nauman constructs scenes out of time and violence. Especially in his later work, I'm thinking of his scenes of violence, domination, and death—psychological, physical, and otherwise. Nauman, like these directors, stages vignettes launched by such a fierce personal obsession that it heaves furious manias into some timeless, weightless etherea.

Carousel, 1988, endlessly drags itself around and around; whining away time, endlessly going nowhere. *Violent Incident,* 1986, continuously rehearses the theme of rising passion and its variations. The decorum of a polite, but banal dinner is suddenly clevered, escalating from a gag to rupturing violence in only a glint of time. She kicking him in the balls, he slapping her in the face. But Nauman retools that sudden flare of unbridled fury into something perpetual. This collapse of flash-

A different version of this essay was originally published in *Frieze Magazine,* May 1995, 58.

ing violence and endless time, this deathless-savagery is in part why Nauman's art is as frustrating to summarize as his commentators have noted. It defers epilogues on contact. And while I too believe Nauman's creative ether lies beyond our powers of description, comparisons with a few directors on the subject of time and violence surface easily, if not obviously, shedding some light along the way. *White Anger, Red Danger, Yellow Peril, Black Death* scrolls me to the scene in *Taxi Driver* where Scorsese, playing DeNiro's fare, sits in the taxi with the meter running spying on the silhouettes of his character's wife in an affair with a black man. Even though Scorsese lets the meter run on, he has composed the scene to suspend time so as to leave the audience no other choice but to witness his racist and sexist rants about what a large handgun might do to the female body.

Granted, comparisons of this ilk are in shorthand, but nonetheless, they reveal something of consequence about the way Nauman links time with violence. *One Hundred Live and Die* is redolent of the sequence of blinking lights that aggressively crawled across the Big Board in Kubrick's *Dr. Strangelove*, on their way toward Armageddon. More literally, *Untitled (Suspended Chair, Vertical)* shadows the toggle switch Tarantino slowly fingers in *Reservoir Dogs,* flipping reality upside-down. Bound to a chair in an airless space, remote in time and place, the rookie policeman is tortured gradually but deliberately—his ear cut off to the sliding dance rhythms of *Stealer's Wheel. Learned Helplessness in Rats* indexes the point-blank reeducation scene in *Clockwork Orange,* and so on. As useful as it is to consider Nauman in this company of directors, I am not driving us toward an equation between his sculpture and filmic technique. Instead, I have in mind the crafting of fierce scenes of physical and psychological fury, but in such a way that time seems lazy, and torturously so.

I want to consider Nauman's *Clown Torture*, 1987, mindful of these few directors and their construction of unhurried delirium. *Clown Torture* consists of four separate videotapes concurrently appearing on monitors and projected on the wall. On the left wall *Clown Taking a Shit* shows a circus clown sitting on a toilet in a public bathroom, waiting for the obvious to occur. With magazine in hand, he fiddles with the toilet paper. He hangs there in the kind of pedestrian time we all waste in. He is a fellow witness to the silly-madness that fills the room. The monitors picture the clown in two other predicaments. In the first, he is precariously stranded, holding a goldfish bowl to the ceiling with a broom, and in the second he repeatedly walks through a door on

which a bucket of water has been balanced, waiting for the next hapless victim to stumble beneath that old gag. In another video, the clown incessantly rehearses the childhood riddle: "Pete and Repeat were sitting on a fence. Pete fell off. Who was left? Repeat. Pete and Repeat were sitting on . . ." And in one final video sequence the clown rants and pleads "No No No No No No No No . . ." Nauman weaves his scenes in such a way that, while there is an abundance of action, an overload of fussy anxiety, and plenty of clown-manufactured violence, time never moves along. Rather, he assembles his scenes so as to usher us into the condition of the clown, swamping us with dread and suspending us there.

"My definition of anxiety," Nauman once said, "is the gap between the now and the later. . . .We have no future if we fill this void, we only have sameness." There is a psychological savagery that accompanies this kind of sameness. In Tarantino's *Pulp Fiction*, and not surprisingly in Oliver Stone's *Natural Born Killers*, this sense of being suspended in the marbleized fluid of violence has been used with great, and remarkably similar effects. Fretting over (which is stark raving terror if you are a clown) the inevitable fatigue that spells death for the fish, the clown is chained to a level of anxiety and dread he is helpless to overcome. As we gaze into the monitors seeing the clown succumbing to his ridiculous plight, Nauman situates us in-between the now and the later. My thoughts float to the level of absurdity that defines the clown's predicament; I reason with myself that for this mean-spirited foolishness to end he and his fish must be resigned to their fate, to the fact that they cannot turn the tide of events. Inevitably a pale boredom sets in and my attention drifts until it is called back by the clown's scream, and the watery crash. My eyes bolt back to the screen but never to see more than a drenched clown and the shards of glass.

Like the clown, I begin the vigil from the top, stranded once more between now and later. Similarly, "Pete and Repeat," the moronic riddle whose only answer commands as it condemns the clown to an endless loop, is itself a life sentence. He is as incapable as he is helpless to effect his own escape from the awful logic of the conundrum. Occasionally the final video breaches the ongoing sequences, in effect extracting the clown from all this ceaseless folly. From another place that affords him a certain detachment he looks back on himself and on the rest of us suspended in Nauman's unforgiving sameness. Compassion unexpectedly grips the clown as he witnesses our awful plight, and he denies what he sees. "No No No No No No No No . . ."

III Interviews

Willoughby Sharp

Two Interviews

Interview I

Within the past five years, Bruce Nauman has produced a highly complex body of work that retains strong affinities with the new sculpture but is quite independent from its dominant modes of expression. He began making sculpture in 1965 as a graduate student at the University of California—narrow fiberglass strips cast in a sketchy manner from plywood molds so that each work has a rough and ragged look resembling what is now referred to as Poor Art. Later that year, he did a series of latex mats backed with cloth, which hung from the wall or were heaped on the floor; but by the time of his first one-man show at Nicholas Wilder's Los Angeles gallery early in 1966, Nauman had outgrown these kinds of sculptural concerns and had begun to explore a wider range of media. He started filming physical activities like bouncing balls and pacing around the studio so that these everyday events were also incorporated into his oeuvre. That year he made about twenty pieces of sculpture using unusual materials like aluminum foil, foam rubber, felt, grease, galvanized iron, cardboard, lead, and vinyl in which lengthy, explicit titles play a crucial role in the conception and understanding of the artistic enterprise. A work such as *Collection of Various Flexible Materials Separated by Layers of Grease with Holes the Size of My Waist and Wrists* would be unintelligible without reference to its mildly ironic title. Aside from an isolated outdoor work, *Lead Tree Plaque*, bearing the inscription "A ROSE HAS NO TEETH," most of the sculptural objects from late 1966 are concerned with seeing the human body in new ways. The subject and scale of these works is often a

Originally published as "Nauman Interview," in *Arts Magazine*, March 1970.

direct ratio of unusual measurements taken from sections of the body. To realize the punning piece, *From Hand to Mouth* (1967), Nauman cast that part of his own body in plaster and pea green wax, an introspective and detached statement of a self-mocking sensibility. After moving to New York for his one-man exhibition at the Leo Castelli Gallery in January 1968, he started producing videotapes, one of which shows him saying "lip sync" as it gradually goes out of sync.

The presentation of the body in straightforward physical movements is a recurring theme of Nauman's recent work as seen in several of his latest one-man exhibitions. He showed *Six Sound Problems*— "Walking and bouncing balls," "Violin sounds in the gallery," and so on—in July 1968 at Konrad Fischer's Düsseldorf gallery; the *Making Faces* holograms at Ileana Sonnabend's Paris gallery in December 1969; and a video performance piece at the Nicholas Wilder Gallery this month.

Willoughby Sharp: What are you doing for your one-man show at the Nicholas Wilder Gallery this month?

Bruce Nauman: The piece I want to do will have a set of walls running the whole length of the 40-foot-long gallery. The distance between the walls will vary from about 3 feet to about 2 or 3 inches, forming corridors, some of which can be entered and some of which can't. Within the wider corridors, some television cameras will be set up with monitors so that you can see yourself. Body parts of me or someone else going in and out of those corridors will also be shown on videotape. Sometimes you'll see yourself and sometimes you'll see a videotape of someone else. The cameras will be set upside down or at some distance from the monitor so that you will only be able to see your back. I have tried to make the situation sufficiently limiting, so that spectators can't display themselves very easily.

WS: Isn't that rather perverse?

BN: Well, it has more to do with my not allowing people to make their own performance out of my art. Another problem that I worked out was using a single wall, say 20 feet long, that you can walk around. If you put a television camera at one end and the monitor around the corner, when you walk down the wall you can see yourself just as you turn the corner, but only then. You can make a square with the same

function—as you turn each corner, you can just see your back going around the corner. It's another way of limiting the situation so that someone else can be a performer, but he can do only what I want him to do. I mistrust audience participation. That's why I try to make these works as limiting as possible.

WS: This work seems like an extension of your *Performance Corridor*.

BN: Yes, that work consisted of two parallel walls 20 inches apart. Originally, it was just a prop for a videotape I was making in my Southampton studio of me walking up and down the corridor.

WS: I don't think many people realized they were supposed to enter it.

BN: Well, that was difficult. I didn't want to write it down, or have an arrow, so it was left open. That piece is important because it gave me the idea that you could make a participation piece without the participants being able to alter your work.

WS: Was it only possible to get in from one end?

BN: Yes, it ran directly into the wall, like a channel. It was much rougher in the studio, because you could only see down the corridor on the videotape. I walked very slowly toward and away from the camera, one step at a time. My hands were clasped behind my neck, and I used a very exaggerated contrapposto motion.

WS: How did the videotape read?

BN: The way you saw it, the camera was placed so that the walls came in at either side of the screen. You couldn't see the rest of the studio, and my head was cut off most of the time. The light was shining down the length of the corridor and made shadows on the walls at each side of me.

WS: It is significant that your head couldn't be seen?

BN: In most of the pieces I made last year, you could see only the back of my head, pictures from the back or from the top. A lot of people asked why I did that.

WS: There is a similar attitude in some of your objects, like *Henry Moore Bound to Fail (back view)*.

BN: Someone said that it made the pieces more about using a body than autobiographical.

WS: Do you ever let others carry out your works?

BN: I always prefer to do them myself, although I've given instructions to someone else from time to time. It's a bit more difficult than doing it myself; I have to make the instructions really explicit, because I trust myself as a performer more than I do others. What I try to do is to make the situation sufficiently specific, so that the dancer can't interpret his position too much.

WS: Could you say something about your relation to the California scene, because the contribution of West Coast artists is often overlooked.

BN: The artists that I knew in San Francisco were a little older than I am and had lived there a long time. They were connected to a hiding-out tradition. I think that had something to do with the confusion about my work. When people first saw it, they thought it was funk art. In my mind it had nothing to do with that, it just wasn't in my background at Wisconsin. It looked like it in a way but really I was just trying to present things in a straightforward way without bothering to shine them and clean them up.

WS: What works were you doing then?

BN: Plastic pieces and rubber pieces, the 1965 fiberglass things on the floor. I was still in school then, and I don't know that they're particularly strong works. I still like some of the rubber pieces and a couple of the fiberglass ones.

WS: In what ways are you critical of them now?

BN: I don't think they were really clear. A little later, in 1966, I started to feel that they were like doing things with sculpture, and that I wasn't doing work based on my thinking. I didn't know what to do with those

thoughts. So I stopped making that kind of work and then I did the first pieces with neon and with wax.

WS: How were the early pieces unclear?

BN: It is difficult to think about them. They involved simple things like making a mold, taking the two halves, and putting them together to make a hollow shape and turning it inside out. I tried to create a confusion between the inside and outside of a piece. One side is smooth so that it looks like the outside, and the other is rough because that's the way the fiberglass was cast, but you can see it as well.

WS: So there were formal considerations and technical problems.

BN: But I wanted to get beyond those problems. So when I made the rubber pieces, I used the same kinds of molds but on soft materials. Then I made the neon piece of my name exaggerated fourteen times.

WS: The latex rubber floor piece which you did in 1965–66 seems to be a prototype of your late work. How was that made?

BN: Well, that work consists of four or five pieces of latex rubber which were all cast in the same shape, fastened together, painted slightly different colors, and just dropped on the floor. There were others. I think the one Walter Hopps has is one of the best, it is about 7 or 8 feet long and 10 inches wide, with slits cut down the length of it. It's hung by one strip so that it drops open.

WS: What led you to start cutting into materials?

BN: It was a specific formal problem. I was making those pieces when I was still at graduate school at Davis in California. The first real change came after that when I had a studio. I was working very little, teaching a class one night a week, and I didn't know what to do with all that time. I think that's when I did the first casts of my body and the name parts and things like that. There was nothing in the studio because I didn't have much money for materials. So I was forced to examine myself, and what I was doing there. I was drinking a lot of coffee, that's what I was doing.

WS: Have your feelings about using your own body in your work changed since then?

BN: No, not really. It's getting a little clearer to me now. At the time it took the form of acting out puns, like in *From Hand to Mouth*. Now I can make dance pieces and I can go back to something like *Performance Corridor* for a very simple problem.

WS: Doesn't *From Hand to Mouth*, which is a wax impression of a part of your body, have different concerns from a performance or a video-tape?

BN: Well, it does. But the only things that I could think of doing at the time were presenting these objects as extensions of what I was thinking about in the studio.

WS: What were you thinking about when you made *From Hand to Mouth*?

BN: Well, things like language games and making objects and how I could put those together.

WS: You almost had to make an object. That's what an artist did, so you did that. But a pun became a way of going beyond just making an object.

BN: That's more or less it. I was very involved with making objects. But also at about the time I did *Flour Arrangements*. I did those to see what would happen in an unfamiliar situation. I took everything out of my studio so that *Flour Arrangements* became an activity which I could do every day, and it was all I would allow myself to do for about a month. Sometimes it got pretty hard to think of different things to do every day.

WS: You forced yourself to do flour arranging rather than make something?

BN: Yes, and a lot of the work after that deals with the same problem, like the films of bouncing two balls in the studio and pacing in the studio. Playing the violin was a more arbitrary situation, because I didn't

know how to play the violin. Some were very logical, like pacing, because that's just what I was doing around the studio. My activities were reasonably straightforward.

WS: There seems to be a great diversity in your work, from *Flour Arrangements* to the films.

BN: I've always had overlapping ways of going about my work. I've never been able to stick to one thing.

WS: Would you say that *Flour Arrangements* was a test of your strength?

BN: Yes, I suppose it was a way of testing yourself to find out if you are really a professional artist. That's something I was thinking about at the time.

WS: Is that still a problem?

BN: No. Last year I was reading *Dark Is the Grave wherein my Friend Is Laid*, Malcolm Lowry's last book . . . it's a complicated situation. The main character, an alcoholic writer, has problems finishing his books and with his publishers. He is sure that other writers know when their books are finished and how to deal with publishers and with their own lives. I suppose it's the normal artist's paranoia and that was more or less the way I felt at the time, kind of cut off, just not knowing how to proceed at being an artist.

WS: You often use words in your work, but you mistrust them a lot, don't you?

BN: My work relies on words less and less. It has become really difficult to explain the pieces. Although it's easier to describe them now, it's almost impossible to explain what they do when you're there. Take *Performance Corridor,* which I've already talked about. It's very easy to describe how the piece looks, but the experience of walking inside it is something else altogether which can't be described. And the pieces increasingly have to do with physical or physiological responses.

WS: Could you describe some of the word pieces?

BN: Well, a couple of years ago I made a piece called *Dark*. It's just a steel plate with the word "Dark" written on the bottom. I don't know how good it is but it seemed to be a germinal piece to me.

WS: In what way?

BN: The feeling of the weight of the piece. I thought I made a good job of getting the word with the piece, having the word "Dark" underneath so that you can't see it.

WS: Could you have used other words?

BN: I did think of the word "Silent," but that was the only other word I really considered.

WS: Is it absolutely necessary to have the word there?

BN: If I did the piece now I probably wouldn't put the word there. But it seems that having the word there helps you think about that bottom side and what it might be like under there.

WS: What is your attitude to making outdoor works now?

BN: Well, last fall I designed a couple of other pieces for outdoors. One is simply to drill a hole into the heart of a large tree and put a microphone in it. The amplifier and speaker are put in an empty room so that you can hear whatever sound might come out of the center of the tree. Another one had to do with placing odd-shaped steel plates and mirrors over a large shrub garden—that was the only work in which I tried to put objects outside, and even in that case it's not really a natural situation because it was supposed to be in a garden rather than out in nature. But neither of them has been done.

WS: One of your most striking works is *Self Portrait of the Artist as a Fountain*. Is that one of your first photographic works?

BN: Yes.

WS: How did you come to do that?

BN: I don't know.

WS: Did you take several photographs of that piece?

BN: Yes. There was also a black-and-white photograph taken in a garden.

WS: To present a photograph as a work in 1966 was pretty advanced. There weren't very many sculptors, I can't think of any, who were presenting photographs as the work at the time. Can you say anything about what made you decide to do it?

BN: Well, I've always been interested in graphics, prints, drawings, and paintings and I was a painter before I started making sculpture. I guess I first started using photographs to record *Flour Arrangements*. Then I started thinking about the *Fountain* and similar things. I didn't know how to present them. I suppose I might have made them as paintings if I had been able to make paintings at the time. In fact, I think I did get some canvas and paint but I had no idea of how to go about making a painting anymore. I didn't know what to do. Perhaps if I had been a good enough painter I could have made realistic paintings. I don't know, it just seemed easier to make the works as photographs.

WS: In *Flour Arrangements*, the photographs documented a work, whereas in *Self Portrait of the Artist as a Fountain* the photo documented you as a work. Does that mean that you see yourself as an object in the context of the piece?

BN: I use the figure as an object. More recently that's roughly the way I've been thinking, but I didn't always. And when I did those works, I don't think such differences or similarities were clear to me. It's still confusing. As I said before, the problems involving figures are about the figure as an object, or at least the figure as a person and the things that happen to a person in various situations—to most people rather than just to me or one particular person.

WS: What kind of performance pieces did you do in 1965?

BN: I did a piece at Davis that involved standing with my back to the wall for about forty-five seconds or a minute, leaning out from the wall, then bending at the waist, squatting, sitting, and finally lying

down. There were seven different positions in relation to the wall and floor. Then I did the whole sequence again standing away from the wall, facing the wall, then facing left and facing right. There were twenty-eight positions and the whole presentation lasted for about half an hour.

WS: Did it relate to sculptural problems that you were thinking about then?

BN: Yes, that was when I was doing the fiberglass pieces that were inside and outside, in which two parts of the same mold were put together.

WS: Did you identify your body with those fiberglass pieces?

BN: Yes. In a way I was using my body as a piece of material and manipulating it.

WS: Then there is a body-matter exchange which plays a very strong part in your thinking?

BN: Yes. I had another performance piece in 1965; I manipulated an 8-foot fluorescent light fixture. I was using my body as one element and the light as another, treating them as equivalent and just making shapes.

WS: I see that there is a close correlation between the performances and the sculptural objects such as the fiberglass works.

BN: I think of it as going into the studio and being involved in some activity. Sometimes it works out that the activity involves making something, and sometimes that the activity is the piece.

WS: Could you talk more specifically about a performance piece and a sculptural object that are based on similar ideas?

BN: Well, take the twenty-eight positions piece and the fiberglass pieces. I vaguely remember making lists of things you could do to a straight bar: bend it, fold it, twist it; and I think that's how the performance piece finally came about, because it was just that progression of actions, standing, leaning, and so on, which I carried out. I don't know whether it was that clear.

WS: How did you come to use videotape in the first instance?

BN: When I was living in San Francisco, I had several performance pieces which no museum or gallery was interested in presenting. I could have rented a hall, but I didn't want to do it that way. So I made films of the pieces, the bouncing balls and others. Then we moved to New York, and it was harder to get film equipment. So I got the videotape equipment, which is a lot more straightforward to work with.

WS: How did the change from film to videotape affect the pieces?

BN: Mainly they got longer. My idea was to run the films as loops, because they have to do with ongoing activities. The first film I made, *Fishing for Asian Carp*, began when a given process started and continued until it was over. Then that became too much like making movies, which I wanted to avoid, so I decided to record an ongoing process and make a loop that could continue all day or all week. The videotapes can run for an hour—long enough to know what's going on.

WS: Are you working only with videotapes at the moment?

BN: No, I've been working with film again. The reason they are films again is because they're in super-slow motion; I've been able to rent a special industrial camera. You really can't do it with the available videotape equipment for amateurs. I'm getting about 4,000 frames per second. I've made four films so far. One is called *Bouncing Balls*, only this time it's testicles instead of rubber balls. Another one is called *Black Balls*. It's putting black makeup on testicles. The others are *Making a Face*, and in the last one I start out with about 5 or 6 yards of gauze in my mouth, which I then pull out and let fall to the floor. These are all shot extremely close up.

WS: You could call that body sculpture.

BN: Yes, I suppose.

WS: Are there any precedents for this in your early work?

BN: The works of this kind that I did were the holograms, *Making Faces* (1968), which came up in a very formal way when I was thinking about arrangements.

WS: What kind of facial arrangements did you do?

BN: They were usually contortions, stretching or pulling my face. I guess I was interested in doing a really extreme thing. It's almost as though if I'd decided to do a smile. I wouldn't have had to take a picture of it. I could just have written down that I'd done it or made a list of things that one could do. There was also the problem with the holograms, of making the subject matter sufficiently strong so that you wouldn't think about the technical side so much.

WS: Mitigating the media is a real concern then?

BN: It was particularly difficult with the holograms, because of their novelty.

WS: Are you still working with holograms?

BN: There is one more set that I want to do, using double exposures. That piece would involve my body in a much more passive way than the others.

WS: It seems that one could almost divide your work into two categories: the pieces that are directly related to your body, and the ones that aren't.

BN: Well, in the works I've tried to describe to you, the one with the television cameras and the walls, and others I have in the studio using acoustic materials, I have tried to break down this division in some way, by using spectator response. These pieces act as a sort of bridge.

WS: Like the work with a tape recorder, *Steel Channel*, that you showed in "9 at Castelli." What sound did you use?

BN: It was a loud whisper. Let's see, how did it go . . . "Steel channel, lean snatch, lean channel, steel snatch." "Lean snatch" is a cheating anagram of "Steel channel." It's not one of my favorite pieces.

WS: What other audio works have you done?

BN: There are two different groups of tapes: one was in *"Theodoron Foundation: Nine Young Artists"* at the Guggenheim in August 1969, of rubbing the violin on the studio floor, the violin tuned *D, E, A, D*, and one other. Then I did a piece at Ileana Sonnabend in December. It was a large L-shaped wall covering two walls of her Paris gallery. It was flush with the wall with very thin speakers in it. For that there were two different tapes: one was of exhaling sounds, and the other of pounding and laughing alternately. You couldn't locate the sound. That was quite a threatening piece, especially the exhaling sounds.

WS: What are the sources of the punning in your work?

BN: I don't know. I just do it.

WS: *Duchamp?*

BN: Yes, I can't argue with that, but I don't think he's a very important influence. He leads to everybody and nobody.

WS: Well, one source that you have mentioned is Dada and surrealism.

BN: I would like to back out of that too. Those questions were brought up by other people rather than by me. I really don't give these things that much thought.

WS: Is there an affinity in some of your work with Duchamp's body casts?

BN: Yes, there's no question about that. On the other hand, when I made a lot of that work, it had more to do with Wittgenstein's *Philosophical Investigations*, which I was reading at that time. That work had a lot to do with the word-game thing.

WS: What particularly impressed you in *Philosophical Investigations?*

BN: Just the way Wittgenstein proceeds in thinking about things, his awareness of how to think about things. I don't think you can point to any specific piece that's the result of reading Wittgenstein, but it has to do with some sort of process of how to go about thinking about things.

WS: In 1966 you exhibited *Shelf Sinking* at Nicholas Wilder Gallery. It seemed to me to be the most complicated piece you had done up to that point.

BN: It was one of my first pieces with a complicated title, a sort of functional title. I like the piece quite a bit. I took a mold and made plaster casts of the spaces underneath the shelf. I suppose the elaborate title enables you to show a mold with its casts without presenting the work as such.

WS: How important is the title to a work like *Henry Moore Bound to Fail (back view)*?

BN: I don't know. There's a certain amount of perverseness involved, because the piece could probably just have been left the way it was. I mean, it could have just stood without any kind of descriptive title. It could have been just "bound to fail." When I made the piece a lot of young English sculptors who were getting publicity were putting down Henry Moore, and I thought they shouldn't be so hard on him, because they're going to need him. That's about all the explanation I can give about adding Moore to the title.

WS: How did you make that work?

BN: Well, a photograph of my back was taken, then I modeled it in wax. It's not a cast of anyone.

WS: That's one of the very few figures or parts of a figure that you've actually modeled.

BN: Yes.

WS: This perverseness is of course something that a lot of people have mentioned. Do you think you are deliberately perverse?

BN: It's an attitude I adopt sometimes to find things out—like turning things inside out to see what they look like. It had to do with doing things that you don't particularly want to do, with putting yourself in unfamiliar situations, following resistances to find out why you're resisting, like therapy.

WS: So you try to go against your own nature, and to go against what people expect: exhibiting things from the back or that you can't see.

BN: Yes. But I tend to look at those things in a positive way and I've often been surprised when people take them in the opposite way and think I'm being perverse. It's like the John Coltrane mirror piece. To talk about perversion because you're hiding the mirror. . . . That wasn't what I had intended at all. To me it seemed that hiding the mirror was a positive thing, because it made for an entirely different kind of experience—the mirror reflecting and yet not being able to reflect the floor.

WS: That piece is so private . . .

BN: Yes. I remember talking to someone about public art and private art. My art tends to fall in the private category.

WS: Would you say that the works are more about you than they are about art itself?

BN: Well, I wouldn't say it, no.

Interview II

During the first week of May 1970, Nauman made a V-shaped corridor piece at San Jose State College, California. The following discussion was videotaped in the college's studio on May 7 and later edited in collaboration with the artist.

Willoughby Sharp: How did you arrive at the San Jose piece? Did it grow out of your *Performance Corridor?*

Bruce Nauman: Yes, because the first pieces that were at all like it were just corridors that ended at a wall and then made into a V. Then I put in another V and finally I put in the mirror.

Originally published as "Interview," in *Avalanche*, no. 2 (Winter 1971): 22–31. Also published in the catalogue for the touring exhibition, "Bruce Nauman," Kunstmuseum, Wolfsburg; Centre Georges Pompidou, Paris; Hayward Gallery, London; Nykytaiteen Museo, Helsinki, 1997/1999. *Bruce Nauman* (London: South Bank Centre, 1998), 88–97.

WS: Why did you decide to use it that way?

BN: The mirror?

WS: No, the change in the interior, the second V.

BN: When the corridors had to do with sound damping, the wall relied on soundproofing material that altered the sound in the corridor and also caused pressure on your ears, which is what I was really interested in: pressure changes that occurred while you were passing by the material. And then one thing to do was to make a V. When you are at the open end of the V, there's not too much effect, but as you walk into the V the pressure increases quite a bit, it's very claustrophobic.

WS: Pressure is also felt on the spectator's own body. Does that come from your ears?

BN: It has a lot to do with just your ears.

WS: So space is felt with one's ears?

BN: Yeah, that's right.

WS: The light inside had a particularly soft quality that really got to my body. How did you control the light that way?

BN: Because the piece goes to the ceiling, all of the light is reflected into the two entrances, so it's very indirect light.

WS: Well, I noticed that the exterior wall started just the other side of one of the light fixtures recessed in the ceiling. Was the piece carefully planned to block off that light?

BN: No. I built it so that there wouldn't be any lights in the space. The light in there is more or less accidental.

WS: When I walked inside, the mirror cut off my head and the shock of seeing myself headless was a strong part of the piece. But if a shorter person is standing close to the mirror, he can see his face. Are these differences important?

BN: Yes. When I put the mirror in the first time, it was 6 feet tall, which was half as high as the ceiling. That was too high—you couldn't feel the space behind the mirror at the apex of the V. So I cut it off to a little less than 5 1/2 feet, which is just below my eye level.

WS: Then you adjusted the piece after experiencing it. Do you also make that kind of adjustment while you're constructing the piece?

BN: Yeah. I first made that piece in my studio.

WS: So you knew what you were dealing with in terms of space.

BN: Yes, but it was much more crude in the studio.

WS: It's really hard to know what I felt in there, but somehow it brought me closer to myself. From your own experience of being in there, how would you say it affects you?

BN: Well, the corridors that you walk down are 2 feet wide at the beginning and they narrow down to about 16 inches. So going into it is easy, because there is enough space around you for you not to be aware of the walls too much until you start to walk down the corridor. Then the walls are closer and force you to be aware of your body. It can be a very self-conscious kind of experience.

WS: So you find yourself in a situation where you are really put up against yourself.

BN: Yes, and still the interest—since you are looking into the mirror and seeing out of the other corridor—the visual interest is pretty strong and it's centered somewhere else; it's either in the mirror or looking beyond the mirror into the end of the V.

WS: Some people don't see over the top of the mirror into the end of the V.

BN: Well, if you are shorter than I am and you see your whole self in the mirror, then you probably wouldn't look over the mirror, so that's really difficult to. . . . If the mirror is too short, it doesn't work either because you look over the mirror; you just see your feet in the mirror,

and the bottom of the corridor. So the piece is effectively limited to people who are built somewhat like I am.

WS: Then the size of the spectator plays a role in the success of the piece.

BN: A big person couldn't go in at all.

WS: Right. I didn't get a chance to see your last Wilder show. How does the San Jose corridor piece compare with the ones at Wilder?

BN: Well, there were parts of the Wilder piece that you could experience immediately, but the thing was so large and complicated that I think it took much longer to grasp.

WS: Do you think this piece is more successful?

BN: No, just more immediate.

WS: What relation do these corridor pieces have to your recent videotape works like *Come?*

BN: It's really like the corridor pieces only without the corridors. I tried to do something similar, but using television cameras and monitors, and masking parts of the lenses on the cameras. . . . If one camera is at one end of the room and the monitor is at the other, then the camera lens can be masked so that an image appears maybe on a third or a quarter of the screen. The camera is sometimes turned on its side, sometimes upside down, and that creates a corridor between the camera and the monitor. You can walk in it and see yourself from the back, but it's hard to stay in the picture because you can't line anything up, especially if the camera is not pointing at the monitor. Then you have to watch the monitor to stay in the picture and at the same time stay in the line of the camera.

WS: How did you decide on the title *Come?*

BN: I don't remember.

WS: Have you finished those slow-motion films of gauze in your mouth and painting your body?

BN: Yeah.

WS: Could you talk about some of them?

BN: There were four films in which the frame speed varied between 1,000 frames a second and 4,000 frames a second, depending on how large an area I was trying to photograph and what light I could get. In one I was making a face, in another I had about 4 or 5 yards of gauze in my mouth which I pulled out very slowly. There were two others, one of which was called *Black Balls*. I put black makeup on my testicles. The other was called *Bouncing Balls* and it was just bouncing testicles.

WS: How long are they?

BN: Four hundred feet of film, that runs for about ten minutes. They take from six to twelve seconds to shoot, depending on the frame speed. The action is really slowed down a lot. Sometimes it is so slow that you don't really see any motion but you sort of notice the thing is different from time to time.

WS: Do they have color in the system?

BN: You can shoot color, but the film speed is not so fast. I suppose you could push it. I just shot black and white.

WS: And there is a fourth one?

BN: That's four.

WS: Do these films stimulate you to work further in that direction with the same equipment?

BN: Not yet. It was pretty much something I wanted to do and just did.

WS: I know it often happens that you do certain things in one medium, then you do something similar in another medium. How does that come about? Is it because you cannot take a project further at a particular moment?

BN: Originally a lot of the things that turned into videotapes and films were performances. At the time no one was really interested in presenting them, so I made them into films. No one was interested in that either, so the film is really a record of the performance. After I had made a few films I changed to videotape, just because it was easier for me to get at the time. The camera work became a bit more important, although the camera was stationary in the first ones.

WS: Were these the films of bouncing balls?

BN: Yeah. The videotapes I did after those films were related, but the camera was often turned on its side or upside down, or a wide-angle lens was used for distortion. . . . As I became more aware of what happens in the recording medium I would make little alterations. Then I went back and did the performance, and after that . . .

WS: Which performance?

BN: The one at the Whitney during the "Anti-Illusion" show in 1969. I had already made a videotape of it, bouncing in the corner for an hour. At the Whitney the performance was by three people, instead of just myself, and after that I tried to make pieces where other people could be involved in the performance situation, individuals.

WS: Why did you find that desirable?

BN: It makes it possible for me to make a more . . . it's difficult for me to perform, and it takes a long time for me to need to perform. And doing it once is enough. I wouldn't want to do it the next day or for a week, or even do the same performance again. So if I can make a situation where someone else has to do what I would do, that is satisfactory. Quite a lot of these pieces have to do with creating a very strict kind of environment or situation so that even if the performer doesn't know anything about me or the work that goes into the piece, he will still be able to do something similar to what I would do.

WS: Some of the works must be stimulated by a desire to experience particular kinds of situations. Just to see how they feel. Are you doing the work basically for yourself?

BN: Yes, it is going into the studio and doing whatever I'm interested in doing, and then trying to find a way to present it so that other people could do it too without having too much explanation.

WS: The concern for the body seems stronger now than when we did the *Arts Magazine* interview.

BN: Well, the first time I really talked to anybody about body awareness was in the summer of 1968. Meredith Monk was in San Francisco. She had thought about or seen some of my work and recognized it. An awareness of yourself comes from a certain amount of activity and you can't get it from just thinking about yourself. You do exercises, you have certain kinds of awarenesses that you don't have if you read books. So the films and some of the pieces that I did after that for videotapes were specifically about doing exercises in balance. I thought of them as dance problems without being a dancer, being interested in the kinds of tension that arise when you try to balance and can't. Or do something for a long time and get tired. In one of those first films, the violin film, I played the violin as long as I could. I don't know how to play the violin, so it was hard, playing on all four strings as fast as I could for as long as I could. I had ten minutes of film and ran about seven minutes of it before I got tired and had to stop and rest a little bit and then finish it.

WS: But you could have gone on longer than the ten minutes?

BN: I would have had to stop and rest more often. My fingers got very tired and I couldn't hold the violin anymore.

WS: What you are saying in effect is that in 1968 the idea of working with calisthenics and body movements seemed far removed from sculptural concerns. Would you say that those boundaries and the distance between them has dissolved to a certain extent?

BN: Yes, it seems to have gotten a lot smaller.

WS: What you have done has widened the possibilities for sculpture to the point where you can't isolate video works and say, they aren't sculpture.

BN: It is only in the past year that I have been able to bring them together.

WS: How do you mean?

BN: Well, even last year it seemed pretty clear that some of the things I did were either performance or recorded performance activities, and others were sculptural—and it is only recently that I have been able to make the two cross or meet in some way.

WS: In which works have they met?

BN: The ones we have been talking about. The first one was really the corridor, the piece with two walls that was originally a prop in my studio for a videotape in which I walked up and down the corridor in a stylized way for an hour. At the Whitney "Anti-Illusion" show I presented the prop as a piece, called *Performance Corridor*. It was 20 inches wide and 20 feet long, so a lot of strange things happened to anybody who walked into it . . . just like walking in a very narrow hallway.

WS: You had been doing a lot of walking around in the studio. When did you start thinking about using corridors?

BN: Well, I don't really remember the choice that led me to . . . I had made a tape of walking, of pacing, and another tape called *Rhythmic Stamping in the Studio*, which was basically a sound problem, but videotaped. . . . I was just walking around the studio stamping in various rhythms.

WS: Did you want the sound to be in sync?

BN: The sound was in sync on that one. In the first violin film the sound is out of sync, but you really don't know it until the end of the film. I don't remember whether the sound or the picture stops first.

WS: I think you stop playing the violin but the sound goes on.

BN: The sound is fast and distorted and loud, and you can't tell until all at once . . . it is a strange kind of feeling.

WS: Is the film of the two bouncing balls in the square out of sync? Did you play with the sync on that?

BN: No. I started out in sync but there again, it is a wild track, so as the tape stretches and tightens it goes in and out of sync. I more or less wanted it to be in sync but I just didn't have the equipment and the patience to do it.

WS: What do you think of it?

BN: It was alright. There's one thing that I can't remember—I think I cut it out of some of the prints and left it in others. At a certain point I had two balls going and I was running around all the time trying to catch them. Sometimes they would hit something on the floor or the ceiling and go off into the corner and hit together. Finally I lost track of them both. I picked up one of the balls and just threw it against the wall. I was really mad.

WS: Why?

BN: Because I was losing control of the game. I was trying to keep the rhythm going, to have the balls bounce once on the floor and once on the ceiling and then catch them, or twice on the floor and once on the ceiling. There was rhythm going and when I lost it that ended the film. My idea at the time was that the film should have no beginning or end: one should be able to come in at any time and nothing would change. All the films were supposed to be like that, because they all dealt with ongoing activities. So did almost all of the videotapes, only they were longer, they went on for an hour or so. There is much more a feeling of being able to come in or leave at any time.

WS: So you didn't want the film to come to an end.

BN: I would prefer that it went on forever.

WS: What kind of practice did you have for those films? Did you play the violin to see what sound you were going to get?

BN: I probably had the violin around for a month or two before I made the film.

WS: Did you get it because you were going to use it, or did it just come into your life?

BN: I think I bought it for about fifteen dollars. It just seemed like a thing to have. I play other instruments, but I never played the violin and during the period of time that I had it before the film I started diddling around with it.

WS: When did you decide that it might be nice to use it?

BN: Well, I started to think about it once I had the violin and I tried one or two things. One thing I was interested in was playing . . . I wanted to set up a problem where it wouldn't matter whether I knew how to play the violin or not. What I did was to play as fast as I could on all four strings with the violin tuned D, E, A, D. I thought it would just be a lot of noise, but it turned out to be musically very interesting. It is a very tense piece. The other idea I had was to play two notes very close together so that you could hear the beats in the harmonics. I did some tapes of that but I never filmed it. Or maybe I did film it while I was walking around the studio playing. The film was called *Playing a Note on the Violin While I Walk around the Studio*. The camera was set up near the center of the studio facing one wall, but I walked all around the studio, so often there was no one in the picture, just the studio wall and the sound of the footsteps and the violin.

WS: I saw most of these four films about a week ago at the School of Visual Arts—I liked them even better the second time I saw them. You made a simple, repetitive activity seem very important.

BN: I guess we talked about this before, about being an amateur and being able to do anything. If you really believe in what you're doing and do it as well as you can, then there will be a certain amount of tension—if you are honestly getting tired, or if you are honestly trying to balance on one foot for a long time, there has to be a certain sympathetic response in someone who is watching you. It is a kind of body response, they feel that foot and that tension. But many things that you could do would be really boring, so it depends a lot on what you choose, how you set up the problem in the first place. Somehow you have to program it to be interesting.

WS: So you reject many ideas on aesthetic grounds.

BN: Besides you make mistakes, so it doesn't all come out.

WS: Do you ever see one of your films and then decide that you don't want to show it to anyone?

BN: Oh yeah. I have thrown a lot of things away.

WS: What percentage do you destroy?

BN: Gee, I don't know.

WS: Does it happen frequently?

BN: Oh, pretty often. Maybe half the time.

WS: On what grounds? Could you explain a piece that you finally rejected?

BN: I couldn't remember. I can't remember any of the other film problems.

WS: You did mention that you threw one film away, or you weren't sure. Which one was that?

BN: I think we mentioned one, but it wasn't necessarily a film. For the videotapes it is harder to say, because I had the equipment in the studio. With the films I would work over an idea until there was something that I wanted to do, then I would rent the equipment for a day or two. So I was more likely to have a specific idea of what I wanted to do. With the videotapes I had the equipment in the studio for almost a year; I could make test tapes and look at them, watch myself on the monitor or have somebody else there to help. Lots of times I would do a whole performance or tape a whole hour and then change it.

WS: Edit?

BN: I don't think I would ever edit but I would redo the whole thing if I didn't like it. Often I would do the same performance but change the

camera placement and so on.

WS: In the film of the bouncing balls, it looks as if the camera was just placed there. How carefully did you set up the camera in that film?

BN: It was set up to show an area of the studio.

WS: With a certain definite cutoff point.

BN: Yeah. It had a lot to do with the lenses I had—I was limited to the three standard lenses. I was using the widest-angle lens on the camera.

WS: But take the film in which you do a dance step around two squares of masking tape on the floor. The near side of the outermost square is cut off. Now that was obviously deliberate. You knew you weren't getting the nearest line on the film and that your feet wouldn't be seen when you came along that line. Do you remember why you made that decision?

BN: No, I don't remember. It was just better that way.

WS: Did you try it out so that both squares were completely visible?

BN: I don't remember. It's been a long time.

WS: How much time did you spend setting up the camera?

BN: I don't know. Sometimes it really takes a long time, and other times it's just obvious how it must be done.

WS: Did you consider using a video system in the San Jose piece?

BN: Well, in this piece the mirror takes the place of any video element. In most of the pieces with closed circuit video, the closed circuit functions as a kind of electronic mirror.

WS: So you are really throwing the spectator back on himself. That's interesting. I hadn't realized the similarity between the mirror and the video image before. Is there a natural extension into video from a certain situation, such as this piece? Or didn't you even consider that?

BN: I didn't consider it. The mirror allows you to see some place that you didn't think you could see. In other words you are seeing around the corner. Some of the video pieces have to do with seeing yourself go around a corner, or seeing a room that you know you can't get into like one where the television camera is set on an oscillating mount in a sealed room.

WS: That was at the Wilder show, wasn't it?

BN: Yes. The camera looks at the whole room; you can see the monitor picture of it, but you can't go into the room and there is a strange kind of removal. You are denied access to that room—you can see exactly what is going on and when you are there but you can never get to that place.

WS: People felt they were being deprived of something.

BN: It is very strange to explain what that is. It becomes easier to make a picture of the pieces or to describe what the elements are, but it becomes much more difficult to explain what happens when you experience them. I was trying to explain that to somebody the other night. It had to do with going up the stairs in the dark, when you think there is one more step and you take the step, but you are already at the top and have the funny . . . or going down the stairs and expecting there to be another step, but you are already at the bottom. It seems that you always have that jolt and it really throws you off. I think that when these pieces work they do that too. Something happens that you didn't expect and it happens every time. You know why, and what's going on but you just keep doing the same thing. It is very curious.

WS: The Wilder piece was quite complicated.

BN: It is hard to understand. The easiest part of the piece to get into was a corridor 34 feet long and 25 inches wide. There was a television camera at the outside entrance, and the picture was at the other end. There was another picture inside too but that's irrelevant to this part of it. When you walked into the corridor, you had to go in about 10 feet before you appeared on the television screen that was still 20 feet away from you. I used a wide-angle lens, which disturbed the distance even more. The camera was 10 feet up, so that when you did see yourself on

the screen, it was from the back, from above and behind, which was quite different from the way you normally saw yourself or the way you experienced the corridor around yourself. When you realized that you were on the screen, being in the corridor was like stepping off a cliff or down into a hole. It was like the bottom step thing—it was really a very strong experience. You knew what had happened because you could see all of the equipment and what was going on, yet you had the same experience every time you walked in. There was no way to avoid having it.

WS: Would you like to do something for network TV?

BN: I'd like CBS to give me an hour on my terms. I'd like to do color work, which I haven't done yet because of the expense involved. I haven't been strongly motivated to either. I suppose if I really wanted to I could hustle it somehow. But if it became available to me I would like to use color. Some people in Europe have been able to use it. I forget who. A Dutch artist did something called the *Television as a Fireplace.* Apparently a fire was broadcast on the screen for fifteen minutes or so. All you saw was the fire.

WS: Right. Jan Dibbets did that last New Year's Eve.

BN: In Holland all the stations are government-owned. The European television setup is much lower-key than the American, so time is not as valuable as it is here. It is a little easier to do things like that, but it's still difficult.

WS: Do you see that as a goal? It seems to me that one of the reasons for working with videotape is that the work can get out to far more people so that obviously CBS . . .

BN: I would . . . I'm not interested in making compromises in order to do that, although I still want to do it. I would like to have an hour or half an hour to present some boring material.

WS: Do you feel that you could subvert television, change it?

BN: I'm not really interested in actively spending my time trying to get those people to let me use their time. If time was offered to me I would

use it, and I would want to do things my way. But to take the trouble to do whatever one has to do . . .

WS: What I meant specifically was that if the new art is going to be significant for a larger segment of the culture, working with videotape gives you the means to help bring that about.

BN: Oh, I think it is not . . . although there would be a wider audience. But I would still want to have my time available and have only four people watching the piece, just because of what I could do with equipment that I wouldn't have access to otherwise.

WS: So there really isn't a strong desire to change the existing level of communication.

BN: No.

WS: Then we come back to where we ended the last time: who is your art for?

BN: To keep me busy.

Robert C. Morgan

Interview with Bruce Nauman

Robert Morgan: In recent years, from the work of yours I've seen in New York, Chicago, and Los Angeles, it seems that there's a strong interest in behavioral relationships between people, especially in the neon work, whereas the earlier work seemed more directly related to the body, a more Duchampian style of investigation. I'm wondering how you see the connection between the two?

Bruce Nauman: Part of it has to do with working alone in the studio. You haven't got much in the way of materials besides yourself. And that's how I felt—examining myself. And then you make an assumption that if you examine yourself you make certain propositions that help with the work, certain conclusions. Other people are interested because those are common experiences, if you make that assumption. Maybe in the later work there's a certain amount of security and you make more generalizations and find a way to involve more kinds of social situations and people in the work. At a certain point, there was a certain amount of participation—audience participation—such as in the corridor pieces. There's a trust that people can have the same kinds of experience you do and they will be interested, if the work is presented. I guess what I'm trying to say is that you finally have to learn to trust your art to carry itself.

RM: The neon work—how did that evolve into the use of figures?

Interview conducted at the New Museum of Contemporary Art, New York City, September 10, 1987.

BN: The first piece was a sign, very ordinary. I think the earliest ones that had to do with body shapes and body parts with neon were used to outline and describe. They were very simple and straightforward. But then the more recent pieces that I did had the neon figures, and they were very difficult for me because I hadn't done anything that had a full figure except for the videotapes and photographs. I had made a pen and ink drawing of a bunch of figures that eventually turned into a neon piece, but it took a couple of years of looking at it on the wall of the studio before I figured out what to do with it.

RM: In other words, you were interested in the idea but you didn't know which medium to use?

BN: I didn't know how to proceed with it. I thought at one point, rather than doing figures with neon, that I would make computer games out of them or something like that.

RM: There's a more kinetic feeling about the neon pieces as compared with the earlier pieces, which appeared as static realizations of yourself—with the exception, of course, of the films and videotapes. Your interest in signs—signs of behavior, perhaps? There seems to be a lot of aggression or intense, sometimes violent, interaction.

BN: The way those pieces worked out, they are kind of stereotypes; they're, at least, abstracted to some extent. The other thing that interested me was that you have a sort of sex and violence or sexual violence and political violence. This is the kind of range covered in the group of neon signs. Then the other kind of violence that occurs is when you start to program them. You can program them to do these activities— hitting, kicking, fucking, whatever—which are all human activities; and then because you're breaking them down in a mechanical way their arms move, and the parts move. You can also program in a very abstract way. Say I've got twenty-seven parts here—what are the various possible ways that twenty-seven things can flash on and off in different combinations without any regard for which part is connected to an action a figure might do? In that sense, there's a violence to them; but not all the signs do that.

RM: A kind of abruptness? What you've got is a condition of the medium in a way.

BN: Yes, but you treat them not as figures at all. Then you can have arms and legs flashing on and off just as units that flash on and off with no sequence and no sense of being connected with the body. You can think of it as abstract. When you look at it there are objects that you recognize and that have some connection; for example, the arms connect at the shoulders. If you look at them only as figures, so that none of that matters, then it's a very violent perception of tearing apart the figure.

RM: At the recent Whitney Biennial there were three rooms that you did—one with neon, another with video, and a third with sound. Each of these rooms had a different way of addressing human relationships through some kind of action or interaction. What was your intention in the separation of the spaces?

BN: Basically the piece was three separate pieces that had been made over a period of three years and were never intended to be put together. No, that's not true. There were two pieces, really—the video part and the hanged man, the neon part, were separate pieces. The addition of the audio with the voice, the chanting, was taken from another earlier piece. They all ended up dealing with or using the idea of dying and death, the fear of death. And that was really the connecting link, the connection between the rooms. I liked the idea very much of taking parts—of taking things—and putting them together where there is some unifying element that, at the same time, had a very broad connotation. The kind of thinking that went into each one was quite different because they were intended as separate pieces. And so I feel there are a lot of ways they connect, and a lot of ways they don't. So they were in one large room at the same time as they were in three smaller rooms.

RM: What was your concern in dealing with the subject of death in relation to this culture?

BN: I don't know. On the one hand, it wasn't really a major concern, but it was part of all three of those sections, something that connected them.

RM: Did you feel it was a primary issue? A friend of mine teaches Comparative Religions at a state university in California and is writing a

book on this subject. I believe he calls it *The Sacred Art of Dying*. He has studied this from many cultural points of view, and he feels that it's something that's very awkward and somehow not permissible for Americans to think about as part of the culture we live in.

BN: Well, it was a concern. It was part of it. In our culture there's been a lot of difficulty in trying to figure out how to deal with death. There's a basic fear of death. There's not a good cultural way of dealing with it. We don't have any clear rituals anymore, since religion has become less important to the culture. So we don't accept it as part of our life. But there's a lot of things involved in that. We're not clear about a lot of things.

RM: You mentioned ritual, and it seems that much of your earlier work, in which you were making impressions of your body using various media, dealt with a kind of personal, hermetic ritual in relation to materials and ideas. In doing those pieces were you thinking in terms of a formal approach to sculpture, or were you thinking more in terms of ritual and content?

BN: Content, not ritual.

RM: Something that I have perceived about your work over the years is the use of repetition. I saw something reproduced in a photograph recently of a series of phrases that related to the audio component of the Whitney installation which were repeated and color-coded in a systemic manner—in Chicago, I believe. There have been other works. I remember seeing a film you made ten or twelve years ago called *Pursuit*, in which the concern for modularity and time, sequence and repetition, seemed a fundamental concern. In your earlier videotapes, working in the studio—sawing, cutting, and arranging wood—there was this repetitive quality. I'm wondering how you see this in your work?

BN: That came out of the performance work—making films, trying to figure out how to structure time as opposed to drawing and sculpture. Certainly the early Warhol films were very influential. You can go back to Satie as somebody who was interested in that extension of time. And La Monte Young, whose idea was that the music was always going on and you just tap into it during the performance. I never saw any of the performances where apparently he would be playing before anyone arrived, and playing after everyone left. There wasn't a beginning

and end. And I liked that idea very much. So repetition was one way of doing it.

RM: What did you like about that idea? It's almost like a kind of cyclicality.

BN: You don't have to tell a story. There is no story. And I liked the idea that you could arrive someplace, watch something for a while, then you could leave and go to lunch and come back and it would still be going on. In a sense you knew what was going on so you could understand the whole thing. On the other hand, if you watched for a half an hour or an hour, and came back the next day, there would be no surprises. It would be a different kind of experience. In a way it's like telling someone this performance could last half an hour, and it might seem kind of boring. It might even be boring, but if you know it's going to be a half hour you can handle that because you know that there's not going to be a plot or a structure you'll have to get through.

RM: It's like engaging in an event. It will simply take its own course.

BN: You don't set up any expectations either, so there's no cause for people to feel impatient and wonder when is this going to be over or when are we going to find out what happens here. It's like reading Shakespeare more than once; everybody knew the story so there was no sense of the ending being spoiled or finding out what happened. There's an enjoyment of the performance, not the story, waiting for the story to unfold . . .

RM: You mentioned performance a few times in our conversation. Is this an integral part of how you see sculpture?

BN: Yes, I think in some cases, because I am looking for a way to present, to involve people in the work. Sculpture was always involved in performance in the sense that it involves the spectator, because the spectator has to walk around it. In that sense you become a participant or a performer. . . . I remember when the Whitney did one of their Biennials—one of their first major corporation-sponsored ones—they took a bunch of David Smith's and stuck them in front of photomurals of landscapes. It flattened out the sculpture and made it impossible to walk around them. What you got was an artificial experience where

you had to stand in one place. By taking those kinds of sculpture and putting them up against the wall, it flattens out the space. You aren't allowed to participate with them in the way they ought to be viewed.

RM: I understand. Certainly, your corridor pieces and those cubic rhomboids—what did you call them?—

BN: *Forced Perspectives.*

RM: Yes, I believe they were shown in New York several years ago. With those pieces there is a kind of performative involvement which the viewer has in relation to the field of objects. . . . In the figurative neons there isn't that ambulatory involvement. There's another kind of performative element going on. Instead, there's almost a setup for the viewer.

BN: In a sense they're much less formally complex. You can stand in one spot and they do their thing to you. You don't have a chance to absorb it slowly. They're much more visual than they are physical.

RM: What about those pieces in terms of content? It seems to me that there's much more specific content than some of the more formal/perceptual pieces. From my perspective, they appear more about semiotics than phenomenology, a kind of decoding of behavior. Why this shift?

BN: *(laughs)* I don't know. It just came out that way.

RM: How do you feel about working in New Mexico compared with southern California? What about the spatial, perceptual changes—is that something you are conscious of in relation to your thinking?

BN: I don't know how that has anything to do with the work at this point. There may be, but it doesn't seem obvious to me. It's the kind of space that I enjoy personally. Maybe if I had grown up or spent more of my early years in that kind of country . . . maybe it would have made more of an impression on what I do. At this point, I don't see any specific results of that move.

RM: What have you learned from the drawing retrospective that opened today in New York?

BN: I think the main thing that became more and more apparent, which I kind of knew but hadn't paid a lot of attention to, was how the ideas connect, how something I thought about in 1968 or 1972 connects to something I'm working on in 1985 or today. Sometimes formal connections, attitudes, and ideas seem to go back and forth, a lot more than I was aware of. Also, trying different ways of working on the catalogue with Coosje (van Bruggen) and Dieter (Koepplin) I discovered some interesting connections. Even in this installation, with certain kinds of juxtapositions that Marcia (Tucker) did which are different from the ones in the catalogue and which are different from those in other installations in Europe that I saw, it makes sense.

RM: When you work do you think in terms of a formal approach to the material and the idea, or do you think in terms of delivering a certain content?

BN: Well, both things. If the idea's not delivered then there's no point in worrying about the formal problem. The formal problem is always interesting, and it's not always possible to separate them. I think one thing I can see happening if I'm working with plaster, which was for some period of time starting to really strain, is that it was not functioning in relation to a particular idea. You push the medium too far and it can't hold the idea anymore.

RM: So what are you working on now?

BN: I'm working on some tapes, more tapes.

RM: What interests you about video?

BN: Well, initially it was the immediacy of the medium. It was a lot easier and cheaper than film, a very intimate kind of medium. When you work with it with someone else, you do that in a different way than you do film, a more comfortable way . . .

RM: Do you see the video monitor as having an object presence in relation to the spectator?

BN: Yes, it does. I'm generally not interested in that. I'm more interested in things happening in time . . . over a period of time.

RM: There is a question I've always wanted to ask you—that early neon sign from the 1960s which reads: "The True Artist Helps the World by Revealing Mystic Truths." Is that a tongue-in-cheek statement, or did you really mean that?

BN: I've always felt that I believed it in some sense, but maybe not in the sense I thought about it initially. It's one of those things you say to find out what you think about it, testing yourself.

RM: So you don't feel your work has to answer questions; you just have to see them revealed?

BN: Yes, it's more that I figure out what those questions are.

Joan Simon

Breaking the Silence

Reflecting on two decades of his own work, Nauman discloses some
verbal and visual ties between his recent political allegories and his
earlier use of puns, body parts, and space.

The heterogeneity of Nauman's early work not only challenged
the purity of minimal or late-formalist sculpture, but it also demon-
strated Nauman's characteristic attitude toward art-making, which
often treats linguistic fragments and material issues as interchange-
able. . . . During 1965–66 Nauman produced his first fiberglass
pieces and performances based on simple procedures and body
movements. . . . In the 1970s, Nauman's work shifted from the body
and elements in the studio to quasi-architectural installations (in-
cluding many corridor pieces) which often incorporated sound or
video. . . . Nauman's 1980s work focuses increasing attention on so-
cial and political subject matter.

Bruce Nauman: There is a tendency to clutter things up, to try to make
sure people know something is art, when all that's necessary is to pre-
sent it, to leave it alone. I think the hardest thing to do is to present an
idea in the most straightforward way.

What I tend to do is see something, then remake it and remake it
and remake it and try every possible way of remaking it. If I'm persis-

Originally published in *Art in America* 76, no. 9 (September 1988): 140–203.
Also published in the catalogue for the touring exhibition, "Bruce Nauman,"
Kunstmuseum, Wolfsburg; Centre Georges Pompidou, Paris; Hayward
Gallery, London; Nykytaiteen, Helsinki, 1997/1999. *Bruce Nauman* (Lon-
don: South Bank Centre, 1998). Thank you to Joan Simon and *Art in
America* for this interview. © Joan Simon 1988.

tent enough, I get back to where I started. I think it was Jasper Johns who said, "Sometimes it's necessary to state the obvious."

Still, how to proceed is always the mystery. I remember at one point thinking that someday I would figure out how you do this, how you do art—like, "What's the procedure here, folks?"—and then it wouldn't be such a struggle anymore. Later, I realized it was never going to be like that, it was always going to be a struggle. I realized it I would never have a specific process; I would have to reinvent it, over and over again. That was really depressing.

After all, it was hard work; it was a painful struggle and tough. I didn't want to have to go through all that every time. But of course you do have to continually rediscover and redecide, and it's awful. It's just an awful thing to have to do.

On the other hand, that's what's interesting about making art, and why it's worth doing: it's never going to be the same, there is no method. If I stop and try to look at how I got the last piece done, it doesn't help me with the next one.

Joan Simon: What do you think about when you're working on a piece?

BN: I think about Lenny Tristano a lot. Do you know who he was? Lenny Tristano was a blind pianist, one of the original—or maybe second-generation—bebop guys. He's on a lot of the best early bebop records. When Lenny played well, he hit you hard and he kept going until he finished. Then he just quit. You didn't get any introduction, you didn't get any tail—you just got full intensity for two minutes or twenty minutes or whatever. It would be like taking the middle out of Coltrane—just the hardest, toughest part of it. That was all you got.

From the beginning I was trying to see if I could make art that did that. Art that was just there all at once. Like getting hit in the face with a baseball bat. Or better, like getting hit in the back of the neck. You never see it coming; it just knocks you down. I like that idea very much: the kind of intensity that doesn't give you any trace of whether you're going to like it or not.

JS: In trying to capture that sort of intensity over the past twenty or so years you've worked in just about every medium: film, video, sound, neon, installation, performance, photography, holography, sculpture, drawing—but not painting. You gave that up very early on. Why?

BN: When I was in school I was a painter. And I went back and forth a couple of times. But basically I couldn't function as a painter. Painting is one of those things I never quite made sense of. I just couldn't see how to proceed as a painter. It seemed that if I didn't think of myself as a painter, then it would be possible to continue.

It still puzzles me how I made decisions in those days about what was possible and what wasn't. I ended up drawing on music and dance and literature, using thoughts and ideas from other fields to help me continue to work. In that sense, the early work which seems to have all kinds of materials and ideas in it, seemed very simple to make because it wasn't coming from looking at sculpture or painting.

JS: That doesn't sound simple.

BN: No, I don't mean that it was simple to do the work. But it was simple in that in the 1960s you didn't have to pick just one medium. There didn't seem to be any problem with using different kinds of materials—shifting from photographs to dance to performance to videotapes. It seemed very straightforward to use all those different ways of expressing ideas or presenting material. You could make neon signs, you could make written pieces, you could make jokes about parts of the body or casting things, or whatever.

JS: Do you see your work as part of a continuum with other art or other artists?

BN: Sure there are connections, although not in any direct way. It's not that there is someone in particular you emulate. But you do see other artists asking the same kinds of questions and responding with some kind of integrity.

There's a kind of restraint and morality in Johns. It isn't specific, I don't know how to describe it, but it's there. I feel it's there. It's less there, but still important, in Duchamp. Or in Man Ray, who also interests me. Maybe the morality I sense in Man Ray has to do with the fact that while he made his living as a fashion photographer, his artworks tended to be jokes—stupid jokes. The whole idea of Dada was that you didn't have to make your living with your art, so that generation could be more provocative with less risk. Then there is the particularly American idea about morality that has to do with the artist as workman. Many artists used to feel all right about making a living with

their art because they identified with the working class. Some still do. I mean, I do, and I think Richard Serra does.

JS: No matter how jokey or stylistically diverse or visually dazzling your works are, they always have an ethical side, a moral force.

BN: I do see art that way. Art ought to have a moral value, a moral stance, a position. I'm not sure where that belief comes from. In part it just comes from growing up where I grew up and from my parents and family. And from the time I spent in San Francisco going to the Art Institute, and before that in Wisconsin. From my days at the University of Wisconsin, the teachers I remember were older guys—they wouldn't let women into teaching easily—and they were all WPA guys.[1] They were socialists and they had points to make that were not only moral and political, but also ethical. Wisconsin was one of the last socialist states, and in the 1950s, when I lived there and went to high school there, Milwaukee still had a socialist mayor. So there were a lot of people who thought art had a function beyond being beautiful—that it had a social reason to exist.

Early Work

JS: What David Whitney wrote about your *Composite Photo of Two Messes on the Studio Floor,* 1967—that "it is a direct statement on how the artist lives, works and thinks"—could apply in general to the variety of works you made in your San Francisco studio from 1966–68.

BN: I did some pieces that started out just being visual puns. Since these needed body parts in them, I cast parts of a body and assembled them or presented them with a title. There was also the idea that if I was in the studio, whatever I was doing was art. Pacing around, for example. How do you organize that to present it as art? Well, first I filmed it. Then I videotaped it. Then I complicated it by turning the camera upside down or sideways, or organizing my pacing to various sounds.

In a lot of the early work I was concerned with ideas about inside and outside and front and back—how to turn them around and confuse them. Take the *Window or Wall Sign*—you know, the neon piece that says, "The true artist helps the world by revealing mystic truths." That idea occurred to me because of the studio I had in San Francisco at the time. It had been a grocery store, and in the window there was still a beer sign which you read from the outside. From the inside, of

course, it was backwards. So when I did the earliest neon pieces, they were intended to be seen through the window one way and from the inside another way, confusing the message by reversing the image.

JS: Isn't your interest in inverting ideas, in showing what's "not there," and in solving—or at least revealing—"impossible" problems related in part to your training as a mathematician?

BN: I was interested in the logic and structure of math and especially how you could turn that logic inside out. I was fascinated by mathematical problems, particularly the one called "squaring the circle." You know, for hundreds of years mathematicians tried to find a geometrical way of finding a square equal in area to a circle—a formula where you could construct one from the other. At some point in the nineteenth century, a mathematician—I can't remember his name—proved it can't be done. His approach was to step outside the problem. Rather than struggling inside the problem, by stepping outside of it, he showed that it was not possible to do it at all.

Standing outside and looking at how something gets done, or doesn't get done, is really fascinating and curious. If I can manage to get outside of a problem a little bit and watch myself having a hard time, then I can see what I'm going to do—it makes it possible. It works.

JS: A number of early pieces specifically capture what's "not there." I'm thinking about the casts of "invisible spaces": the space between two crates on the floor, for example, or the "negative" space under a chair.

BN: Casting the space under a chair was the sculptural version of de Kooning's statement: "When you paint a chair, you should paint the space between the rungs, not the chair itself." I was thinking like that: about leftovers and negative spaces.

JS: But your idea of negative space is very different from the sculptor's traditional problem of locating an object in space or introducing space into a solid form.

BN: Negative space for me is thinking about the underside and the backside of things. In casting, I always like the parting lines and the seams—things that help to locate the structure of an object, but in the finished

sculpture usually get removed. These things help to determine the scale of the work and the weight of the material. Both what's inside and what's outside determine our physical, physiological, and psychological responses—how we look at an object.

JS: The whole idea of the visual puns, works like *Henry Moore Bound to Fail* and *From Hand to Mouth*, complicates this notion of how we look at an object. They are similar to ready-mades. On the one hand, they translate words or phrases into concrete form—in a sense literalizing them. On the other hand, they are essentially linguistic plays, which means abstracting them. I'm curious about the thought process that went into conceiving those works. For instance, how did *From Hand to Mouth* come about?

BN: In that case, the cast was of someone else, not of myself as has generally been assumed—but that doesn't really matter. It was just supposed to be a visual pun, or a picture of a visual pun.

I first made *From Hand to Mouth* as a drawing—actually, there were two or three different drawings—just the idea of drawing "from hand to mouth." But I couldn't figure out exactly how to make the drawing. My first idea was to have a hand in the mouth with some kind of connection—a bar, or some kind of mechanical connection. I finally realized that the most straightforward way to present the idea would be to cast that entire section of the body. Since I couldn't cast myself, I used my wife as the model.

I worked with the most accurate casting material I could find, something called "moulage." I found the stuff at some police shop. You know, they used it to cast tire prints and things like that. It's actually a very delicate casting process; you could pick up fingerprints in the dust with it. The moulage is a kind of gel you heat up. Because it's warm when you apply it to a body, it opens up all the pores—it picks up all that, even the hairs. But it sets like five-day-old Jell-O. You have to put plaster or something over the back of it to make it hold its shape. Then I made the wax cast, which became very super-realistic—hyper-realistic. You could see things you don't normally see—or think about—on people's skin.

JS: All your work seems to depend not only on this kind of tactile precision, but also on a kind of incompleteness—a fragmentariness, a sense

of becoming. As a result, your pieces accrue all sorts of meaning over time. With *From Hand to Mouth*—completed over twenty years ago—what other meanings have occurred to you?

BN: Well, it's funny you should ask that, because not long ago I read this book in which a character goes to funeral homes or morgues, and uses this moulage stuff on people and makes plaster casts—death masks—for their families. I had no idea that this was a profession. But it turns out that this moulage is a very old, traditional kind of material, and was often used this way. But it just connects up in a strange sort of way with my more recent work, since over the past several years I have been involved with both the idea of death and dying and the idea of masking the figure.

Masks and Games

JS: An early example of masking the figure—your figure, to be precise—was your 1969 film *Art Make-Up*.

BN: That film—which was also later a videotape—has a rather simple story behind it. About twenty years ago—this was in 1966 and 1967—I was living in San Francisco, and I had access to a lot of film equipment. There were a lot of underground filmmakers there at the time and I knew a bunch of those guys. And since everybody was broke, I could rent pretty good 16 mm equipment for $5 or $6 a day—essentially the cost of gas to bring it over. So I set up this *Art Make-Up* film.

 Of course, you put on makeup before you film in the movies. In my case, putting on the makeup became the activity. I started with four colors. I just put one on over the other, so that by the time the last one went on it was almost black. I started with white. Then red on the white, which came out pink; then green on top of that, which came out gray; then something very black on top of that.

 One thing which hadn't occurred to me when I was making the film was that when you take a solid color of makeup—no matter what color—it flattens the image of the face on film. The flatness itself was another kind of mask.

JS: The whole idea of the mask, of abstracting a personality, of simultaneously presenting and denying a self, is a recurring concern in your work.

BN: I think there is a need to present yourself. To present yourself through your work is obviously part of being an artist. If you don't want people to see that self, you put on makeup. But artists are always interested in some level of communication. Some artists need lots, some don't. You spend all of this time in the studio and then when you do present the work, there is a kind of self-exposure that is threatening. It's a dangerous situation and I think that what I was doing, and what I am going to do and what most of us probably do, is to use the tension between what you tell and what you don't tell as part of the work. What is given *and* what is withheld become the work. You could say that if you make a statement it eliminates the options; on the other hand if you're a logician, the opposite immediately becomes a possibility. I try to make work that leaves options, or is open-ended in some way.

JS: The tenor of that withholding—actually controlling the content or subject—changed significantly when you stopped performing and began to allow the viewer to participate in some of your works. I'm thinking of the architectural installations, in particular the very narrow corridor pieces. In one of them, the viewer who could deal with walking down such a long claustrophobic passage would approach a video monitor on which were seen disconcerting and usually "invisible" glimpses of his or her own back.

BN: The first corridor pieces were about having someone else do the performance. But the problem for me was to find a way to restrict the situation so that the performance turned out to be the one I had in mind. In a way, it was about control. I didn't want somebody else's idea of what could be done.

There was a period in American art, in the 1960s, when artists presented parts of works, so that people could arrange them. Bob Morris did some pieces like that, and Oyvind Fahlstrom did those political-coloring-book-like things with magnets that could be rearranged. But it was very hard for me to give up that much control. The problem with that approach is that it turns art into game-playing. In fact, at the time, a number of artists were talking about art as though it were some kind of game you could play. I think I mistrusted that idea.

Of course, there is a kind of logic and structure in art-making that you can see as game-playing. But game-playing doesn't involve any responsibility—any moral responsibility—and I think that being an artist

does involve moral responsibility. With a game you just follow the rules. But art is like cheating—it involves inverting the rules or taking the game apart and changing it. In games like football or baseball cheating is allowed to a certain extent. In hockey breaking the rules turns into fighting—you can't do that in a bar and get away with it. But the rules change. It can only go so far and then real life steps in. This year warrants were issued to arrest hockey players; two minutes in the penalty box wasn't enough. It's been taken out of the game situation.

JS: Nevertheless, many of your works take as their starting point very specific children's games.

BN: When I take the game, I take it out of context and apply it to moral or political situations. Or I load it emotionally in a way that it is not supposed to be loaded. For instance, the *Hanged Man* neon piece (1985) derives from the children's spelling game. If you spell the word, you win; if you can't spell the word in a certain number of tries, then the stick figure of the hanged man is drawn line by line with each wrong guess. You finally lose the game if you complete the figure—if you hang the man.

With my version of the hanged man, first of all, I took away the part about being allowed to participate. In my piece you're not allowed to participate—the parts of the figure are put into place without you. The neon "lines" flash on and off in a programmed sequence. And then the game doesn't end. Once the figure is complete, the whole picture starts to be recreated again. Then I added the bit about having an erection or ejaculation when you're hanged. I really don't know if it's a myth or not.

I've also used the children's game "musical chairs" a number of times. The simplest version was *Musical Chair (Studio Piece)* in 1983, which has a chair hanging at the outside edge of a circumference of suspended steel Xs. So, when the Xs swing or the chair swings, they bang into each other and actually make noise—make music. But of course it was more than that because musical chairs is also a cruel game. Somebody is always left out. The first one to be excluded always feels terrible. That kid doesn't get to play anymore, has nothing to do, has to stand in the corner or whatever.

Large-Scale Sculpture

JS: There seems to be something particularly ominous about your use of chairs—both in this and other works. Why a chair? What does it mean to you?

BN: The chair becomes a symbol for a figure—a stand-in for the figure. A chair is used, it is functional; but it is also symbolic. Think of the electric chair, or that chair they put you in when the police shine the lights on you. Because your imagination is left to deal with that isolation, the image becomes more powerful, in the same way that the murder offstage can be more powerful than if it took place right in front of you. The symbol is more powerful.

I first began to work with the idea of a chair with that cast of the space underneath a chair—that was in the 1960s. And I remember, when I think back to that time, a chair Beuys did with a wedge of suet on the seat. I think he may have hung it on the wall. I'm not sure. In any case, it was a chair that was pretending it was a chair—it didn't work. You couldn't sit in it because of that wedge of grease or fat or whatever it was—it filled up the space you would sit in. Also, I'm particularly interested in the idea of hanging a chair on the wall. It was a Shaker idea, you know. They had peg boards that ran around the wall, so they could pick up all the furniture and keep the floors clean. The chairs didn't have to be on the floor to function.

In 1981, when I was making *South American Triangle,* I had been thinking about having something hanging for quite a long time. The *Last Studio Piece,* which was made in the late 1970s when I was still living in Pasadena, was made from parts of two other pieces—plaster semicircles that look like a cloverleaf and a large square—and I finally just stuck them together. I just put one on top of the other and a metal plate in between and hung it all from the ceiling. That was the first time I used a hanging element. I was working at the same time on the "underground tunnel pieces." These models for tunnels I imagined floating underground in the dirt. The same ideas and procedures, the same kind of image, whether something was suspended in water, in earth, in air.

JS: *South American Triangle* in a certain sense continues these ideas of game-playing, suspension, inside and outside, and the chair as a stand-

in for the figure. In this case though, we're talking about a big steel sculpture hanging from the ceiling, with the chair isolated and suspended upside-down in the middle of the steel barrier. This seems considerably more aggressive than the earlier work, although the content is still covert, an extremely private meditation. But the title hints at its subject matter and begins to explicate its intense emotional and political presence. I'm wondering what your thoughts were when you were making this piece?

BN: When I moved to New Mexico and was in Pecos in 1979, I was thinking about a piece that had to do with political torture. I was reading V. S. Naipaul's stories about South America and Central America, including *The Return of Eva Peron* and especially *The Killings in Trinidad*—that's the one that made the biggest impression on me. Reading the Naipaul clarified things for me and helped me continue. It helped me to name names, to name things. But it didn't help me to make the piece. It didn't help me to figure out how the bolts went on. It just gave me encouragement.

At first, I thought of using a chair that would somehow become the figure: torturing a chair and hanging it up or strapping it down, something like that. And then torture has to take place in a room (or at least I was thinking in terms of it taking place in a room), but I couldn't figure out how to build a room and how to put the chair in it. Well, I'd made a number of works that had to do with triangles, like rooms in different shapes. I find triangles really uncomfortable, disconcerting kinds of spaces. There is no comfortable place to stay inside them or outside them. It's not like a circle or square that gives you security.

So, in the end, for *South American Triangle,* I decided that I would just suspend the chair and then hang a triangle around it. My original idea was that the chair would swing and bang into the sides of the triangle and make lots of noise. But then when I built it so that the chair hung low enough to swing into the triangle, it was too low. It didn't look right, so I ended up raising it. The triangle became a barrier to approaching the chair from the outside.

Again, it becomes something you can't get to. There is a lot of anger generated when there are things you can't get to. That's part of the content of the work—and also the genesis of the piece. Anger and frustration are two very strong feelings of motivation for me. They get me into the studio, get me to do the work.

JS: That sense of frustration and anger also becomes the viewer's problem in approaching and making sense of your work, especially a piece as disturbing as *South American Triangle*. One critic, Robert Storr, said recently, "Unlike settling into the reassuring 'armchair' of Matisse's painting, to take one's seat in Nauman's art is to risk falling on one's head."

BN: I know there are artists who function in relation to beauty—who try to make beautiful things. They are moved by beautiful things and they see that as their role: to provide or make beautiful things for other people. I don't work that way. Part of it has to do with an idea of beauty. Sunsets, flowers, landscapes: these kinds of things don't move me to do anything. I just want to leave them alone. My work comes out of being frustrated about the human condition. And about how people refuse to understand other people. And about how people can be cruel to each other. It's not that I think I can change that, but it's just such a frustrating part of human history.

Recent Videos

JS: Recently, you've returned to video for the first time since the late 1960s. In *Violent Incident*, 1986, you not only moved from "silents" to "talkies," but you also used actors for the first time. Nevertheless, the video seems to pick right up on issues you've explored from the beginning. The chair is a central element in the action and the whole tape centers on a cruel joke. Again there is this persistent tension between humor and cruelty.

BN: *Violent Incident* begins with what is supposed to be a joke—but it's a mean joke. A chair is pulled out from under someone who is starting to sit down. It intentionally embarrasses someone and triggers the action. But let me describe how it got into its present form. I started with a scenario, a sequence of events which was this: two people come to a table that's set for dinner with plates, cocktails, flowers. The man holds the woman's chair for her as she sits down. But as she sits down he pulls the chair out from under her and she falls on the floor. He turns around to pick up the chair, and as he bends over, she's standing up, and she gooses him. He turns around and yells at her—calls her names. She grabs the cocktail glass and throws the drink in his face. He slaps her, she knees him in the groin, and, as he's doubling over, he grabs a

knife from the table. They struggle and both of them end up on the floor.

Now this action takes all of about eighteen seconds. But then it's repeated three more times: the man and woman exchange roles, then the scene is played by two men and then by two women. The images are aggressive, the characters are physically aggressive, the language is abusive. The scripting, having the characters act out these roles and the repetition all build on that aggressive tension.

JS: Sound is a medium you've explored since your earliest studio performances, films, and audiotapes. The hostile overlayering of angry noises contributes enormously to the tension of *Violent Incident*.

BN: It's similar with the neon pieces that have transformers, buzzing and clicking and what not; in some places I've installed them, people are disturbed by these sounds. They want them to be completely quiet. There is an immediacy and an intrusiveness about sound that you can't avoid.

So with *Violent Incident*, which is shown on twelve monitors at the same time, the sound works differently for each installation. At one museum, when it was in the middle of the show, you heard the sound before you actually got to the piece. And the sound followed you around after you left it. It's kind of funny the way *Violent Incident* was installed at the Whitechapel. Because it was in a separate room, the sound was baffled; you only got the higher tones. So the main thing you heard throughout the museum was "Asshole."

JS: That's sort of the subliminal version of a very aggressive sound piece you used to install invisibly in empty rooms, isn't it?

BN: You mean the piece that said, "Get out of the room, get out of my mind"? That piece is still amazingly powerful to me. It's really stuck in my mind. And it's really a frightening piece. I haven't heard it for a few years, but the last time I did I was impressed with how strong it was. And I think that it is one of those pieces that I can go back to. I don't know where it came from or how I managed to do it because it's so simple and straightforward.

JS: How did that come about?

BN: Well, I had made a tape of sounds in the studio. And the tape says over and over again, "Get out of the room, get out of my mind." I said it a lot of different ways: I changed my voice and distorted it. I yelled it and growled it and grunted it. Then, the piece was installed with the speakers built into the walls, so that when you went into this small room—10 feet square or something—you could hear the sound, but there was no one there. You couldn't see where the sound was coming from. Other times, we just stuck the speakers in the corners of the room and played the tape—like when the walls were too hard to build into. But it seemed to work about as well either way. Either way it was a very powerful piece. It's like a print I did that says, "Pay attention motherfuckers" (1973). You know, it's so angry it scares people.

JS: Your most recent videotapes feature clowns. I can see a connection to the *Art Make-Up* film we talked about, but why did you use such theatrical clowns?

BN: I got interested in the idea of the clown first of all because there is a mask, and it becomes an abstracted idea of a person. It's not anyone in particular, see, it's just an idea of a person. And for this reason, because clowns are abstract in some sense, they become very disconcerting. You, I, one, we can't make contact with them. It's hard to make any contact with an idea or an abstraction. Also, when you think about vaudeville clowns or circus clowns, there is a lot of cruelty and meanness. You couldn't get away with that without makeup. People wouldn't put up with it, it's too mean. But in the circus it's okay, it's still funny. Then, there's the history of the unhappy clown: they're anonymous, they lead secret lives. There is a fairly high suicide rate among clowns. Did you know that?

JS: No, I didn't. But it seems that rather than alluding to this melancholic or tragic side of the clown persona the video emphasizes the different types of masks, the historically specific genres of clowns or clown costumes.

BN: With the clown videotape, there are four different clown costumes: one of them is the Emmett Kelly dumb clown; one is the old French Baroque clown (I guess it's French); one is a sort of traditional polkadot, red-haired, oversize-shoed clown; and one is a jester. The jester and the Baroque type are the oldest, but they are pretty recognizable

types. They were picked because they have a historical reference, but they are still anonymous. They become masks, they don't become individuals. They don't become anyone you know, they become clowns.

JS: In your tape *Clown Torture,* 1987, the clowns don't act like clowns. For one thing, they're not mute. You have the clowns tell stories. Or, I should say, each of the clowns repeats the same story.

BN: Each clown has to tell a story while supporting himself on one leg with the other leg crossed, in such a way that it looks like he is imitating sitting down. So there is the physical tension of watching someone balance while trying to do something else—in this case, tell a story. The takes vary because at some point the clown gets tired and falls over. Then I would stop the tape. Each of the four clowns starts from the beginning, tells the story about fifteen times or so, falls over and then the next clown starts.

This circular kind of story, for me, goes back to Warhol films that really have no beginning or end. You could walk in at any time, leave, come back again, and the figure was still asleep, or whatever. The circularity is also a lot like La Monte Young's idea about music. The music is always going on. You just happen to come in at the part he's playing that day. It's a way of structuring something so that you don't have to make a story.

JS: What's the story the clowns tell?

BN: "It was a dark and stormy night. Three men were sitting around a campfire. One of the men said, 'Tell us a story, Jack.' And Jack said, 'It was a dark and stormy night. Three men were sitting around a campfire. One of the men said, 'Tell us a story, Jack.' And Jack said, 'It was a dark and stormy night . . .'"

Notes

This text is an excerpt from interviews with Nauman for the film, *Four Artists: Robert Ryman, Eva Hesse, Bruce Nauman, Susan Rothenberg* (Michael Blackwood Productions, 1988). The interviews were recorded in January 1987 while Nauman was installing a retrospective of his work at the Whitechapel Art Gallery in London. Simultaneously, a retrospective of Nauman's drawings, organized by the Kunstmuseum Basel toured Europe and was later shown in the United States.

1. Works Progress Administration.

Christopher Cordes

Talking with Bruce Nauman

Part I: An Overview

Christopher Cordes: What do you like about making prints?

Bruce Nauman: There is a directness to making marks—lithography, in particular, involves a very wonderful surface to draw on. You don't get that quality of working with the stone or the plate when you just make a drawing. It seems like every time I've worked on a group of lithographs, the first ones have a lot to do with making marks on the stone and drawing with a crayon, making washes, and things like that. As I work at it for a period of time, a lot of that disappears or I get that out of the way. There is a finish I can get, a kind of tightness and clarity I really like.

In printmaking there is a sense of stepping back more. This is almost a contradiction because there is a directness in drawing, but in printmaking there is an added element of allowing the technique to be a buffer between me and the image. I like that, too—the mechanicalness of it. Sometimes, just because the image is reversed, there is a sense of removal, like I was left-handed. There is also a sense of ritualizing the image.

CC: Do you get that feeling because you are working on a lithographic stone or an intaglio plate, which are both three-dimensional surfaces?

BN: No, I think the "objectness" of the stone is very important, but it has more to do with the printing process. Somehow you hook yourself into a process like hooking onto a machine: you give it some information, it does something with it, and a result comes out. If you under-

Originally published in *Bruce Nauman: Prints 1970–89* (New York: Leo Castelli Graphics, 1989), 22–34.

stand how the machine works, then you understand what the output is going to be. But there will still be some extra work not done by you, and that just fascinates me.

CC: How does the printmaking process affect your approach to drawing?

BN: Most of the drawings I make are to help me figure out the problems of a particular piece I'm working on. The first time I did lithographs, I was making lots of drawings in the studio and I thought I could just go into the shop and continue to make those drawings as prints. But it never worked out that way; it always ends up that I don't want the prints to be drawings, I want them to be part of the process of making prints—just making a drawing doesn't feel sufficient. A clearer or more independent statement is there in the prints.

Since I tend to make them in groups with long lapses in between, there is a struggle each time to rediscover what I think printmaking can be. An important aspect of this is how comfortable I feel in a particular workshop. All these things influence the work that comes out. I go in with some fixed ideas, and then in the process of trying to get those ideas out, they change a lot. I've often felt best about either the very first work I do when I go in, or the last work; sometimes the stuff in the middle tends to be real muddled. Perhaps it is because with the first work, I'm still clear about my conception of what I want and I just get it down; by the last work, I'm much clearer about the kinds of processes I'm comfortable with. But there is some confusion in the work done in the middle.

CC: In the catalogue *Bruce Nauman: Work from 1965 to 1972,* Jane Livingston emphasized your concern to find "nonartistic" mediums to work in. If that is the case, how do you feel about printmaking, which is full of "art" implications?

BN: That quote comes from a much earlier period of my work, and I don't even have a response to it now. I did try to make the block-letter word prints in a nonprintlike way—just printing the image—but I don't think I was particularly concerned with nonart mediums.

CC: How do you decide which printing process is best suited for the image you have in mind?

BN: I think my first impression is to draw it. When I need to work out something while I am making the drawing, it seems to be easier to make a lithograph. And when I am working on a lithograph, I prefer to work on a stone rather than a plate because plates don't allow me enough latitude for making changes. Most of the lithographs on stone end up having a lot of scraping, over-drawing, and wiping off—all kinds of changes made during the work.

The times that I have made drypoints, I wanted to make that particular kind of line; I really like the quality of that line and the quality of the ink. I think I have only used a screen when just using typeface for a printed word message—it's more mechanical. I don't have a real strong feeling for the way the ink sits on the paper with a screen. I like how the ink seems to be more a part of the paper in the other processes.

In almost all cases where I can't get the image clean or clear enough, I'll go to some other process: perhaps cutting the image as a stencil and shooting it photographically on a litho plate, like in the *Perfect* prints, or maybe cutting the stencils for a silkscreen instead. *Silver Grotto/Yellow Grotto* was done as a screenprint because it was too large to do on a plate.

CC: Are the decisions to incorporate lithography with screenprinting made for reasons of economy? For example, both *Sugar/Ragus* and *Clear Vision* have a screenprinted flat (an unvaried application of ink over a block area) similar to the hand-printed flat in *Tone Mirror*.

BN: Sometimes the decision was made because I wanted to get a certain quality to the ink on the flat that was hard to achieve with the lithographic ink, but you could get it by using a screen. There is a yellow-and-green in *Sugar/Ragus* that was run as a screen; I did it that way because the printer was able to mix the color and draw it more easily than I could on stone. It was economy, but it was also just easier to print.

CC: How do you respond to color? For instance, what is the relationship between the implications of a word-image and its color?

BN: It is very hard for me to use color. It's real powerful and has been a problem for me in printmaking—probably because I don't do enough printmaking to be comfortable with it.

If I'm working on a stone, I generally get the whole image with the first drawing. Extra stones tend to be ways to make changes I can no

longer make on the first one. You run another stone when you can't fix the first stone anymore, if you can't open the stone up because you might lose some grays, or if you've lost the grays and have to add some. Sometimes there is also a nice quality when you run two different kinds of blacks. Often the image is already fairly complete and functioning in black-and-white, so even if there are two or three stones, I'm still dealing pretty much with a black-and-white problem.

Occasionally I have tried to add color, but that's kind of silly to do just because I feel I want some color. In the prints where I started out knowing that I wanted to do color, I have been able to break it down and be more successful; it requires being clear about the final image before I start working, so I tend to work the whole thing out ahead of time. I don't think that you would say these are not color problems in a painterly sense, but I don't come in thinking in terms of making a lithograph and having it read as a color statement. If there is color in it, it's a necessary part of the print but probably not the main energy of the print.

CC: Although your prints are not overtly colorful, one senses a lot of color in them; on some you have to look carefully to see the multiple color printings.

BN: I don't think you have to be able to see the number of runs. It's there in the richness of the print, and you understand that when you see it. My brother always used to put too much salt on everything because he thought when you salted food, you should be able to taste salt and not the flavor. I have a hard time with color and it seems to work best for me when it's used in a clear but sparing way. If I try to get too many colors into it, it breaks down. In many of the prints where there is a tone, the tone will often have a lot of color in it: greens get used a lot so black doesn't always read as black. When I was a student, I was a painter and I tended to try to make colors that looked like mud. I was interested in getting them as close as possible to mud but still have them function as color.

CC: Considering the sculptural concerns of your work, why have the majority of your prints been word-images as opposed to sculpturally related drawing?

BN: Most of the word pieces were produced during a period when I was

doing a lot of writing; the print medium seemed the most reasonable way to get them out. I've also made neon signs out of them, but I started to feel uncomfortable with that; it was like encumbering the information—the poetry—with this technology that didn't seem very important. It was as if I was doing them as neons just because that's the way I did them, and that didn't seem like reason enough. But when I began to see the information as poetry, doing them as prints made sense, and then in a way, making prints became about just being really careful with the typography and the layout.

The presence of the words on paper and the way they were printed were very important to me. The first time I wanted to use large, clean letters was with *Suck Cuts,* so I picked a typeface and we sent it off to the typesetters. When the type came back, all they had done was blow up the largest size they had. It looked terrible because it was very crude; when it was small you didn't see that. Large printed signs like billboards generally aren't very clean images, but it's not that important because the message is there and you get it. I wanted the typography to be really precise and sharp so that my visual statement would coincide with what the words said in just one vision. I ended up drawing it myself, which required a lot more work than I expected—it's not easy to draw that stuff and get it real clean.

CC: All of your prints relating to sculptural ideas are either intaglio drypoints, etchings, or lithographic line engravings. Why do you want that fine, linear quality when you make sculpturally related prints?

BN: When I draw in the studio, I draw mainly with a pencil; things are worked out in terms of line. At a much later stage of working on an idea, I can visualize it so that I can use brush strokes or the flat side of a piece of chalk to indicate the volumes. But my first impulse is to use a pencil.

The lithographs involve large areas of dark and light. They are almost always worked out directly with a big brush or a fat crayon, and generally involve a very shallow space of some kind. In my favorites, *Clear Vision* and *M. Ampere,* I thought of it in terms of stone-chiseling and shallow relief—an inch or less deep—so the surfaces appear flat.

CC: Ludwig Wittgenstein has referred to language as a "mirror image" of the world. What prompted your concern with front/back ideas and image reversal in prints?

BN: I don't know, but I was doing it for a long time. I first became aware of front/back interplay when I was making my early fiberglass sculptures. They were made in molds and each mold was interesting in itself—I would look at the back of it the whole time I was making the piece. In a similar way, most printmaking reverses the image during the process. I forget that it will be a mirror image, so the decision to do it frontward or backward happens then.

I like the way front/back interplay confuses the information. Not knowing what you're supposed to look at keeps you at a distance from the art while the art keeps you at a distance from me; the combination produces a whole set of tensions one can learn to exploit. I think that's a very strong part of my work—giving you some information about myself by giving you a piece of art, but also not letting you get any closer to me. It's like trying to get close yet not being allowed to get too close. Those kinds of tensions are very interesting; communication in general interests me. An artist is in a peculiar position—you know you're not talking to your best friend, but you have to assume you're speaking to people who are interested in what you are doing. It is difficult to address yourself to an anonymous public.

CC: Some of your prints, such as *Vision* and *No Sweat,* require a physical closeness to be perceived, while others, because of their bold word content—some as warnings, some as pleas—imply distancing. Are there any general concerns that you take into consideration regarding the viewer?

BN: I think pretty much in terms of how I respond to my work, and assume that other people will have at least a similar response.

CC: How do you deal with the workshop environment when you are making prints? Do the energies there interfere with your vision?

BN: My relationship to the printers in the workshop is very important. It's a special kind of relationship, different than always being by myself in the studio where the work has nothing to do with other people or places. In a sense, the prints can be isolated into groups, and my response to each group has a lot to do with the place where they were done. When I am doing the prints, I experience a kind of distillation of my personal state of mind with the workshop. When I'm finished with that experience, the prints are finished—it doesn't have as much to do with how the prints are made.

I don't do anything consistently; I don't make drawings or sculpture consistently. If I haven't drawn for months and I have something that I think I need to draw, I might have to do it over several times to remember how to make that particular kind of drawing. I ask myself, "What do I need to learn in order to get this idea on paper?" The same thing happens in making sculpture, and every time I make prints it seems I have to relearn how to make them.

When I go into a printshop and I haven't made drawings for a while, I try to make them in what I remember as being the way I made drawings the last time I worked on prints. Often that doesn't carry over because the idea has changed. It is always a struggle the first few days trying to draw the image on the stone or plate, but if you enjoy working with the medium, you get seduced by the nice things about it.

CC: Most printmakers are seduced by the appearance of a technique and they let that be the reason for its being.

BN: I am very impatient and mistrustful of that. I remember a painting teacher I had who would stand by the student painting racks so all he could see were the edges of the paintings, which all looked fantastic. If you pulled one out of the racks, the middle looked awful because that was the part the student was working on. The edges were kind of the leftover parts they hadn't even thought about, but this teacher would say, "Oh, the edges look great. How could you care about the middle? It looks terrible!"

In printmaking, I think there is a lot of accidental stuff that gets to be too important. This is probably the reason why washes and other techniques are very hard for me to deal with; I would rather not have any there at all. They look so wonderful I don't know what to do with them. Maybe it also has to do with the struggle I have with color. I am always seduced by that rich layering of transparencies but I don't know how to use them. They are not really a part of my statement, so trying to stick them in is often a mistake. When it's time for them to be there; they will just be there; to try to do it because it looks good somewhere else is rarely successful.

CC: That is another one of the traps many printmakers fall into.

BN: I have often been surprised when there have been eleven or sometimes even twenty-three runs in a print by Jasper [Johns] but it doesn't

look like that many runs—it looks like it might have been done in just three. Maybe when you look close you see it couldn't have been done in three, and perhaps it's twenty-three because he changed his mind after four runs and he needed to make corrections. I have no idea how it occurs, but the image doesn't look thick and turgid; it looks clean and clear. The fact that there were twenty-three runs just doesn't matter—it's only important to people who care about counting.

When I first learned about printmaking in the Midwest, all of those high-powered people—Hayter, Peterdi, and Lasansky—set the example that everyone had to imitate. You had to do a minimum number of processes to the stone or plate or piece of wood; it just involved a lot of density. I remember when David Hockney's *A Rake's Progress* (a suite of sixteen prints dated 1961–63) came out. These very simple etchings were heavily attacked by that whole Midwestern contingent. They thought the work had nothing to do with printmaking; that is a narrow point of view.

CC: Print works by artists who are not formal printmakers tend to evolve out of other urgencies.

BN: There are all kinds of art you can do that fulfill the need for busy work when you don't have many ideas. Professional photographers generally don't have anywhere near as much equipment as amateur photographers do—they couldn't carry it all around with them because they have work to do. They require only what it takes to meet the needs of the photograph. But amateurs don't have a specific job to get done, so their equipment seems just like a lot of fun toys and tools for taking up their time in the darkroom.

CC: And forget about image-making.

BN: Yes. I think the manipulations you can do are imitation creativity. It's more obvious in printmaking because printmakers have more tools and techniques to play with, but it happens to painters as well. When there is really no vision, painting has to do with the manipulation of materials.

CC: You have assembled a curious group of words and phrases in the course of making art—many of which are quite startling when viewed

within the context of everyday language. When discussing your prints in relation to philosophy, linguistics, and language, one must also consider the parallel importance of your use of nonwords to connote feelings that are experienced but indescribable. How does your work reflect your views on the use of language today?

BN: I am really interested in the different ways that language functions. That is something I think a lot about, which also raises questions about how the brain and the mind work. Language is a very powerful tool. It is considered more significant now than at any other time in history and it is given more importance than any of our faculties.

It's difficult to see what the functioning edges of language are. The place where it communicates best and most easily is also the place where language is the least interesting and emotionally involving—such as the functional way we understand the word "sing" or the sentence "Pick up the pencil." When these functional edges are explored, however, other areas of your mind make you aware of language potential. I think the point where language starts to break down as a useful tool for communication is the same edge where poetry or art occurs.

Roland Barthes has written about the pleasure that is derived from reading when what is known rubs up against what is unknown, or when correct grammar rubs up against nongrammar. In other words, if one context is different from the context that was given to you by the writer, two different kinds of things you understand rub against each other. When language begins to break down a little bit, it becomes exciting and communicates in nearly the simplest way that it can function: you are forced to be aware of the sounds and the poetic parts of words. If you deal only with what is known, you'll have redundancy; on the other hand, if you deal only with the unknown, you cannot communicate at all. There is always some combination of the two, and it is how they touch each other that makes communication interesting. Too much of one or the other is either unintelligible or boring, but the tension of being almost too far in either direction is very interesting to think about.

I think art forms in general are most interesting when they function in the same way. For instance, if de Kooning makes paintings, we give him a lot of credit for it. But if someone else makes a fantastic painting that you think is a de Kooning when you see it, a curious argument arises after you find out that it is not by de Kooning. Why do you feel

so cheated? I think it is because you have entered into a "friction" in your understanding of de Kooning, which somehow makes you feel cheated out of the rest of his paintings.

Art is interesting to me when it ceases to function as art—when what we know as painting stops being painting, or when printmaking ceases to be printmaking—whenever art doesn't read the way we are used to. In this manner, a good piece of art continues to function, revealing new meaning and remaining exciting for a long time, even though our vision of what art is supposed to be keeps changing. After a while, however, our point of view as to how art can function changes radically enough that the work of art becomes art history. Eventually, our perspective is altered so much that its functions just aren't available to us anymore and art becomes archaeology.

Part II: Questions Regarding Specific Prints

CC: Are the *Studies for Holograms* (a–e), 1970, exaggerated facial manipulations of the first five letters of the alphabet— "A" through "E"—or are they more generalized facial gestures? How did you decide on those manipulations?

BN: They aren't about the letters *A* to *E* at all—that is simply an identification sequence added later for cataloguing the prints. The idea of making faces had to do with thinking about the body as something you can manipulate. I had done some performance pieces—rigorous works dealing with standing, leaning, bending—and as they were performed, some of them seemed to carry a large emotional impact. I was very interested in that: if you perform a bunch of arbitrary operations, some people will make very strong connections with them and others won't. That's really all the faces were about—just making a bunch of arbitrary faces. We photographed a lot of them and then I tried to pick the ones that seemed the most interesting. Of course, when you make photographs of the manipulations the emotional connections are more confusing than in the performance pieces, but the same idea was behind the images.

CC: What prompted you to do those images as prints?

BN: I did a whole series of them as photographs first, then I tried making films of them. Eventually, I ended up with the holograms as the

most satisfactory way of expressing the images. Since they required a lot of equipment, it seemed necessary to have very powerful images in order to make you forget that there was this big pile of paraphernalia around. I had the slides for a long time, and we made prints just because they seemed like nice images.

CC: *Raw-War,* 1971, was your first word-image print. Were you thinking about the 1970 neon *Raw-War* or the word/language manipulations implied in the *Studies for Holograms?*

BN: I don't remember why it came up again. When I did the holograms, I was practicing making faces while I worked in front of a mirror. Later, in 1968 and 1969, I made a series of videotapes in which I used the camera as a mirror by watching myself in the monitor. There was one tape called *Lip Sync* (1969) that had the image upside-down and the sound of the repeated text, "lip sync," going alternately in and out of synchronization with the lip movement. That particular video seems directly related to *Raw-War.*

CC: Do you think of *Raw-War* as a political statement? "War" is a word loaded with connotations, and your color choices in both the lithograph and the neon sign heighten the political references. Were these works done in response to the Vietnam War?

BN: Well, certainly there are political feelings present in them, but nothing more specific than that.

CC: Are the two untitled drypoints of 1972 based on sculptural drawings?

BN: When I was making those drypoints, they were finished when the visual image read in a clear and strong way; I didn't try to make them explain the sculpture. In fact, that's one difference I feel between making drawings and making prints: I don't try to let the job of explaining the idea of a sculpture interfere with the print image. I want the print to be able to exist without reference to the object outside of itself. But with the drawings I am explaining something to myself about a specific problem in sculpture, so the relationship to the object is very strong and I usually don't try to make a separation.

CC: I find *Suposter,* 1973, to be an enigmatic and difficult image.

BN: Yes, I do, too. Making it was a real struggle; I thrashed around a lot with it. That print was done because I had the show at the Los Angeles County Museum ("Bruce Nauman: Work from 1965 to 1972," a retrospective organized in conjunction with the Whitney Museum of American Art, New York). It was sold to benefit the museum; Gemini G.E.L. donated their services to print it so all the proceeds went to the museum.

CC: What does "ters opus" relate to? The words sound like terse opus, which means succinct work.

BN: That is what it's supposed to mean. But it also refers to the third way of doing it: "ters" suggests tres—the Spanish word for three. All the various imaginations of those words, and then all the different conflicts they presented, mixed together in my mind and it came out in the print. It got very complex and wordy—I let it do all that, but it was really a struggle the whole time.

CC: What does the reference to "short rest" mean?

BN: "Opus" is a work or labor: "rest" is the opposite.

CC: *Sugar/Ragus,* 1973, reminds me of your 1967 drawing *T into B,* which physically transforms two letters of the alphabet into one another by abstracting the verbal signs. How did you arrive at this particular word-image and what does it imply?

BN: That's simple: it comes from an old college football cheer. Some guy used to get up in the stands and yell, "Give me an 'R'"—and everybody would give him an "R." After spelling out the rest of the letters "R-A-G-U-S" in the same manner, he would say. "What's that spell? What's that spell?" and the crowd yelled back, "Ragus!" Then he'd say. "What's that spell backwards?" and everybody would yell, "Sugar!" I don't know how the cheer started, but that's where I got it from.

CC: A horizon line supports the word and the background color changes—did you mean for this print to have any landscape reference?

BN: It didn't start out that way, but it does make those connections.

CC: Why did you choose fluorescent colors for this print?

BN: We had the black image completed and I was drawing on one of the proofs with crayons; I don't remember why I picked that colored crayon.

CC: Does the anagram "ragus" have any meaning other than as an abstracted verbal sign?

BN: It becomes an object when you think about the letters. With a number of the other prints as well—such as *Clear Vision* and *M. Ampere*—I had a strong image of the letters chiseled into the stone while I was drawing, so there is a sense of sculptural relief in those prints.

CC: Were you thinking of them as neon signs, where the space is physically shallow?

BN: No, more like chiseled monuments in low relief. I think I also liked the idea that I was working on stone and the image of something chiseled in stone, as opposed to drawn on stone. *Malice* was worked out in a similar way, although not as clearly.

CC: Do you view the word prints as objects?

BN: In certain cases, some of the word prints become objects. When that happens, they get very close to being signs you could hang on the wall—just like that exit sign over there. They have the same scale and almost serve the same purpose, but I don't think they ever really quite achieve that.

CC: In this group of prints, when the major portion of the image is worked out in one drawing on stone, the most successful ones are those with the chiseled illusion.

BN: Yes, I tend to fill the whole page in shallow relief—not just the letters, but the overall image is worked on to get shallow space. *Pay Attention,* 1973, is very much a drawn image on stone; it clearly has hand-

drawn letters with no attempt to make anything else. When I work on drawings outside of printmaking they are not so much about themselves—their point is to explain how a piece functions. When the explanation is clear, then I am finished making the drawing. But in the prints, I confront what the drawing is supposed to be more often. It is a more complex investigation somehow, and is probably as close as I get anymore to thinking about how paintings should be made.

CC: Like *Clear Vision,* 1973, the word-images in *Pay Attention* become visual opposites of their meanings. The way the word "attention" is drawn looks almost like you weren't paying attention—it becomes obscured and loses accuracy.

BN: I was drawing with one of those big, fat grease sticks—a rubbing crayon—and it reminded me of when Richard Serra was working at Gemini. He made his prints by drawing over and over on the stone, getting a thick, greasy buildup. Of course, when they printed them, all that surface was gone—there was just flat black. He was getting real frustrated because he was into that surface and it just wouldn't be there. A lot of the same effort is in *Pay Attention;* I drew over and over with the rubbing crayon to get a thick texture but, of course, it's not there in the print.

CC: In comparison with the similar layout of *Doe Fawn,* 1973, *Pay Attention* seems almost to need more space.

BN: That was something else I was trying to achieve: a real aggressive pushing at the edges and at the surface. That is a more accurate statement of what the print is about than the literal meaning of the words "pay attention"—even though that's in there, too. It was really hard to leave that print. At some point, I was just finished with it; it was either good enough to keep or throw away—like the experience I went through while making it. In other words, I was finished with the print whether the print was finished or not.

Doe Fawn is another print that I have a lot of mixed feelings about. I really like it, but again, it was real hard for me to leave it the way it was—to call it finished. I love the uncomfortableness that I have with it; I'm not sure why.

CC: Was the source for your image in *Clear Vision* Wittgenstein's reference to "clear vision" in his *Philosophical Investigations*?

BN: I didn't remember that he had used that term when I made the print, but who knows what one chooses not to remember. I was very interested in the difference between the way you think of the words "vision" and "clear vision"—the implied meanings are really far apart. "Vision" is there twice, but as soon as you say "clear" vision you think about what a "clear vision" means. I was interested in the *Perfect* prints of 1973—"door" and "odor" in particular—for the same reason. What is a "perfect door" or a "perfect odor"? Objects can be thought of as perfect in some way, so you might have a "perfect door" in a specific situation. But a "perfect odor" is something you just don't think about because that's not the right way to classify odors.

CC: Was there a deliberate distillation of the words in the *Perfect* prints to transpose the letters of "door" to "rodo" and "odor"?

BN: I started out first with the "perfect door" image. It was only going to be one print, but at some point later I realized that I also got "odor" so I did the second image. Finally, I tried to see what other words I could get and I decided to use "rodo"—a nonword you could make, but without any of the logical connections that "door" and "odor" have.

CC: Is there any relationship among the concept of perfection, the visual clarity of the words, and the printing process?

BN: I just wanted a good clean image.

CC: *Doe Fawn* and the *Perfect* prints are reminiscent of the word games children play by reversing the sounds of words, inadvertently adding new dimensions and discovering hidden resources in language. What sort of thought process did you use to arrive at these specific word groups?

BN: I don't know; they just came out. I do a lot of word transposition in everyday conversation. Sometimes, when they have strong poetic associations and I really feel them, I stick with them and get used to them.

CC: Do you like poetry?

BN: Not particularly. I like to read writers who pay very careful attention to the words, making them work beautifully—mostly as prose. There is very little poetry that I like.

CC: What prompted you to start investigating and evaluating the functions of language?

BN: I have always read a lot; I read in chunks and will read almost anything. I even have a certain kind of taste in awful books, so there are some things I won't read. There just came a point when I wanted to get what I was interested in into my work.

CC: You have published four books: *Pictures of Sculpture in a Room*, 1965–66; *Clear Sky*, 1967–68; *Burning Small Fires*, 1968; and *LA Air*, 1970. What were you attempting to do in each of these books?

BN: *Pictures of Sculpture in a Room* was done when I was a student. My aim was to make an object of the book to confuse the issue a little bit. It is a total object, but it has pictures—however, it is a book, not a catalogue. *Clear Sky* was a way to have a book that only had colored pages—pictures of the sky. I like the idea that you are looking into an image of the sky, but it is just a page; you are not really looking into anything—you are looking at a flat page. *LA Air* was the same idea, but it was also a response to *Clear Sky* using polluted colors instead. Similarly, *Burning Small Fires* was a response to Ed Ruscha's book, *Various Small Fires* (1964).

CC: The prints you made at Cirrus in 1973 seem calmer, sometimes almost banal, when compared to your earlier Gemini prints; they appear to be more concerned with questioning pragmatic thinking, while the Gemini prints are more introspective and raw.

BN: A lot of that had to do with what was going on in my private life at the time. When I did my first Gemini prints, I was teaching a class at U.C.L.A. two days a week, in addition to working three or four days a week at Gemini. The teaching alone would have been an extra load for me, but having to spend five or six days a week away from my studio was really a strain. There also were too many artists working at the

same time at Gemini, so there was a lot of pressure in the workshop. I think everybody felt the printers were not very happy—it was not a comfortable situation. Much of the work was done partly in response to that environment, and partly in response to never being in my studio. I was totally exhausted by the time I finished my semester of teaching, which was just about the same period that I worked on the prints.

CC: *Tone Mirror,* 1974, was done for the portfolio *Mirrors of the Mind.* Obviously, "tone" could refer to lithographic potential, but what were you thinking of in relation to the portfolio theme?

BN: I was thinking in terms of sounds: the word "tone" and a sound or note, plus the idea of reversing a sound. What does it mean to have a "mirror" of a tone? A tone is a system, so it is like reversing time or something. I don't know if any of this is explicit in the print, but that is what was of interest to me when I did it.

CC: The group of nine prints from 1975 that you call *Sundry Obras Nuevas* are brutal images. Are they personal pleas and warnings, as opposed to more generalized statements concerning reality?

BN: Once again, I think it had to do with the things going on in my life at that time.

CC: Why the group name—which means *Various New Works*—what was the reason for this thematic presentation?

BN: Gemini wanted something to put on the announcement postcard, and since there was a range in the prints—a couple of them were kind of weird—just used that title to unify the group.

CC: *Oiled Dead* has a visual elegance that camouflages the haunting message. Was this ambiguity deliberate?

BN: Originally, it started out as two print images: "dead fish" and "oiled meat." I was not happy with either one, so I started collaging them together and ended up with *Oiled Dead.* I had "dead fish" pinned up on the wall in my studio for about a year before I did anything with it. I don't remember where it came from, and I never knew what to do with

it, so I tried to use it in a print. It's hard to reconstruct how the other parts came to me.

CC: Does *Proof of Pudding* refer to the adage about proving one's own worth? All eighteen prints in the edition are unique impressions demonstrating a technical virtuosity in inking that must have presented a test for the printer.

BN: I was debating whether to do a print that would say "no two alike" even though they would all be the same, or to do each one as a proof so there would be no edition. My idea was that no matter how good the printer was or how hard he tried to make them exactly alike, they couldn't really be quite the same; there would always be something different.

CC: What is the curious mark in the lower left corner of the image?

BN: That's a brush stroke. I was testing out the brush and it was supposed to be taken off the print, but then we left it on for more color in that area.

CC: *No Sweat* and *Proof of Pudding* are similar in that they both use slang jargon. But the physical configuration of the image in *No Sweat* implies a tightly sealed personal enclosure that metaphorically locks the viewer inside its confining space. What is the relationship between this physical and mental confinement and the term "no sweat"?

BN: In the poem I wrote in 1974 called *False Silences,* "no sweat" has to do with a person— myself, or whomever—as a consumer of everything: someone who is always taking information or other people's intelligence, who uses but doesn't give back anything in return. They don't defecate, they don't sweat, they don't talk—nothing. There is that closed feeling because something that just takes from you and never gives anything back feels very suffocating.

I had a friend I used to talk to, and there was an interval in the relationship when we would talk for long periods of time and when I was finishing talking, I would feel sucked dry—just wiped out. It would take days to recover. It was almost like he had somehow taken my personality away from me without giving me anything back—he would just consume information, things, energy. There are people like that; they need so much—they drain you. I had that image in mind when I

did the print, not that person specifically, but a very frightening, powerful image of something that just takes everything from you and doesn't give anything back.

CC: And these same implications seem to be present as well in *Silver Grotto/Yellow Grotto*.

BN: Yes, that's right.

CC: What is the "grotto" reference about?

BN: The visual image I have is of a very beautiful, but somewhat frightening cave—the kind that you could sail a boat into and see reflections. Since "silver" also suggests nonhuman, you can go inside the grotto but you don't really like to make contact with it. That's the image I carry around with me. The space in which the print or the original neon version hangs is the "Silver Grotto" where this information functions. It communicates a group of separate statements that don't quite line up because they aren't exactly parallel assertions. Each of those words performs differently on you—if you stand over here, this one will affect you, but if you are standing over there, that part works, and so on.

CC: Therefore, the last line in the print—"I can suck you dry"—is not the summation of an equational configuration, but instead just a continuation of the specific ambience?

BN: Right.

CC: I believe *Help Me Hurt Me* is a landmark for printmaking in the 1970s. The drawing gesture, the integration and connotation of the color, and the verbal/mental implications are combined in a monumental presence. How did this image evolve in relation to the over-printing (the word "dead" is printed over the image "help me hurt me")?

BN: I remember trying over-printing on a couple of different ones when we were proofing it, but I don't remember specifically how I arrived at that.

CC: Why do you ask your audience for "help" and "hurt" in this print, while antithetically asking them to "placate" your work in *Doe Fawn?*

BN: All of those messages have to do with making contact. "Help me hurt me" communicates a personal appeal and "placate art"—my art— is a more general appeal to put art outside of yourself, where it becomes something you don't have any control over. Sometimes making art seems like a process that just occurs, rather than something that people do. And it gets out of control sometimes; the art goes on outside of your own volition in some sense or another, and then art and culture, in general, go on. It also has to do with the confusion about being an artist and being a person, and whether there is a difference between the two. Sometimes there appears to be an enormous distinction yet at other times it feels like there is no difference at all. I think all these ele- ments are in there.

I struggle a lot with those issues. It seems as though more of my life is concerned with things I care about that I can't get into my work. It is im- portant to me to be able to get these things into the work so that the art isn't just something I do off in the corner, while going hiking in the mountains remains separate. I want there to be more continuity; going hiking isn't doing art, but I want the feelings that I have there to be avail- able in the other parts of my life. I don't want the art to be too narrow.

There is an outdoor piece I did in 1968 that consists of a steel slab— 4 feet square and 4 inches thick—with the word "dark" inscribed on its underside, facing the ground. The feelings I had about that piece and the way it functioned for me were important for a long time. I was able to make a statement in it that let things out of me that I hadn't been able to get out before. There are a few pieces like that every now and then, but it's hard to figure out how to make the art broad enough to absorb more of these concerns. It takes a long time for some kind of change to occur in the work.

CC: Have there ever been times when the art-making activity has be- come separate?

BN: Yes, at different times it has. That's one of the reasons why the words started coming into my work in the first place. I began to feel very limited when I was making those early fiberglass pieces; I felt a real lack and I just didn't know how to get the other things I was interested in—like reading and the way words function—into the work. You are supposed to be an artist and you think this is what art is over here, but you are really interested in all these other things that are taking up more and more energy. I just didn't know how to integrate that energy

until I was finally able to use it in the most obvious way possible by making a sign—or whatever—and it felt good.

CC: In 1977, you deviated from an almost consistent use of word-imagery and returned to sculpturally related drawing in *False Passage*, and the two *Underground Passage* prints, which were published by Gemini in 1981. Why did you go back to schematic drawing in these prints, and are they conceptually related to the circular image found in the untitled drypoint of 1972?

BN: I hadn't done much writing in 1977, so those prints were based on drawings for the sculpture I was making at the time. The sculpture does relate to the earlier drypoint, but I was unaware of the relationship until I got the intaglio plates for the later drypoints and I just started back working on the same ideas.

CC: What do the three drypoints of 1981 explain about the sculpture you were making at the time?

BN: They all refer to the models for large-scale underground pieces. The circles are underground spaces—tunnels and shafts—that you could walk around inside of if they were built to full scale. In the flat, open ones, the top edge is at ground level where you would enter and then walk down a slope toward the center of the piece.

When I was working on those prints, I originally wanted to start out by just making line drawings with the line functioning within the circular images. Then, after doing an edition like that, I planned to go back in and rework the plates to try to get them into large areas of dark and light where the lines wouldn't function so much. I wanted to see what would happen when I tried to make that change.

CC: If that was your original plan, why did you choose the intaglio process for these prints? The transition from linear to tonal would have been easier and more immediate in lithography.

BN: I had the idea that there would be a kind of precision involved in working with the tools on the metal plates. I like the kind of line you get in a drypoint—it functions in the way I want it to; it's different from the kind of line that I get when I work on a litho stone. In some ways I wanted to start out doing etchings instead, but the first plate I

worked on was absolutely unsatisfactory. Slipping around on the plate with the ground on it was really uncomfortable. With drypoint, I like the resistance of the plate to the tool making marks.

CC: In the end, you chose not to rework the images from linear to tonal?

BN: Yes. At the time, I thought maybe that was the way of making the image—draw, print it, and then work on it again. But the completion of print-images is less clear to me than it is with drawing; I tend to think that I should work on a print more. Eventually, there just came a point in the project when it seemed finished in my mind.

CC: The title of *False Passage* implies its own impossibility—what were you exploring in this print?

BN: The image is an optical illusion; it's not a thing that can be made. It appears to be a description of something that could be made as a physical object, but it is forced to be only a drawing. Although appearing to describe something, the print ends up being only itself because it no longer has a reference to sculpture or drawing.

CC: What made you decide to do another word-image print when you did *Malice* in 1980?

BN: I don't know. I already had the idea to do a word-image when I went to work in the printshop at Ohio University. Actually, I had several in mind and they all dealt with the idea of human malice.

CC: How did it feel to switch from intaglio back to lithography? Was there any relearning of the thought and drawing process?

BN: Well, I had not drawn for quite a while and we did have some trouble—we lost a couple of stones because of the etching procedures and another one broke in the press—but I enjoyed working on a stone again. Although I like the resistance of drypoint, I am more comfortable with stone and with the image I can get. Maybe that's the reason I never went back to rework the three drypoints of 1981.

CC: Why did you make a neon sign of the word "malice" as well as the lithograph?

BN: I guess for the same reason I did the print—I really like the image.

CC: Your other neon works either extracted another word from the main word like *Eat Death*, 1972, or formed a new word from the reversal of the main word, such as *Raw War*. Some neon pieces, like the *Perfect* group of 1973 and your 1967 *Window or Wall Sign*, are just that— neon signs. Why does the word appear frontward and backward in *Malice?* The reverse of the word doesn't extend information or read as a pure sign; in fact, the information becomes somewhat confused.

BN: That is its intent—the malice of the situation—to make it hard to read, to be contrary. "Malice" is frontward and backward in the print, too, except there the words are on top of one another instead of superimposed. Actually, the words are different sizes in the neon piece and you have to look through it to see that the letters are not exactly superimposed.

CC: The green light of the neon becomes an intense white because of its saturation by the red neon light. What are your criteria for choosing color in the neon pieces?

BN: I pick them so the color functions as color, although with the one-color pieces, it may be a symbolic choice. I like the fact that you can have very warm and very cold colors in neon, and I try to use these variables in combinations.

CC: What is the origin of the "mask" reference in the two 1981 lithographs *Life Mask* and *Pearl Masque?*

BN: I was thinking about the stone piece I did in Buffalo, New York (*The Consummate Mask of Rock*, 1975, which was first exhibited at the Albright-Knox Art Gallery). How does an artist present himself? What is masked and what is not—that tension between what is given and what is held back.

CC: There is an implied violence in your hanging chair pieces of the early 1980s and in some of the neon signs from the same period, like *Violins Violence Silence*, 1981–82, that is reflected in the 1985 drypoints *Violins/Violence* and *Supended Chair*. Concurrently, the large, tiered neon word works, like *One Hundred Live and Die*, 1984, and the 1985 prints *Shit and Die* and *Live or Die*, all seem by the nature of their word

content to be about aggressive posturing. When your first figure neons were seen in 1985, the blatant violence and sexual combat that are depicted in them came as a real visual jolt—*Sex and Death*, for instance, or *Double Poke in the Eye II*. What were your developmental criteria through these shifts in your work?

BN: From the suspended chair pieces, it was just a natural progression. Instead of organizing a formalized plan with violence as a theme, it seemed more interesting to take the idea and just go with it—seeing what would happen when I moved forward and just made the work. With the figure neons, the timing sequence is very important—it becomes violent. The pace and repetition make it hard to see the figures, and although the figures are literally engaged in violent acts, the colors are pretty—so the confusion and dichotomy of what is going on are important, too.

CC: In 1988, the image of a clown appeared in the two lithographs *TV Clown* and *Clown Taking a Shit*. This is the first time that you have used a human figure in your printwork. What does the clown represent, and what are the origins of this image in your work?

BN: I did an earlier clown print at Gemini, but it has never been released. The basic idea came from the clown videotapes I did (*Clown Taking a Shit*, 1987, for example). Like the reference to a "mask," the clown is another form of disguise. A similar kind of distancing was also used in my early videotapes when the human figure was shot from above or behind so it was more of an object than a personality. The traditional role of a clown is to be either funny or threatening—their position or function is ambiguous, and I like that.

CC: Your most recent work incorporates animal representation—as seen in *Hanging Carousel (George Skins a Fox)*, 1988. Suspended from your carousel pieces are plastic replicas of skinned animal carcasses that are ordinarily used in taxidermy to facilitate the mounting of hides. Why are you using these manufactured surrogates, which clearly denote a dead presence?

BN: They are beautiful things. They are universally accepted, generic forms used by taxidermists yet they have an abstract quality that I really like.

CC: Is there anything about the procedure of taxidermy which you relate to your personal methodology for making art?

BN: No, not particularly. The images in the two *Carousel* prints done in 1988 were based on standard taxidermy forms—still intact—like the ones used in the sculpture. But with the new prints that I'm working on now, the forms have been reassembled. I had some forms cast in metal and when they came back from the foundry they were cut in pieces, I guess because it was easier to cast them that way. The casts were around the studio for a while, and then I started putting them back together in different ways—rearranging them into new shapes that became more abstract.

CC: Has your relationship to printmaking changed over the years? Do you have any new concerns or objectives in the most recent works?

BN: I don't think so. I am a little clearer now about what I can do, but that is just because I've made more prints.

CC: Are there any underlying factors or goals encompassed in your total print involvement when seen as a complete group?

BN: I don't think I have ever tried looking at the prints just to see if they have any underlying relationship from one end to the other. When I think about doing art, I think about it as an investigation of the function of an artist, or the function of myself as an artist. Each piece of work is a result of what I do in the studio every day, year by year. I think: "How do you spend your life being an artist?" and I attempt to be honest with myself about that, while having some sort of moral or ethical position and some integrity about being an artist. Individual works point at this from different directions, so when you experience a body of work over a long period of time, you get a little more understanding of what an artist is.

Tony Oursler

Ways of Seeing:

The Warped Vision of Bruce Nauman

Tony Oursler: Do you ever get artist's block?

Bruce Nauman: Yeah, several times. Somewhere in the early or middle 1970s I had a really serious one—the first one I'd ever really had. It was pretty scary, because you start thinking, "Well, now what am I going to do? I'll have to get a job." It lasted maybe six months. When I started working (again), the work didn't really change much from the work I did before. I still have kind of long ones from time to time.

TO: Did putting together your retrospective make you go back in time and think about all of the stuff that you hadn't really had to think about in a long time?

BN: I guess so. I'm not sure why, because some of the work I couldn't really relate to anymore at all. I couldn't even figure out why I did it or put myself in that kind of situation in any way; and other work was kind of interesting to look at because the thoughts appear in the work continually.

TO: What pieces did you have no connection with?

BN: I think the early fiberglass pieces and the rubber pieces. I could kind of remember why I did them and what I was thinking about, but

Originally published in *Paper Magazine* 2, no. 10 (April 1995): 104. Also published in the catalogue for the touring exhibition, "Bruce Nauman," Kunstmuseum, Wolfsburg; Centre Georges Pompidou, Paris; Hayward Gallery, London; Nykytaiteen Museo, Helsinki, 1997/1999. *Bruce Nauman* (London: South Bank Centre, 1998), 116–18.

it's not work that interests me anymore. In fact, I told them if they're going to put it in the show, then they're totally responsible for figuring it out, because I can't.

TO: What does it feel like to have this huge block of stuff, which is somehow representing you personally, out there moving around?

BN: After a time, you train yourself that once the work is out of the studio, it's up to somebody else how it gets shown and where it gets shown. You can't spend all your time being responsible for how the work goes out in the world, so you do have to let go. What happens is that it starts to become overbearing and I catch myself getting frustrated and angry about the situation. Then I see that it's taken over, and then I can let go.

TO: You mentioned anger. I've been doing a lot of work with various ways that people relate to emotions and trying to put that in the work as a kind of barometer, which is something I've always found interesting in your work. Is a lot of it motivated by emotional states that you get in?

BN: I think so, although I'm always puzzled by this myself—trying to figure out where work comes from, what gets you to go and try and do work, what gets you in the studio. Roy Lichtenstein, when he first started doing comic-book paintings, said he didn't know what else to do. I just have to do something, so I do something and it might be really stupid, but I just can't think of anything else to do. Sometimes it even gets put aside because it's such a stupid idea, but oftentimes when I go back to it, it has a lot of power because it was created totally out of the need to make something.

TO: And then sometimes other works of yours seem very methodical.

BN: Yeah, I think I have to have work that is really justifiable and has reasons. I suppose that's the stuff that appears to be more methodical. Then you get caught up in that too much, then you think, "Gee, this is so self-important and so serious." You need to be able to be stupid and make mistakes, too.

TO: Speaking of being stupid, do you watch television at all?

BN: Not a huge amount. [My wife] Susan likes to watch *Seinfeld* because it's her connection to New York. So that works. But if I watch it too often I get really annoyed with it. I used to like to watch baseball, but we don't have baseball anymore. But I like to lie on the couch on Saturday or Sunday afternoon and fall asleep in front of some sort of ball game. It doesn't seem to matter if it was baseball or football or whatever, I could always fall asleep. It was kind of nice.

TO: I was wondering: If you were, say, 25, a woman, and just got out of art school, what kind of work would you be making?

BN: I don't see why I wouldn't be doing the work I'm doing now. I remember saying many years ago to a friend that I wish I had spent more time hiking in the mountains when I was younger. Like I said, "When I was 18, I should have been doing that stuff." He said. "Well, what the fuck are you talking about? Why can't you do that now?" It's just a stupid thing—of course I can do that now. So I did. Maybe if you're not a well-known artist, if you don't have the opportunity to show work, you might not do certain kinds of work. I've always felt that I've worked with whatever money's been available and whatever equipment's been available. You just do the work. Using those things as an excuse, like "I haven't got the money or the equipment or the room," are bad excuses for not doing work.

TO: You've always been attracted to using new technologies.

BN: When I did the holograms, that was probably the most advanced I've ever gotten in terms of new technology. In general, I think I just use stuff that's there. Sometimes you push a little bit, but not too much. It gets too expensive or too hard to find, then it's just not interesting. But I was interested in having an object but not having an object, the 3-D stuff. It's not gotten any easier for anyone to do that sort of work since that time.

TO: I have a really off question: Do you have any beliefs or experiences with UFOs?

BN: I've never had any experience. But there are people here [in New Mexico] who believe in them and think that they have a landing place where they actually go into the mountain. I've always been kind of curious about how I'd react if confronted with a being of some sort—if I'd be scared shitless or curious. I'm just waiting to see, I guess.

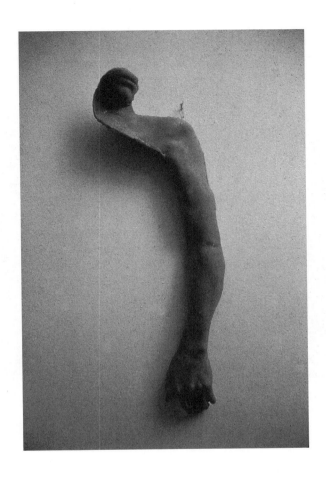

From Hand to Mouth, 1967. Wax over cloth. 28 × 10⅜ × 4⅜ inches
(71.1 × 26.4 × 11.1 cm). Collection Hirshhorn Museum and
Sculpture Garden, Smithsonian Institution, Washington, D.C.,
Joseph Hirshhorn Purchase Fund, Holenia Purchase Fund, and
Museum Purchase, 1993. Courtesy Sperone Westwater, New York.
© 2000 Bruce Nauman / Artists Rights Society (ARS) New York.

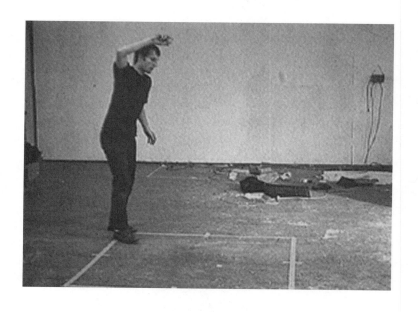

Bouncing Two Balls between the Floor and Ceiling with Changing Rhythms, 1967–68. Courtesy of Electronic Arts Intermix, New York. © 2000 Bruce Nauman / Artists Rights Society (ARS) New York.

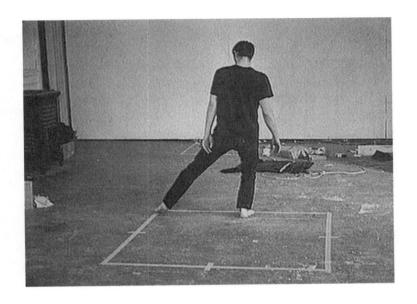

Dance or Exercise on the Perimeter of a Square (Square Dance),
1967–68. Courtesy of Electronic Arts Intermix, New York.
© 2000 Bruce Nauman / Artists Rights Society (ARS) New York.

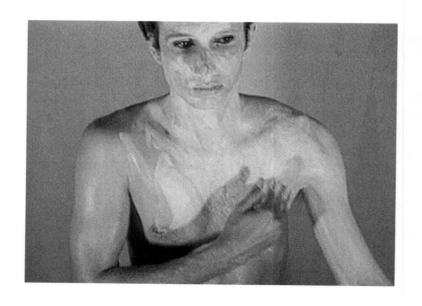

Art Make-Up (Nos. 1–4), 1967–68. Courtesy of Electronic Arts Intermix, New York. © 2000 Bruce Nauman / Artists Rights Society (ARS) New York.

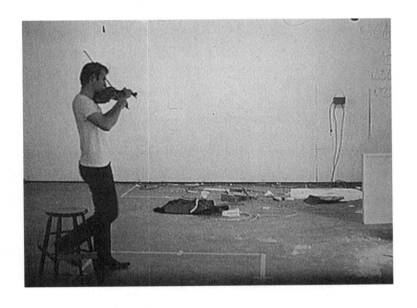

Playing a Note on the Violin While I Walk around the Studio,
1967–68. Courtesy of Electronic Arts Intermix, New York.
© 2000 Bruce Nauman / Artists Rights Society (ARS) New York.

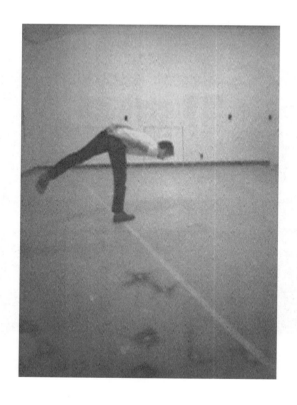

Slow Angle Walk (Beckett Walk), 1968. Courtesy of Electronic Arts Intermix, New York. © 2000 Bruce Nauman / Artists Rights Society (ARS) New York.

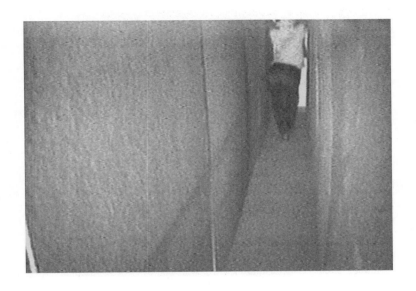

Walk with Contrapposto, 1968. Courtesy of Electronic Arts
Intermix, New York. © 2000 Bruce Nauman / Artists Rights
Society (ARS) New York.

Pulling Mouth, 1969. Courtesy of Electronic Arts Intermix,
New York. © 2000 Bruce Nauman / Artists Rights Society (ARS)
New York.

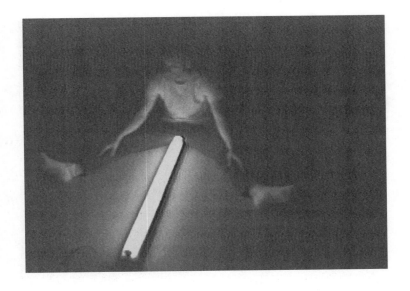

Manipulating a Fluorescent Tube, 1969. Courtesy of Electronic Arts
Intermix, New York. © 2000 Bruce Nauman / Artists Rights
Society (ARS) New York.

Black Balls, 1969. Courtesy of Electronic Arts Intermix, New York.
© 2000 Bruce Nauman / Artists Rights Society (ARS) New York.

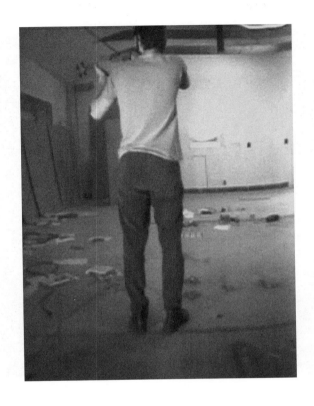

Violin Tuned D E A D, 1969. Courtesy of Electronic Arts Intermix, New York. © 2000 Bruce Nauman / Artists Rights Society (ARS) New York.

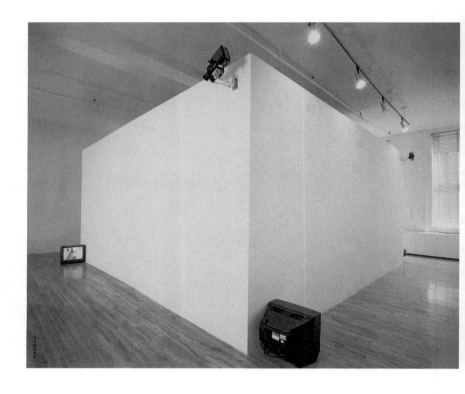

Going Around the Corner Piece, 1970. Wallboard, four video
cameras, and four video monitors. Walls: 120 × 240 inches
(304.8 × 609.6 cm) each. Collection Musee National D'Art
Moderne Centre Georges Pompidou, Paris. Courtesy Sperone
Westwater, New York. © 2000 Bruce Nauman / Artists Rights
Society (ARS) New York.

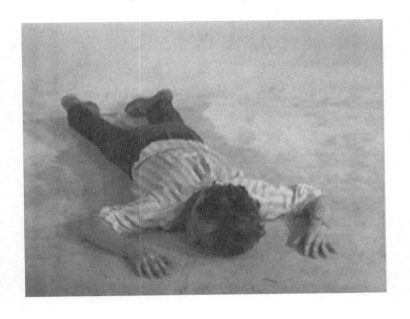

Tony Sinking into the Floor, Face Up and Face Down, 1973.
Courtesy of Electronic Arts Intermix, New York. © 2000 Bruce
Nauman / Artists Rights Society (ARS) New York.

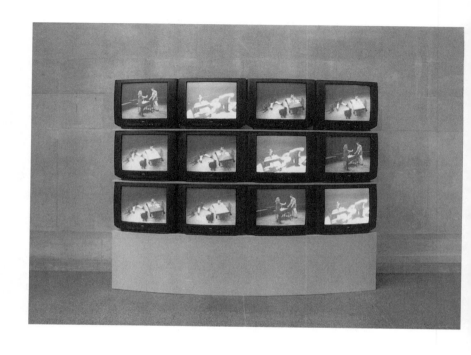

Violent Incident, 1986. Twelve 26-inch monitors with loudspeaker, four videodisc players, four videodiscs (color/sound). Exhibition copy. 260 × 267 × 47 cm. Collection Tate Gallery, London. Courtesy Art Resource, New York. © 2000 Bruce Nauman / Artists Rights Society (ARS) New York.

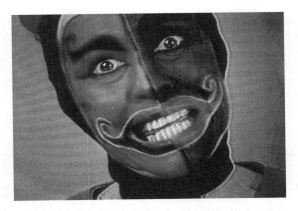

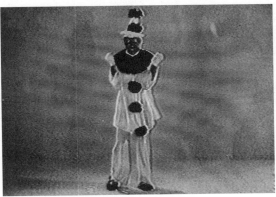

a. *Clown Torture: I'm Sorry*, 1987. b. *Clown Torture: No, No, No, No*, 1987. Two video projectors, two 20-inch monitors, four loudspeakers, four videodiscs (color/sound). Exhibition copy. Collection Art Institute of Chicago. © 2000 Bruce Nauman / Artists Rights Society (ARS) New York.

Raw Material with Continuous Shift—MMMM, 1990. One video
projector with reverse mechanism, two monitors with
loudspeakers, two videodisc players, two videodiscs (color/sound).
Exhibition copy. Private Collection, Switzerland. © 2000 Bruce
Nauman / Artists Rights Society (ARS) New York.

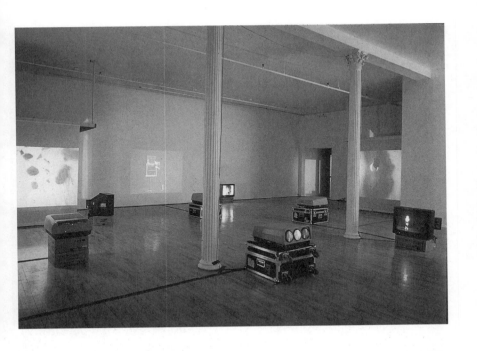

Shadow Puppets and Instructed Mime, 1990. Three wax heads,
linen, wood, four color video monitors, four video projectors, six
videotape players, six videotapes (color/sound). Dimensions
variable. Collection Emmanuel Hoffmann-Stiftung Basel,
Museum für Gegenwartskunst, Basel. Courtesy Sperone
Westwater, New York. © 2000 Bruce Nauman / Artists Rights
Society (ARS) New York.

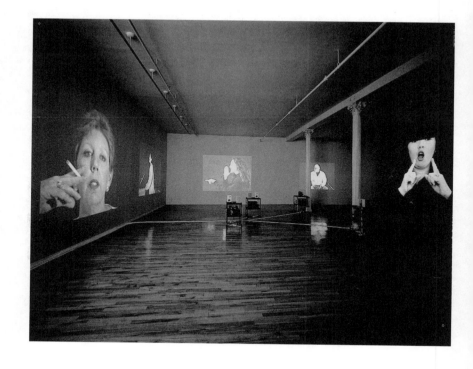

World Peace (Projected), 1996. Five video discs, five video
projectors, five videodisc players, five pairs of auxiliary speakers,
remote control, six utility carts. Room size: 30 × 36 feet maximum.
Collection Bayerisch Staatsgemaldesammlungen, Munich.
Staatsgalerie Moderner Kunst. Courtesy Sperone Westwater,
New York. © 2000 Bruce Nauman / Artists Rights Society (ARS)
New York.

IV Artist's Writings

Performance (Slightly Crouched)

You must hire a dancer to perform the following exercise each day
of the exhibition for 20 minutes or 42 minutes at about the same time
each day; the dancer dressed in simple street or exercise clothes
will enter a large room of the gallery. the guards will clear the
room, only allowing people to observe through the doors. dancer,
eyes front, avoiding audience contact, hands clasped behind his neck,
elbows forward, walks about the room in a slight crouch—as though
the ceiling were 6 inches or a foot lower than his normal height—
placing one foot in front of the other heel touching toe, very slowly
and deliberatly.
It is necessary to have a dancer or person of some professional
annonymous presence.
At the end of the time period, the dancer leaves and the guards again
allow people into the room.
If it is not possible to finance a dancer for the whole of the exhibition
period a week will be satisfactory, but no less.

My five pages of the book will be publicity photographs of the dancer
hired to do my piece with his name affixed.

Transcript from the homonymous text piece, 1968. A photograph of the
piece was originally published in the catalogue for the touring exhibition,
"Bruce Nauman," Museo Nacional Centro de Arte Reina Sofia, Madrid;
Walker Art Center, Minneapolis; Museum of Contemporary Art, Los Ange-
les; Hirshhorn Museum and Sculpture Garden, Smithsonian Institution,
Washington, D.C.; Museum of Modem Art, New York, 1993–1995. *Bruce
Nauman* (Minneapolis: Walker Art Center, 1994), 133. Below the typewritten
text, the note "never carried out" is written in pencil.

Notes and Projects

It has been shown that at least part of the information received by the optical nerves is routed through and affected by the memory before it reaches the part of the brain that deals with visual impulses (input). Now René Dubos discusses the distortion of stimuli: we tend to symbolize stimuli and then react to the symbol rather than directly to the stimuli. Assume this to be true of other senses as well . . .

FRENCH PIECE (August, 1968)

1. Piece of steel plate or bar 4 inches by 4 inches by 7 feet, to be gold plated, and stamped or engraved with the word "guilt" in a simple type face about 1 or 2 centimeters high. The weight will be about 380 pounds.

2. If the bar cannot be plated, the plain steel bar should be stamped or engraved "guilt bar," the letters running parallel to and close to a long edge.

3. Both pieces may be made.

lighted steel channel twice
leen lech Dante'l delight light leen snatches
light leen lech Dante'l delight leen snatches
leen leche'l delight Dantes light leen snatch
light leen snatch'l delight Dantes leen leech
light leen leech'l delight Dantes leen snatch
snatch leen leen leeche'l delight light Dante

When I want to make a painting of something covered with dust or in fog should I paint the whole surface first with dust or fog and then pick out

Originally published in *Artforum* 9, no. 4 (1970): 44.

318

those parts of objects which can be seen or first paint in all the objects and then paint over them the dust or fog?

Hire a dancer or dancers or other performers of some presence to perform the following exercises for one hour a day for about ten days or two weeks. The minimum will require one dancer to work on one exercise for ten to fourteen days. If more money is available two dancers may perform, one dancer performing each exercise at the same time and for the same period as the other. The whole may be repeated on ten- or fourteen-day intervals as often as desired.

(A) Body as a Cylinder

Lie along the wall/floor junction of the room, face into the corner and hands at sides. Concentrate on straightening and lengthening the body along a line which passes through the center of the body parallel to the corner of the room in which you lie. At the same time attempt to draw the body in around the line. Then attempt to push that line into the corner of the room.

(B) Body as a Sphere

Curl your body into the corner of a room. Imagine a point at the center of your curled body and concentrate on pulling your body in around that point. Then attempt to press that point down into the corner of the room. It should be clear that these are not intended as static positions which are to be held for an hour a day, but mental and physical activities or processes to be carried out. At the start, the performer may need to repeat the exercise several times in order to fill the hour, but at the end of ten days or so, he should be able to extend the execution to a full hour. The number of days required for an uninterrupted hour performance of course depends on the receptivity and training of the performer.

Goedel's Proof

1931: On Formally Undecidable Propositions of Principia Mathematica and Related Systems." 1) If a system is consistent then it is incomplete. 2) (Goedel's incompleteness theorem) implies impossibility of construction of calculating machine equivalent to a human brain.

Film Set A: Spinning Sphere

A steel ball placed on a glass plate in a white cube of space. The ball is set to spinning and filmed so that the image reflected on the

surface of the ball has one wall of the cube centered. The ball is center frame and fills most of the frame. The camera is hidden as much as possible so that its reflection wilt be negligible. Four prints are necessary. The prints are projected onto the walls of a room (front or rear projection; should cover the walls edge to edge). The image reflected in the spinning sphere should not be that of the real room but of a more idealized room, of course empty, and not reflecting the image projected on the other room walls. There will be no scale references in the films.

Film Set B: Rotating Glass Walls

Film a piece of glass as follows: glass plate is pivoted on a horizontal center line and rotated slowly. Film is framed with the center line exactly at the top of the frame so that as the glass rotates one edge will go off the top of the frame as the other edge comes on the top edge of the frame. The sides of the glass will not be in the frame of the film. Want two prints of the glass rotating bottom coming toward the camera and two prints of bottom of plate going away from camera. The plate and pivot are set up in a white cube as in Set A, camera hidden as well as possible to destroy any scale indications in the projected films. Projection: image is projected from edge to edge of all four walls of a room. If the image on one wall shows the bottom of the plate moving toward the camera, the opposite wall will show the image moving away from the camera.

DANCE PIECE

You must hire a dancer to perform the following exercise each day of the exhibition for 20 minutes or 40 minutes at about the same time each day. The dancer, dressed in simple street or exercise clothes, will enter a large room of the gallery. The guards will clear the room, only allowing people to observe through the doors. Dancer, eyes front, avoiding audience contact, hands clasped behind his neck, elbows forward, walks about the room in a slight crouch, as though the ceiling were 6 inches or a foot lower than his normal height, placing one foot in front of the other, heel touching toe, very slowly and deliberately.

It is necessary to have a dancer or person of some professional anonymous presence.

At the end of the time period, the dancer leaves and the guards again allow people into the room.

If it is not possible to finance a dancer for the whole of the exhibition period a week will be satisfactory, but no less.

My five pages of the book will be publicity photographs of the dancer hired to do my piece, with his name affixed.

Manipulation of information that has to do with how we perceive rather than what.

Manipulation of functional (functioning) mechanism of an (organism) (system) person.

Lack of information input (sensory deprivation) = breakdown of responsive systems. Do you hallucinate under these circumstances? If so, is it an attempt to complete a drive (or instinct) (or mechanism)?

Pieces of information which are in "skew" rather than clearly contradictory, in other words, kinds of information which come from and go to unrelated response mechanism. Skew lines can be very close or far apart. (Skew lines never meet and are never parallel. How close seems of more interest than how far apart. How far apart = surrealism?)

Withdrawal as an Art Form

<div align="center">

activities

phenomena

</div>

Sensory Manipulation
 amplification
 deprivation
Sensory Overload (Fatigue)

Denial or confusion of a Gestalt invocation of physiological defense mechanism (voluntary or involuntary). Examination of physical and psychological response to simple or even oversimplified situations which can yield clearly experienceable phenomena (phenomena and experience are the same or undifferentiable).

Recording Phenomena
 Presentation of recordings of phenomena as opposed to stimulation of phenomena. Manipulation or observation of self in extreme or controlled situations.

 • Observation of manipulations.
 • Manipulation of observations.
 • Information gathering.
 • Information dispersal (or display).

Microphone/Tree Piece

Select a large solid tree away from loud noises.

Wrap the microphone in a layer of 1/4 or 1/8 inch foam rubber and seal it in a plastic sack.

Drill a hole of large enough diameter to accept the encased microphone to the center of the tree at a convient height, and slip the microphone to within an inch of the end of the hole.

Plug the hole with cement or other waterproof sealant.

Extend the microphone wire inside to the pre-amp, amp, and speaker system.

Transcript from the homonymous text piece, 1971. A photograph of this piece was originally published in the catalogue for the touring exhibition, "Bruce Nauman," Museo Nacional Centro de Arte Reina Sofia, Madrid; Walker Art Center, Minneapolis; Museum of Contemporary Art, Los Angeles; Hirshhorn Museum and Sculpture Garden, Smithsonian Institution, Washington, D.C.; Museum of Modem Art, New York, 1993–1995. *Bruce Nauman* (Minneapolis: Walker Art Center, 1994), 143. Grinstein Family Collection, Los Angeles.

Flayed Earth/Flayed Self (Skin/Sink)

Peeling skin peeling earth—peeled earth
raw earth, peeled skin
The problem is to divide your
skin into six equal parts
lines starting at your feet and
ending at your head (five lines to make six
equal surface areas) to twist and spiral
into the ground, your skin peeling off
stretching and expanding to cover the surface
of the earth indicated by the spiraling
waves generated by the spiraling twisting
screwing descent and investiture (investment
or investing) of the earth by your swelling body.
Spiraling twisting ascent descent screwing in
screwing out screwing driving diving
invest invert convert relent relax control
release, give in, given. Twisting driving down.
Spiraling up screwing up screwed up screwed
Twisted mind, twist and turn, twist and shout.
Squirm into my mind so I can get into
your mind your body our body
arcing ache, circling warily then
pressed together, pressing together,
forced.

Originally published in *Flayed Earth/Flayed Self* (Santa Monica, Calif.:
Nicholas Wilder Gallery, 1974).

Surface reflection, transmission, refraction—
surface tension absorption, adsorbtion
Standing above and to one side of your-
self—schizoid—not a dislocation, but a
bend or brake (as at the surface of water or a
clear liquid—quartz or a transparent crystal)
(transparent crying)
I HAVE QUICK HANDS MY MIND IS ALERT
I HOLD MY BODY READY FOR INSPIRATION
ANTICIPATION ANY SIGN RESPIRATION
ANY SIGH I THINK NEITHER AHEAD NOR
BEHIND READY BUT NOT WAITING NOT
ON GUARD NOT PREPARED.
Rushing:
I AM AN IMPLODING LIGHT BULB
(imagine a more perfect abstract sphere)
Draw in energy rushing toward you—
toward your center.
(Fools rush in—Russian fools)
Try to get it down on paper—try to
get it in writing (try to get it written down—
try to write it down): Some evidence of a
state—a mark to prove you were there: Kilroy
(make a mark to prove you are here)
Suspension of belief, suspension of an object
object of suspension—to hang.
Talking of a particular space—the space a
few inches above and below the floor and within
the area bounded by and described by the taped
lines.
NOW INFORMATION RUSHING AWAY FROM THE CENTER
TOWARD THE PERIMETER A FEW INCHES ABOVE THE FLOOR.
A kind of vertical compression of space or do you
see it as a lightening or expanding opening in
space—just enough to barely let you in—not
so you could just step into it but so that you might
be able to crawl into it to lie in it to bask in it
to bathe in it.

Can it crush you—very heavy space—(gravity is
very important here) (or for important read strong)
You want to turn at an ordinary rate, as though
you want to speak to someone there, behind you
but you want not to speak, but to address your-
self to a situation. (everything will feel the
same and it will not have a new meaning THIS
DOES NOT MEAN ANYTHING ANYWAY) but now there
is either a greater density or less density
and if you turn back (when you turn back)
the change will be all around you. Now you
cannot leave or walk away. Has to do with your
ability to give up your control over space. This
is difficult because nothing will happen—and
later you will be no better or worse off for it.
This is more than one should require of another
person. THIS IS FAR TOO PRIVATE AND DANGEROUS
BECAUSE THERE IS NO ELATION NO PAIN NO KNOWLEDGE
AN INCREDIBLE RISK WITH (BECAUSE) NOTHING IS
LOST OR GAINED NOTHING TO CATCH OUT OF THE
CORNER OF YOUR EYE—YOU MAY THINK YOU FELT SOME-
THING BUT THAT'S NOT IT THAT'S NOT ANYTHING
YOU'RE ONLY HERE IN THE ROOM:
MY SECRET IS THAT I STAYED THE SAME FOR A SHORT TIME.

Instructions

A. LIE DOWN ON THE FLOOR NEAR THE CENTER OF THE
 SPACE,
 FACE DOWN, AND SLOWLY ALLOW YOURSELF TO SINK
 DOWN
 INTO THE FLOOR. EYES OPEN.

B. LIE ON YOUR BACK ON THE FLOOR NEAR THE CENTER
 OF
 THE SPACE AND SLOWLY ALLOW THE FLOOR TO RISE UP
 AROUND YOU. EYES OPEN.

This is a mental exercise.
Practice each day for one hour
1/2 hour for A, then a sufficient break to clear
the mind and body, then 1/2 hour practice B.

At first, as concentration and continuity are broken
or allowed to stray every few seconds or minutes,
simply start over and continue to repeat the exercise
until the 1/2 hour is used.

The problem is to try to make the exercise continuous
and uninterrupted for the full 1/2 hour. That is, to take
the full 1/2 hour to A. Sink under the floor, or B.
to allow the floor to rise completely over you.

In exercise A it helps to become aware of peripheral vision
—use it to emphasise the space at the edges of the room

Originally published in *Interfunktionen*, no. 11 (1974): 122–24.

and begin to sink below the edges and finally under the floor.

In B. begin to deemphasise peripheral vision—become aware of tunneling of vision—so that the edges of the space begin to fall away and the center rises up around you.

In each case use caution in releasing yourself at the end of the period of exercise.

Cones/Cojones

Cones

Floater: Rising time/count-up sequence.

A finite number of concentric circles not equally spaced: starting at the outside and measuring inward, the distances between circumferences is a geometric progression (expanding or contracting).

Concentric circles becoming progressively closer either from their center or measured from the outer circumference, describing the intersection of the plane through your center parallel to the floor and a very large but finite series of concentric cones whose common center is located through the center of the earth at a distant place in the universe.

The point of the universe which is the apex of a countable number of concentric cones whose intersection with the plane parallel to the floor passing through your center describing an equal number of concentric circles, appear to radiate, inward or not, that point, moving with the universe, expanding, and so changing, the shape, of the cones, and circles, at this rate.

Originally published in *Bruce Nauman: Cones/Cojones* (New York: Leo Castelli Gallery, 1975).

Earth Moves

The massive center moves about tides.

Black hole functions: contraction. concentration, compression, collapse, contour inversion, contour immersion. inverse/diverse/divest.

Thinking feeling.

Sinking, feeling.

Expansion Ethics

Release the gas and the container is contained.

Free thinking free thinker; free thinker thinking free.
Floater flauting flauter floating.

Fit into an enormous space where a great deal of time is available as the continually rapidly expanding distances are enormous. Stay inside the cone; avoid the walls; compact yourself; avoid compression. Now time is short.

(You can't get there from here but you can get here from there if you don't mind the **t** left over.)

What I mean is everything is finite, every thing is closed, *nothing touches.*

It doesn't mean anything to say there are no spaces in between.

It is meaningless to say there are spaces between.

As though the water had recently been removed.

As though water had emptied.

Cojones

I want to get the whole. I'm trying to get everything, accurate.

I want to get the whole,
Here is every.
Here is the whole, everything, accurate, precise:

Imagine accidentally coming upon a line and adjusting yourself so that the center of your body lies on that line. When you accomplish this there is no next step.

Take my meaning not my intention.

You will just have to do something else.

Here is every.

Here is my precision.
Here is everything.
Apparently this is my hole.
Apparently this is my meaning.

(I have precise but mean intentions.)

Ere he is very.

1. Let's talk about control.
2. We were talking about control.
3. We are talking about control.

There is no preparation for this occurrence.

There is no excuse for this occurrence, there is no reason, no need, no urgency, no . . .

Apparently this is what I mean, although it's not what I intended.

This *accuracy* is not my intention.

Oh, my shrinking, crawling skin

and the need within me to stretch myself to a point.

This accuracy is my intention. *Placate my art.*

False Silences

I DONT SWEAT
I HAVE NO ODOR
IN INHALE, DONT EXHALE
NO URINE
I DONT DEFECATE: NO EXCRETIONS OF ANY KIND
I CONSUME ONLY
OXYGEN, ALL FOODS, ANY FORM
I SEE, HEAR
I DONT SPEAK, MAKE NO OTHER SOUNDS, YOU CANT HEAR
 MY HEART, MY FOOTSTEPS
NO EXPRESSION, NO COMMUNICATION OF ANY KIND
AN OBSERVER, A CONSUMER, A USER ONLY
MY BODY ABSORBS ALL COMMUNICATIONS, EMOTIONS, SUCKS
 UP HEAT AND COLD
SUPER REPTILIAN SOAKING UP ALL KNOWLEDGE,
 COMPACTOR OF ALL INFORMATION
NOT GROWING
I FEEL DONT TOUCH

I HAVE NO CONTROL OVER THE KINDS AND QUALITIES OF
 THOUGHTS
I COLLECT. I CANT PROCESS
I CANT REACT TO OR ACT ON SENSATION
NO EMOTIONAL RESPONSE TO SITUATIONS
THERE IS NO REACTION OF INSTINCT TO PHYSICAL OR MEN-
 TAL THREATS

Originally published in *Vision*, no. 1 (September 1975): 44–45.

YOU CANT REACH ME, YOU CANT HURT ME
I CAN SUCK YOU DRY

YOU CANT HURT ME
YOU CANT HELP ME
SHUFFLE THE PAGES
FIND ME A LINE
ARAPAHOE, ARAPAHOE
WHERE DID YOU GO
I BLINK MY EYES
TO KEEP THE TIME

The Consummate Mask of Rock

1. mask
2. fidelity
3. truth
4. life
5. cover
6. pain
7. desire
8. need
9. human companionship
10. nothing
11. COVER REVOKED
12. infidelity
13. painless
14. musk/skum
15. people
16. die
17. exposure.

2

1. This is my mask of fidelity to truth and life.
2. This is to cover the mask of pain and desire.
3. This is to mask the cover of need for human companionship.
4. This is to mask the cover.
5. This is to cover the mask.
6. This is the need of cover.
7. This is the need of the mask.

Originally published in *The Consummate Mask of Rock* (Buffalo, N.Y.: Albright-Knox Art Gallery, 1975).

8. This is the mask of cover of need.
 Nothing and no
9. No thing and no mask can cover the lack, alas.
10. Lack after nothing before cover revoked.
11. Lack before cover
 paper covers rock
 rock breaks mask
 alas, alack.
12. Nothing to cover.
13. This is the mask to cover my infidelity to truth.
 (This is my cover.)
14. This is the need for pain that contorts my mask conveying the
 message of truth and fidelity to life.
15. This is the truth that distorts my need for human companionship.
16. This is the distortion of truth masked by my painful need.
17. This is the mask of my painful need distressed by truth and
 human companionship.
18. This is my painless mask that fails to touch my face but floats
 before the surface of my skin my eyes my teeth my tongue.
19. Desire is my mask.
 (Musk of desire)
20. Rescind desire
 cover revoked
 desire revoked
 cover rescinded.
21. PEOPLE DIE OF EXPOSURE.

3

CONSUMMATON/CONSUMNATION/TASK

(passive)
paper covers rock

(active–threatening)
scissors cuts paper

(active–violent)
rock breaks scissors

1. mask	4. desire
2. cover	5. need for human companionship
3. diminish	6. lack

desire covers mask

need for human companionship
masks desire

mask diminishes need for human companionship

need for human companionship diminishes cover

desire consumes human companionship

cover lacks desire

THIS IS THE COVER THAT DESIRES THE MASK OF LACK THAT CONSUMES THE
NEED FOR HUMAN COMPANIONSHIP.
THIS IS THE COVER THAT DESPISES THE TASK OF THE NEED OF HUMAN COMP
THIS IS THE TASK OF CONSUMING HUMAN COMP.

5

 1. some kind of fact
 2. some kind of fiction
 3. the way we behaved in the past
 4. what we believe to be the case now
 5. the consuming task of human companionship
 6. the consummate mask of rock

(1.) Fiction erodes fact.
(2.) Fact becomes the way we have behaved in the past.
(3.) The way we have behaved in the past congeals into the consummate mask of rock.
(4.) The way we have behaved in the past contributes to the consuming task of human companionship.
(5.) The consuming task of human comp. erodes the consummate mask of rock.
However (2.) Fact becomes the way we have behaved in the past may be substituted
into (3.) and (4.) so that
(6.) Fact congeals into the consummate mask of rock.
But (5.) the consuming task of human comp. erodes the consummate mask of rock or

the consuming task of human comp. erodes fact, then from (I.) it follows that

THE CONSUMING TASK OF HUMAN COMPANIONSHIP IS FALSE

6

THE CONSUMMATE MASK OF ROCK HAVING DRIVEN THE WEDGE OF DEISRE

THAT DISTINGUISHED TRUTH AND FALSITY LIES COVERED BY PAPER.

7

1. (This young man, taken to task so often, now finds it his only sexual relief.)

2. (This young man, so often taken to task; now finds it his only sexual fulfillment.)

3. (This man, so often taken to task as a child . . .)

4. (This man, so often taken to task, now finds it satisfies his sexual desires.)

 arouses needs

5. This man, so often taken as a child, now wears the consummate mask of rock and uses it to drive his wedge of desire into the ever squeezing gap between truth and falsity.

6. This man, so often taken as a child, now uses his consummate mask of his rock to drive his wedge of his desire into his ever squeezing (his) gap between his truth, his falsity.

7. (This) man, (so often) taken as (a) child, finding his consummate mask of rock covered by paper, he finding his wedge being squeezed (from) between his desired truth (truth desired) and his desireless falsity (falsity desireless), he unable to arouse his satisfaction, he unable to desire his needs, he proceeds into the gap of his fulfillment his relief lacking the task of human companionship.

Moral

Paper cut from rock, releases rock to crush scissors.
Rock freed from restrictions
of paper/scissors/rock, tacking context proceeds.

Good Boy Bad Boy

1. I was a good boy
2. You were a good boy
3. We were good boys
4. That was good
5. I was a good girl
6. You were a good girl
7. We were good girls
8. That was good
9. I was a bad boy
10. You were a bad boy
11. We were bad boys
12. That was bad
13. I was a bad girl
14. You were a bad girl
15. We were bad girls
16. That was bad
17. I am a virtuous man
18. You are a virtuous man
19. We are virtuous men
20. This is virtue
21. I am a virtuous woman
22. You are a virtuous woman
23. We are virtuous women
24. This is virtue
25. I am an evil man

Transcription of video installation at Museum Haus Esters, Krefeld, Germany, 1985. Printed in accompanying brochure.

26. You are an evil man
27. We are evil men
28. This is evil
29. I am an evil woman
30. You are an evil woman
31. We are evil women
32. This is evil
33. I'm alive
34. You're alive
35. We're alive
36. This is our life
37. I live the good life
38. You live the good life
39. We live the good life
40. This is the good life
41. I have work
42. You have work
43. We have work
44. This is work
45. I play
46. You play
47. We play
48. This is play
49. I'm having fun
50. You're having fun
51. We're having fun
52. This is fun
53. I'm bored
54. You're bored
55. We're bored
56. Life is boring
57. I'm boring
58. You're boring
59. We're boring
60. This is boring
61. I have sex
62. You have sex
63. We have sex
64. This is sex
65. I love

66. You love
67. We love
68. This is our love
69. I hate
70. You hate
71. We hate
72. This is hating
73. I like to eat
74. You like to eat
75. We like to eat
76. This is eating
77. I like to drink
78. You like to drink
79. We like to drink
80. This is drinking
81. I (like to) shit
82. You (like to) shit
83. We (like to) shit
84. This is shit(ing)
85. I piss
86. You piss
87. We piss
88. This is piss
89. I like to sleep
90. You like to sleep
91. We like to sleep
92. Sleep well
93. I pay
94. You pay
95. We pay
96. This is payment
97. I don't want to die
98. You don't want to die
99. We don't want to die
100. This is fear of death

Violent Incident

The scene includes a table set for two with chairs in place and cocktails on the table.

The scene is shot in one take starting with a tightly framed low angle shot that will spiral up and away and clockwise until the finish of the action with the camera at a fairly high angle looking down on the scene from above head level and having made one revolution of the scene.

Both part one and part two are shot with the same directions. I would see the action taking place on the left side of the table. Shot in accurate color.

I

1. The man holds a chair for the woman as she starts to sit down. The man pulls the chair out from under her and she falls to the floor. Man is amused but woman is angry.

2. Man turns and bends over to retrieve the chair and as she gets up she gooses him.

3. Man stands up and turns and faces her now very angry also and calls her a name (shit-asshole-bitch-slut-whatever).

4. The woman reaches back to the table and takes a cocktail and throws it in the man's face.

5. Man slaps woman in the face.

6. Woman knees or kicks man in the groin.

7. Man is hurt and bends over, takes knife from table, they struggle and she stabs.

Originally published in *Parkett*, no. 10 (September 1986): 50.

8. He is stabbed.

II

All instructions are the same except the roles are reversed. Woman holds chair for man, pulls it away, man falls, gooses woman; she calls him a name, he throws drink, she slaps, he kicks, she stabs and he stabs her.

Biography

1941	Born in Fort Wayne, IN
1964	B.S. University of Wisconsin, Madison
1966	M.F.A. University of California, Davis
1979	Living and working in New Mexico

Selected Solo Exhibitions

1966	Nicholas Wilder Gallery, Los Angeles, CA
1967	"Slant Step," Berkeley Gallery, Berkeley, CA
1968	Leo Castelli Gallery, New York
	Galerie Konrad Fischer, Dusseldorf, Germany
1969	Sacramento State College Art Gallery, Sacramento, CA
	"Holograms, Videotapes and Other Works," Leo Castelli Gallery, New York
	Nicholas Wilder Gallery, Los Angeles, CA
	Galerie Ileana Sonnabend, Paris, France
	20-20 Gallery, London, Ontario, Canada
	Galerie Konrad Fischer, Dusseldorf, Germany
1970	Nicholas Wilder Gallery, Los Angeles, CA
	"Studies for Hologram," Galerie Rolf Ricke, Cologne, Germany
	Galerie Konrad Fischer, Dusseldorf, Germany
	Galleria Sperone, Turin, Italy
	Galerie Ileana Sonnabend, Paris, France
	San Jose State College, San Jose, CA
1970–71	Reese-Paley Gallery, San Francisco, CA
1971	Galerie Ileana Sonnabend, Paris, France

343

Galery Bischofberger, Zurich, Switzerland

Leo Castelli Gallery, New York

Galerie Konrad Fischer, Dusseldorf, Germany

Leo Castelli Gallery, New York

Helman Gallery, St. Louis, MO

Betty Gold Fine Modern Prints, Los Angeles, CA

Ace Gallery, Vancouver, Canada

1971–72 Galleria Francoise Lambert, Milan, Italy

1972 "Bruce Nauman: 16mm Films 1967–1970," Projection Gallery, Ursula Wevers, Cologne, Germany

1972–73 "Bruce Nauman: Works from 1965–1972," Los Angeles County Museum of Art, Los Angeles, CA, and Whitney Museum of American Art, New York (traveled to Kunsthalle, Bern; Stadtische Kunsthalle, Dusseldorf; Stedelijk Van Abbemuseum, Eindhoven; Palazzo Reale, Milan; Contemporary Arts Museum, Houston, TX; San Francisco Museum of Modern Art)

1973 "Bruce Nauman—Floating Room," University of California, Irvine, CA

"Floating Room," Leo Castelli Gallery, New York

Cirrus Gallery, Los Angeles, CA

1973–74 "Flayed Earth/Flayed Self (Skin/Sink)," Nicholas Wilder Gallery, Los Angeles, CA

1974 Ace Gallery, Vancouver, Canada

Galerie Art in Progress, Munich, Germany

Galerie Konrad Fischer, Dusseldorf, Germany

"Wall with Two Fans," Wide White Space, Antwerp, Belgium

"Yellow Triangular Room," Santa Ana College Art Gallery, CA

1975 "Cones/Cojones," Leo Castelli Gallery, New York

"The Mask to Cover the Need for Human Companionship," Albright-Knox Art Gallery, Buffalo, NY

"Sundry Obras Nuevas," Gemini G.E.L., Los Angeles, CA

1975–76 "Forced Perspective," Galerie Konrad Fischer, Dusseldorf, Germany

1976 "Enforced Perspective, Allegory and Symbolism," Ace Gallery, Vancouver, Canada

"White Breathing," UNLV Art Gallery, University of Nevada, Las Vegas, NV

Leo Castelli Gallery, New York

"The Consummate Mask of Rock," Sonnabend Gallery, New York

Sperone Westwater Fischer Gallery, New York

"Enforced Perspectives (Drawings)," Ace Gallery, Los Angeles, CA

"Enforced Perspectives," Ace Gallery, Venice, CA

1977 "The Consummate Mask of Rock," Nicholas Wilder Gallery, Los Angeles, Bruno Soletti, Milan, Italy

"Bruce Nauman Sculpture," Collection of Robert Rowan, on loan to the Sculpture Garden of the Art Center, College of Design, Los Angeles, CA

1978 Leo Castelli Gallery, New York

"Floating Room," InK, Zurich, Switzerland

"Recent Sculpture," Ace Gallery, Vancouver, Canada

Galerie Konrad Fischer, Dusseldorf, Germany

"1/12 Scale Study in Fibreglass and Plaster for Cast Iron of a Trench and Four Tunnels in Concrete at Full Scale," California State University, San Diego, CA

Minneapolis Institute of Arts, College Gallery, Minneapolis, MN

"White Breathing," UNLV Art Gallery, University of Nevada, Las Vegas, NV

Leo Castelli Gallery, New York

Sperone Westwater Fischer Gallery, New York

Sonnabend Gallery, New York

1979 Galerie Schmela, Dusseldorf, Germany

Marianne Deson Gallery, Chicago, IL

"Bruce Nauman: An Installation," Portland Center for the Visual Arts, Portland, OR

Hester van Royen Gallery, London, England

1980 Leo Castelli Gallery, New York

"Smoke Rings," Hill's Gallery of Contemporary Art, Santa Fe, NM

Galerie Konrad Fischer, Dusseldorf, Germany

Carol Taylor Art, Dallas, TX

1981 Nigel Greenwood, London, England

"Bruce Nauman: 1972–81," Rijksmuseum, Kroller-Muller, Otterlo, Holland (traveled to Staatliche Künsthalle, Baden-Baden, Germany)

"Bruce Nauman: New Iron Casting, Plaster and Drawings," Young Hoffmann Gallery, Chicago, IL

InK, Zurich, Switzerland

Maud Boreel Print Art, The Hague, Holland

Galerie Konrad Fischer, Dusseldorf, Germany

The Albuquerque Museum, Albuquerque, NM

Ace Gallery, Venice, CA

Texas Gallery, Houston, TX

1982 Sperone Westwater Gallery, New York

Leo Castelli Gallery, New York

1982–83 "Bruce Nauman: Neons," Baltimore Museum of Art

1983 Carol Taylor Art, Dallas, TX

Galerie Konrad Fischer, Dusseldorf, Germany

"Dream Passages," Museum Haus Esters, Krefelder Kunstmuseum, Krefeld, Germany

1984 Daniel Weinberg Gallery, Los Angeles, CA

Leo Castelli Gallery, New York

Sperone Westwater Gallery, New York

Carol Taylor Art, Dallas, TX

1985 Leo Castelli Gallery, New York

Donald Young Gallery, Chicago, IL

Galerie Elisabeth Kaufmann, Zurich, Switzerland

Galerie Konrad Fischer, Dusseldorf, Germany

1986 Galerie Jean Bernier, Athens, Greece

"Oeuvres Sur Papier," Galerie Yvon Lambert, Paris, France

"Bruce Nauman," Kunsthalle Basel, Switzerland (traveled to ARC, Musee d'Art Moderne de la Ville de Paris; Whitechapel Art Gallery, London, England)

"American/European Paintings and Sculpture 1986, Part I," L.A. Louver Gallery, Los Angeles, CA

Texas Gallery, Houston, TX

Recipient of the 1986 Skowhegan Medal, Assorted Media at the Skowhegan 40th Anniversary Dinner

1986–87 "Bruce Nauman, Drawings 1965–86," Museum für Gegenwartkunst, Basel, Switzerland (traveled to Kunsthalle, Tubingen, Stadtisches Kunstmuseum, Bonn, Germany; Museum Boymans-van-Beuningen, Rotterdam, The Netherlands; Kunstraum Munchen, Munich, Germany; Badischer Kunstverein, Karlsruhe, Germany; Kunsthalle, Hamburg, Germany; New Museum of Contemporary Art, New York; Contemporary Arts Museum, Houston, TX; Museum of

Contemporary Arts, Los Angeles, CA; University Art Museum, Berkeley, CA)

"Bruce Nauman: Neon and Video," Donald Young Gallery, Chicago, IL

Daniel Weinberg Gallery, Los Angeles, CA

"Bruce Nauman 1965–1986," and video installation of *Clown Torture,* Museum of Contemporary Art, Los Angeles, CA

"Bruce Nauman: Drawings," Kunsthalle Basel, Basel, Switzerland

1988 "Bruce Nauman: Sex and Death 1985," Elisabeth Kaufmann, Zurich, Switzerland

"Bruce Nauman: Drawings, 1965–1986," University Art Museum, University of California, Berkeley, CA

"Southern California Summer 1988," Cirrus Gallery, Los Angeles, CA

Sperone Westwater Gallery, New York

"Bruce Nauman: Drawings, 1965–1986, Video," Museum of Contemporary Art, Los Angeles, CA

Galerie Micheline Szwajcer, Antwerp, Belgium

"Vices and Virtues," University of California at San Diego, San Diego, CA

"Sleep of Reason," Museum Fridericanum, Kassel, Germany

1989 "Bruce Nauman, New Work," Museum für Gegenwartskunst Basel, Basel, Switzerland

"Zeitlos," curated by Harald Szeeman, Berlin, Konrad Fischer, Dusseldorf, Germany

Texas Gallery, Houston, TX

Yvon Lambert, Paris, France

"Bruce Nauman: Prints 1970–89," Donald Young Gallery, Chicago, IL

"Druckgraphik 1970–1988," Galerie Fred Jahn, Munich

Saatchi Collection, London, England

1990 "Radierungen, Lithographien, Multiples," Jurgen Becker Galerie, Hamburg, Germany

"Figuring the Body," Museum of Fine Arts, Boston, MA

"Bruce Nauman Sculpture and Installations 1985–1990 (Human Nature/Animal Nature)," Museum für Gegenwartskunst Basel, Switzerland (traveled in 1991 to Stadtische Galerie im Stadelschen Kunstinstitut, Frankfurt am Main, Germany)

"Bruce Nauman, Prints 1970–89," Lorence-Monk Gallery, New York

"Animal Pyramid," Permanent Installation, Des Moines Art Center, Des Moines, IA

Langer Fain Galerie, Paris, France

"Bruce Nauman: A Survey," Anthony D'Offay Gallery, London, England

Sperone Westwater Gallery, New York

Leo Castelli Gallery, New York

Galerie B. Coppens and R. van de Velde, Brussels, Belgium

Daniel Weinberg Gallery, Santa Monica, CA

65 Thompson Street, New York

1991 Daniel Weinberg Gallery, Santa Monica, CA

"Bruce Nauman, Prints and Multiples" (organized by Thea West-reich, New York) (traveled to: Museum van Hedendaagse Kunst, Ghent, Belgium; Douglas Hyde Gallery, Trinity College, Dublin, Ireland; Museum Boymans-van Beuningen, Rotterdam, The Netherlands; Heiligenkreuzerhof, Hochschule für Angewandte Kunst, Vienna, Austria; City Museum, Stoke on Trent, England)

"Human Nature—Animal Nature" (An Installation of Sculpture and Works on Paper), Stadtische Galerie im Stadel, Frankfurt, Germany

"Bruce Nauman Graphik 1970–89," Galerie Hummel, Vienna, Austria

"Bruce Nauman: Prints," Gallery 360°, Tokyo, Japan

"Bruce Nauman—OK OK OK," Portikus, Frankfurt, Germany

Galerie Metropol, Vienna, Austria

"Bruce Nauman," Fundacio Espai Poblenou, Barcelona, Spain

1992 "Bruce Nauman: Use Me (Graphics, Multiples, Videos and Installa-tions)," Institute of Contemporary Art, London, England

"Bruce Nauman Neons," Anthony d'Offay Gallery, London, England

"Bruce Nauman," Ydessa Hendeles Foundation, Toronto, Ontario, Canada

"Bruce Nauman: Prints, Multiples and Video," Tel Aviv Museum of Art, Tel Aviv, Israel

"Bruce Nauman," Museo Nacional Centro de Arte Reina Sofia, Madrid (traveling exhibition organized by the Walker Art Center in association with the Hirshhorn Museum and Sculpture Garden)

"Bruce Nauman," Salzburger Kunstverein, Salzburg, Austria

1993 "Light Works," Washington University Gallery of Art, St. Louis, MO

"Prints," Galerie Rupert Walser, Munich, Germany

"Bruce Nauman" (curated by Morgan Spangle), Shoshona Wayne Gallery, Santa Monica, CA

"Bruce Nauman," Galleri Faurschou, Copenhagen, Denmark

1994 "Falls, Pratfalls and Sleights of Hand," Leo Castelli Gallery, New York

"Prints and Drawings," Leo Castelli Gallery, New York

"Seven Virtues and Seven Vices," Galerie Konrad Fischer, Dusseldorf, Germany

"Falls, Pratfalls and Sleights of Hand," Anthony d'Offay Gallery, London. England

"Bruce Nauman," Walker Art Center, Minneapolis, MN (traveling exhibition organized by the Walker Art Center in association with the Hirshhorn Museum and Sculpture Garden)

"Bruce Nauman," Wexner Center, Columbus, OH (traveling exhibition organized by the Walker Art Center in association with the Hirshhorn Museum and Sculpture Garden)

"Bruce Nauman," Museum of Contemporary Art, New York (traveling exhibition organized by the Walker Art Center in association with the Hirshhorn Museum and Sculpture Garden)

"Bruce Nauman," Hirshhorn Museum and Sculpture Garden, Washington, DC (traveling exhibition organized by the Walker Art Center in association with the Hirshhorn Museum and Sculpture Garden)

"Bruce Nauman Prints 1970–1988," Cirrus Gallery, Los Angeles, CA

"Dirty Version," Galerie Konrad Fischer, Dusseldorf, Germany

"Falls, Pratfalls and Sleights of Hand" (video installation, Dirty Version), Galerie Tschudi, Glarus, Switzerland

1995 "Elliot's Stones," Museum of Contemporary Art, Chicago, IL

"Bruce Nauman—Falls, Pratfalls and Sleights of Hand, 1993 (Dirty Version)," Jean Bernier, Athens, Greece

"Bruce Nauman," Kunsthaus Zurich, Zurich, Switzerland

"Bruce Nauman," Museum of Modern Art, New York (traveling exhibition organized by the Walker Art Center in association with the Hirshhorn Museum and Sculpture Garden)

"Bruce Nauman—Fingers and Holes," Gemini G.E.L. at Joni Moisant Weyl, New York

"Bruce Nauman, Selected Prints and Drawings," Earl McGrath Gallery, New York

1996 "Bruce Nauman: Rotating Glass Walls," Museum Boymans-van Beuningen, Rotterdam, The Netherlands

"Bruce Nauman," Konsthall Stockholm, Stockholm, Sweden

"Bruce Nauman: Spring 1996 Exhibition," Galerie Konrad Fischer, Dusseldorf

"Fifteen Pairs of Hands, White Bronze, 'End of the World,' with Lloyd Maines," Leo Castelli Gallery, New York

"Bruce Nauman—Video and Sculpture," Sperone Westwater Gallery, New York

1997 "Bruce Nauman: Shadow Puppet Spinning Head," Galerie Hauser & Wirth, Zurich, Switzerland

"Bruce Nauman: Violent Incident," Saint-Gervais Genève, Switzerland

"Bruce Nauman: 1985–1996, Drawings, Prints, and Related Works," The Aldrich Museum of Contemporary Art, Ridgefield, CT (traveled to Cleveland Center for Contemporary Art, Cleveland, OH)

1997–99 "Bruce Nauman, Image/Text 1966–1996," Kunstmuseum Wolfsburg, Wolfsburg, Germany (traveled to Centre Georges Pompidou, Paris, France; Hayward Gallery, London, England; and Taiteen Museo/Museum of Contemporary Art, Helsinki, Finland)

1998 "Bruce Nauman: Selected Works: 1970–1996," Galleri Riis, Oslo, Norway

1999 Donald Young Gallery, Chicago, IL

Selected Group Exhibitions

1966 "Eccentric Abstraction," Fischbach Gallery, New York

"The Slant Step Show," Berkeley Gallery, San Francisco, CA

"William Geis and Bruce Nauman," San Francisco Art Institute, San Francisco, CA

"New Directions," San Francisco Museum, San Francisco, CA

1967 "American Sculpture of the Sixties," Los Angeles County Museum of Art, Los Angeles, CA

1968 "Documenta IV," Kassel, Germany

"9 at Leo Castelli," Leo Castelli Warehouse, New York

"West Coast Now," Portland Art Museum, Portland, OR

"Prospect 68," Stadtische Kunsthalle, Dusseldorf, Germany

"Anti-Form," John Gibson Gallery, New York

"Three Young Americans," Allen Art Museum, Oberlin, OH

1969 "When Attitudes Become Form," Kunsthalle, Bern, Switzerland (traveled to Museum Haus Lange, Krefeld, Germany, and the Institute of Contemporary Art, London, England)

"Op Losse Schroeven," Stedelijk Museum, Amsterdam, The Netherlands

"Nine Young Artists," Theodoron Foundation Awards, The Solomon R. Guggenheim Museum, New York

"Anti-Illusion: Materials/Procedures," Whitney Museum of American Art, New York

"Soft Sculpture," American Federation of the Arts Circulating Exhibition

"Here and Now," Steinberg Gallery of Art, Washington University, St. Louis, MO

"31st Biennial of American Painting," Corcoran Gallery of Art, Washington, DC

Galerie Heiner Friedrich, Munich, Germany

Wide White Space Gallery, Antwerp, Belgium

"The Sky's the Limit," University of St. Thomas, Houston, TX

"7 Objects/69," Galerie Ricke, Cologne, Germany

Galerie Rudolf Zwirner, Cologne, Germany

"Art by Telephone," Museum of Contemporary Art, Chicago, IL

The Gallery of the School of Visual Arts, New York

"Contemporary Drawing Show," Fort Worth Art Center, Fort Worth, TX

"West Coast 1945–1969," Pasadena Art Museum, Pasadena, CA (traveled to The City Art Museum, Saint Louis, MO; Art Gallery of Ontario, Canada; Fort Worth Art Center, Fort Worth, TX)

"Konzeption/Conception," Schloss Morsbroich, Leverkusen, Germany

1969–70 "Kompas IV West Coast USA," Stedelijk van Abbemuseum, Eindhoven, The Netherlands

"Art in Progress," Finch College Museum of Art, New York

1970 "Conceptual Art and Conceptual Aspects," New York Cultural Center, New York

"Information," Museum of Modern Art, New York

"String and Rope," Sidney Janis Gallery, New York

"N Dimensional Space," Finch College Art Museum, New York

The Helman Gallery, St. Louis, MO

"Conceptual Art, Arte Povera, Land Art," Galleria Civica d'Arte Moderna, Turin, Italy

"Grafiek van de West Coast," Seriaal, Amsterdam, The Netherlands

"Body Works," Breen's Bar, San Francisco, CA

"American Art Since 1960," Princeton University Art Museum, Princeton, NJ

University of California at San Diego, San Diego, CA

"Holograms and Lasers," Museum of Contemporary Art, Chicago, IL

"Tokyo Biennale '70: Between Man and Matter," 10th International Art Exhibition of Japan, Tokyo Metropolitan Art Gallery, Tokyo, Japan (traveled to Kyoto Municipal Art Museum, Kyoto; Aichi Prefectural Art Gallery, Nagoya; Fukoka Prefectural Culture House, Fukoka, Japan)

"Drawings of American Artists," Galerie Yvon Lambert, Paris/Galerie Ricke, Cologne, Germany

"Against Order: Chance and Art," Institute of Contemporary Art, Philadelphia, PA

"Whitney Annual: Sculpture 1970," Whitney Museum of American Art, New York

"Looking West," Joslyn Art Museum, Omaha, NE

"Young Bay Area Sculptors," San Francisco Art Institute, San Francisco, CA

"300: New Multiple Art," Whitechapel Art Gallery, London, England

1971 "Sonsbeek 71," Park Sonsbeek, Amsterdam, The Netherlands

"11 Los Angeles Artists," Hayward Gallery, London, England (traveled to Palais des Beaux-Arts, Brussels, Belgium; Akademie der Kunst, Berlin, Germany)

"Sixth Guggenheim International Exhibition," The Solomon R. Guggenheim Museum, New York

"Prospect 71," Stadtische Kunsthalle, Dusseldorf, Germany

Galerie Francoise Lambert, Milan, Italy

"Body" (Performances and Films), New York University, New York

"Projected Art: Artists at Work," Finch College Museum of Art, New York

"Air," Stedelijk Museum, Amsterdam, The Netherlands

"Kid Stuff," Albright-Knox Art Gallery, Buffalo, NY

"The Artist as Filmmaker," Hausen-Fuller Gallery, San Francisco, CA

"Modern Painting, Drawing and Sculpture Collected by Louise and Joseph Pulitzer, Jr.," Fogg Art Museum, Cambridge, MA

"Works on Film," Leo Castelli Gallery, New York

Wide White Space Gallery, Antwerp, Belgium

"Recorded Activities," Moore College of Art, Philadelphia, PA

"The Biennale at Nuremberg," Kunsthalle Nuremberg, Germany

John Gibson Gallery, New York

"Septieme Biennale de Paris," Paris, France

1972 "Documenta 5," Museum Fridericianum, Kassel, Germany

"Diagrams and Drawings," Rijksmuseum Kroller-Muller, Otterlo, The Netherlands (traveled to Kunstmuseum, Basel, Switzerland)

"Dealer's Choice," La Jolla Museum of Contemporary Art, La Jolla, CA

"Spoleto Festival," Spoleto, Italy

"Zeichnungen," Galerie Ricke, Cologne, Germany

"USA West Coast," Kunstverein, Hamburg, Germany

"Films By American Artists," Whitney Museum of American Art, New York

1973 "Art in Progress," Grafik, Zurich, Switzerland

Galerie Ricke, Cologne, Germany

Lucio Amelio, Modern Art Agency, Naples, Italy

Texas Gallery, Houston, TX

Amerika Haus, Berlin, Germany

"Art in Evolution," Xerox Square Exhibit Center, Rochester, NY

"Inventory," Janie C. Lee Gallery, Dallas, TX

"Video Tapes by Gallery Artists," Leo Castelli Gallery, New York

"3D Into 2D: Drawing for Sculpture," The New York Cultural Center, New York

"American Art—Third Quarter Century," The Seattle Art Museum, Seattle, WA

Kunsthalle Bern, Bern, Switzerland

Galerie Art in Progress, Munich, Germany

Sperone Gian Enzo & Konrad Fischer, Rome, Italy

"Drawings: Seventies," Joseloff Gallery, Hartford Art School, Hartford, CT

"Graphics," Courtney Sale Gallery, Dallas, TX

"Amerikanische und Englische Graphik der Gegenwart," Staatsgalerie, Graphische Sammlung, Stuttgart, Germany

"American Drawings: 1963–1973," Whitney Museum of American Art, New York

"Bilder, Objekte, Filme, Konzepte: Herbig Collection," Stadtische Galerie Im Lenbachhaus, Munich, Germany

"Contemporaneo," Parcheggio di Villa Borghese, Rome, Italy

1974 "Cirrus Editions," The Oakland Museum, Oakland, CA

"Drawings," Leo Castelli Gallery, New York

"Artiste della West Coast," Francoise Lambert, Milan, Italy

"Idea and Image in Recent Art," The Art Institute of Chicago, Chicago, IL

"Videotapes: Six from Castelli," deSaisset Art Gallery, University of California at Santa Clara, Santa Clara, CA

"Record as Artwork," Galerie Ricke, Cologne, Germany

"The Ponderosa Collection," The Contemporary Arts Center, Cincinnati, OH

"Images—Words," The New Gallery, Cleveland, OH

"Art Now," The John F. Kennedy Center for the Performing Arts, Washington, DC

"Painting and Sculpture Today 1974," The Indianapolis Museum of Art, Indianapolis, IN; The Contemporary Art Center, and the Taft Museum, Cincinnati, OH

The Tate Gallery, London, England

"Prints from Gemini G.E.L.," Walker Art Center, Minneapolis, MN

"4 x Minimal Art," Galerie Ricke, Cologne, Germany

University of Nevada, Las Vegas, NV (Organized by Nicholas Wilder)

"Castelli at Berggruen," John Berggruen Gallery, San Francisco, CA

"Art/Voir," Musee National d'Art Moderne, Centre Georges Pompidou, Paris, France

1975 "Drawing Now," Museum of Modern Art, New York (traveled to Kunsthalle, Zurich, Switzerland; Stadtische Kunsthalle, Baden-Baden, Germany; Albertina Museum, Vienna, Austria; Sonia Henie-Neils Onstad Foundations, Oslo, Norway)

"Light/Sculpture," William Hayes Ackland Memorial Art Center, Chapel Hill, NC

"Menace," Museum of Contemporary Art, Chicago, IL

"Zeichnungen 3, USA," Stadtisches Museum Leverkusen, Schloss Morsbroich, Leverkusen, Germany

"Language and Structure in North America," Kensington Art Association Gallery, Toronto, Canada, traveling exhibition

"Body Works," Museum of Contemporary Art, Chicago, IL

"Sculpture, American Directions 1974–1975," National Collection of Fine Arts, Smithsonian Institution, Washington, DC

Gian Enzo Sperone, Rome, Italy

"Functions of Drawings," Rijksmuseum Kroller-Muller, Otterlo, The Netherlands

"Spiralen und Progressionen," Kunstmuseum Luzern, Lucerne, Switzerland

1976 "200 Years in American Sculpture," Whitney Museum of American Art, Sonia Henie-Niels Onstad Foundation, Oslo, Norway

"Drawing Now," The Museum of Modern Art, New York (traveled to Kunsthaus, Zurich, Switzerland, Staatliche Kunsthalle Baden-Baden, Germany; Graphische Sammlung Albertina, Vienna, Austria; Sonja Henie–Niels Onstad Foundations, Oslo, Norway; The Tel Aviv Museum, Tel Aviv, Israel)

"Functions of Drawings/Seichnen/Bezeichnen," Kunstmuseum, Basel, Switzerland

"American Artists: A New Decade," The Detroit Institute of the Arts, Detroit, MI (traveled to Fort Worth Art Museum, Fort Worth, TX)

"Ideas on Paper 1970–76," The Renaissance Society of the University of Chicago, Chicago, IL

"Drawing (In the U.S.A.)," Cannaviello Studio d'Arte, Rome, Italy

"The Artist and the Photograph," Israel Museum, Jerusalem, Israel

Sable-Castelli Gallery, Toronto, Canada

"Autogeography," Whitney Downtown Museum, New York

"Survey—Part II," Sable-Castelli Gallery, Toronto, Canada

"The Seventy-second American Exhibition," The Art Institute of Chicago, Chicago, IL

Sequential Imagery in Photography," The Broxton Gallery, Los Angeles, CA

"Rooms P.S.1." P.S.1, Long Island City, NY

1977 "Skulptur/Sculpture," Westfalisches Landesmuseum für Kunst und Kulturgeschichte, Munster, Germany

"Painting and Sculpture in California: The Modern Era," San Francisco Museum of Art, San Francisco, CA (traveled to Smithsonian Institution, Washington, DC, National Collection of Fine Arts)

"The Dada/Surrealist Heritage," Sterling & Francine Clark Institute, Williamstown, MA

"Two Decades of Exploration: Homage to Leo Castelli on the Occasion of his 20th Anniversary," The Art Association of Newport, Newport, RI

National Collection of Fine Arts, Smithsonian Institution, Washington, DC

"1977 Biennial Exhibition, Contemporary American Art," The Whitney Museum of American Art, New York

"Ideas in Sculpture 1965–1977," The Renaissance Society at the University of Chicago, Chicago, IL

"Word at Liberty," Museum of Contemporary Art, Chicago, IL

"Documenta 6," Museum Fridericianum, Kassel, Germany

"A View of the Decade," Museum of Contemporary Art, Chicago, IL

"Drawings for Outdoor Sculpture: 1946–77," John Weber Gallery, New York (traveled to Amherst College, Amherst, MA; University of California at Santa Barbara, CA; Laguna Gloria Art Museum, Austin, TX; M.I.T., Cambridge, MA)

"Works on Paper by Contemporary American Artists," Madison Art Center, Madison, WI

"Surrogates/Self-Portraits," Holly Solomon Gallery, New York

"Works from the Collection of Dorothy and Herbert Vogel," The University of Michigan Museum of Art, Ann Arbor, MI

"Watercolors and Related Media by Contemporary Californians," Baxter Art Gallery, California Institute of Technology, Pasadena, CA

1978 "Made by Sculptors," Stedelijk Museum, Amsterdam, The Netherlands

"Three Generations: Studies in Collage," Margo Leavin Gallery, Los Angeles, CA

"Nauman, Serra, Shapiro, Jenney," Blum Helman Gallery, New York

"Salute to Merce Cunningham, John Cage and Collaborators," Thomas Segal Gallery, Boston, MA

"Drawings and Other Work on Paper," Sperone Westwater Fischer Gallery, New York

"Conceptual Art," Julian Pretto Gallery, New York

"20th Century American Drawings: Five Years of Acquisitions," Whitney Museum of American Art, New York

XXXVIII Biennale di Venezia, Venice, Italy

InK, Zurich, Switzerland

"Sculpture," Richard Hines Gallery, Seattle, WA

"Space, Time, Sound: Conceptual Art in the San Francisco Bay Area: The 70's," San Francisco Museum of Art, San Francisco, CA

"Related Figurative Drawings," Hansen Fuller Gallery, San Francisco, CA

"The Sense of the Self: From Self-Portrait to Autobiography," The New Gallery of Contemporary Art, Cleveland, OH

"Words, Words," Museum Bochum, Bochum, Germany (traveled to Palazzo Ducale, Genova, Italy)

"The Broadening of the Concept of Reality in the Art of the 60's and 70's," Museum Haus Lange, Krefeld, Germany

"Images of the Self," Hampshire College Gallery, Amherst, MA

"Drawings by Castelli Artists," Castelli Graphics, New York

"Great Big Drawing Show," Institute for Art & Urban Resources, P.S.1, Long Island City, NY

"73rd American Exhibition," The Art Institute of Chicago, Chicago, IL

"American Portraits of the Sixties and Seventies," Aspen Center for the Visual Arts, Aspen, CO

"From Allan To Zucker," Texas Gallery, Houston, TX

"Art of the 70's from the Crex Collection," Stadtische Galerie in Lebachaus, Munich, Germany

"New Spaces: The Holographer's Vision," The Franklin Institute, Philadelphia, PA

"Thirty Years of Box Construction," Suzanne Savage Gallery, Boston, MA

"Artists and Books: The Literal Use of Time," Ulrich Museum of Art, Wichita State University, Wichita, KS

1980 "Sculpture in California, 1975–80," San Diego Museum of Art, San Diego, CA

"Pier + Ocean," Hayward Gallery, London (traveled to Rijksmuseum Kroller-Muller, Otterlo, The Netherlands)

"From Reinhardt to Christo," Allen Memorial Art Museum, Oberlin College, Oberlin, OH

"Southern California Drawings," Joseloff Gallery, University of Hartford, Hartford, CT

"Leo Castelli: A New Space," Leo Castelli Gallery, New York

"The New American Filmmakers Series," Whitney Museum of American Art, New York

"Contemporary Art in Southern California," High Museum of Art, Atlanta, GA

"20 Years of Sculpture," Wenkenpark, Riehen-Basel, Switzerland

"Contemporary Sculpture: Selections from the Permanent Collection of the Museum of Modern Art," Museum of Modern Art, New York

"Donald Judd/Bruce Nauman/Richard Serra: Sculpture," Richard Hines Gallery, Seattle, WA

"Master Prints by Castelli Artists," Castelli Graphics, New York

"Zeichnungen Neuerwerbungen 1976–1980," Museum Haus Lange, Krefeld, Germany

"Fall 1980," Leo Castelli Gallery, New York

"Architectural Sculpture," Los Angeles Institute of Contemporary Art, Los Angeles, CA (traveled to Baxter Art Gallery, California Institute of Technology, Pasadena, CA)

"Bruce Nauman, Barry Le Va," Nigel Greenwood, Inc., London, England

"Venice Biennale," Venice, Italy

"American Drawing in Black and White," The Brooklyn Museum, Brooklyn, NY

"Drawings to Benefit the Foundation for the Contemporary Performance Arts, Inc.," Leo Castelli Gallery, New York

1981 "Che Fare? / Was Tun?, Kounellis, Merz, Nauman, Serra," Museum Haus Lange, Krefeld, Germany

"Working Drawings," Hunter College Art Gallery, New York

Krefelder Kunstmuseen, Krefeld, Germany

"Lessons," Texas Gallery, Houston, TX

New Dimensions in Drawing," Aldrich Museum of Contemporary Art, Ridgefield, CT

Seventeen Artists in the Sixties, The Museum as Site: Sixteen Projects," Los Angeles County Museum, Los Angeles, CA

"California: A Sense of Individualism," L.A. Louver Gallery, Venice, CA

Neon Fronts: Luminous Art for the Urban Landscape," D.C. Space for Washington Project for the Arts, Washington, DC

"Soundings," Neuberger Museum, State University of New York, Purchase, NY

"Cast, Carved, Constructed," Margo Leavin Gallery, Los Angeles, CA

"Drawing Distinctions," Louisiana Museum, Humlebaek, Denmark (traveled to Kunsthalle, Basel, Switzerland; Stadtische Galerie Im Leubachaus, Wilhelm Hack Museum, Ludwigshafen am Rhein, Germany)

"Selections from Castelli: Drawings and Works on Paper," Neil G. Ovsey Gallery, Los Angeles, CA

"Instruction Drawings," The Gilbert and Lila Silverman Collection, Cranbrook Academy of Art Museum, Bloomfield Hills, MI

"Schemes: A Decade of Installation Drawings," Elise Meyers, Inc., New York

"Peter Stuyvesant Collection: A Choice Within a Choice," Provincial Begijhof, Hasselt, Belgium

1982 "Documenta 7," Kassel, Germany

"Eight Lithographs," Margo Leavin Gallery, Los Angeles, CA

"Livres d'Artistes," Musee d'Art Contemporain, Montreal, Canada

"Bronze," Patricia Hamilton Gallery, New York

"Gemini G.E.L.—Group Show," Thomas Babeor Gallery, La Jolla, CA

"Amerikanische Zeichnungen der 70er Jahre Lenbachhaus," Stadtische Gallerie, Munich, Germany

"Antiform et Arte Povera, Sculptures, 1966–1969," Centre d'Arts Plastiques Contemporains de Bordeaux, Bordeaux, France

"Works on Paper," Larry Gagosian Gallery, Los Angeles, CA

"Castelli and His Artists: Twenty-five Years," La Jolla Museum of Contemporary Art, La Jolla, CA (traveled to The Aspen Center for the Visual Arts, Aspen, CO; Galerie Bruno Bischofberger, Zurich, Switzerland)

"Works from the Crex Collection," Kunsthalle Basel, Basel, Switzerland

"Casting: A Survey of Cast Metal Sculpture in the Eighties," Fuller Goldeen Gallery, San Francisco, CA

"Works in Wood," Margo Leavin Gallery, Los Angeles, CA

"Attitudes/Concepts/Images," Stedelijk Museum, Amsterdam, The Netherlands

"Postminimalism," The Aldrich Museum, Ridgefield, CT

"The Written Word," Downey Museum of Art, Downey, CA

"Sculptors at UC Davis: Past and Present," UC Davis, Davis, CA

"Group Exhibition," Leo Castelli Gallery, New York

"74th American Exhibition," Art Institute of Chicago, Chicago, IL

"Kunst neu/Kunst unserer Zeit," Kunsthalle Wilhelmshaven, Germany (traveled to Groninger Museum, Groningen, The Netherlands)

"Reinhard Mucha, Bruce Nauman," Max-Ulrich Hetzler, Stuttgart, Germany

"Halle 6," Kampnagelfabrik, Hamburg, Germany

"20 American Artists, Sculpture 1982," San Francisco Museum of Art, San Francisco, CA

1982–83 "A Century of Modern Drawing from the Museum of Modern Art," Museum of Modern Art, New York (traveled to British Museum, London, England; Museum of Fine Arts, Boston, MA; Cleveland Museum of Art, Cleveland, OH)

1983 "Neue Zeichnungen aus Dem Kunstmuseum Basel," Kunstmuseum, Basel, Switzerland (traveled to Kunsthalle, Tubingen and Neue Galerie, Staatliche und Stadtische Kunstsammlungen, Kassel, Germany)

"De Statua," Stedelijk Van Abbemuseum, Eindhoven, The Netherlands

"Prints," Galleriet, Lund, Sweden

"Black & White: A Print Survey," Castelli Graphics, New York

"Drawing Conclusions—A Survey of American Drawings: 1958–1983," Daniel Weinberg Gallery, Los Angeles, CA

"Small Bronzes: A Survey of Contemporary Bronze Sculpture," McIntosh/Drysdale Gallery, Houston, TX

"Group Show," Galerie Konrad Fischer, Dusseldorf, Germany

"The Slant Step Revisited," Richard L. Nelson Gallery, University of California at Davis, Davis, CA

"Sammlung Helga und Walther Lauffs im Kaiser Wilhelm Museum Krefeld," Krefelder Kunstmuseum, Krefeld, Germany

"The First Show, Painting and Sculpture from Eight Collections: 1940–80," The Museum of Contemporary Art, Los Angeles, CA

"Objects, Structures, Artifice: American Sculpture 1970–1982,"

SVC/Fine Arts Gallery, University of South Florida, Tampa, FL

"Recent Acquisitions," The Museum of Modern Art, New York

"Minimalism to Expressionism: Painting and Sculpture since 1965 from the Permanent Collection," Whitney Museum of American Art, New York

"John Duff, Robert Mangold, Bruce Nauman," Blum Helman Gallery, New York

"Kunst mit Photographie der Sammlung R. H. Krauss," National-galerie, Berlin, Germany

Sperone Westwater Gallery, New York

"Bruce Nauman & Martin Puryear: Recent Outdoor Projects," Donald Young Gallery, Chicago, IL

"Conceptual," Rhona Hoffman Gallery, Chicago, IL

"Aspects of Minimalism," Flow Ace Gallery, Los Angeles, CA

"American/European Painting & Sculpture Part I," L.A. Louver Galleries, Venice, CA

"Works on Paper," Annemarie Verna Galerie, Zurich, Switzerland

"The Sculptor as Draftsman: Selections from the Permanent Collection," Whitney Museum of American Art, New York

"Word Works," Walker Art Center and the Minneapolis College of Art and Design, Minneapolis, MN

"American Sculptures from the Permanent Collection," The Solomon R. Guggenheim Museum, New York

"Drawings, Photographs," Leo Castelli Gallery, New York

"Sculpture," Leo Castelli Gallery, New York

1984 "Sculpture in the 20th Century," Brulinger Park, Basel, Switzerland

"Arte, Ambient, Scena," Venice Biennale, Venice, Italy

"Sculptors' Drawings: 1910–1980, Selections from the Permanent Collection," organized by the Whitney Museum of American Art, New York (traveled to The Visual Arts Gallery, Miami, FL; Museum of Fine Arts, Aspen, CO; Art Museum of South Texas, Corpus Christi, TX; Philbrook Art Center, Tulsa, OK)

"10th Anniversary Exhibition," Hirshhorn Museum, Washington, DC

"1964–1984," Donald Young Gallery, Chicago, IL

"Works on Paper: Graduate Students from U.C. Davis, 1965–82," Fine Arts Collection, Department of Art, University of California, Davis, CA

"Quartetto: Joseph Beuys, Enzo Cucchi, Luciano Fabro, Bruce Nauman," L'Academia Foundation, Venice, Italy

"Content: A Contemporary Focus 1974–1984," Hirshhorn Museum and Sculpture Garden, Smithsonian Institution, Washington, DC

"Little Arena: Drawings and Sculpture from the Collection of Adri, Martin and Geertjan Visser," Rijksmuseum Kroller-Muller, Otterlo, The Netherlands

"Bruce Nauman/Dennis Oppenheim: Drawings and Models for Albuquerque Commissions," University Art Museum, University of New Mexico, Albuquerque, NM

"Artists Choose Artists III," CDS Gallery, New York

"American Sculpture," Donald Young Gallery, Chicago, IL

"Group Show," Hallen für Neue Kunst, Schasshausen, Germany

"Skulpture im 20. Jahrhundert," Wenkenpark, Merian-Basel, Switzerland

"Selections from the Collection: A Focus on California," Los Angeles County Museum of Art, Los Angeles, CA

"Projects: World's Fair, Waterfronts, Parks and Plazas," Rhona Hoffman Gallery, Chicago, IL

"American and European Painting, Drawing & Sculpture," L.A. Louver Gallery, Los Angeles, CA

"American Sculpture," Margo Leavin Gallery, Los Angeles, CA

"Drawings by Sculptors: 2 Decades of Non-Objective Art in the Seagram Collection," The Montreal Museum of Fine Arts, Montreal, Canada (traveled to Vancouver Art Gallery, Vancouver, Canada; The Nickle Arts Museum, Calgary, Canada; Seagram Building, New York; London Regional Art Gallery, London, Canada)

"Praxis Collection," Vancouver Art Gallery, Vancouver, Canada

"An Invitational Exhibit of Neon Art and Sculpture," Madison Gallery, Albuquerque, NM

"ROSC '84. The Poetry of Vision," The Guiness Hop Stop, Dublin, Ireland

"The Sculptor as Draftsman," The Visual Arts Gallery, Florida International University, Miami, FL

"New Drawings by Castelli Artists," Castelli Graphics, New York

"Night Lights," Dart Gallery, Chicago, IL

"Group Exhibition," Carpenter & Hochman Gallery, Dallas, TX

"L'Architecte est absent: Works from the Collection of Annick and

Anton Herbert," Stedelijk van Abbemuseum, Eindhoven, The Netherlands

Castelli di Rivoli, Turin, Italy

"The Fine Art of the Knife," Elaine Horwitch Galleries, Santa Fe, NM

1985 "Transformations in Sculpture, Four Decades of American and European Art," The Solomon R. Guggenheim Museum, New York

"Dialog," Gulbenkian Foundation, Lissabon, Museum Haus Lange, Krefeld, Germany

"New Work on Paper 3," Museum of Modern Art, New York

"Large Drawings," Bass Museum of Art, Miami Beach, FL (traveled to Madison Art Center, Madison, WI; Santa Barbara Museum, Santa Barbara, CA)

"Large Scale Drawings by Sculptors," The Renaissance Society at the University of Chicago, Chicago, IL

"The Sculptor as Draftsman," Visual Arts Museum, New York

"Schwarz auf Weiss von Manet bis Kiefer," Galerie Beyeler, Basel, Switzerland

"Beuys, Disler, Nauman," Elisabeth Kaufman, Zurich, Switzerland

"The Maximal Implications of the Minimal Line," Edith C. Blum Art Institute, Bard College, Annandale-on-Hudson, New York

"Whitney 1985 Biennial Exhibition," Whitney Museum of American Art, New York

"Exhibition-Dialogue/Exposicao-Dialogo," Centro de Arte Moderna, Dundacao Caloust Gulbenkian, Lisbon, Portugal

"A Tribute to Leo Castelli," The Mayor Gallery, London, England

"Selections from the William J. Hokin Collection," Museum of Contemporary Art, Chicago, IL

"A Printer's Prints from Gemini G.E.L., 1970–75," Pink's Fine Arts, Santa Monica, CA

"Recent Editions by Castelli Artists," Castelli Graphics, New York

"Artschwager, Judd, Nauman 1965–85," Donald Young Gallery, Chicago, IL

"Mile 4. Chicago Sculpture International," Illinois Not-For-Profit Organization, State Street Mall, Chicago, IL

"Illuminations: The Quality of Light," Pittsburgh Center for the Arts, Pittsburgh, PA

"American/European Painting and Sculpture 1985, Part I," L.A. Louver Gallery, Los Angeles, CA

"New Works," Gemini G.E.L., New York

"Affiliations: Recent Sculpture and Its Antecedents," Whitney Museum of American Art, Fairfield County, Stamford, CT

"Dreibig Jahre durch die Kunst, 1955–85," Museum Haus Lange, Krefeld, Germany

"Doch Doch," Arenberg Institute, Leuven, Belgium

Galerie Max Hetzler, Cologne, Germany

"Large Drawings," Norman Mac Kenzie Fine Art Gallery, University of Regina, Saskatchewan, Canada (traveled to Anchorage Historical and Fine Arts Museum, Anchorage, Alaska)

"Werke aus dem Basler Kupferstichkabinett," Staatliche Kunsthalle, Baden-Baden, Germany (traveled to Tel Aviv Museum, Tel Aviv, Israel)

"Aids Benefit Exhibition—Works on Paper," Daniel Weinberg Gallery, Los Angeles, CA

"The Carnegie International," Museum of Art, Carnegie Institute, Pittsburgh, PA

"American Eccentric Abstraction," Blum Helman Gallery, New York

Staatliche Kunsthalle, Baden-Baden, Germany

Drawing Exhibition, Barbara Toll Gallery, New York

"Drawings," Lorence-Monk Gallery, New York

"Vom Zeichnen. Aspekte der Zeichnung 1960–1985," Frankfurter Kunstverein, Frankfurt, Germany (traveled to Kasseler Kunstverein, Kassel, Germany; Museum Modern Kunst, Vienna, Austria)

"Amerikanische Zeichnungen 1930–1980," Stadtische Galerie im Stadelschen Kunstinstitut, Frankfurt, Germany

"Drawing," Knight Gallery, Charlotte, NC

"Benefit for the Kitchen," Brooke Alexander Gallery, New York

"An American Renaissance: Painting and Sculpture Since 1940," Museum of Art, Fort Lauderdale, FL

"Lost/Found Language: The Use of Language as Visual or Conceptual Component, Deriving Directly or Indirectly from Popular Culture," Lawrence Gallery, Rosemont College, Rosemont, PA

1986 "The Real Big Picture," The Queens Museum, Queens, NY

"Individuals: A Selected History of Contemporary Art, 1945–1986," The Museum of Contemporary Art, Los Angeles, CA

"Inaugural Exhibition," Fort Wayne Museum of Art, Fort Wayne, IN

"Oeuvres Inedites," Galerie Roger Pailhas, Marseilles, France

"Steirischer Herbst," Stadtmuseum Graz, Graz, Austria

"Monumental Drawings," Brooklyn Museum, Brooklyn, NY

Galerie Gabrielle Maubrie, Paris, France

"Beuys zu Ehren," Stadtische Galerie im Lenbachhause, Munich, Germany

"Salute to Leo Castelli," Thomas Segal Gallery, Boston, MA

"Sculpture," Waddington Galleries, London, England

"Recent Acquisitions," Donald Young Gallery, Chicago, IL

"Drawings by Sculptors," Nohra Haime Gallery, New York

"Art from Two Continents," Helander Gallery, Palm Beach, FL

"Irony of Freedom: Violent America," Emily Lowe Gallery, Hofstra University, Hempstead, NY

"Leo Castelli," Chicago International Art Expo, Chicago, IL

"Preview Exhibition, MOCA Benefit Auction," Margo Leavin Gallery and Gemini G.E.L., Los Angeles, CA

"Between Geometry and Gesture: American Sculpture, 1965–75," Palacio de Velasquez, Madrid, Spain

"Surrealismo!" Barbara Braathen Gallery, New York

"Deconstruct," John Gibson Gallery, New York

"Drawings," Sperone Westwater Gallery, New York

"Sonsbeek '86: International Sculpture," Arnhem, The Netherlands

"Chambres d'Amis," Museum van Hedendaagse Kunst, Ghent, Belgium

"American/European Painting and Sculpture, 1986," L.A. Louver Gallery, Venice, CA

"Illuminating Color: Four Approaches in Contemporary Painting and Photographs," Pratt Manhattan Center Gallery, New York and the Pratt Institute Gallery, Brooklyn, NY

"Light: Perception-Projection," Centre International d'Art Contemporain, Montreal, Canada

"The American Artist as Printmaker," The Brooklyn Museum, Brooklyn, NY

"Drawings from the Collection of Herbert and Dorothy Vogel," Department of Art Galleries, the University of Arkansas at Little Rock, AR (traveled to Moody Gallery of Art, the University of Alabama, Tuscaloosa, AL; Museum of Art, the Pennsylvania State University, University Park, PA)

"The Spiritual in Art/Abstract Painting 1890–1985," Los Angeles County Museum of Art, Los Angeles, CA (traveled to Museum of Contemporary Art, Chicago, IL; Haags Gemeentemuseum, The Hague, The Netherlands)

"De Sculptura," Wiener Fest Wochen, U-Halle des Messepalastes, Vienna, Austria

"The Science of Fiction, The Fiction of Science," Herron Gallery, Indianapolis Center for Contemporary Art, Indianapolis, IN

"Leo Castelli at Gagosian," Larry Gagosian Gallery, Los Angeles, CA

"Sculpture," Waddington Galleries, London, England

"Sculpture and Drawings by Sculptors," L.A. Louver Gallery, Venice, CA

1987 "Skulptur-Projekte in Munster, 1987," Westfalisches Landesmuseum für Kunst und Kulturgeschicte in der Stadt Munster, Munster, Germany

"1987 Biennial Exhibition," Whitney Museum of American Art, New York

"The Avant-Garde in the Eighties," Los Angeles County Museum of Art, Los Angeles, CA

"L'Epoque-La Mode-La Morale-La Passion," Centre Georges Pompidou, Paris, France

"Leo Castelli and His Artists: Thirty Years of Promoting Contemporary Art," Centro Cultural/Arte Contemporaneo, Mexico City, Mexico

"Merce Cunningham and His Collaborators," Lehmans Center, Lehman College, New York

"Nauman, Serra, Sonnier," Stadtisches Museum Abteiberg, Monchengladbach, Germany

"Multiples," Galerie Daniel Buchholz, Cologne, Germany

"Photography and Art: Interactions Since 1946," Los Angeles County Museum of Art, Los Angeles, CA (traveled to Museum of Art, Fort Lauderdale, FL; Queens Museum, Flushing, NY; Des Moines Art Center, Des Moines, IA)

"1987 Phoenix Biennial: Regionalism, Nationalism, Internationalism," Phoenix Museum of Art, Phoenix, AZ

"Computer and Art," Everson Museum of Art, Syracuse, NY

"Corps Etrangers," Yvon Lambert Gallery, Paris, France

"Fifty Years of Collecting: An Anniversary Selection; Sculpture of a Modern Era," The Solomon R. Guggenheim Museum, New York

"The Great Drawing Show 1587–1987," Michael Kohn Gallery, Los Angeles, CA

"Aspects of Conceptualism in American Work: Part II—Modern and Contemporary Conceptualism," Avenue B Gallery, New York

"Schizophrenia," Joseph Baer Gallery, New York

"Works on Paper," Galerie Bernd Kluser, Munich, Germany

"Bruce Nauman, Richard Nonas, David Smith," Harm Bouckaert Gallery, New York

"Homage to Leo Castelli: Dedicated to the Memory of Toiny Castelli," Galerie Daniel Templon, Paris, France

"Sculpture," Galerie Lelong, New York

"Early Concepts of the Last Decade," Holly Solomon Gallery, New York

"Great Prints," Carl Solway Gallery, Cincinnati, OH

"Curator's Choice," Long Beach Museum of Art, Long Beach, CA

"Light," Centro Cultural Arte contemporaneo, Mexico City, Mexico

"About Sculpture," Anthony d'Offay Gallery, London, England

Galerie Daniel Templeton, Paris, France

"Artschwager, Nauman, Stella," Leo Castelli Gallery, New York

"Sculpture of the Sixties," Margo Leavin Gallery, Los Angeles, CA

"Works on Paper," Anthony d'Offay Gallery, London, England

"An Exhibition to Benefit the Armitage Ballet," Mary Boone Gallery, New York

Burnett Miller Gallery, Los Angeles, CA

"L.A. Prints: Prints from Southern California," Brody's Gallery, Washington, D.C.

"Big Drawings," Center for Contemporary Art of Santa Fe, Santa Fe, NM

"Collection Agnes Frits Becht," Centre Regionale d'Art Contemporain, Midi-Pyrenees, France

"Pictorial Grammar," Barbara Krakow Gallery, Boston, MA

"Imi Knoebel, Barry Le Va, Bruce Nauman," Barbara Gladstone Gallery, New York

"Lead," Hirschl & Adler Modern, New York

"Three Decades of Exploration—Homage to Leo Castelli," Museum of Art, Fort Lauderdale, FL

"Leo Castelli at Gagosian," Larry Gagosian, Los Angeles, CA

"The Great Drawing Show 1587–1987," Michael Kohn, Los Angeles, CA

"Light Works: 1965–1986," Rhona Hoffman Gallery, Chicago, IL

1988 "Exhibition for the Benefit of the Foundation for Contemporary Performance Arts," Leo Castelli Gallery, New York

"Permanent Installation," The Stuart Collection, University of California San Diego, San Diego, CA

"Planes of Memory—Three Video Installations," Long Beach Museum of Art, Long Beach, CA

"Artists Series Project," The New York City Ballet, New York

Galerie Elisabeth Kaufman, Zurich, Switzerland

Donald Young Gallery, Chicago, IL

"1988—The World of Art Today," The Milwaukee Art Museum, Milwaukee, WI

"Zeitlos: Kunst von Heute," Hamburger Bahnhof, Berlin, Germany

"Parkett Kunstler—Collaborations," Galerie Susan Wyss, Zurich, Switzerland

"Welcome Back: Painting, Sculpture and Works on Paper by Contemporary Artists from Indiana," Indianapolis Center for Contemporary Art, Herron Gallery, Indianapolis, IN

"Committed to Print," Museum of Modern Art, New York

"Images Du Futur 1988," Vieux-Port de Montreal, Quebec, Canada

"Objects," Lorence Monk Gallery, New York

"Hommage a Toiny Castelli: Prints," Galerie des Ponchettes, Nice, France

"Language in Art Since 1960," Whitney Museum of American Art, Federal Reserve Plaza, New York

"Carl Andre, Jannis Kounellis, Bruce Nauman," Barbara Gladstone Gallery, New York

"SMS," Reinhold-Brown Gallery, New York

"Contemporary Sculptors' Maquettes and Drawings," Hofstra University, Hempstead, NY

"Jasper Johns, Bruce Nauman, David Salle," Leo Castelli Gallery, New York

"Works, Concepts, Processes, Situations, Information," Galerie Hans Mayer, Dusseldorf, Germany

"The Spiritual in Art: Abstract Paintings 1890–1985," L.A. County Museum of Art, Los Angeles, CA (traveled to Museum of Contemporary Art, Chicago, IL; Geemente-museum, The Hague, The Netherlands)

Barbara Gladstone Gallery, New York

"Leo Castelli: A Tribute Exhibition," The Butler Institute of American Art, Youngstown, OH

"Individuals: A Selected History of Contemporary Art, 1945–1986," The Museum of Contemporary Art, The Temporary Contemporary, Los Angeles, CA

"Altered States," Kent Fine Art, New York

"The Sonnabend Collection," Centro de Arte Reina Sofia, Madrid, Spain

"Life Like," Lorence Monk Gallery, New York

"Castelli Graphics 1969–1988," Castelli Graphics, New York

"Sculptors on Paper: New Work," Bassett, Steenbock, & Brittingham Galleries, Madison, WI (traveled to Pittsburgh Center for the Arts, Pittsburgh, PA; Sheldon Memorial Art Gallery, University of Nebraska, Lincoln, NE)

"Nobody's Fools," Stichting de Appel, Amsterdam, The Netherlands

"Avant-Garde in the Eighties," Los Angeles County Museum of Art, Los Angeles, CA

"L.A. Hot & Cool; Pioneers & Futura," Bank of Boston Art Gallery, Boston, MA

"Illuminations: The Art of Light," The Cleveland Museum of Art, Cleveland, OH

"Marcel Duchamp und die Avantgarde seit 1950," Museum Ludwig, Cologne, Germany

"Works on Paper," Texas Gallery, Houston, TX

"Sleep of Reason," Museum Fridericianum, Kassel, Germany

"Sculpture from the 60's and 70's," Sperone Westwater Gallery, New York

1988–89 "Three Decades," Oliver Hoffman Collection, Museum of Contemporary Art, Chicago, IL

"Identity: Representations of the Self," Whitney Museum of American Art, New York

1989 "Bilderstreit: Wilderspruch, Einheit und Fragment in der Kunst Seit

1960," Eine Austellung des Museums Ludwig in den Rheinhallen, Cologne, Germany

"Selected Photographs from the Donnelly Collection," Barbara Gladstone Gallery, New York

"Colleccio d'Art de la Fundacio Caixa de Pensions," Barcelona, Spain

"Video-Skulptur/A Retrospektiv und Aktuell," Kolnischer Kunstverein, Cologne, Germany

Saatchi Collection, London, England

"Repetition," Hirschl & Adler Modern, New York

"Encontros," Fundacao Calouste, Gulbenkian, Lisbon, Portugal

"Hardware," Museum Boymans-van Beuningen, Rotterdam, The Netherlands

"Works on Paper," Leo Castelli Gallery, New York

"Seven Virtues Seven Vices," Stuart Collection, University of California San Diego, La Jolla, CA

"Seeing Is Believing," Christine Burgin Gallery, New York

"Collection Panza: Richard Long, Bruce Nauman," Musee d'Art Moderne, Saint-Etienne, France

"Bruce Nauman, Cindy Sherman and John Boskovich," Laurie Rubin Gallery, New York

"Innovators Entering into the Sculpture," Ace Gallery, Los Angeles, CA

"Multiples," Marc Richards Gallery, Los Angeles, CA

"Major Sculpture," Fred Hoffman Gallery, Santa Monica, CA

"Image World: Art and Media Culture," Whitney Museum of American Art, New York

"1st Triennial de Dibuix," Fundacio Joan Miro, Barcelona, Spain

"Wiener Diwan: Sigmund Freud: Heute," Museum des 20. Jahrhunderts, Vienna, Austria

"Words," Tony Shafrazi Gallery, New York

"A Decade of American Drawing," Daniel Weinberg Gallery, Los Angeles, CA

"Modern Master Works from the Permanent Collection of the Museum of Fine Arts," Santa Fe, NM

"First Impressions," Walker Art Center, Minneapolis, MN

Hallen für Kunst, Schaffhausen, Switzerland

"Robert Gober and Bruce Nauman," Galerij Micheline Szwajcer, Antwerp, Belgium

"Time Span," Fundacio Caixa de Pensions, Barcelona, Spain

1990 "Faces," Marc Richards Gallery, Santa Monica, CA

"John Baldessari, Donald Judd, Bruce Nauman," Brooke Alexander Editions, New York

"Leo Castelli Post Pop Artists," Nadia Bassanese Studio dArte, Trieste, Italy

"The Transparent Thread: Asian Philosophy in Recent American Art," Hofstra Museum, Hofstra University, Hempstead, NY (traveled to Edith C. Blum Art Institute, Annandale-on-Hudson, NY; Salina Art Center, Kansas City, KS; Sarah Campbell Blaffer Gallery, Houston, TX; Crocker Art Museum, Sacramento, CA; Laguna Art Museum, Laguna Beach, CA)

"High and Low: Modern Art and Popular Culture," Museum of Modern Art, New York (traveled to Art Institute of Chicago, Chicago, IL; Museum of Contemporary Art, Los Angeles, CA)

"Multiples," Hirschl & Adler Modern, New York

"Minimalism," Nicola Jacobs Gallery, London, England

"Exposed," Vivian Horan Fine Art, New York

"Works on Paper 1965–1975," Galerie Georges-Philipe Vallois, Paris, France

Massimo Audiello Gallery, New York

"Selected Works from the Avant-Garde," Kent Gallery, New York

"Seven American Artists," Vivian Horan Fine Art, New York

"A Tribute to Nicholas Wilder," Stuart Regen Gallery, Los Angeles, CA

"Chris Burden, Mario Merz, Bruce Nauman," Fred Hoffman Gallery, Santa Monica, CA

"The Sydney Biennial," Sydney, Australia

"American Masters of the 60's: Early and Late Works," Tony Shafrazi Gallery, New York

"Drawings," Lorence Monk Gallery, New York

"Sculpture," Daniel Weinberg Gallery, Santa Monica, CA

"Sculptor's Drawings," L.A. Louver Gallery, Venice, CA

"Art What Thou Eat," Edith C. Blum Art Institute, Milton and Sally Avery Center for the Arts, The Bard Center, Annandale-on-Hudson, NY

"Committed to Print," Newport Harbor Art Museum, Newport Beach, CA

"Work in Progress," Fundacio Caja de Pensiones, Madrid, Spain

"Foire Internationale d'Art Contemporain (FIAC)," Grand Palais, Paris, France

Salon de Mars, Paris, France

Donald Young Gallery, Chicago, IL

"Figuring the Body," Museum of Fine Arts, Boston, MA

"Video," Art Institute of Chicago, Chicago, IL

"Pharmakon '90," Makuhari Nesse Contemporary Art Exhibition, Nippon Convention Center, Tokyo, Japan

"Neon Stucke," Sprengle Museum, Hannover, Germany

"Affinities and Intuitions," Art Institute of Chicago, Chicago, IL

"The 60's Revisited: New Concepts/New Materials," Castelli Graphics, New York

"Fragments, Parts, Wholes, The Body and Culture," White Columns, New York

"The Future of the Object—A Selection of American Art; Minimalism and After," Galerie Ronny van de Velde, Antwerp, Belgium

"Territory of Desire," Louver Gallery, New York

"The New Sculpture 1965–75: Between Geometry and Gesture," Whitney Museum of American Art, New York

"7 Objects/69/90," University Gallery, University of Massachusetts at Amherst, Amherst, MA

"Beyond the Frame," Rubin Spangle Gallery, New York

"Energies," Stedelijk Museum, Amsterdam, The Netherlands

1991 "International Video Week," Saint Gervais Geneve, Geneva, Switzerland

"Suck Cuts," Museum für Modern Kunst, Frankfurt, Germany

"Dislocations," Museum of Modern Art, New York

"Metropolis," Martin Gropius Bau, Berlin, Germany

"Telekinesis," Mincher-Wilcox Gallery, San Francisco, CA

"Twentieth Century Collage," Margo Leavin Gallery, Los Angeles, CA

"Contemporary Sculpture: Masterworks," Blum Helman Gallery, New York

"Gunther Forg, Bruce Nauman," Museum van Hedendaagse Kunst, Ghent, Belgium

"1991 Biennial Exhibition," Whitney Museum of American Art, New York

"Summer Group Exhibition," Leo Castelli Gallery, New York

"Selections from the Elaine and Werner Dannheisser Collection: Painting and Sculpture from the '80's and '90's," The Parrish Museum, Southampton, NY

"Immaterial Objects," Whitney Museum of American Art, New York

"Devil on the Stairs/Looking Back on the Eighties," Institute of Contemporary Art, University of Pennsylvania, Philadelphia, PA

Carnegie International, The Carnegie Museum of Art, Pittsburgh, PA

"Beyond the Frame: American Art 1960–1990," Setagaya Art Museum, Tokyo, Japan (traveled to The National Museum of Art, Osaka, Japan and Fukuoka Art Museum, Fukuoka, Japan)

"The Interrupted Life," The New Museum, New York

1992 "Bourgeois, Jaar, Kounellis, Solano, Tapies, Nauman," Galerie Lelong, New York

"Words," Kukje Gallery, Seoul, South Korea

"The Devil on the Stairs: Looking Back on the Eighties," Newport Harbor Art Museum, Newport Beach, CA

"Nauman, Oppenheim, Serra: Early Works 1968–1971," Blum Helman Warehouse at 80 Greene Street, New York

"Habeus Corpus," Stux Gallery, New York

"15th Anniversary Exhibition," Rhona Hoffman Gallery, Chicago, IL

"Documenta 9," Kassel, Germany

"Transform BildObjektSkulptur im 20. Jahrhundert," Kunsthalle Basel, Basel, Switzerland

"Szenenwechsel," Museum für Moderne Kunst, Frankfurt, Germany

"Re: Framing Cartoons," Wexner Center for the Arts, Ohio State University, Columbus, OH

"Cross Section," Battery Park City and the World Financial Center, New York

"Both Art and Life: Gemini at 25," Newport Harbor Art Museum, Newport Beach, CA

"Center of Gravity," Kaiser Wilhelm Museum, Krefeld, Germany

"Nauman, Serra, Sonnier," Leo Castelli Gallery, New York

"Eadweard Muybridge and Contemporary American Photography:

Motion and Document—Sequence and Time," National Museum of American Art, Smithsonian Institution, Washington, DC (traveled to Addison Gallery of American Art, Andover, MA; Long Beach Museum of Art, Long Beach, CA; Henry Art Gallery, Seattle, WA; Wadsworth Atheneum, Hartford, CT; International Museum of Photography, Rochester, NY)

"Allegories of Modernism," Museum of Modern Art, New York

"Arte Americana 1930–1970," Lingotto, Turin, Italy

1993 "Grace and Gravity: The Changing Condition of Sculpture 1965–1975," Hayward Gallery, London, England

"Works on Paper," Galerie Ghislaine Hussenot, Paris, France

"European and American Drawings 1961–1969," Nolan Eckman Gallery, New York

"Out of Sight Out of Mind," Lisson Gallery, London, England

"Twentieth Anniversary Exhibition," Daniel Weinberg Gallery, Santa Monica Gallery, Santa Monica, CA

"Spirit of Drawing," Sperone Westwater Gallery, New York

"Sculpture," Leo Castelli Gallery, New York

"American Art in the 20th Century—Painting and Sculpture 1913–1993," Martin Gropius Bau, Berlin, Germany (traveled to Royal Academy of Art, London, England)

"Suite Substitution," Hotel du Rhone, Geneva, Switzerland

"New York on Paper," Galerie Beyeler, Basel, Switzerland

"Disorderly Conduct," PPOW Gallery, New York

"La Biennale d'art Contemporain," Lyons, France

"Pour La Vie: Gilbert and George, Jeff Koons, Bruce Nauman," capcMusee d'art Contemporain, Bordeaux, France

"Graphics," Galerija Dante, Umag, Croatia

"Action/Performance and the Photograph," Turner/Krull Gallery, Los Angeles, CA

"Group Drawing Exhibition," Akira Ikeda Gallery, Nagoya, Japan

"Don't Ask, Don't Tell, Don't Pursue—Sexual Identity in Printmaking," Lucaks Gallery, Fairfield University, Fairfield, CT

"Sculptures 1832–1992," Marc Blondeau Gallery, Paris, France

Video Group Show, Barbara Gladstone Gallery, New York

"Sculpture," Laura Carpenter Fine Art, Santa Fe, NM

1994 "Some Kind of Fact, Some Kind of Fiction," Sperone Westwater Gallery, New York

"Animal Farm," James Corcoran Gallery, Santa Monica, CA

"1969," Jablonka Gallery, Cologne, Germany

"Arte Contemporanea della Collezione della Federazione Cooperative Migos," Museo Cantonale d'Arte, Lugano, Switzerland

"Drawings 1894–1994," Galerie Marc Blondeau, Paris, France

"Multiplas Dimensoes," Centro Cultural de Belem, Lisbon, Portugal

"Summer Exhibition," Donald Young Gallery, Seattle, WA

"Summer '94," Leo Castelli Gallery, New York

"Bruce Nauman and H.G. Westerman," Laurence Markey Gallery, New York

"Drawing on Sculpture," Cohen Gallery, New York

"Visceral Responses," Holly Solomon Gallery, New York

"Drawn in the 1970's," Brooke Alexander Gallery, New York

"Nauman, Palermo, Schwarzkogler: Spaces," The Arts Club of Chicago, Chicago, IL

"Starlight—James Turrell, Maurizio Nannucci, Bruce Nauman," Aarhus Kunstmuseum, Arhus, Denmark

"Uma Selecao por Leo Castelli dos Seus Artistas," Renato Magalhars Gouvea, São Paulo, Brazil

"Self/Made Self/Conscious—Janine Antoni & Bruce Nauman," Museum of Fine Arts, Boston, MA

"The Essential Gesture," The Newport Harbor Art Museum, Newport Beach, CA

1995 "Facts and Figures—Selections from the Lannan Foundation Collection," Lannan Foundation, Los Angeles, CA

"Hors Limites, l'Art et la Vie, 1952–1994," Centre Georges Pompidou, Paris, France

"Light into Art: From Video to Virtual Reality," Contemporary Arts Center, Cincinnati, OH

"From Acconci to Ryrnan: American Drawings from the 1970's & 1980's," Kunsthaus, Zurich, Switzerland

"Sculpture," Anthony d'Offay Gallery, London, England

"Figur Natur," Sprengel Museum, Hannover, Germany

Nathalie Karg, Ltd., New York

"Outside the Frame: Performance and the Object," Newhouse Cen-

ter for Contemporary Art/Snug Harbor Cultural Center, Staten Island, NY

"Attitudes/Sculptures, Works from 1963–1972," capcMusee d'art Contemporain de Bordeaux, France

"MEDIA-TED IMAGES," Pamela Auchincloss Gallery

"Five Rooms," Anthony d'Offay Gallery, London, England

Venice Biennale, Venice, Italy

"Site Santa Fe, Longing and Belonging: From the Faraway Nearby," Museum of Fine Arts, Santa Fe, NM

"Prints," 234 Gallery at Hannah, Wellfleet, MA

"Temporarily Possessed, the Semi-Permanent Collection," The New Museum of Contemporary Art, New York

"1965–1975: Reconsidering the Object of Art," MOCA at the Temporary Contemporary, Los Angeles, CA

"Line Etchings, An Exhibition of Prints," Alan Cristea Gallery, London, England

"Soyons Serieux. . . . Points de vue sur l'art des annees 80–90," Musee d'art Moderne, Villeneuve d'Ascq, France

"Made in L.A.: The Prints of Cirrus Editions," Los Angeles County Museum of Art, Los Angeles, CA

"Of The Human Form," Waddington Galleries, London, England

"Prints to Benefit the Foundation for Contemporary Performance Arts," Brooke Alexander, New York

"La Biennale d'art Contemporain," Musee d'art Contemporain, Lyons, France

"Night and Day," Anthony Reynolds Gallery, London, England

"Everything That's Interesting Is New," The Dakis Joannou Collection, Athens School of Fine Art, Athens, Greece

1996 "The Human Body in Contemporary American Sculpture," Gagosian Gallery, New York

"Gallery Artists," Leo Castelli Gallery, New York

"Collage," Leo Castelli Gallery, New York

"Narcissism: Artists Reflect Themselves," California Center for the Arts Museum, Escondido, CA

"Autoreverse," Centre National d'Art Contemporain de Grenoble, Grenoble, France

"NowHere," Louisiana Museum of Modern Art, Humlebaek, Denmark

"fremdKörper—corps étranger—Foreign Body," Museum für Gegenwartskunst, Basel, Switzerland

1996–97 "Being & Time: The Emergence of Video Projection," organized by the Albright-Knox Art Gallery, Buffalo, NY (traveled to Cranbrook Art Museum, Bloomfield Hills, MI; Portland Art Museum, Portland, OR; Contemporary Arts Museum, Houston, TX; Site Santa Fe, Santa Fe, NM)

1997 "Angel, Angel," Kunsthalle, Vienna, Austria

"Views from Abroad: European Perspectives on American Art 2," Whitney Museum of American Art, New York

"a/drift," Center for Curatorial Studies Museum, Bard College, Annandale-on-Hudson, NY

"Contemporary New Mexico Artists: Sketches & Schemas," SITE Santa Fe, Santa Fe, NM

"Views from Abroad: European Perspectives on American Art," Whitney Museum of American Art, New York, and Museum für Moderne Kunst, Frankfurt, Germany

"The Artists of the Castelli Gallery 1957–1997: Forty Years of Exploration and Innovation," Leo Castelli Gallery, New York

1998 "Surrogate: The Figure in Contemporary Sculpture and Photography," Henry Art Gallery, Seattle, WA

2000 "Crossroads of American Sculpture," Indianapolis Museum of Art, Indianapolis, IN (traveled to New Orleans Museum of Art)

Videography

Note: The number in parentheses following the title of the video work refers to the entry number in *Bruce Nauman,* catalogue raisonné (Minneapolis: Walker Art Center, 1994), essays by Neal Benezra, Kathy Halbreich, Paul Schimmel, and Robert Storr.

Abstracting the Shoe, 1966 (made with William Allan) (#30)
16 mm film, color, silent
2 min., 41 sec.

Building a New Slant Step, 1966 (made with William Allan) (#32)
16 mm film, black and white, silent
approx. 8 min. (unfinished)

Fishing for Asian Carp, 1966 (made with William Allan and Robert Nelson) (#41)
16 mm film, color, sound
2 min., 44 sec.

Legal Size, 1966 (made with William Allan) (#43)
16 mm film, color, silent
3 min., 47 sec.

Manipulating the T-Bar, 1965-66 (#44)
16 mm film, black and white, silent
400 feet, approx. 10 min.

Opening and Closing, 1965–66 (#47)
16 mm film, black and white, silent
400 feet, approx. 10 min.

Revolving Landscape, 1965–66 (#51)
16 mm film, black and white, silent
400 feet, approx. 10 min.

Span, 1966 (made with William Allan) (#56)
16 mm film, color, silent
10 min., 37 sec.

Thighing, 1967 (#91)
16 mm film, color, sound
400 feet, approx. 10 min.

Art Make-Up, No. 1: White, 1967 (#98)
Art Make-Up, No. 2: Pink, 1967–68
Art Make-Up, No. 3: Green, 1967–68
Art Make-Up, No. 4: Black, 1967–68
four 16 mm films, color, silent
400 feet, approx. 10 min. each

Bouncing in the Corner, No. 1, 1968 (#99)
videotape, black and white, sound
60 min., to be repeated continuously

Bouncing Two Balls between the Floor and Ceiling with Changing Rhythms,
1967–68 (#100)
16 mm film, black and white, sound
400 feet, approx. 10 min.

Dance or Exercise on the Perimeter of a Square, 1967–68 (#106)
16 mm film, black and white, sound
400 feet, approx. 10 min.

Flesh to White to Black to Flesh, 1968 (#110)
videotape, black and white, sound
60 min., to be repeated continuously

Pinch Neck, 1968 (#119)
16 mm film, color
approx. 75 feet, 2 min.

Playing a Note on the Violin While I Walk around the Studio, 1967–68 (#120)
16 mm film, black and white, sound
400 feet, approx. 10 min.

Slow Angle Walk (Beckett Walk), 1968 (#123)
videotape, black and white, sound
60 min., to be repeated continuously

Stamping in the Studio, 1968 (#124)
videotape, black and white, sound
60 min., to be repeated continuously

Walk with Contrapposto, 1968 (#136)
videotape, black and white, sound
60 min., to be repeated continuously

Walking in an Exaggerated Manner Around the Perimeter of a Square, 1967–68
(#137)
16 mm film, black and white, silent
400 feet, approx. 10 min.

Wall-Floor Positions, 1968 (#138)
videotape, black and white, sound
60 min., to be repeated continuously

Black Balls, 1969 (#142)
16 mm film, black and white, silent
8 min.

Bouncing Balls, 1969 (#143)
16 mm film, black and white, silent
9 min.

Bouncing in the Corner, No. 2: Upside Down, 1969 (#145)
videotape, black and white, sound
60 min., to be repeated continuously

Gauze, 1969 (#146)
16 mm film, black and white, silent
8 minutes

Lip Sync, 1969 (#148)
videotape, black and white, sound
60 min., to be repeated continuously

Manipulating a Fluorescent Tube, 1969 (#149)
videotape, black and white, sound
60 min., to be repeated continuously

Pacing Upside Down, 1969 (#150)
videotape, black and white, sound
60 min., to be repeated continuously

Pulling Mouth, 1969 (#152)
16 mm film, black and white, silent
8 min.

Revolving Upside Down, 1969 (#154)
videotape, black and white, sound
60 min., to be repeated continuously

Video Corridor for San Francisco (Come Piece), 1969 (#168)
two video cameras, two video monitors
dimensions variable

Violin Tuned D E A D, 1969 (#169)
videotape, black and white, sound
60 min., to be repeated continuously

Audio Video Piece for London, Ontario, 1969–70 (#171)
video camera, oscillating mount, video monitor, audiotape player, audiotape
dimensions variable

Corridor Installation (Nick Wilder Installation), 1970 (#172)
wallboard, three video cameras, scanner and mount, five video monitors, videotape player, videotape (black and white, silent)
dimensions variable

Four Corner Piece, 1970 (#176)
wallboard, four video cameras, four video monitors
dimensions variable

Going Around the Corner Piece, 1970 (#178)
wallboard, four video cameras, four video monitors; walls: 120 x 240 inches

Going Around the Corner Piece with Live and Taped Monitors, 1970 (#179)
wallboard, video camera, two video monitors, videotape player, videotape; wall: 96 × 300 inches

Live Taped Video Corridor, 1970 (#183)
wallboard, video camera, two video monitors, videotape player, videotape
dimensions vary

Rotating Glass Walls, 1970 (#187)
16 mm film, black and white, silent (transferred to four Super-8 mm film loops)
projected continuously

Spinning Spheres, 1970 (#188)
16 mm film, color, silent (transferred to four Super-8 mm film loops)
projected continuously

Untitled, 1970 (#193)
performance, videotape, two video monitors

Video Surveillance Piece (Public Room, Private Room), 1969–70 (#194)
two video cameras, oscillating mounts, two video monitors
dimensions variable

After-Image Piece, 1971 (#D-24)
two projectors, color filters
dimensions variable
destroyed by the artist

Film, circa 1972 (#212)
proposal for film

Indoor/Outdoor, 1972 (#216)
video camera, video monitor, microphone, amplifier
dimensions variable

Elke Allowing the Floor to Rise Up over Her, Face Up, 1973 (#225)
videotape, color, sound
40 min., to be repeated continuously

Tony Sinking into the Floor, Face Up and Face Down, 1973 (#228)
videotape, color, sound
60 min., to be repeated continuously

Audio-Video Underground Chamber, 1972–74 (#230)
concrete chamber, video camera, microphone, rubber gasket, steel plate, bolts,
cord, black-and-white video monitor
chamber: $27^1/2 \times 35^1/2 \times 86^1/2$ inches; buried $98^1/2$ inches deep

Pursuit, 1975 (made with Frank Owen) (#245)
16 mm film, color, sound
28 min.

Dream Passage (Version I), 1983 (#301)
plywood or wallboard, paint, eight 8-foot fluorescent lights (four yellow, two red,
two green), two color video cameras, two color video monitors, two steel tables,
two steel chairs; corridor: 96 × 192 × 36 inches; room: 96 × 96 × 96 inches

Chambres d'Amis (Krefeld Piece), 1985 (#332)
installation of videotapes *(Good Boy Bad Boy),* audiotape *(One Hundred Live
and Die),* neon *(Hanged Man)*
dimensions variable

Good Boy Bad Boy, 1985 (#337)
two color video monitors, two videotape players, two videotapes (color, sound)
dimensions variable

Violent Incident, 1986 (#360)
twelve color video monitors, four videotape players, four videotapes (color,
sound)
approx. $102^1/8 \times 105 \times 18^1/2$ inches

Violent Incident: Man-Woman Segment, 1986 (#361)
videotape (color, sound)
30 min.

Clown Torture, 1987 (#365)
four color video monitors, four speakers, four videotape players, two video
projectors, four videotapes (color, sound)
dimensions variable

Clown Torture: Dark and Stormy Night with Laughter, 1987 (#366)
two color video monitors, two videotape players, two videotapes (color, sound)
dimensions variable

Clown Torture: I'm Sorry and No, No, No, No, 1987 (#367)
two color video monitors, two videotape players, two videotapes (color, sound)
dimensions variable

Dirty Joke, 1987 (#369)
two color video monitors, two videotape players, two videotapes (color, sound)
dimensions variable

No, No, New Museum, 1987 (#371)
color video monitor, videotape player, videotape (color, sound)
dimensions variable

Double No, 1988 (#381)
two color video monitors, two videotape players, two videotapes (color, sound)
dimensions variable

Green Horses, 1988 (#382)
two color video monitors, two videotape players, one video projector, two
videotapes (color, sound), one chair
dimensions variable

Hanging Carousel (George Skins a Fox), 1988 (#383)
steel, polyurethane foam, video monitor, videotape (color, sound)
204 inches, suspended $74^{1}/_{2}$ inches above the floor

Learned Helplessness in Rats (Rock and Roll Drummer), 1988 (#384)
Plexiglas maze, video camera, scanner and mount, switcher, two videotape
players, 13-inch color video monitor, 9-inch black-and-white video monitor,
video projector, two videotapes (color, sound)
dimensions variable; maze: 22 × 126 × 130 inches

Rats and Bats (Learned Helplessness in Rats II), 1988 (#386)
Plexiglas maze, video camera, six video monitors, video projector, three video-
tapes (color sound)
dimensions variable

Set design for *Rollback,* 1988 (#388)
screens, two film projectors, two films (transferred from video, color, sound)
dimensions variable

Perfect Balance (Pink Andrew with Plug Hanging with TV), 1989
wax head, color video monitor, videotape player, videotape
height: approx. 75 inches; head: $11^{7}/_{16}$ × $9^{7}/_{8}$ × $6^{11}/_{16}$ inches

Raw Material—"BRRR," 1990 (#454)
video projector, two color video monitors, two videotape players, two video-
tapes (color, sound)
dimensions variable

Raw Material—"MMMM," 1990 (#455)
video projector, two color video monitors, two videodisc players, two video-
discs (color, sound)
dimensions variable

Raw Material—"OK, OK, OK," 1990 (#456)
video projector, two color video monitors, two videotape players, two video-
tapes (color, sound)
dimensions variable

Shadow Puppets and Instructed Mime, 1990 (#459)
three wax heads, linen, wood, four color video monitors, four video projectors,
six videotape players, six videotapes (color, sound)
dimensions variable

Shit in Your Hat—Head on a Chair, 1990 (#460)
chair, wax head, rear-screen projector and screen, videotape (color, sound)
dimensions variable

Shadow Puppet Spinning Head, 1990 (#461)
wax head, white sheet, video projector, video monitor, videotape player,
videotape (color, sound)
dimensions variable

Anthro/Socio (Rinde Facing Camera), 1991 (#466)
six videodisc players, six color monitors, three video projectors, six videodiscs
(color, sound)
dimensions variable

Raw Material with Continuous Shift—BRRR, 1991 (#471)
video projector, two color video monitors, two videodisc players, two video-
discs (color, sound)
dimensions variable

Raw Material with Continuous Shift—MMMM, 1991 (#472)
video projector, two color video monitors, two videodisc players, two video-
discs (color, sound)
dimensions variable

Raw Material with Continuous Shift—OK, OK, OK, 1990 (#473)
video projector, two color video monitors, two videodisc players, two video-
discs (color, sound)
dimensions variable

Anthro/Socio (Rinde Spinning), 1992 (#476)
three video projectors, six color video monitors, six videodisc players, six
videodiscs (color, sound)
dimensions variable

Coffee Spilled and Balloon Dog, 1993 (#480)
two color video monitors, two videodisc players, two videodiscs (color, sound)
dimensions variable

Falls, Pratfalls and Sleights of Hand, 1993
five video projectors, five videodisc players, five videodiscs
continuous play

Falls, Pratfalls and Sleights of Hand (Dirty Version), 1993
five video projectors, five videodisc players, five videodiscs
continuous play

Work, 1993
two stacked monitors, two videodisc players, two videodiscs (color, sound)
continuous play

Think, 1993
two stacked monitors, two videodisc players, two videodiscs (color, sound)
continuous play

Jump, 1994
two stacked monitors, two videodisc players, two videodiscs (color, sound)
continuous play

Poke in the Eye/Nose/Ear 3/8/94 Edit, 1994
video projector, one videodisc player, one videodisc (color, sound)

Bar Tricks, 1995
three monitors displayed in three different rooms, one videodisc player, one
videodisc

World Peace—Day 2 (Brooke's Lips), 1995
two stacked monitors, two videodisc players, two videodiscs

World Peace (Received), 1996
five video monitors arranged in half circle, five videodisc players, five video-
discs, stool

World Peace (Projected), 1996
five video projectors, five videodisc players, five videodiscs, auxiliary speakers

End of the World (with Lloyd Maines), 1996
three video projectors, three videodisc players, three videodiscs
58 min., continuous play

Washing Hands (Normal), 1996
two video monitors, two videodisc players, two videodiscs

Washing Hands (Abnormal), 1996
two video monitors, two videodisc players, two videodiscs

Select Bibliography

Antin, David. "Another Category; Eccentric Abstraction." *Artforum* 5, no. 3 (November 1966): 56–57.

Burton, Scott. "Time on Their Hands." *Art News* 68, no. 4 (Summer 1969): 40–43.

Butterfield, Jan. "Bruce Nauman, the Center of Yourself" (interview). *Arts Magazine*, February 1975, 53–55.

Cathcart, Linda L. *The Consummate Mask of Rock* (catalogue). Buffalo, N.Y.: Albright-Knox Art Gallery, 1975.

Celant, Germano. "Bruce Nauman." *Casabella* 345, no. 34 (February 1970): 38–41.

Danieli, Fidel A. "The Art of Bruce Nauman." *Artforum* 6, no. 4 (December 1967): 15–19.

Heynen, Julian. *Bruce Nauman*. Krefeld: Krefelder Kunstmuseum, Museum Haus Esters, 1983.

Jenkins, Nicholas. "Bruce Nauman: Museum of Modern Art." *Art News* 94, no. 5 (May 1995): 145.

Koepplin, Dieter. "Begrundete Zeichnungen." In *Bruce Nauman: Drawings/Zeichnungen*. Basel: Museum für Gegenwartskunst, 1986.

Kozloff, Max. "9 in a Warehouse." *Artforum* 7, no. 6 (February 1969): 38–40.

L'Academia Foundation. *Quarteto*, with essays by Achille Bonito Oliva, Alanna Heiss, and Kaspar Konig. Venice, 1984.

Lippard, Lucy. "Eccentric Abstraction" (reprinted brochure). *Art International* 10, no. 9 (November 1966): 28, 34–40.

Livingston, Jane, and Marcia Tucker. *Bruce Nauman: Work from 1965 to 1972* (catalogue). Los Angeles: Los Angeles County Museum of Art, 1972.

Lusk, Jennie. *Bruce Nauman: 1/12 Scale Models for Underground Pieces*. Albuquerque: Albuquerque Museum, 1981.

Meyer, Franz. "Mass Nehmen an Bruce Nauman." *In Bruce Nauman: Drawings/Zeichnungen 1965–86*. Basel: Museum für Gegenwartskunst, 1985.

Monte, James, and Marcia Tucker. Essays in *Anti-Illusion: Materials/Procedures* (catalogue). New York: Whitney Museum of American Art, 1969.

Nauman, Bruce. "Body Works" (photoessay). *Interfunktionen,* September 6, 1971, 2–8.

———. "Notes and Projects." *Artforum* 9, no. 4 (December 1970): 44.

Pincus-Witten, Robert. "Bruce Nauman: Another Kind of Reasoning." *Artforum* 10, no. 6 (February 1972): 30–37.

Plagens, Peter. "Cousin Brucie." *Artforum* 33, no. 8 (April 1995): 63.

———. "Roughly Ordered Thoughts on the Occasion of the Bruce Nauman Retrospective in Los Angeles." *Artforum* 11, no. 7 (March 1973): 57–79.

Raffaele, Joe, and Elizabeth Baker. "The Way Out West: Interviews with 4 San Francisco Artists." *Art News* 66, no. 4 (Summer 1967): 39–40, 75–76.

Relyea, Lane. "Cast Against Type." Artforum 33, no. 8 (April 1995): 63–69, 106.

Richardson, Brenda. *Bruce Nauman: Neons.* Baltimore: Baltimore Museum of Art, 1983.

Rose, Bernice. *New York on Paper 3.* New York: Museum of Modern Art, 1985.

Sauer, Christel. "Dokumentation 1" (text). Zurich: InK, 1978.

Schjeldahl, Peter. "Bruce Nauman." In *Art of Our Time.* Vol. 1. London: The Saatchi Collection, 1984.

———. "Profoundly Practical Jokes: The Art of Bruce Nauman." *Vanity Fair* 46, no. 3 (May 1983): 88–93.

Schmidt, Katherina, Ellen Joosten, and Seigman Holsten. Essays in *Bruce Nauman, 1972–1981* (catalogue). Baden-Baden: Rijksmuseum Kroller-Muller, Otterlo, and Staatliche Kunsthalle, 1981.

Sharp, Willoughby. "Bruce Nauman." *Avalanche,* no. 2 (Winter 1971): 23–35.

———. "Nauman Interview." *Art Magazine* 44, no. 5 (March 1970): 22–27.

Smith, Bob. "Interview with Bruce Nauman." Journal published by the Los Angeles Institute of Contemporary Arts, no. 32 (Spring 1982): 35–36.

Smith, Roberta. "Comfortable? Easy? Not for Bruce Nauman." *New York Times* (weekend), March 3, 1995.

Solomon, Andrew. "Complex Cowboy: Bruce Nauman." *New York Times Magazine,* March 5, 1995.

Tucker, Marcia. "PheNAUMANology." *Artforum* 9, no. 4 (December 1970): 38–44.

Van Bruggen, Coosje. *Bruce Nauman.* New York: Rizzoli International Publishers, 1988.

———. "Bruce Nauman: Entrance, Entrapment, Exit." *Artforum* (Summer 1985): 88–98.

———. "The True Artist is an Amazing Luminous Fountain." In *Bruce Nauman: Drawings/Zeichnungen.* Basel: Museum für Gegenwartskunst, 1986.

Whitechapel Gallery. Catalogue with essays by Joan Simon and Jean-Christophe Ammann. London, 1985.

Whitney, David. *Bruce Nauman* (catalogue). New York: Leo Castelli Gallery, 1968.

Contributor Notes

BROOKS ADAMS is senior editor of *Art in America* and has coordinated a number of important editorial projects for several international exhibitions. He is co-author of *Sensation: Young British Artists from the Saatchi Collection* (Thames & Hudson, 1998).

KENNETH BAKER has been art critic for the *San Francisco Chronicle* since 1985. The author of *Minimalism: Art of Circumstance* (Abbeville, 1989), Baker has taught and lectured at various universities, including Brown, Stanford, Ohio State, and the Claremont Graduate University. A regular contributor to *The Art Newspaper, Smithsonian,* and other periodicals, he is currently completing a monograph on Walter De Maria's *Lightning Field.*

NEAL BENEZRA is deputy director and the Frances and Thomas Dittmer Curator of Modern and Contemporary Art at the Art Institute of Chicago. Previously he served as assistant director for art and public programs at the Hirshhorn Museum and Sculpture Garden, and prior to that he also served as a curator at the Art Institute of Chicago and the Des Moines Art Center. He received undergraduate and graduate degrees from the University of California, Berkeley and Davis, and from Stanford University. He has organized exhibitions of the work of Robert Arneson, Stephan Balkenhol, Ed Paschke, and Martin Puryear, and he co-organized the Bruce Nauman retrospective in 1993. He has also co-organized "Distemper: Dissonant Themes in the Art of the 1990's" and "Regarding Beauty: A View of the Late Twentieth Century." He is currently preparing exhibitions of the work of William Kentridge, Juan Muñoz, and Edward Ruscha.

CHRISTOPHER CORDES edited the catalogue raisonné *Bruce Nauman: Prints 1970–89* (New York, 1989). The catalogue was published in conjunction with an exhibition at Castelli Graphics and the Lorence Monk Gallery in New York and the Donald Young Gallery in Chicago, 1989.

REGINA CORNWELL has been a specialist in video and interactive media since the early days. She is the author of *Snow Seen: The Films and Photographs of Michael Snow.*

ARTHUR C. DANTO is Emeritus Johnsonian Professor of Philosophy at Columbia University, New York. He is the author of numerous books, including *Nietzsche as Philosopher, Mysticism and Morality, The Transfiguration of the Commonplace, Narration and Knowledge, Connections to the World: The Basic Concepts of Philosophy,* and *Encounters and Reflections: Art in the Historical Present,* a collection of art criticism that won the National Book Critics Circle Prize for Criticism, 1990. His most recent book is *Embodied Meanings: Critical Essays and Aesthetic Meditations.* Art critic for *The Nation,* he has also published numerous articles in other journals. In addition, he is an editor of the *Journal of Philosophy* and consulting editor for various other publications.

NANCY GOLDRING is an artist living and working in New York City who sometimes writes about art and architecture. Her "drawings with fotoprojections"—a unique synthesis of graphic, photographic, and projected media— have been exhibited for twenty-five years nationally and internationally. A book about her work was published by the Southwest Museum of Photography in conjunction with a major retrospective in the spring of 2000.

JONATHAN GOODMAN is instructor in fine arts at Pratt Institute, New York. He has been working for *Art News, Scientific American, Global Medical Communications,* and *Jewish Book Club.* He has been writing on contemporary art in *Art on Paper, Art in America, Art News, Drawing, Art Asia Pacific, World Art, Parachute, Sculpture, Contemporary Visual Art,* and *Space.* He edited monographs on Kurt Schwitters and Samuel Johnson and published *Metropolitan Rooms,* a book of poems.

KATHRYN HIXSON is an artist and editor of *New Art Examiner,* a nonprofit monthly visual art magazine based in Chicago. She teaches courses in contemporary art and conceptual art at the School of the Art Institute in Chicago. She has written about contemporary art for over fifteen years, including for magazines such as *Arts Magazine* in New York, *Flash Art* in Milan, and *Atelier* in Tokyo. She has curated several exhibitions and written numerous catalogues for galleries and museums.

JOAN HUGO is an art writer who lives in Los Angeles and is currently an administrator at CalArts. She has been an art librarian and independent curator, and was Southern California Editor for *Artweek* for ten years.

RONALD JONES, an artist and writer, is represented by Metro Pictures and the Sonnabend Gallery. He is a frequent contributor to *Artforum* and *frieze.* He has recently completed designing a garden complex for the city of Hamburg, Germany.

MICHAEL KIMMELMAN is chief art critic for the *New York Times*. He worked as music critic for the *Philadelphia Inquirer* and culture editor of *US News and World Report*, Washington. He is the author of *Portraits: Talking with Artists at the Met, the Modern, the Louvre and Elsewhere* (New York and Toronto: Random House, 1998).

JEAN-CHARLES MASSÉRA is a writer and art critic who lives and works in Paris. His fiction works include *Gangue son* (Méréal, 1994); *La vie qui va avec* (a fiction radio documentary with Vincent Labaume) (France Inter, été 1997); and *France guide de l'utilisateur* (P.O.L., 1998). The theater work *United Problems of Flexibilité* (Brigitte Mounier, 2001). "Dance with the Law" is a reworked excerpt of *Amour, gloire et CAC 40. Esthétique, sexe, enterprise, croissance, mondialisation et médias* (Paris: P.O.L., 1999) published by Lukas & Steinberg Inc. in New York.

PAUL MATTICK is the author of *Social Knowledge* and editor of *Eighteenth-Century Aesthetics and the Reconstruction of Art*. He has written criticism for *Art in America* and other publications.

ROBERT C. MORGAN received his M.F.A. in 1975 from the University of Massachusetts and his Ph.D. from New York University in 1978. He has written and published numerous articles and reviews in a vast range of magazines and professional journals worldwide. He is a contributing editor for *Sculpture Magazine* and *Tema Celeste* (Milan) and adjunct professor of fine arts at Pratt Institute in Brooklyn, New York. Recent books include *Between Modernism and Conceptual Art* (1997) and *The End of the Art World* (1998). A collection of Morgan's lectures, *Duchamp y los artistas contemporaneos postmodernos*, was published by Eubeda (Buenos Aires). He is the editor of a previous volume in the Art + Performance series on Gary Hill (2000). In 1999, he was given the first Arcala award in art criticism (Salamanca) and was selected as a juror for the UNESCO prize during the Venice Biennale. He lives and works in New York.

TONY OURSLER is a video artist who has exhibited extensively in America and abroad. His exhibitions have appeared in MoMA, New York; The Institute of Contemporary Art of Boston; The Whitney Museum of American Art, New York; the Museum of Modern Art of Oxford; the Lisson Gallery, London; and Metro Pictures, New York, among many other venues. He is professor at the Massachusetts College of Art, the author of *Vampire* (Communications Video, 1988), and contributor to the volume *Illuminating Video: An Essential Guide to Video Art* (1990).

DAVID PAGEL is a Los Angeles-based art critic and instructor at Claremont Graduate University. He is a regular contributor to the *Los Angeles Times*, a contributing editor to *Bomb*, and Reviews Editor of *Art Issues*.

PETER PLAGENS is a critic and painter who has been exhibited at the Whitney Museum of American Art, New York; MoMA, New York; Hirshhorn Museum and Sculpture Garden, Washington; and the Nancy Hoffman Gallery, New York, among many other venues. He worked as a curator for the Long Beach Museum of Art, and as a contributing editor for *Artforum*. He is currently the art critic for *Newsweek*.

PAUL RICHARD is art critic for the *Washington Post*.

JERRY SALTZ is art critic for *The Village Voice*, New York, and teacher at the School of Visual Arts in New York.

INGRID SCHAFFNER is an independent curator and writer based in New York. She is the author of *Deep Storage: Collecting, Storing and Archiving in Art* (Prestel, 1998) and *Julien Levy: Portrait of an Art Gallery* (MIT, 1998).

PETER SCHJELDAHL was born in Fargo, North Dakota, in 1942 and has been an art critic in New York since 1965. At present, he is the art critic for the *New Yorker* and teaches part-time at Harvard University.

WILLOUGHBY SHARP, owner/publisher of *Avalanche* magazine from 1970 to 1976, also served as a curator for the "Conceptual Art" show at the Museum of Modern Art in 1971. He was curator of the video section of the "Joseph Beuys" retrospective at the Guggenheim Museum in 1979–80. From 1988 to 1990, he was the director of the Art Center at the University of Rhode Island, where he curated major solo exhibitions of Bryan Hunt, Joan Jonas, Adrian Piper, and Lawrence Winer. In 1988 he opened the Willoughby Sharp Gallery in SoHo, New York, which reopened in 2000.

JOAN SIMON has been a writer for *Art in America* for a number of years and was the senior editor of the catalogue of the Bruce Nauman traveling retrospective in Madrid, Minneapolis, Los Angeles, Washington, and New York. She is the author of *Susan Rothenberg* (Harry N. Abrams, 2000) and she is currently working on a book on Joan Jonas for Johns Hopkins University Press/PAJ Books.

ROBERT STORR is an artist and critic and a senior curator in the Department of Painting and Sculpture at the Museum of Modern Art, New York. He has curated a wide range of modern and contemporary exhibitions, both at MoMA and at other institutions. He is also the author of many catalogues and brochures written in conjunction with these shows; monographs on artists such as Philip Guston, Chuck Close, and Louise Bourgeois; and books, essays and articles on a variety of artistic issues. His criticism appears regularly in major art journals and magazines, including *Artforum* and *Parkett,* and he is a contributing editor for *Art in America* and *Grand Street*. A frequent lecturer in this country and abroad, he has taught painting, drawing, art history, and criticism

at numerous colleges and art schools, such as Rhode Island School of Design, Tyler Art School, and the New York Studio School. He is a professor at The Graduate Center, CUNY, and has also taught at the Institute of Fine Arts, NYU, the Bard Center for Curatorial Studies, and Harvard University.

MARCIA TUCKER was the founder and director of the New Museum of Contemporary Art from 1977 to 1999, a museum dedicated to innovative art and artistic practice. She is the series editor of *Documentary Sources in Contemporary Art*, five books of theory and criticism published by the New Museum and MIT Press. Prior to founding the museum, she was curator of painting and sculpture at the Whitney Museum of American Art from 1969 to 1977. She has organized exhibitions, taught, written, lectured, and published widely in America and abroad.

COOSJE VAN BRUGGEN is the author of *Claes Oldenburg: Mouse Museum/Ray Gun Wing* (Cologne: Museum Ludwig, 1979); *The Realistic Imagination and Imaginary Reality of Claes Oldenburg* in *Claes Oldenburg: Drawings 1959–1969* (Valencia: IVAM Centro Julio Gonzalez, 1989); *Claes Oldenburg: Just Another Room* (Frankfurt am Main: Museum für Moderne Kunst, 1989); *Bruce Nauman* (Rizzoli International Publications, 1989); and *John Baldessari* (Rizzoli International Publications, 1990). Her essay, "Today Crossed Out," was published in 1991 in *Urzeit/Uhrzeit*, a limited edition artist book by Hanne Darboven (Rizzoli International Publications). She is co-author, with Claes Oldenburg, of *Claes Oldenburg/Coosje van Bruggen: Large-Scale Projects* (Monacelli Press, 1994). Her most recent publication is *Frank O. Gehry, Guggenheim Museum Bilbāo* (Guggenheim Museum Publications, 1997).

AMEI WALLACH is an art critic, author, filmmaker, television commentator, and president of AICA/USA. She contributes to the *New York Times* and its *Magazine*, as well as *The Nation, Town & Country, New York Magazine*, WNYC Radio, and MSNBC Internet. She is currently completing a feature film on the artist Louise Bourgeois, together with the filmmaker Marion Cajori. Her recent publications include *Ilya Kabakov: The Man Who Never Threw Anything Away* (Abrams, 1996) and *Reflections on Nature: Paintings by Joseph Raffael* (Abbeville, 1998). She is currently writing a book on Germany between the wars.

ANDREW WINER holds a B.A. in Fine Art from UCLA, an M.F.A. in Painting from CalArts, and an M.F.A. in English from the Program in Writing at the University of California at Irvine, where he currently teaches fiction writing. In addition to writing art criticism for various magazines and exhibiting his paintings in Los Angeles and New York, he has been a participant in the Squaw Valley Community of Writers, and has sold feature scripts to Hollywood. He is currently finishing his first novel.

JORG ZÜTTER has been director of the Museé Cantonal des Beaux-Arts, Lausanne, Switzerland, since 1991. He has edited books on Julian Schnabel, Bruce Nauman, Aristide Maillol, Balthus, Cobra, Gustave Courbet, and Christian Boltanski, among others. His most recent publications are *Le Sommeil ou quand la raison s'absente* (Lausanne, 1999) and *Ernest Biéler 1863–1948. Du réalisme à l'Art nouveau* (Lausanne, 1999–2000).

Credits

Grateful acknowledgment is made for permission to reprint from the following writers and publishers: Brooks Adams: "The Nauman Phenomenon," *Art and Auction* 13, no. 5, December 1990, Rotterdam, pp. 118–25; Kenneth Baker: "Nauman was the man to watch," *San Francisco Chronicle Datebook*, December 25–31, 1994; Neal Benezra: "Raw Material," *Art Press*, no. 184, Paris, October 1993, pp. 10–20; Neal Benezra: "Surveying Nauman," catalogue for the touring exhibition "Bruce Nauman," Museo Nacional Centro de Arte Reina Sofia, Madrid; Walker Art Center, Minneapolis; Museum of Contemporary Art, Los Angeles; Hirshhorn Museum and Sculpture Garden, Smithsonian Institution, Washington, D.C.; Museum of Modern Art, New York, 1993–1995. "Bruce Nauman," Walker Art Center, Minneapolis, 1994, pp. 13–46; Christopher Cordes: "Talking with Bruce Nauman," in *Bruce Nauman: Prints 1970–89* (New York: Leo Castelli Graphics, 1989), pp. 22–34; Regina Cornwell: "A Question of Public Interest," *Contemporanea* 3, no. 2 (New York, February 1990), pp. 38–45; Arthur C. Danto: "Bruce Nauman," *The Nation*, May 8, 1995; Nancy Goldring: "Identity: Representations of the Self," *Arts Magazine* 63, no. 7, New York, March 1989, p. 85; Jonathan Goodman: "From Hand to Mouth to Paper to Art: The Problems of Bruce Nauman's Drawings," *Arts Magazine*, February 1988; Kathryn Hixson: "Nauman: Good and Bad," *New Arts Examiner*, Chicago, December 1994; Joan Hugo: "Bruce Nauman," *Art issues* #35 (November/December 1994), © 2000 The Foundation for Advanced Critical Studies, Inc. Reprinted by permission; Ronald Jones: "Bruce Nauman," *frieze*, May 1995; Michael Kimmelman: "Space Under a Chair, Sound from a Coffin," *New York Times*, New York, April 24, 1994. Copyright © 1994 by the New York Times Co. Reprinted by permission; Jean-Charles Masséra: "Dance With the Law," in *Bruce Nauman*, catalogue for the touring exhibition "Bruce Nauman," Kunstmuseum, Wolfsburg; Centre Georges Pompidou, Paris; Hayward Gallery, London; Nykytaiteen Museo, Helsinki, 1997/1999. *Bruce Nauman* (London: South Bank Centre, 1998), pp. 20–33. A revised version of this essay has also appeared in *Amour, gloire et CAC 40. Esthétique, sexe, enterprise, croissance, mondialisation et médias*, P.O.L., Paris, 1999, pp. 59–60 and 193–217. Translated from French by Brian Holmes; Paul Mattick: "Bruce Nauman," *Trans* (Vol. 1, No. 1), 1995; Bruce Nauman: Epigraph to the book was originally published as a quote in "Eccentric Abstraction and Postminimalism," Robert C. Morgan, *Flash Art*, no. 144, January/February 1989, New York, p. 77; Tony Oursler: "Ways of Seeing: The Warped Vision of Bruce Nauman," *Paper Magazine*, April 1995, vol. II, no. 10, p. 104. Also published in the catalogue for the touring exhibition "Bruce Nauman," Kunstmuseum, Wolfsburg; Centre Georges Pompidou, Paris; Hayward Gallery, London; Nykytaiteen Museo, Helsinki, 1997/1999. *Bruce Nauman* (London: South Bank Centre, 1998); David Pagel: "Bruce Nauman," *Art issues* # 8 (December 1989/January 1990), © 2000 The Foundation for Advanced Critical Studies, Inc. Reprinted by permission; Peter Plagens: "Return of the Galisteo Kid," *Newsweek*, May 30, 1994. © 1994 *Newsweek*, Inc. All rights reserved. Reprinted by permission; Paul Richard: "Watch out! It's here!" *Washington Post*, November 3, 1994, *Washington Post*. Reprinted by permission; Jerry Saltz: "Assault and Battery, Surveillance and Captivity," *Arts Magazine* 63, no. 8, New York, April 1989, p. 13; Ingrid Schaffner: "Circling Oblivion/Bruce Nauman through Samuel Beckett," in *Bruce Nauman 1985–1996: Drawings, Prints & Related Works*, catalogue, Aldrich Museum of Contemporary Art, Ridgefield, Connecticut, 1997, pp. 15–31; Peter Schjeldahl: "Only Connect," *Village Voice*, January 20–26, 1982. Also published in *The Hydrogen Jukebox: Selected Writings of Peter Schjeldahl, 1978–1990* (Berkeley and Los Angeles: University of California Press, 1991), pp. 105–108; Peter Schjeldahl: "The Problem with Nauman," *Art in America*, New York, April 1994, pp. 82–91; Willoughby Sharp: "Interview," *Avalanche* (no. 2), winter 1971, pp. 22–23. Also published in the catalogue for the touring exhibition "Bruce Nauman," Kunstmuseum, Wolfsburg; Centre Georges Pompidou, Paris; Hayward Gallery,

London; Nykytaiteen Museo, Helsinki, 1997/1999. *Bruce Nauman* (London: South Bank Centre, 1998), pp. 88–97; Willoughby Sharp: "Interview," originally published as "Nauman Interview" in *Arts Magazine*, New York, March 1970; Joan Simon: "Breaking the Silence," *Art in America*, 76, New York, September 1988, no. 9, pp.140–203. Also published in the catalogue for the touring exhibition "Bruce Nauman," Kunstmuseum, Wolfsburg; Centre Georges Pompidou, Paris; Hayward Gallery, London; Nykytaiteen Museo, Helsinki, 1997/1999. *Bruce Nauman* (London: South Bank Centre, 1998). © Joan Simon 1988; Robert Storr: "Flashing Lights in the Shadow of Doubt," *MOMA Magazine*, Spring 1995; Marcia Tucker: "PheNAUMANology," *Artforum*, December 1970, no. 4, pp. 38–44. Also published in the catalogue for the touring exhibition "Bruce Nauman," Kunstmuseum, Wolfsburg; Centre Georges Pompidou, Paris; Hayward Gallery, London; Nykytaiteen Museo, Helsinki, 1997/1999. *Bruce Nauman* (London: South Bank Centre, 1998), pp. 82–87; Coosje van Bruggen. "Sounddance," in *Bruce Nauman* (New York: Rizzoli International, 1988); Amei Wallach: "Artist of the Showdown," *Newsday*, January 8, 1989. *Newsday*, Inc. © 1989. Reprinted with permission; Andrew Winer: "Bruce Nauman," *Art issues* #17 (April/May 1991), © 2000 The Foundation for Advanced Critical Studies, Inc. Reprinted by permission; Jorg Zütter: "Alienation of the Self, Command of the Other in the Work of Bruce Nauman," *Parkett* 27, 1991, pp. 155–58, translation David Britt. Reprinted with permission of Parkett Publishers; for writings and artworks by Bruce Nauman, grateful acknowledgment is made for reprint permission and photographic reproductions to the following: Artists Rights Society, New York; Art Resource, New York; Tate Gallery, London; Donald Young Gallery, Chicago; Emmanuel Hoffmann Foundation and the Museum of Contemporary Art Basel, Sperone Westwater Gallery; Collections du Centre Georges Pompidou, Musée national d'art moderne, Paris; Electronic Arts Intermix, New York.